Walt,

 It takes one
to know one!

 Marc

Collecting

AN UNRULY PASSION

*

Collecting

AN UNRULY PASSION

*

PSYCHOLOGICAL PERSPECTIVES

By Werner Muensterberger

PRINCETON UNIVERSITY PRESS

PRINCETON, NEW JERSEY

Library of Congress Cataloging-in-Publication Data
Muensterberger, Werner, 1913–
Collecting : an unruly passion : psychological perspectives /
by Werner Muensterberger.
p. cm.
Includes bibliographical references (p.) and index.
ISBN 0-691-03361-7
1. Collectors and collecting—Psychological aspects. I. Title.
AM231.M84 1993 93-2174

This book has been composed in Laser Palatino

Princeton University Press books are printed
on acid-free paper and meet the guidelines
for permanence and durability of the Committee
on Production Guidelines for Book Longevity
of the Council on Library Resources

Printed in the United States of America

2 4 6 8 10 9 7 5 3 1

For Helene

and

in memory of Nick

∗ *Contents* ∗

CONTENTS

* Preface *

THE SOURCE OF this book is curiosity, closely linked to the dimensions of my psychoanalytic work and my complementary research in anthropology, in the field as well as at the desk. The connection is in no way coincidental because the common aim is a deeper comprehension of the essential nature of man and my concern with the emotional content of the human experience as we find and observe it in the vast arsenal of affects, feelings, and perception.

My larger inquiry goes back several decades after reading Donald W. Winnicott's seminal essay on what he described as transitional objects and transitional phenomena providing a widened spectrum in our understanding of the intermediacy of "objects that are not part of the infant's body yet are not fully recognized as belonging to the external world," (p. 230).* Here Winnicott draws attention to the infant's integrative needs and capacity and the reliance on maternal and subsequently environmental support. The essence of this support is illusory because it depends on what the baby creates out of the object, regardless whether it is a doll, a blanket, a teddybear, even a lullaby. The importance lies in the experience of an object or, rather, the subjective relationship to the object, transitional or temporary as it may be, because it is meant to undo the trauma of aloneness when the infant discovers mother's absence. This is the causative factor for the baby's reaching out and, by having and holding the object, denying the fact of separation.

This point of view extends and enriches earlier psychoanalytic propositions with respect to the emotional antecedents of the motivational forces to collect.

This book is written from a psychoanalytic perspective. But while my findings concur with many previous approaches such as the obsessional leanings of the passionate collector, they

* See D. W. Winnicott, "Transitional Objects and Transitional Phenomena," *International Journal of Psycho-Analysis*, 34 (1953). Reprinted in *Collected Papers: Through Paediatrics to Psycho-Analysis* (London: Tavistock, 1958).

consider variables other than genetically defined fixations, and my widened outlook owes much to my talks with Donald and Clare Winnicott.

A study of this kind can only be carried out with the help and cooperation of many people and institutions. I benefited from my participation in a conference on "Collectors and Collecting," organized by Paul Mocsanyi at the New School for Social Research in New York, in the late 1960s. I spoke of "Why do we collect?" At the suggestion of my late friend Lionel Trilling I submitted an outline of my ideas to the John Simon Guggenheim Memorial Foundation, received a fellowship, and made the acquaintance of the president, the late Gordon Ray, himself a devoted book collector. We soon became friends. Mitchell S. Rosenthal, another friend, introduced me to a colleague, the late Douglas Bond, president of the Grant Foundation, which also decided to support my research. I gratefully acknowledge their interest and generosity.

My attempts to validate my ideas and theoretical approach owe much to patients, friends, colleagues, and the many collectors who understood my aim and cooperated with my project.

A number of collectors preferred to remain anonymous. I am much indebted to David Daniels for our talks at the early time of my project. They helped me to first scan the various libidinal forces accounting for the collector's zeal.

I have been fortunate in my meetings and correspondence with Sir David Attenborough, Frederick Baekeland, the late Marquess of Bath, Monique Barbier-Mueller, the late Peter Bull, Robert Benson, the late Bruce Chatwin, the late Ralph Colin, Andrew Ciechanowiecki, Giuseppe Eskenazi, Everett Fahy, Count Baudouin de Grunne, Carlos van Hasselt, E. Haverkamp-Begemann, the late H. P. Kraus, Annemarie Logan, Edward Lucie-Smith, the late Frits Lugt, Neil MacGregor, Malcolm MacLeod, Agnes Mongan, Carlo Monzino, the late A. N. L. Munby, Edgar Munhall, Peter Neubauer, J. W. Niemeijer, George Ortiz, the late Mario Praz, the late Charles Ratton, the late Nelson Rockefeller, Frieda Rosenthal, Francis Russell, David Sainsbury, Sir Robert and Lady Sainsbury, A. W. Scheller, the late Count Antoine Seilern, the Freules Six, David Somerset, the Duke of Beaufort, the late Paul Wallraf, the late Katherine White, N. M. A. ter Wolbeek, M. L. Wurfbain, and Helmut and Marianne Zimmer.

I thankfully acknowledge their readiness to talk to me and thus further my research.

My colleague Bernard L. Pacella was instrumental for an introduction to the Vatican where I found much cooperation from Msgrs. C. Brown, C. Rogers, and Mario Testori.

My inquiry in historical sources was much facilitated by the opportunity to work in that unique institution, the London Library. I want to thank the ever ready help of its chief librarian, Mr. Douglas Matthews and his staff as well as the staff of the Bibliothèque Nationale in Paris and Mr. T. D. Rogers at the Bodleian Library in Oxford and the Robinson Trust. The Hampstead Clinic in London kindly permitted me to consult their case histories with respect to children's collecting.

I am not sure whether this book would have seen daylight had it not been for Irwin Hersey's persistence and encouragement.

I am very appreciative of Elizabeth Dickey's, Benjamin Kilborne's, and Allen Rosenbaum's counsel after reading a draft of the manuscript. Mark Johnson assisted me patiently in the preparation of this book.

PART ONE

PRELUDES TO COLLECTING

*

* CHAPTER 1 *

Passion, or the Wellsprings of Collecting

CERTAIN ASPECTS of human conduct seem at first glance not at all exceptional or mysterious. Yet on closer inspection we see that they can be quite perplexing and not easily understood. One such trait is collecting. Collectors themselves—dedicated, serious, infatuated, beset—cannot explain or understand this often all-consuming drive, nor can they call a halt to their habit. Many are aware of a chronic restiveness that can be curbed only by more finds or yet another acquisition. A recent discovery or another purchase may assuage the hunger, but it never fully satisfies it. Is it an obsession? An addiction? Is it a passion or urge, or perhaps a need to hold, to possess, to accumulate?

Observing collectors, one soon discovers an unrelenting need, even hunger, for acquisitions. This ongoing search is a core element of their personality. It is linked to far deeper roots. It turns out to be a tendency which derives from a not immediately discernible sense memory of deprivation or loss or vulnerability and a subsequent longing for substitution, closely allied with moodiness and depressive leanings.

It is not even the phenomenon of collecting as such which may seem strange to the outsider, but rather the spectacle many collectors make of themselves, their emotional involvement in the pursuit of objects, their excitement or distress in finding or losing them, and their at times peculiar attitudes and behavior. Indeed, a detached observer often finds it difficult to understand the immense passion and overriding concern a collector can exhibit about such things as old maps or a rare coin or military ribbons.

Is it more like an unquenchable thirst? Even a very serious and reflective collector is hard put to offer a clear, convincing explanation of his inclination or the intense emotion that occasionally occurs in the process of obtaining an object.

The aim of this book is to throw some light upon the habits of collectors in an effort to answer these questions and explore the

underlying emotional and experiential conditions that provide a setting for this kind of craving. In order to do so, I shall first offer a definition of what I consider collecting. I will define collecting simply as *the selecting, gathering, and keeping of objects of subjective value.* Note that I emphasize the subjective aspect of collecting because the emotion and often the ardor attached to the collected object or objects is not necessarily commensurate with its specialness or commercial value, nor does it relate to any kind of usefulness. To the truly dedicated collector, the "things" he collects have a different meaning and indeed even a potentially captivating force.

It is, of course, a given that whatever is collected is of particular significance to the individual collector. Obviously, his collection is bound to reflect certain aspects of his own personality, his taste, his sophistication or naïveté; his independence of choice or his reliance on the judgment of others. While others go their own independent way with no need for role models and with little or no regard for what is in fashion in this respect, many collectors tend to be affected by current trends or the opinion of fellow collectors, specialists, or dealers.

Here is a reason why it is not uncommon to find collectors among the nouveaux riches, for the objects contribute to their sense of identity and function as a source of self-definition. They then seem to justify a feeling of pride, even superiority.

Irrespective of what kind of objects collectors choose to assemble, there are clues that help us understand their behavior and the nature of their passion, which is often marked by feelings of exhilaration and states of transport but is also reflected in moments of tension, sensations of distress or restless nights, and harrowing doubts. Often the very process of acquisition is a transparent source of excitement, though at the same time it may prompt stirrings of guilt and dis-ease. If one observes collectors in pursuit of an object, one quickly recognizes conspicuously telling individual attributes—the different ways of how they go about acquiring a new object, how they express their craving, or how they transmit overwhelming feelings of pleasure; on the other hand, after having obtained an object, they may maltreat themselves with doubts and self-reproach, often quite incomprehensible to the noncollector. For there is no "average collector."

Many years ago, I was fortunate enough to make the acquaintance of an outstanding and truly dedicated man, Georg Tillmann. A German by birth, he was first known as a collector of exquisite porcelain. Scholars, always welcome guests in his house, made studies of many objects in his possession. He visibly enjoyed company with which he and occasionally his wife could share his interest. His astonishing knowledge and discerning eye enabled him to assemble superb specimens, and his name is still mentioned with awe among porcelain connoisseurs to this day, more than half a century after his death.

Tillmann eventually left his native Hamburg for the Netherlands where he first became acquainted with ethnographica, especially Indonesian works of art and textiles. Here, not at all untypical for collectors, he embarked on an entirely new collection, containing predominantly sculptures and textiles from West and Central Africa, Indonesia, and the Pacific. As before with porcelain, he ventured into his newfound field with zeal and thoroughness, and the sure instinct of a man of impeccable taste. He sent scouts to Indonesia and West Africa, again sought the acquaintance of specialists in the respective fields, and soon became as knowledgeable as he had been with porcelain.

Tillmann was a very engaged collector who liked to share his enthusiasm with like-minded people—fellow collectors, specialists, students, and aestheticians. He also kept an extensive correspondence and often had prominent scholars as houseguests, who had a small cottage located behind his townhouse at their disposal. A man with boundless energy, he was often carried away with a new find, a recent purchase, or the result of his last research. There seemed to be no end to his passion. Among other things, he made a study of Indonesian textile designs, and discovering what he felt was a hitherto unknown or different pattern or type was like a spiritual victory for him, and quickly became an incentive for elaborate enquiries and spirited discussions. I recall when my telephone rang long after midnight. When I answered, he did not even mention his name but spoke right away about an exquisite African mask he had just brought from Paris and asked me to come over and share his excitement.

A telephone call at any hour of day or night was no exception. It was a testimony to his total engagement. When in the company of fellow collectors or scholars, he often forgot about

time and conventions, not infrequently carrying on conversations until the early morning hours. Such conversations usually took place in a very large kitchen clearly designed for the purpose because these gatherings were often accompanied by memorable meals which he himself would prepare while continuing to talk with his guests about this or that object either in his collection or in a museum or in somebody else's hands.

I am sketching this setting because scenarios of this kind are not at all uncommon among collectors who delight in sharing their joy and appreciation with like-minded enthusiasts. Such dedication of collectors can be all-absorbing—now and then exhilarating, at times tyrannizing, and, indeed, occasionally ruinous.

In some instances collecting can become an all-consuming passion, not unlike the dedication of a compulsive gambler to the gaming table—to the point where it can affect a person's life and become *the* paramount concern in his or her pursuit, overshadowing all else: work, family, social obligations and responsibilities. We know of numerous cases in which moral standards, legal considerations, and societal taboos have been disregarded in the passion to collect.

Historical examples of this mental attitude are indeed too numerous to mention. There was, as an instance, Philip von Stosch (1691–1757), a German scholar and antiquarian, who became a willing spy for the British government in order to fulfill his overwhelming passion for the finest gems, and apparently thought nothing of stealing from collections he was invited to visit as one of the foremost experts of his day. Or take Sir Thomas Phillipps (1792–1872), who, in his never-ending pursuit of "one copy of every book in the world," was not perturbed by letting his wife and daughters live in squalor and putting off his material obligations to the suppliers of his books and manuscripts for years, in some cases driving the dealers to bankruptcy. Even so august a collector as Queen Christina of Sweden, whom Hugh Trevor-Roper described as "that dreadful woman, the crowned termagant and predatory bluestocking of the North,"[1] was not above letting her passion swamp her moral sense, as in 1648, when she seized the extraordinary art collection of Rudolf II, Holy Roman Emperor, only a few days before

the Peace of Westphalia, bringing an end to the Thirty Years' War, was to be signed.

In the context of our observations, there is a valuable lesson to be learned from such examples. For the dedicated, the "hooked" collector—an occasionally fitting designation used by some collectors in referring to their own habit—the experience is not simply recreational but an enriching respite from the sometimes frustrating demands of everyday life. My focus is psychological. By that I mean that I want to explore the generative conditions leading up to the cause of the collector's obsessional infatuation with the objects. Their presence reduces—for a period—an inner longing or, in psychoanalytic terms, the tension between id and ego. Inner longing and external representation achieve a temporary balance. Anyone acquainted with habitual collectors is well aware of how much of their time and effort is absorbed by their hobby and how the never-ending search for yet another acquisition generates excitement, anxious expectations, a thrill, but also, almost unavoidably, uncertainty and indecision as well. At the same time, it is transparent that this kind of involvement has also other dimensions and is usually determined by unconscious concerns as a device to screen off and master deeper doubts and ambiguities, a point I shall deal with in greater detail.

Still, I must emphasize that, while the response to ownership, the love of one's possessions, the inner pressure for more and more acquisitions, and the manner of giving expression to the ownership of the objects, among other things, exist in all collectors, neither personal style nor circumstances are ever identical. Rather, they differ according to the inner causes or what one might describe as the particular individual's *collecting sentiments*. This is true even when collectors pursue similar objects and similar aims.

Indeed, each single item in a collection usually has a distinct meaning for the owner, and this meaning is inevitably determined by a great many external and experiential factors. Thus, while two collectors may crave the same object (think of several bidders for a specimen in the salesroom), their causal reason for desiring it, and the way they may go about obtaining it, may be, and usually are, entirely different. As a result, their individual

7

choices or tastes may coincide, but what drives them depends on their personality, on particular sociocultural conditions, and, in a deeper sense, on the nature of their antecedent mental experience.

There is, then, a distinctly individual and often wide disparity in the private incentives that motivate collectors. My stress lies on the affective value which pari passu contains both a projective and a creative element by contributing to the collector's fantasy world. The reasons they themselves give for their infatuation, their taste, and their personal preferences are, needless to say, subjective, and, considering the unavoidable self-consciousness of collectors I have interviewed, I tend to question the validity of the various conscious explanations they give in this regard. Taste, choice, style are inevitably affected, albeit often unconsciously, by the Zeitgeist, the spirit and the sociocultural climate of an era.

What concerns us here is the question of the causality of the drive to collect. This can only be understood if one is aware of certain underlying factors, the most important of which is the constant search for new objects, new additions or acquisitions. My emphasis is on the overwhelming significance of *objects* to the collector. In this context I should stress that the area of specialization is not without relevance, but my focus is centered on the complexity of the collector's total experience.

It is this aspect of his or her concerns that should provide some clues to the individual collector's urge if not nagging obsession. It is an intrinsic element in any collector's repertoire, although it should be evident that this is but a surface deflection. I could describe it as a feedback mechanism arising from deeper needs and salient causes. There is an essential underlying condition that is reflected in the collector's use of the object.

Observing dedicated collectors in their often consuming pursuits, one can detect an overmastering search for objects. Paying attention to certain people as they browse through flea markets, one has here and there a chance to recognize a kind of persistence behind which seems to lie a compulsive preoccupation, and like all compulsive action is molded by irrational impulses. As I shall describe shortly, these may range from such concrete incidents as physical hurt or emotional trauma or actual neglect

to more or less tangible states of alarm and anxiety, particularly when no real help and comfort was forthcoming. In one case, I encountered a collector of bells of all sorts, from cowbells from the Swiss Alps to Tibetan prayer bells and Chinese temple bells. I soon learned that the man had been brought up in a Catholic missionary orphanage under conditions that seemed pitifully grim and depressing. Only the sound of the bells of the little mission church had seemed to provide some source of comfort. There may be other considerations that motivated this man, but there is much empirical evidence to indicate how crucial such childhood experiences are.

The significance of early events like these lies in the fact that they may establish a disposition for special techniques to alleviate the lingering dread of a repetition of exposure to trauma providing the hurt child with a sense of security. Child observation shows us that the infant may look to alternative solutions for dealing with the anticipation of vulnerability, of aloneness and anxiety, and often will be looking for a tangible object like a comforter, a cushiony doll, or the proverbial security blanket to provide solace which is not, or rather was not, forthcoming. Thus, the collector, not unlike the religious believer, assigns power and value to these objects because their presence and possession seems to have a modifying—usually pleasure-giving—function in the owner's mental state. From this point of view objects of this kind serve as a powerful help in keeping anxiety or uncertainty under control. This has little to do with an objective appraisal of the actual situation. Rather, emotionally fragile children may just be afraid of the dark and seek protection by holding on to an object that will, in the child's mind, magically alleviate the dread of aloneness and provide instant support.

Thus, favoring things instead of people may be one of several solutions for dealing with emotions that echo old traumata and uncertainties. What I am suggesting is that affection becomes attached to *things*, which in the eyes of the beholder can become animatized like the amulets and fetishes of preliterate humankind or the holy relics of the religionist. Such special objects may even be given a name, like a person, and help assure the child of companionship and open an avenue for mastering doubt and anxiety.

This is not a fanciful assumption. Many observers have pointed out how one or the other kind of fear or anxiety can invoke a wide array of precautionary measures. Giving a doll or some other object a "soul" or a name is one telling example. This is a phenomenon anthropologists are long acquainted with. It is known as animism. In psychological terms, it has been described as "attachment," or "clinging response," not only among children but in adults as well.

The concrete manifestations vary. Some people remember a favorite toy; others recall the first attempts at collecting baseball cards or campaign buttons, or perhaps going in search of shells or minerals. Preferences and taste are under the influence of prevailing trends and environmental conditions, especially as one grows older. Still, despite all possible variations, there is reason to believe that the true source of the habit is the emotional state leading to a more or less perpetual attempt to surround oneself with magically potent objects.

Over many decades, I have encountered all kinds of collectors, from all walks of life, of all different ages, ranging from children to octogenarians. Some of them recalled childhood events of a clearly circumscribed kind, which caused anxiety—war, a parent's suicide, prolonged illness, physical handicaps, death of a sibling, or simply not-good-enough early care. As one example, I shall discuss the case of one of France's most outstanding authors, Honoré de Balzac, who suffered from parental neglect throughout his childhood. Regardless of his eventual achievements as an author as well as a man of the world, it remained a gnawing pain and led to his restless pursuit of various possessions: bric-à-brac, paintings, porcelain, rare carpets—anything that struck his momentary fancy. Or there is the example of Sir Thomas Phillipps (whom I have mentioned before), an utterly capricious and stubborn personality who clearly took up the collecting habit out of severe inner problems. Born out of wedlock, he grew up without any maternal care. His first ostensible interest was in local documents such as church registers and gravestone inscriptions. It is not difficult to suspect that this manic interest—first in the history of his county in the Cotswolds in England, later in other sources of historical relevance, and eventually in any sort of printed material—was intimately connected with the circumstance of his illegitimate birth.

Some of my informants had had traumatic war experiences or had suffered from severe childhood diseases. Others were torn between divorced parents. The Marquess of Bath recalled his mother as being an invalid for as long as he could remember.

Whatever the motivation, there is little question that collecting is much more than the simple experience of pleasure. If that was the case, one butterfly, or one painting, would be enough. Instead, repetition is mandatory. Repeated acquisitions serve as a vehicle to cope with inner uncertainty, a way of dealing with the dread of renewed anxiety, with confusing problems of need and longing. The sense following the acquisition is usually that of blissful satisfaction and excitement, at times accompanied by flagrantly exhibitionistic elation (as I spoke of when Georg Tillmann wanted to show me an object he had just brought home, even though it was long after midnight).

Perhaps a look at a rather different kind of collecting will shed some light on some underlying driving factors. There are, to be sure, all sorts of collectors and facets of collecting. While one would ordinarily not think of the infamous Spanish nobleman Don Juan Tenerio as a collector, did he not in fact *collect* the chaste young maidens he seduced one after the other?

A young patient of mine, to all appearances a good-looking man of superior intelligence, self-possessed, well spoken, and in his mid-twenties, seemed to be following in the footsteps of the original Don Juan. He used to refer to the numerous women who caught his fancy and whom he was able to seduce as *objects*. "I discovered an irresistible object in the subway," he began one of his sessions, not without challenging pomposity. He had little love for these young ladies who used to fall for him. He idolized them as long as they were out of reach and served as subjects for his fantasies. Their main attraction lay in the kind of a pleasantly hallucinatory state they first evoked in him. The less accessible they were, the more infatuated he became, and he would find strikingly ingenious ways to approach them and make his pitch.

The final "conquest," as he liked to put it, had a magical, but unfortunately only momentary, healing effect on his deeply disturbed self-image, for his sense of victory was always short-lived. Once he had succeeded in his seduction maneuvers, he was in pursuit of yet another conquest.

11

The Don Juan theme has inspired nearly four hundred varia-
tions and artistic elaborations since the Spanish monk who
wrote under the assumed name of Tirso de Molina brought out
the first play about him, *El Burlador de Seville* (*The Rake of Seville*),
in the seventeenth century. All these plays and operas depict in
a variety of colorful details the wish-fulfilling fantasies of Don
Juan, and all suggest an ardent yearning, a driven passion that
can only be checked for a short while, but never fully mastered
or gratified.

The lustful escapades of Don Juan were not just an unusual
young man's unusual adventures. C. G. Jung might have seen
Don Juan as the archetype of prurience and fickleness. How-
ever, this would be a lopsided interpretation of the true nature
of his instinctual demands. Don Juan is more than simply a
champion of license and lustfulness. He is not driven by a plau-
sible purpose or concerned with understanding his amorous ad-
ventures. Notwithstanding his numerous affairs, he is sensitive
to his own feelings. He is not truly loving but in need of reassur-
ance that he is wanted and lovable. In essence he is lonely and
forever trying to gain reassurance from what our young Don
Juan described as *objects*.

Against this background, it can be seen that much of what has
been said about the Don Juan also applies to many devoted and
passionate collectors. The intricacies of the find; its discovery or
attainment; the sometimes clever ploys utilized to effect an ac-
quisition; the fortuitous circumstances of the lucky strike; the
energy expended in obtaining the object, and occasionally the
waste of time; the preoccupation with the challenge, with ri-
valry and jealousy—all these emotions are shared by devoted
collectors and Don Juans alike.

Seen as a script, the quest of the Don Juan does not vary ap-
preciably from that of the fervent collector. Both savor the re-
wards with at least a preconscious knowledge that no acquisi-
tion, no new encounter, will break the spell. An old and often
well-disguised urge, an emotional hunger, seems to lay the
foundation for this needfulness. It is frequently accompanied by
a vivid and even imaginative fantasy that embodies the inner
drama the satisfaction-seeking collector can experience.

This unconsciously continual urge motivates the search—an-
other woman in the case of the Don Juan; another painting or

clock or autograph in the case of the collector. The true significance lies in the, as it were, momentary undoing of frustrating neediness but is felt as an experience of omnipotence. Like hunger, which must be sated, the obtainment of one more object does not bring an end to the longing. Instead, it is the *recurrence* of the experience that explains the collector's mental attitude. The compelling concern to go in search, to discover, to add to one's store, or holding, or harem, is not generated by conscious planning. Rather, every new addition, whether found, given, bought, discovered, or even stolen, bears the stamp of promise and magical compensation. It can as well be understood as a momentary symbolic *experiment* in self-healing of an ever-present sense of frustration. The successful *experiment* is usually followed by a short-lived sense of elation, of triumph and mastery.

I have followed the trail of these emotional conditions in the life histories of many collectors. They reveal the need of the phallic-narcissistic personality. We see them in show-offs of all kinds. They like to pose or make a spectacle of their possessions. But one soon realizes that these possessions, regardless of their value or significance, are but stand-ins for themselves. And while they use their objects for inner security and outer applause, their deep inner function is to screen off self-doubt and unassimilated memories. The roots of their passion can almost always be traced back to their formative years, often hidden from their conscious awareness. In the light of these personal histories, sometimes remembered, in other cases reconstructed, or only perceived as hurtful or arduous, we see how collecting has become an almost magical means for undoing the strains and stresses of early life and achieving the promise of goodness.

First Possessions

Listen to a dedicated collector's penetrating observation regarding his own habits: "The most profound enchantment for the collector is the locking of individual items within a magic circle in which they are fixed as the final thrill, the thrill of acquisition, passes over them. . . . One has only to watch a collector handle the objects in his glass case. As he holds them in his hands, he seems to be seeing through them into their distant past as though inspired."[2]

This is part of a self-observation by Walter Benjamin, a highly perceptive essayist who loved books. Benjamin was musing over his books' past. But here, quite obviously, the books' past and the collector's harking back to his own early experiences and memories, seem to merge. It is almost as if the new owner is reliving old, hidden, and either actual or perhaps illusory sensations of former times, and, in doing so, ascribes to his objects a life and history of their own.

Thus, by searching for objects and, with any luck, discovering and obtaining them, the passionate collector combines his own re-created past consoling experiences with the fantasied past of his objects in an almost mystical union.

It is the fiber of these sensations—the excitement of possession, with all its attributes—with which we are concerned here, since we are seeking to find the generative force unconsciously influencing these emotions. If we are to comprehend the collecting phenomenon, we must first pay attention to the striking intensity—sometimes all-consuming and, to the onlooker, rather bewildering—with which the dedicated collector pursues his aim.

What Walter Benjamin described as the collector's "most profound enchantment" is reminiscent of the joy children show over a Christmas or birthday present. This joy is not born out of greed or covetousness, but goes much deeper. It leads back to unconscious or concealed memories, to profound hopes and desires.

It is of course true that the pleasure of collecting is prompted by a delight in possessions. While a book, or a glass, or an old typewriter is to most people simply an object, to the knowing collector, such an object, in Benjamin's words, lives "the period, the region, the craftsmanship, the former owner."[3]

These are the elements that imbue the object with magic or *mana*. (Here, *mana* is taken to mean an intrinsic life force, in the same sense as when the concept is used by the native Melanesians. I shall return to this aspect of experience later.)

It would be an oversimplification to view the collector's longing for objects as an irrational passion. Nor would I do collectors justice by describing the thrill of acquisition as a "discharge of tension," or by reducing what is often a suspenseful, occasionally dramatic, and not always rational state of mind to any schematizing formula. To the passionate collector, no formula or definition can truly express the inner experience he or she undergoes when contemplating and possibly acquiring another new object. Moreover, the visible manifestations of this experience do not tell us, as observers, any more than the fact that the objects collected seem to have a special meaning to their owner, and in fact that they seem to hold a curious power over him or her. I am not reducing the collector's objective or infatuation to an emotional, let alone pathological, state of mind. We are simply trying to comprehend the nature of the collector's unconscious motivations, to trace the affective mainsprings of his zeal and yearning.

In essence, collecting is a highly personal and more often than not solitary affair, as Walter Benjamin clearly understood. "Ownership is the most intimate relationship one can have to objects," he noted. "Not that they come alive in him; it is he who lives in them."[4]

No collector would quarrel with this portrait. In its deliberate subjectivity, it characterizes the transfiguration of objects in the collector's mind. It echoes emotions that have their roots in old affective experiences of oneness; in early sensations of wish fulfillment, and in relief of the child's anxiety and frustration that comes with feeling helpless and being alone. Objects in the collector's experience, real or imagined, allow for a magical escape into a remote and private world. This is perhaps the most intriguing aspect in any collector's scenario. But it is not enough

to escape to this world only once, or even from time to time. Since it represents an experience of triumph in defense against anxiety and the fear of loss, the return must be effected over and over again.

As noted, there is a resemblance here to the recurring state of hunger, and the periodic need for replenishment, with variations in the reliving of the experience itself. Regardless of how often and how much one ingests, within a few hours hunger returns and one must eat again.

Not surprisingly, these phenomena have their root in early childhood. They originate in the baby's experiences not simply with hunger and satiety but with the subjective perception of closeness and belief or, negatively, doubt in magical control. This is usually perceived as a sense of emptiness and disillusionment and the need for both physical and emotional replenishment. Thus, the values attached to one's holdings usually follow an earlier affective prototype of yearning.

In this inner affective state, a soft doll or the edge of a pillow or blanket can provide a sense of touch and the illusion of protection against the dread of being alone and powerless. Later, a toy or some special object can bring the same kind of comfort, thus providing the first passion for possession.[5]

This reference to passion harbors within it the predicament of passivity, almost as though the experience of helplessness lies at the core of the collector's habituation.[6] Walter Benjamin instinctively knew this, for there is in every collector's plight the dialectic tension that exists between rational thought and the force of passion.

If, within this ambiguous climate, we search for the antecedents of the collector's dilemma, it is the demonstrably emotional significance of the child's earliest tangible possessions which lies at the heart of the matter. These are the objects that are always there when the child's need for comfort and a soothing touch is not immediately met; when the child does not have a mother's breast, or a loving pair of arms to allay frustration.

Having discovered the palliative effect of her doll or his teddy bear, the infant soon tends to credit these first possessions with magical power. Out of this intricate nexus of helplessness and let-down, and the comforting relief inherent in touching and

16

holding the object and *having* it, arises the relief from anxiety together with the growing notion that loving care is not always immediately at hand. Children perceive the object or objects in a subjective way.

In each situation internal factors and external circumstances account for the evolving pattern meant to heal the scars of early injuries. Whatever the visible response, it is always marked by some kind of emotional disengagement and by the sheer limitless variety of individual adaptive measures.[7] They may be cautious or boastful, depressed or grandiose, but it implies that they always echo the disappointment or occasional trauma suffered at the time of total dependence on others.

My late friend Katherine White, a prominent American collector of African art, understood this essential link between her childhood experiences and her later devotion to works of art, particularly the hundreds of African masks and sculptures with which she used to surround herself. She was not at all surprised by my inquiry about the origins of her specific interest. In fact, since several people had asked her the same question, she put some of her childhood memories in writing:

> My mother collected as a matter of course. She grew up on a southern plantation in the motionless years after the Civil War. ... My father was killed in an automobile crash when I was three months old, leaving mother to raise the five of us alone. ...
>
> Mother's determination to instill in us what she called herself 'an inquiring mind' saw our growing years pelted with a variety of meaningful exposures. Our trips together were a series of grand entrances into places like the Mellon Gallery, the Smithsonian, the Peabody, the Gaspe Peninsula, Stratford Hall, tours of Natchez, Capistrano, Old Gump's Department Store, Yosemite Park, and the archaeological mesas of New Mexico.
>
> We graduated with the 'cathedral treatment' in Europe when we were at the proper age. And so it was the accident happened. The postcard counter at the Cathedral of Poitiers had among its souvenirs a little American handworn figure astride an antelope.[8]

Kat, as her friends called her, soon began buying all sorts of art objects, ranging from Japanese temple guardians to Navaho bracelets and African artefacts of all kinds, until her large house was once described as "nothing but a rat's nest of precious ob-

jects."[9] Despite all the attention lavished upon her, Kat was not a happy child. Much of her upbringing stemmed from her mother's personal style and widowhood. The fact that she was fatherless and the character of her mother had left their marks on Kat's personality, and she was well aware of this.

People tend to search in later life for the equivalents of the love and tenderness they may have lacked during their early years. Some find relief in religious pursuits; others in an identification with those in need of care and protection. They then become helpers and caretakers such as nurses or even physicians. Still others turn to supposedly magical aids such as alcohol or drugs or indulge in a never-ending search for some kind of cause or some kind of goal to find an expression for their need to relate.

In view of the demonstrable connections between childhood experiences and the adult's personality, it is evident that, if we are to learn what motivates dedicated collectors, we must first examine the various stages in a child's emotional development as the vicissitudes of early life inevitably leave their mark and have their instructive (or destructive) effect on the person's individuality.

To begin with, intimate body contact—touch and suckling—are the first instances of a baby's need for gratification. It is apparent that the feelings that accompany this initial care are of cardinal significance. Is the mother or the mothering person warm and caring, or inattentive or impatient? Was the baby wanted or unwelcome? While the infant's responses to conditions such as these seem soon forgotten, they cannot fail to have an effect on later character development. At a time when helplessness coincides with hopelessness and anxiety, it is easy to see how the first use of defenses such as inklings of magical solutions help tolerate infantile frustrations and come to the baby's rescue. Security is sought elsewhere. The notion of symbolic substitutes is but a short distance from these circumstances.

Take thumb sucking, for example. It is an intuitive substitution for the mother's nipple at the time of weaning or a reaction to the fear of the loss of the nipple and at the same time a means of reassurance. Or should we say that it represents a first step

toward self-sufficiency when the environmental provision is in-adequate or no longer available?

It may be one or the other or conceivably rooted in the baby's living experience. It would be difficult to determine the various elements involved in a child's constant search for substitutes for attachment and tangible closeness. One point is beyond ques-tion: the baby is in need of satisfaction, and may also be halluci-nating a state of well-being and security. But I must emphasize here that the thumb, unlike the nipple, does not supply milk, and a doll, no matter how soft and cushiony, is not a warm com-forting human body. Nonetheless, regardless of such imperfec-tions, the thumb does provide some presence in the mouth and the doll does offer some indication that touch is more than just interacting with another human body. The thumb and the doll thus give the child relief from distress and offer a measure of contentment in the face of frustration, and so imagined or bor-rowed security is provided by handy substitutes. In other words, the thumb and the doll are subjectively invented alter-nates solely to come to terms with insufficient care or other trau-mata at an early age.

This all too brief outline delineates the wider implications of basic factors arising from the interlocking of biological needs and environmental conditions, and the consequences for the child's emotional responses. There is no doubt about the lasting importance of these factors in the development of the child's personality and his or her subsequent motivations in later life. Here is a vast spectrum of experiences and responses that form the basis for future susceptibility to frustration, to vulnerability, to doubt or trust, to introversion and a sense of self-reliance.

It will be noted that this is the kind of dialectical predicament in which the habitual collector finds himself. Particular modes of response to inner and outer stimuli, like grasping and cling-ing and, at a later point, exhibitionistic leanings or accumulative inclinations—characteristics that, to be sure, are quite similar to those found in a goodly number of collectors—can be under-stood to be derivatives of experiences during the crucial steps of individuation.

Seen from this angle, it is easy to understand how a person's basic outlook and attitudes are essentially molded by the effects

of inner processes and outer conditions as well as the overall tone of his total environment; in particular the mode of care and mothering the child receives during the crucial phases of early development.

Much the same is true of other childhood bodily experiences such as bowel training and learning to walk. Collectors are often referred to as anal-retentive types. This, too, has a basis in infancy.

We know from experience that the young child is only gradually prepared and able to hold on to his excretion. And then it may feel good "to collect the stuff and hold it for a while before passing it on."[10] Winnicott refers here to a physiological action which under certain circumstances can contribute to a sense of mastery. But this is not simply mastery over one's bowels. The child soon learns that by holding on or opening up, he or she is in command.

It is already possible here to perceive an echo of certain collectors' dispositions. Once they are actually in possession of a cherished object, they will never let go of it. They may want to show it or they may keep it hidden from anybody else. This is reminiscent of many children's attitude toward their playthings. By the time they have reached that stage of behavior, much has already occurred in the preceding phases. Stubbornness and the symbolic meaning of holding back or letting go are inherently fostered by the emotional conditions of the infant to that stage and the interaction with the immediate environment.

In Western culture, bowel training often coincides with the weaning process,[11] and depending on the ability of the mother to provide the appropriate conditions may frustrate the child and endanger the trust and confidence he has placed in those around him, and thus provoke anxiety. It is often during this period that withholding and collecting his feces essentially constitute a shield against what is construed as threats or deprivation, thus initiating primitivistic defenses such as compulsive obstinacy with the aim to control a sense of deprivation, but, what is more, to express alarm about the more hidden fear of object loss. In fact, infants' reactions can be very complicated. For example, they may derive satisfaction from gathering and clinging to fecal matter or instead make a mess, attitudes that may eventually play an overwhelming part in the broader ap-

proach to ways of collecting—namely, tendencies to select or, on the other hand, to make heaps, or in terms of our context, to hoard indiscriminately.

It is certain that a child's early experiences with excretory functions have an influence later on the adult's ways of giving and taking, of holding back or letting go. Building up "heaps of things" in a collection or piling up money or amassing rubbish such as old newspapers, empty beer cans, or discarded umbrellas, in addition to equally useless items (as I had an opportunity to observe in an aging spinster), often clearly and quite understandably functions as a bulwark against deep-rooted uncertainties and existential dread.

In this regard it has been argued that the typical collector represents an "anal type" who gains satisfaction from symbolic equivalents, much like the toddler who builds mudpies instead of playing with his excretion. "The childhood attitude toward feces is often found transplanted into the later attitude toward the individual's personal achievements. . . . The anal retention, which always contains the two components, fear of loss and enjoyment of a new erogenous pleasure, may also be displaced to another object. Cupidity and collecting mania, as well as prodigality, have their correlating determinants in the infantile attitude toward feces," Otto Fenichel explained.[12]

Provoked by early, possibly unfavorable conditions or the lack of affection on the part of not-good-enough mothering, the child's attempt toward self-preservation quickly turns to some substitute to cling to. Thus, he or she has a need for compensatory objects of one or the other kind. This can also be interpreted as a self-healing attempt. In later life, this attitude leads to a biased weighting for more money or more possessions, as if they could provide magic protection and shield the individual from new frustrations and anxieties.

To put it in another way, such a person requires symbolic substitutes to cope with a world he or she regards as basically unfriendly, even hazardous. So long as he or she can touch and hold and possess and, most importantly, replenish, these surrogates constitute a guarantee of emotional support.

Here one can recognize the first specific link to the grip that the obsessional collector cannot and will not shake off. There is a good deal of logic behind the child's inclination to restore

what has been taken away. But what I am dealing with goes beyond the harmless desire to substitute one thing for another. If a frustrated child responds to not-good-enough mothering, or one or the other kind of harm or injury, by attempting to protect himself against new hurt or disillusionment, the objects he clings to can become a shield against all sorts of dangers, real or imagined. As such, they provide the child with a feeling of mastery and a measure of independence. This is illusory, but it is entirely appropriate and, under the circumstances, an efficacious device.

Freud offered an illuminating example of that magic experience of ownership and control. He had noticed certain routines in what seemed to be play in the behavior of his eighteen-months-old grandson. The little boy had the habit of throwing toys into a corner of the room or under the bed. He had also invented a game with a wooden reel to which a string was attached. When he threw the reel over the edge of his bed, it disappeared. He then mourned the disappearance with an "o-o-o-o" sound, expressing an at the moment puzzling reaction. He pulled the reel up again and hailed its reappearance with a joyful "da" (there).

This was a kind of ritual game. What the little boy enacted was a particular sequence: disappearance, apparent loss, and eventual return. He translated into action a specific series of events, and Freud found the key to his grandson's creative action.

> A further observation subsequently confirmed the interpretation fully. One day the child's mother had been away for several hours and on her return was met by the words, 'Baby, o-o-o-o!' which was at first incomprehensible. It soon turned out, however, that during this long period of solitude the child had found a method of making himself disappear. He had discovered his reflection in a full-length mirror which did not quite reach to the ground, so that by crouching down he could make his mirror-image 'gone'.
>
> The interpretation of the game then became obvious. It was related to the child's great cultural achievement—the instinctual renunciation. . . . which he had made in allowing his mother to go away without protesting. He compensated himself for this, as it

were, by staging the disappearance and return of the objects within reach. . . . At the outset he was in a *passive* situation—he was overpowered by an experience; but by repeating it, unpleasurable though it was, as a game, he took on an active part.[13]

This was not simply a little boy's amusing game. Instead of grumbling over his mother's temporary disappearance, he actively tried to overcome what might have been a residue of separation anxiety. In his mother's absence, he found a substitute companion—himself, in the reflection in the mirror. In addition, there was also a measure of retaliation in the gesture to exorcize the disappointing mother, or possibly even to throw her away. But then it was he who threw her away, and it was thanks to his action that brought her back. It was a magical act that made him feel powerful and gave him a sense of control.

It goes without saying, a mother's or nurse's short absence is part of any child's experience. But in view of the baby's physical and emotional fragility, even a short separation at an inappropriate time or in a strange surrounding can be disheartening and suspend feelings of confidence, trust, and safety. Together with discomfort or pain or thirst or the overall awareness of helplessness, feeling separated and quite literally out of touch is such a critical revelation of vulnerability that it can decisively influence the basic fabric of all further emotional and social development.

It is at this point that imagination and occasionally hallucination and such healthy creative inventions as the game with the string and the reel usher in an age of new awareness, of discovery and mastery. The boy's mirror game is an impressive enactment of a symbolic process. He not only tried to deny the absence of his mother. He also fought a feeling of passivity and aloneness and converted it into action and initiative, and thus managed to cope with his frustration by discovering self-assertion, control, and possibly a measure of independence and ultimately self-respect.

Not every child can solve for himself or herself the disappointment of being left alone or the unavailability of help and care with inventiveness and self-reliance that Freud's grandson showed. No infant can sustain needfulness and separation for an extended period of time. One way or another, however, such

23

traumatic experiences must be dealt with. Depending on the circumstances, the baby may seek rescue in other affective stratagems. Whether he sucks his thumb or holds on to the edge of his pillow, it provides the young child with the feeling of mastery. It relieves the sense of precarious dependence and achieves a modus vivendi.

There is no denying that every child sooner or later is exposed to the dilemma of substitution. Mother is not nearby all the time. Giants and dwarfs, E.T. and Mickey Mouse, populate the child's universe as aloneness and vulnerability seek self-soothing through fictional creations. Dolls, teddy bears, or even a wooden reel become equivalents for people, and objects are used to transform frustration or discontent into a state of well-being, if not pleasure.

Like the dedicated collector, the child absorbed with his toys "dreams his way not only into a remote or bygone world, but at the same time into a better one."[14]

Of Toys and Treasures

THE DISCOVERY THAT the passion for collecting is closely linked to a deep attachment to objects which substitute for, and quite often supplant, people still leaves us with a number of unsolved questions.

Why, for example, do some collectors hoard, while others search and select with great care and discrimination? Why does one man assemble his objects in the most meticulous manner while another one buys or makes his finds at random? Why does one person choose to collect campaign buttons, while another accumulates paperweights, and a third amasses American quilts? What is the lure of candlesticks, or candy wrappers? An outsider may consider them trivia. Inevitably, however, the collectors themselves would hardly share that point of view. Such individual differences pertain also to the way people collect. Why does one collector seek to own only outstanding specimens, or only a handful of objects, while another acquires everything in sight? I have met collectors who seek a single example of everything within a particular category (for instance, masks from the Ivory Coast in West Africa), and others who opt for one specific type of object (such as female representations). It would not be too difficult to draw up a long list of variations. Those variations may depend on historical period, or on fashion and social environment. But the significance the individual collector attaches to the objects themselves and the meaning of what he or she is collecting depends on individual character, on personal taste and sentiment. These are, to be sure, secondary elaborations or maneuvers with the basic aim to attach, often frantically, one's emotions to playthings or objects, or here and there to animals, but not to people. It is apparent that individual tendencies not only reflect different temperaments but correspond in many ways to the individual collector's total personality. To some it may be sheer possessiveness—an unquenchable thirst, as it were. To others it is the thrill of discovery or, as in

the case of antiquities, the powerful emotional experience of owning an object that was cherished a millennium ago, by an appreciative Sicilian or Roman citizen. It serves as evidence of continuity and symbolic communication with a distant past.

We cannot go back and ask whether prehistoric man had an inclination to collect or hold on to a certain object that he did not need. The flints and potsherds found in ancient burial places provide no answer, since we believe that they were offerings or funerary donations designed essentially for the peace of mind of the survivors, rather than for the soul of the departed.

Equally inconclusive is our knowledge of the collecting instinct of animals, even higher mammals. Some gather foodstuff or glittering stones or tree branches or twigs for different purposes, although close examination of animals that gather may teach us something about a variety of certain anthropoid traits and habits with regard to assertiveness or efforts to anticipate seasonal food scarcity.

However, while resemblances may be suggestive, they are not conclusive, and apparent similarities in modes of behavior and attitudes cannot be taken at face value. In fact, even ostensible similarities, like a dog's instinctual impulse of "collecting" toys to play with, can be deceiving. Indeed, we must be aware of our tendency to anthropomorphize higher mammals and to overemphasize certain seeming similarities between their behavior and that of *Homo sapiens*.

The human condition is different in terms of intra- and extrauterine development as well as in physiological and psychological complexity and with respect to sociocultural and economic constellations. As I explained earlier, possibly the most salient feature in human development and individuation—the extent of total helplessness and the absolute dependence on others—implies a fundamental condition of anxiety or imperilment that makes seeking and reaching out for presumably protective objects imperative. Without empathetic mothering and good-enough care over a considerable period of early childhood, no human being can survive to adulthood. This long passage from helpless beginnings to self-awareness in all its facets and vicissitudes is full of hazards and conflicts which, indeed, help mold the core of the individual and color the nuances of preparedness for mastering reality.

To understand this crucial nexus between a child's fundamental early experiences and his later capability to face up to the demands, we must first examine certain universal features of babyhood. No infant is capable of giving full expression to his needs and fears and clearly to indicate pain, hunger, or thirst. It follows that loving care and the attention of others can shield the young child from too much disillusionment.

It is easy to demonstrate that every child has a unique and not reproducible encounter with the outside world. Even siblings and identical twins do not have precisely similar experiences. The overall significance of these conditions lies in the fact that they constitute the basis for specific individual responses by exposing the needful baby to what one can call alternative solutions. To put it more simply: in this fashion, one person may find much satisfaction in exaggerated emphasis on eating, or try to deny his doubts and uncertainty by boasting; or build up his bodily strength by excelling in sports or going in for dangerous endeavors such as mountain climbing. Another individual may come to favor objects instead of people, a tendency often observed in obsessional collectors.

This inherent desire to find relief from anxiety and to avoid the threat of disillusionment and danger can form the basis for a lifelong defensive pursuit of a compensatory store of self-assertion. As I have already pointed out, to the needful baby some object to hold on to is the first substitute for closeness and reassuring touch and, as such, brings into play a disproportionate amount of self-centered affect.

From this point of view, it is evident that the subjective significance of such objects implies the reduction of, or relief from, anxiety and hence their function for protective purposes, particularly when these objects are treated as though they were a live attendant. In some instances not only does an object's original meaning undergo a telling transformation, but the object itself may be preferred to human companionship.

Thus does illusory self-rescue detach objects from the real world, thereby allowing the child to attain a measure of well-being and, implicitly, to distort the distinction between human bondage and its representations. The special appeal lies in the fact that a doll or blanket can be relied upon to satisfy a demand instantly. Their essential function is to be there always.

27

In this context, we would be hard put to deny their value. They are important because they reconcile the needful child to the critical awareness of separation or the threat of being alone or the belief of having been forgotten.

There is a paradox here. These surrogates for people add a new dimension to the child's empirical observations. Touching or holding those objects seems to banish fear and frustration. This fantasy provides the objects with power and helps create the illusion of being able to cope. In trying to overcome these elementary dreads, *being*, *having*, and *holding* are now inextricably interlocked. By discovering that he can improvise companionship, the baby can, at least for a while, push aside the menace of the real world. One has but to observe a young child absorbed in his playthings. Here imagination helps provide what the outside world cannot. The paradox is that although these playthings seem to the child independent of other people, he tends to become even more attached to and dependent on his toys.

Wish fulfillment with the aid of dolls or, for that matter, any other object is no abstract conception. Fancy and illusion enable the child to create a private cosmos of magic secrets and potency. He can now rely on a self-composed universe, something the outer world cannot or does not provide. The toys achieve what nothing else can. They work like a drug or a palliative. They transform the child's feelings of loss and anxiety into wellsprings of activity and imagination and provide some sense of control and dominance, as the example of Freud's grandson showed.

There is an emotional affinity here to the efficacy many preliterate peoples attach to all sorts of inanimate objects such as bones, stones, amulets, carved images, or anything at all that can serve as an agent promising relief or comfort due to its immediacy.[15] Such objects become, then, carriers of intrinsic power. Or, more to the point, they tend to alter the child's disposition (and that of preliterate peoples) because they tend to deter frustration and doubt.

And yet these states of well-being are tenuous and hence always needing to be reinvoked. There is always a restitutive and reparative aim. We have considerable documentation on how children use toys and invoke imaginary playmates to cope with

their lingering, ever-present doubts. This tallies with Winnicott's observation—namely, that in the baby's mind he "creates the object, but the object was there waiting to be created."[16] Surrounding oneself with objects one cares for, and expressing that care by clinging to them, is characteristic of many, though not all, children. Ideally, this is but a transitory stage. Only under particular circumstances will a child keep holding on and continue to give meaning to what is obviously a substitute, for the object is not a loving person.

It is quite evident that there is a close ideational connection between the child's projective animatization of his playthings and the sensory transcendence that is also so prominent in certain religious experiences. For example, one of history's great patrons of the arts, Abbot Suger of St. Denis (1081–1151), left behind a pertinent description. Entranced by the St. Denis altar decorated with precious gems, he tells us:

> When—out of my delight in the beauty of the house of God—the loveliness of the many-colored stones has called me away from external cares, and worthy meditation has induced me to reflect, transferring that which is material to that which is immaterial, on the diversity of sacred virtues; then it seems to me that I see myself dwelling, as it were, in some strange region of the universe which neither exists entirely in the slime of the universe nor entirely in the purity of Heaven; in that, by the Grace of God, I can be transported from this inferior to that higher world in an anagogical manner."[17]

This self-induced, trancelike state of mind is immediately reminiscent of the blissfully absorbed little child who delights in his or her thumb or whose attention is captured by a cuddly doll or some other inanimate object.[18] For the moment, he or she is oblivious to the external world, and indeed seems not to need it. As I explained before, this protective reverie is a defensive technique and has at the same time an adaptive purpose. It represents an escape route that gives the child support enabling him or her to cope with disillusionment and uncertainty.[19]

To extend this argument, I would like to describe the case of a little boy who came to my attention more than a decade ago. At the time, Paul was about four and a half years old. Paul's mother had spoken to me about her son's recent difficulties, at

29

home and with his friends. When I met Paul, he was a grumpy young fellow, rather small for his age, and stubbornly taciturn. His parents were quite concerned about him, as they had been unable to change his mood and attitude. Paul seemed depressed to me, but at the same time willful and tightly controlled. He was determined not to talk to me nor to respond to my questions. According to both parents, there had been a conspicuous change in his entire behavior. What had been responsible for this change?

Ever since he had come home from an extended visit with his grandparents, Paul had refused to go back to kindergarten. He stayed home, sitting in his room and playing with a new toy, a stuffed dog which had become his favorite the moment it had been given to him. He carried the dog around all day, brought it to the dining room table during meals, and even took it to bed with him. All of this did not seem appropriate for the boy's age. According to his parents, the difficulties had started roughly six months earlier. He had spent the summer with his grandparents in a comfortable house in the country. He liked the place. He could play with his grandparents' dog, or wander around in a large garden, and he knew some of the older children in the neighborhood. Meanwhile, Paul's parents had gone abroad, accompanied by the boy's older brother.

This was the longest separation yet from both parents and his brother for Paul. Nobody had paid much attention to this, nor had anyone expected Paul's distress. Paul himself had voiced no objection. Moreover, he was fond of his grandparents and an old housekeeper who used to tell him stories at bedtime.

Then during the second or third week of his visit, the grandfather had had a stroke and been hospitalized. During those anxious days he had seen little of his grandmother, but the old housekeeper had looked after him. One day she presented him with a toy dog, which he gave a name, Micky.

Paul and Micky quickly became inseparable, but a week or so later the boy asked for and received another toy dog. At that point, we could reconstruct, he became withdrawn. The parents told me that, because of the grandfather's illness, the grandmother might have been less attentive to Paul than he might have expected. When his parents and brother returned from their holiday, they too might have shown more concern for the

grandfather than for the little boy. They did bring him several gifts, which he put on a shelf in his room but then absolutely ignored. In the meantime, he had asked for another toy dog, although Micky remained his favorite.

Here the links are clear between certain events in Paul's life and his feeling of having been deserted. There had been no actual threat to his security, nor was there any reason for him to feel estranged in the grandparents' house, since he had been a frequent and welcome visitor there. But then the grandfather's sudden illness seemed to have disoriented Paul's emotions, primarily because attention had shifted away from him to the grandfather. Such were the circumstances when the toy dog came to his rescue. Was Paul merely resorting to the old remedy of a pacifier?

Many weeks after I had met him, Paul confessed that he and Micky conversed in a secret language. Was this perhaps like Abbot Suger's meditation using the glittering stones on the altar of St. Denis as a vehicle for his discourse with God?

In essence, Walter Benjamin's experience was similar. He described every acquisition and addition to a collection as an experience of renewal, "from touching things to giving them names."[20] Paul had stumbled on an effective device to help fortify himself against repeated hurt because of being alone and feeling excluded. With his fetishes, he could suspend his anxiety. Micky together with the other toy dogs would never leave him behind. Their presence helped guarantee him support and not-aloneness. In his self-established collection of toy dogs he had discovered a source of comfort and a specific presence in everybody's absence, at first incomprehensible to his parents. It was a technique I have observed among many collectors. Their involvement keeps them seemingly active, even adventurous and enterprising; however, in a deeper sense, this is only to ward off undercurrents of doubt and a dread of emptiness, even depression. It seemed that only his toy dog could bring relief to little Paul.

But, then, what else are collectibles but toys grown-ups take seriously? They are signposts in the struggle to overcome the reappearance of the notion of old feelings of abandonment, of separation anxiety, as the example of Paul demonstrates. There is evidence of these traits in all dedicated collectors. George

Ortiz, today possibly the most prominent collector of Greek antiquities, stressed his disbelief "in any divinity and life after death." But in his remark regarding artistic accomplishments ("the ultimate" he called them), he found "a message of hope and faith in the inherent goodness of man and his living qualities."[21] Here religious beliefs and unmitigated reliance on God, having lost their intended meaning, are replaced by aesthetic passions and commitment, and finding "pro-life and anti-death manifestations," in Ortiz's words, in aesthetically outstanding works of art.

Evidently, this way of reasoning is anchored to an essentially profound doubt in a supreme power. But such pronouncements are defensive because they but camouflage a child's doubt in parental credibility. In the obsessional search for "goodness," relief is found in narcissistic expansion articulated in the ownership of "things." For men like Ortiz, examples of rare aesthetic beauty are proof of an incomprehensible superhuman power.

There are various approaches to steeling oneself against the reemergence of doubt, of crises, of helplessness and abandonment. One mode is the taking up of manageable companions, be they toy dogs or carefully selected works of art. In point of fact, they may be objects of any kind, as I said in the beginning; they may be pressed flowers, guns, or in some cases even animals.

In the course of my research I met a man who had been bedridden for more than a year at the time of puberty. Neither books, pictures, or toys could alleviate his endless hours of misery and boredom, his illness having occurred before the arrival of television. Visitors came and went, but still he felt half-forgotten, and nothing could lift his mood.

Then one day an empathetic relative brought him a fish tank. All of a sudden the melancholy, reflective boy found companionship and playmates. He could watch the movements of the fish. He could choose his favorite. And, at least in his own experience, he felt renewed vitality as if participating in the activity of his current roommates. (What was perhaps equally helpful was the awareness that finally someone understood his predicament. This was more reassuring than any promise of recovery.) Now he could watch the fish, enjoy their agility, delight in their play, and learn by close observation. It was an informal course in animal behavior, not without revivifying earlier memory

traces or fantasies of primal scene impressions, as he came to understand in the course of our talks. It constituted the basis for a lifetime avocation. By the time of our acquaintance he had become a well-established collector of marine animals and enjoyed the respect of professional ichthyologists.

This is an instructive vignette because it brings to light possible causes of the development of a passion. The effect of early distress or infirmity is oftentimes a significant element in the rise of feelings for objects of all possible kinds. Clearly, inner motivation must invoke enthusiasm for owning a certain kind of thing, be it fish, bus tickets, or toy soldiers. In many cases, the search and obtainment sound like adventure stories or a magical-romantic pursuit.

It is tempting to recognize in such enterprises, as in boys' sometimes habitual rovings, forerunners of a later inclination to collect or perhaps to gather in a more systematic way. Surprisingly enough, this is not often the case. Collectors are not Huckleberry Finns in whose pockets one can find matches, dried flies, a piece of string, an adhesive, a chestnut, and a few coins. This is the actual description of one nine-year-old's accumulation. He was one of those carefree children who roam around in the woods and fields in search of flowers to be pressed or birds' eggs, and who often arrive at home with an injured animal to attend to.

What is brought together under such conditions is very much a matter of what the physical environment can provide. It constitutes a manner of luxuriating in the adventure, reaffirming an earlier inkling of mastery and self-confidence.

Most of us can remember the pride we took as children in a bunch of marbles or postal cards. We liked to show them off or traffic in them. This is usually a whimsical attribute of children, who without even knowing it want to draw attention to themselves and arouse envy in others, often in an attempt to overcompensate for doubt and uncertainty. The true nature of such endeavors became manifest in the case of one three-year-old girl who had been piling up as many Christmas cracker toys as she could lay her hands on. A grown-up gave her what she could. Suddenly the child stopped, looking wonderingly at her adult friend, and in a voice filled with bewilderment and incredulity asked, "Don't *you* want lots?"[22]

Such aspirations may lose their appeal and novelty, and fade away. On close inspection, they are found to be only part of a phase when anything new seems desirable and has its own fascination. Children want to explore and widen their horizons, and the accumulation of such treasures helps them to assert themselves.

This concern with *more* is also found among adult collectors, but not necessarily with an emphasis on amassing one or the other kind of object. Nevertheless, even among some of such collectors quantity is often a defensive maneuver as a representative of an inner experience of security or power, while quality, rarity, or significance of an individual object are more akin to a narcissistic representation: "I have something special" should often be understood as a function of a denial of self-doubt. On the other hand, the man who asks how many items a fellow collector owns is thinking of accumulation as if he were motivated by a quest for food: "How much is in your larder?"

The narcissistic inclination is crystallized in a young man whom I shall call Nick, who owned a single exquisite object. The factor at work here was his intense need for approval; for being outstanding. There could be little doubt that the object was a representation of himself. Nick's entire behavior as a "one-object collector" was characterized by a single-minded attempt to outshine everybody else. He felt driven by an incessant search for yet a better specimen. Once he had discovered it, he always disposed of the previous one.

It is reasonable to ask if one object can accurately be described as a collection. The person who looks for one example of surpassing rarity or perfection, and is satisfied by it, is not a collector by my definition. However, if he continuously searches for a better example, and then another better one, and still cannot put a halt to his search, then he is a collector to me. What must be taken into account here is the obsessive driving force that distinguishes the collector from someone who simply enjoys an object for whatever it means to him.

The elemental cause of Nick's need for exclusivity was a persistent childhood concern. His father, a strong, domineering, ex-army colonel, dreaded by the entire family, allowed no contradictions. He was pedantic and judgmental. No one could live up to his expectations, least of all Nick, the only son. No mark in

school or achievement in sports was good enough. If the boy received an A in one of the subjects, the father's predictable question would be, "Why not an A plus?" usually accompanied by a resounding, "You'll never amount to anything."

Nick reacted with the inevitable feeling of inadequacy. His never-ceasing search showed a vestige of his never-resolved relationship with his father. There remained a sense of vulnerability and irrevocable self-doubt. In some ways, Nick, whom I met when he was over forty, was still a minor and a solitary individual who harbored within himself an ever-ready hope of paternal approval. It was almost as though the entire world had taken over the paternal role; not too far removed from a paranoid variant, Nick felt he had to prove himself time and time again by finding yet another and even better specimen.

Effectively, Nick had been maneuvered into a way of life dominated by this tyrannical father and a demanding ego-ideal. It seemed as though an inner voice was constantly commanding him to recapitulate what he had suffered throughout his childhood—namely, to escape the deficiency he had been accused of. After careful research, he would track down one outstanding piece and then eventually another and far superior one. It was an ongoing venture. He was absorbed in it, even elated, and yet at the same time strangely depressed, since he was chronically haunted by, "Will I ever find a piece worth an A plus?"

Nick had shown the first specimen he had found to a well-known dealer who was a highly regarded connoisseur, a man quite different from his father. Always anticipating repudiation and the concomitant threat to his self-esteem, this man's acceptance and approval of the object he owned at the time brought out a new and hitherto unknown sense of self. The dealer was not only willing to take Nick's object for an unquestionably better one but even suggested an easy installment payment plan.

Nick was elated. What is more, the man's approval had the effect of a release from constant inner persecution. It even tended to transform Nick's obsessive doubt into an intensity of passion quite inconceivable to him. At the same time, he became increasingly devoted to the dealer. The man's role soon shifted to that of a paternal friend, though—understandably—not without a measure of conflict which Nick unconsciously transferred from the father to his guiding patron.

Only years later, after his dealer-friend had retired and moved away, did Nick realize what had caused his constant need to perform well. He became aware that his repeated quest for a better and still better specimen had become the indispensable narcissistic demonstration of the perfection his father had demanded. More profoundly, it was a never-ending means of ultimately gaining the approval of his now long-deceased father.

Once we examine the numerous studies on collecting and the life-histories of a number of collectors, it becomes evident that a relatively high level of ego support appears to be a major motivation of their endeavor. In interviewing a large group of collectors, it became obvious that many different roads are taken to establish proof of selfhood, self-definition, and, often enough, self-absorption, as in the case of Nick, torn between persecution and, on occasion, a phallic-narcissistic display of bravado.

With this understanding, it is not difficult to recognize one central aspect: there has to be a more or less continuous flow of objects to collect. It is this flow that helps sustain the collector's captivation. It might be expected that, since scarcity tends to increase the value and importance of an object, collectors would aim for specimens that are not readily available. Yet almost the exact opposite is true. It has been proven that collectors tend to lose interest in certain types of items when supply diminishes. Clearly, a more or less steady though sometimes difficult flow is essential.

Here one must keep in mind that dedicated collectors expect that obtaining an object is never an easy matter, and that the path to new and worthwhile acquisitions is not without obstacles, sometimes diplomacy, even anguish, and occasionally ingenious detours. Later, I shall deal with some striking routes collectors may take to satisfy their aims or, more strictly speaking, to give way to the relentless and intrinsically narcissistic aim to find tangible support in order to erase the archaic experiences of anxiety and, possibly, to help undo traumata during the formative years.

As I see it, the flow of this essentially nutritive supply should be understood as a magical remedy against doubt and uncertainty and thus as an ego-supporting provision. Here again is an instance of the paradox I mentioned earlier. Collectors who as a rule insist on specialization, and then make a point of owning

only the very best or rarest objects, narrow the area of availability while fostering an almost ritual aura of uncertainty and suspense. Such collectors seek distinction through perfection, but the perfection can only be obtained at a price, namely more or less perpetual apprehension.

Is this an echo of the baby's subtle response to not-good-enough care in providing him with both physical and emotional nutriment? Such nutriment and, for that matter, the fulfillment of all the infant's requirements are key factors because they are the means whereby the child's basic dialogue with the outside world develops.

In this regard, there are indications that people of particular aesthetic sensibility become quite selective at a comparatively early age. George Ortiz's mother told me how, even as a very little boy, her son had shown an inclination toward certain foods, flowers, and colors.

Not that there is a straight path from mouth to eye, but there does seem to be some correlation which might be thought of as a convergence of taste. The taste for finer things seems to begin in the mouth and then wanders to the eyes and ears.

This idea was admirably expressed by the late Paul Sachs, an outstanding collector of master drawings and professor of art history for many years at Harvard University. He stated categorically, "Anyone who professes an interest in the fine arts and is indifferent to the joys of the palate is automatically suspect,"[23] a most acute observation which I have found correct time and again.

I am not speaking of blind impulses here, but rather of the subtle perceptions that bring about *passional states*[24] as well as the agreeable sensations of having and holding into existence, and steer cravings and affects. Professor Sachs was describing the response to pleasing stimuli that give rise to physical and emotional rewards—on the one hand, in the case of oral pleasures; and on the other, fine works of aesthetic appeal.

Around such a display of aesthetic judgment, powerful emotional needs are brought into harmony, in many instances compensating for emotional trauma or physical injury that has left its mark on the subject's inner state.

In this connection, it might be instructive to examine the history and life experience of a different collector's personality. Among Dirk van T.'s first memories were stories and pictures of

animals of various kinds, and of household pets. Cats, dogs, rabbits, and the like were part of his immediate orbit. His childhood coincided with World War II in the Netherlands. One after the other the animals died or disappeared, and, because of the increasing food shortages brought on by the German occupation, they were not replaced. Dirk missed them a great deal and in school soon turned his attention to "insects, roach-like creatures, and sea horses," as he recalled during our talks. Shortly thereafter, he added shells to his list because they are "more beautiful and easier to arrange. Seashells are more interesting than bland land shells," he noted.

He had not been quite ten years old when Holland was invaded by the Germans. His house was damaged by a bomb that exploded across the road. No one was hurt but the family was forced to evacuate the building and move. Dirk stayed with relatives until, more than a year later, the family was reunited. Since the ongoing war created ever-present uncertainty and a continual sense of danger in everyone, the reunion offered only partial relief.

Dirk recalled that he had repeatedly asked for a pet, but to no avail. There was hardly enough food for people, his mother told him. How could he even consider owning an animal? But Dirk responded to his mother's rhetorical explanation as though it was a verdict, a permanent punishment.

Actually, there was no moment of real calm. Not being allowed to own the animal he had been longing for, and the critical conditions of wartime shortage and survival, were two separate events in the ten-year-old's view. One must keep in mind that "peace time" had no internal representation for a child whose conscious memory related only to the happenings of living under the constant threats of war and the ever-threatening occupational forces. He had no expectation nor any mental concept how this condition would come to an end, and he failed to understand how this related to pets, anyway. And so he discovered his shells.

This progression from animals in storybooks and pets to insects and subsequently to sea horses and seashells sounds almost standard. However, once we probed somewhat deeper, the steps that changed him from a child who liked animals into a passionate and virtually uncontrollable collector of all sorts of things began to emerge.

At the time of our encounter Dirk van T.'s personality was reflected in his various collections, but even more so in the manner in which he went about making his finds and acquisitions. A complex and erudite man, he eventually discovered numerous possibilities in gathering specimens in, as it seemed, diverse (though in a deeper sense closely linked) areas, such as old medical instruments, anatomical dissertations, and a particular kind of early clocks. His collection was by no means arbitrary because his primary question seemed to be focused on "How do bodies function?" By the age of thirty he was already a distinguished collector. Each of his collections was as complete as possible, the clocks forming the most comprehensive of its kind. He had even grown proficient in taking some of his clocks apart and putting them together again, although he had no particular mechanical inclination or skills.

He was well aware that his obsessionality had developed out of desire for control. Thus, he had the best and presumably most complete collection of this type. In describing this desire, he suddenly pointed his hand at me and counting on his fingers, he exclaimed: "One-two-three-four-five—Damn it! Get it *all!*" as if to demonstrate his insistence on *allness*. In one stroke he pointed to his goal, ostensibly in the area of accumulation, but even more demonstrating his inner standards bordering on pathological narcissism.

I have heard about this sentiment from many collectors: "I simply must have it!" or "I couldn't live without it!" but never put so explicitly as in Dirk van T.'s case.

The point I am making here is that his imperious demands and consequent action were in part a reparative response to wartime worries and deprivations, especially in consequence of having been separated from his mother at a time of actual danger. Many children shared such experiences, but without becoming prey to a frantic need to achieve *allness*. This was his response to the enforced separation from his mother and his animals. He turned anxiety into infantile aggressive longings, his unconscious motive being: I want *all* of my mother.

Clearly, the habit of collecting itself, and the way one goes about it, depends on a variety of factors in an individual's history and personality structure, even though the empirical connections that reveal a collectors' leanings are often obscured.

Why does one collector insist on *all* while another obsession-ally limits himself to possession of one single object? It often took many encounters with collectors before I could recognize the links between his or her needs and the manner and modalities of obtainment. There are, of course, all kinds of ways collectors go about satisfying their aims, and the process of acquisition is usually as meaningful as actually obtaining the object, something Walter Benjamin recognized in himself. While the eventual addition to their holdings is the culmination of the experience, sometimes the skill involved in making their discoveries, the various strategies—in some cases even deceptions—employed, the detours they were forced to take, or battles fought to get a specific item are all part of the ultimate reaction to the early narcissistic wound, real or imagined. Indeed, for many collectors the often seemingly tortuous process of procuring an object and the emotional and occasionally monetary investment that goes into it reveal much of their basic character.

Dirk van T.'s motives and methods seem to spring from a series of more or less specific traumata and events which make not only the reparation but also the ambition and intensity imperative, in many instances at the cost of emotional attachments to people. Dirk's childhood desire for a pet was probably an early indication of his later primary interest in collectable objects rather than a deeper relationship with people. His imperious claim to "all" sounded like an overweening ambition to win his fight at any cost.

Rightly understood, this kind of accumulation shows an orientation that has vestiges of early demands and, implicitly, an incapability of putting a halt on rapacious appropriation. It aims at nothing less than *all*. It is true that collectors tend to endow their possessions with a life-force or, as I mentioned earlier, with *mana*. However, I must emphasize the affective involvement, for it is evident that the owner achieves through these possessions what are essentially reparative emotions that he dares rarely (if ever) develop in interpersonal relationships. Whatever the objects, in all their guises they are never adequate substitutes for people. They can never provide the emotional dimensions of that attachment to another human being.

"How can one love pieces of wood?" a lady asked Mario Praz, who, like so many of his fellow collectors, could fall "so deeply

in love with [a chandelier]" that he "would have done anything in the world to acquire it."[25]

In the description of his vast apartment in the Villa Giulia in Rome, Praz reminisces about the innumerable objects that used to fill the rooms. Every piece has its story—related to places, people, episodes, and yearnings—that springs from his absorption in and memories of the past.

I met Professor Praz ten years after he had written about that apartment. Since then he had moved to an even more impressive flat, brimming with Empire furniture, decorative objects, and books. It seemed more than fitting that Praz had found a home in the palazzo that Napoleon had occupied during his stay in Rome, although the professor, a small unassuming man, rejected any identification with the emperor. Nevertheless, his "mania for Empire furniture" had found appropriate surroundings. "My limited number of interests tend to become manias: the mania for Empire furniture, the mania for books of emblems, the mania for Russian, just as, when a child, I had the mania for dolls and statuettes of saints and, as a boy, a mania for stamps."[26]

I was received with great kindness. Every corner in the vast apartment, every wall and corridor, the decorations in and on bookcases and cabinets, on tables, credenzas, and even doors reflected the professor's taste, as well as his *horror vacui* (the avoidance of empty space). Seated in his drawing room overlooked by an open library, Praz spoke of the beginnings of his collection but persistently stressed the considerable link with his unhappy personal life. He had had a short-lived marriage, something which might have been foreseeable considering that he had insisted on spending his honeymoon in Roman antique shops, instead of in some more appropriate site for a just-married couple. His major concern was the objects he might possibly discover, and not his new young bride.

The professor was quite aware that some of the manifestations of his collecting could easily be traced to his childhood, and he cited the example of his enthusiasm for wax portraits and busts of famous men for he understood it as a reminder of the good times he had had with his grandmother on frequent visits to churches, where he first admired the wax statues of saints.

41

Some people might find his Roman abode overcrowded, he remarked (not without a measure of irony), but he had different standards; in fact he found it pleasing and very to his liking. From his writings as well as our conversation, I soon became aware that Mario Praz was a man deeply immersed in detailed memories and reflections. He had learned that his objects helped him recall still more of the events of his past.

His intense love for the objects—and he used the expression *love* time and again—be it a chandelier or a decorative emblem, is revealed in his elaborate descriptions of his possessions and his manifest joy in them. His enthusiasm bespeaks an almost erotic excitement. What, one must ask, is the true origin of his passion?

He had been a lonely, only child, he remarked repeatedly. His father had died when Mario was four but had been absent from home earlier, and was probably hospitalized, for he had died of syphilis, to which Praz ascribed his own physical deformity, a clubfoot.

In true Proustian fashion, a distant clap of thunder brought back a forgotten childhood event—a visit to an orthopedic clinic for treatment of his foot. The deformity prevented him from joining the army during World War I. He spoke about his feelings, but also came back to his reactions in writing: "I was unfit, and I felt diminished in front of my companions who went off full of great ideas."[27] The same emotions prevailed while he was a student at the University of Bologna. He mentioned the extent of his depression and loneliness and reminded me of a particular reference in his book. While he was alone and felt excluded, a friend of his had introductions to influential Bolognese families. After an elegant dinner party in one of the aristocratic houses, his friend described to him the "Empire armchairs, with gilt sphinxes, in their drawing room."[28] It was probably the first time that the Empire style had come to his awareness. In any event, he remembered these circumstances, which pointed quite to his eventual predilection.

A visitor to the professor's opulent apartment would immediately become aware of the gilt enrichments and patterned embellishments of the Empire style which dominated the overall taste. Praz had started to acquire Empire furniture and decorative objects as a young man in Florence, when he had to content himself with "modest objects: such was the chest-of-drawers,

42

the fount and origin of mania."[29] However, his conclusion was hardly correct. The acquisition of this chest-of-drawers merely brought his already dormant obsession into the open. The reparative attempts are only too evident. And here Professor Praz himself was witness to the injured child's sense of inferiority and rejection. He had in many respects felt disowned. Now he knew how to outdo his fellow students as well as those aristocratic families to whose houses he had not been invited. Thus, his collecting had become a primary means for sublimating if not healing the trauma of his physical infirmity and an overcompensation for seeing himself as an outcast.

Conditions, or rather preconditions, such as these drive home the fact that the inanimate objects' function is essentially compensatory and that they are being used not only as an attempt to disguise old wounds but at the same time to serve as reminders of past injuries and humiliations.

George Ortiz searches for concrete reassurances of faith and hope in "the ultimate," putting together a collection of objects, most of them of unsurpassed excellence, while Dirk van T. seeks *allness* and Mario Praz wanted an environment grander than the Bolognese aristocrats who, as he indicated to me, had snubbed him. Thus, the objects of whatever kind, whether amassed or selected with the greatest of care and perspicacity, become an attestation of the collector's guard against renewed hurt. It is clear that the passionate collector shows an emotional coherence when it comes to transforming what once had to be passively endured. The reaction can be intense indeed, with old traumatic experiences now overcome through active countermeasures.

It goes without saying that the overt aims of collectors vary considerably. But whether the focus is on the search for the aesthetically pleasing or the completion of sets, or whether the emphasis is on rarity or antiquity, closely related dynamic forces underlie the habit. What is prevalent is a need for reassertion in order to undo an old narcissistic wound. The objects are meant to give a sense of affirmation and magical support. This holds true for little Paul's toy dog, for a believer in holy relics, or the *mana*-laden head taken by the natives from their enemies in Indonesia and Melanesia.

Collectors share a sense of specialness, of once not having received satisfying love or attention or having been hurt or unfairly treated in infancy,[30] and through their objects they feel

43

reassured, enriched, and notable. The overt attitude may range from ostentation to apparent modesty, or occasionally even secretiveness (which after all is often a covert form of exhibitionism). But most characteristically, there is always an addictive component—a potential but always present unconscious modality of affect linked to a powerful reparative need.

Due to this ever-present affect-laden core, the challenge of reassertion by means of more or less constant replenishment, the gathering of what are in essence reparative substitutes of the primary (i.e., maternal) object is the most conspicuous feature of habitual collecting. All sorts of presumably magical objects provide a feeling of contentment because they defuse—temporarily—the reemergence of traumatic anxiety. What follows the acquisition of a new object belongs to the paradoxical state to which I have referred earlier: renewed provision generates pride and pleasure, in some cases subtly, in others phallic-ostentatiously. But we must keep in mind that it is the fundamental condition of this need for repeated nutriment that makes an eventual new supply mandatory.

The intensity of this search is thoroughly attested to by another collector, a man with a lively interest in historical documents. "I am a sponge," was one of his self-critical observations. As he associated in the course of a psychoanalytic session: "I get a feeling for [a particular historical] period. I want to read [certain documentary source materials]. The era when every army officer had an easel and brush in his bag—a whole new set to collect. Primitive paintings by soldiers. I want to suck in everything. Very exciting. The Renaissance man. The sensitive steelworker. The soldier who becomes excited by a rare butterfly or a flower. As if I have to hold it until I know everything. It is like a lust. It is like a burning force. I go into this or that store and try to scoop the whole thing in. I go with my hands along all those things. I cannot be discriminating. I have to have it.[31] The ultimate pleasure is to show them off to the family. [Uncle] Joe and I are alike, stamps and books. He is more pathetic; I am more impressive. It's a hedge against nothingness. I keep busy instead of sitting at the typewriter. I never write more than a page. (There is) always something new, never-ending supply. All those books. I am an expert. I am an authority. I want to be a snotty expert. A never-ending series, a whole apartment house.

I'll have every stamp when I am ninety-nine years old. Taking in the whole world, having a membrane around the world. With every inch I have to touch something, all spread out, soaking it with all my fingers. And *finding* the junk—and more junk, never ending. I can't throw anything out. It's like a nest I lay eggs in."

This highly charged self-portrait brings together different strands. What emerges from this train of thoughts is not a single, nagging source for the incessant urge to accumulate almost indiscriminately. Instead, such phrases as "I want to suck in everything" or "I can't throw anything out" imply that he is fixated to experiences of feeding and elimination, bringing a measure of sadistic drive components into focus. The overall tenor seems to echo the mood-swings prevalent in the pregenital years of personality formation, ranging as it does from anxious incorporative, to retentive and all the way to unbridled exhibitionistic and megalomaniacal fantasies. There is also present nostalgia and a longing for being enveloped and, finally, an almost manic self-indulgence and rapacity that transcends what should be an uplifting, recreational enjoyment.

Obvious or subtle, the various shades of the desire to collect depend on a rich spectrum of meaningful experiences. Such experiences, whether real or imagined, always leave their imprint on a person's specific aims and attitudes. In other words, the experiences provide the modalities of what turn out to be causally determined and thus plausible modes of thoughts.

This becomes even more apparent whenever the different reactions and affectivity of dedicated collectors can be discerned. Nelson Rockefeller once remarked to me: "You see, in my position I must collect. My mother did it, and my grandfather did it. It is an obligation. After all, the Medici's did it too." His position had no "must have," no obsessional motivation. Yet there was a strong emotional undertone, like a sense of commitment. With regard to his well-known collection, I got the acute impression of an affective attribute, when he referred to both mother and grandfather, as if he had to live up to a family ideal in order to become his predecessors' worthy heir. We could ask whether his models—his mother, his grandfather, the Medicis—stood between his autonomous self and his adopted aims, as if his own identity had been preordained by an established family tradition.

45

Carrying on a family tradition by adding to an existing collection or by elaborating on it in a new and creative way is not at all uncommon. Another example is the Marquess of Bath, who inherited a superb collection of printed books. Collecting was a centuries-old family tradition, and the library had been assembled by many generations of his ancestors. As a child, Henry Thynne (Lord Bath) did not expect to fall heir to the title. But when his older brother was killed in World War I, the title came to eleven-year-old Henry quite against his wish. He saw it as an overwhelming responsibility, he pointed out. But while Lord Bath kept the original family collection intact, he chose to collect contemporary children's books and memorabilia connected with Winston Churchill and Adolf Hitler. He had assembled paintings by the Führer, parts of his uniforms, a first edition of *Mein Kampf*, and numerous other items. He also had first editions of all of Churchill's writings, owned a number of his paintings, autographs, and personal belongings—even one of his famous cigars, half-smoked, which a bar attendant had preserved.

I had another encounter that echoes this complex connection with the past. Members of the Six family are well-known for their appreciation of Dutch art. Their most famous ancestor, Jan Six, was the mayor of Amsterdam at Rembrandt's time. The mayor's portrait by the master impresses one still as one of Rembrandt's most sensitive paintings. But there are numerous other and predominantly later works of art in the Six collection, today a private museum. I had the privilege of being received by the Ladies (Freules) Six, two sisters who represent the family. Discussing the family's tradition, I observed numerous works of art not only by seventeenth-century masters but also later and even twentieth-century ones. Commenting about this, the ladies explained quite matter-of-factly, "But the family *always* collected modern," they stressed emphatically. And true enough, when Rembrandt painted their famous forebear it was a contemporary work of art, after all.

These last two examples help us appreciate the broad range of conscious choices available to the collector, which may range from an attempt at undoing frustrations of early childhood experiences to falling in line with examples set by one's ancestors. Still, there is one common denominator—the imperative and compensatory having and holding of the object. Granted that

46

Nelson Rockefeller and the Marquess of Bath were perhaps not collectors entirely of their own choice, since they were following a family tradition. However, to them it was a commitment, almost an obligation, each adding a distinctly personal articulation by emphasizing fields quite different from previous generations.

The American collector was fully prepared to abide by the pattern established by his grandfather. He saw collecting as both a private endeavor as well as a social commitment. Failure to obey a moral responsibility would have aroused inner conflicts, since he saw collecting not just as an endeavor of his own choice but rather as a blending of sentiment, debt, and duty. However, instead of merely adding to the prominent holdings of his family, he followed more in his mother's footsteps by gathering objects that would have pleased her and met with her approval.

Collecting, then, emerges as an instrument designed not only to allay a basic need brought on by early traumata and as an escape hatch for feelings of danger and the reexperience of loss. However, because it is an effective device for relief from these pressures, it is felt as a source of pleasure and wish fulfillment.

Many collectors are aware of this bind and may even go so far as to play one or the other confidence trick on themselves in order to come to terms with their hidden conflict. The late P. C. Meulendijk, a noted Dutch collector of Oriental and tribal art, whose house almost literally overflowed with well-selected although not outstanding examples, assured me that he had never spent more than a limited, and by all standards small, amount for any one object. Not unexpected for a true Dutchman, he observed self-discipline. In fact, he tamed his penchant for acquisitions, using frugality as an alibi to reconcile his needfulness and enthusiasm and, on the other hand, his self-controlling parsimonious inclination.

Such instances of ambiguity are not at all uncommon. Sir Robert Sainsbury, the well-known British collector, told me that he had established an annual budget for acquisitions of works of art. But then his son David impishly added that "on occasion" his father would "borrow" from next year's budget if a very desirable specimen came his way. This is a touching description of an often observable conflict. Do wish-world and internal excita-

tion prevail or should, in terms of what is perceived as common sense, the object be given up? I am describing the inner contention in this way because the situation demonstrates the split between instinctual demands and the role of self-imposed restriction and rational, culture-induced decision-making, especially when there is an established tradition of self-restraint and frugality. It is tempting to recognize here a dramatic variation of the infant's pleasure-seeking impulses to have all of mother for himself or to modify the wish and reconcile his desires with the limitations imposed by the superego.

Irrespective of individual idiosyncrasies of collectors, and no matter what or how they collect, one issue is paramount: the objects in their possession are all ultimate, often unconscious assurances against despair and loneliness. They function as defenses in the service of self-assertion. They are magic remedies to ward off existential doubt and, most of all, they are witnesses of credibility.

PART TWO

MAGIC OBJECTS

*

Skulls and Bones

A<small>N EIGHTEENTH-CENTURY SCHOLAR</small>, had he tackled the sub-
ject of collecting, would hardly have begun with the pursuits of
Don Juan. Nor would he have turned to the treasured posses-
sions of children, since he would have seen no essential link be-
tween a child's anxiety and an adult's passion.

But let us for a moment follow the eighteenth-century
scholar's lead and begin, as he might have done, with the craze
known as Anticomania.[32] Roman collectors of Greek works of
art and artifacts have left behind enough signposts to tell us that
the drive to collect anything Greek was even then not just a mat-
ter of taste and fashion but arose out of enviousness and ex-
cesses of competition. It was these emotions that prompted
prominent citizens like Mummius, Sulla, Julius Caesar, and in
particular the notorious Caius Verres to pillage and plunder
Greece, and its colonies.

The fall of what was formerly Greek Sicily in the third century
B.C. to Roman invaders set off a period of the most ruthless
plundering and open rivalry among the victors, which drained
the subjugated and defenseless people of the island of their
proudest possessions. Livy recognized the fall of Sicily as the
beginning of the true appreciation of Greek works of art. (In ef-
fect, the Romans were the spiritual forerunners of the eigh-
teenth-century German princess who became Catherine the
Great of Russia. She herself was fully aware of her greed and
cupidity. "It is not for love of art; it is voraciousness. I am not an
amateur. I am a gourmandizer."[33])

Latin authors tell us about the unqualified lack of restraint
among the Roman troops, in many ways reminiscent of the ar-
mies of Napoleon and Hitler. After the plundering of Syracuse
in 212 B.C., Marcellus showed how great his victory had been by
bringing huge quantities of Greek works of art back to Rome.[34]

Were the Greek treasures like the trophies headhunters carry
home? Or like the collection of Christmas cracker toys amassed
by the little girl?

A quarter of a century after the plunder of Sicily, Scipio brought back to Rome 134 Greek statues and boatloads of embossed metalwork and coins. Meanwhile, Tarentium had fallen, and the victors appropriated the Hercules of Lysippos, one of the finest examples of Greek sculpture. Then Fulvius Nobilior shipped home 285 bronze sculptures and 230 marble statues from Ambracia. Later, in 167 B.C., Aemilius Paulus led a triumphal procession through Rome that included 250 loads of sculptures, paintings, and vases. And Strabo describes how Roman settlers looted Corinth, leaving no grave untouched. At that time Corinthian works of art and artifacts fetched the highest prices.[35] This unmindful greed of Roman conquerors was a reflection of a trend.

We can read between the lines and see how much pleasure members of Rome's aristocracy derived from the display of ransacked works of Greek art. Initially, all the loot was considered property of the state, but by the middle of the second century B.C., a Senate decision limited the number of statues and other objects to be publicly displayed, thus in effect initiating private ownership. After all, trendiness is often a decisive factor when it comes to collectors' tastes. This encouraged Caius Verres, the provincial governor of Sicily, to luxuriate in self-serving and highly aggressive souvenir hunting on a grand scale. He made no effort to check and conceal his desire to appropriate untold numbers of beautiful statues and the exquisite examples of work in precious metals for himself. His passion, according to his foremost accuser, none other than Cicero himself, made of him a robber and a criminal.[36] Indeed, Verres did not refrain from false accusations, murder, and genocide in order to obtain any object that struck his fancy.

At the time of Cicero and Caesar, Rome epitomized victorious extravagance and conspicuous consumption. Traders from all over the empire gathered there. Art dealers occupied entire city blocks. Some of the richest citizens even had their own private museums. And the thousands of elaborately decorated villas in and close to the city would eventually be copied during the Renaissance. All this reflects not only enormous wealth but also the manner in which cupidity and exhibitionistic tendencies find roundabout ways of being accepted as part of prevailing socio-

cultural trends. However, Verres went too far. Cicero, no mean collector himself, accused him not only of "greed, but the insanity, the madness, [which] sets him apart from all other men," and Pliny agreed.[37] Verres was prosecuted but escaped from Rome, only to commit suicide.

Soon Romans began to go farther afield in their search for art objects. "The store of works of art in Greek countries was inexhaustible enough to satisfy the greed of Romans to the full," Friedländer wrote.[38] For example, Caesar's collections of cameos was famous. Then, as now, and probably at all times, collectors had their secret sources, their spies and agents to track down their trophies for them. Gold, silver, manuscripts, tapestries, and paintings became all the rage. Not surprisingly, along with the increase in the demand for and the value of such objects came a vast trade in copies, bringing many Greek artists and craftsmen to Rome. And when the copies could not keep up with the demand, outright forgeries came on the market as well. When these turned into a flood, expertise soon evolved into a regular profession.

Such developments take cognizance of the historical difference between connoisseurship and mere accumulation. Collectors are often aware of the obsessional drive in their habit, but there is a speculative element as well. The need for authentication and approval by experts is a reflection of two forces existing within the collector—the desire for self-assertion through ownership and a sense of guilt over narcissistic urges and pride. As a result, some people require the concurrence of an authority or, in essence, a parental substitute who by providing guidance helps eliminate inner conflicts, thereby removing the collector's ambivalence or subliminal sense of wrong-doing.

To explain further the compelling force that drives collectors, let us now turn from the eighteenth-century scholar to anthropological observations. The Reverend R. H. Codrington, in his classic account of Melanesian life and thought prior to the contact with the West, described the natives' concept of *mana*, sometimes referred to as soul-substance, or life-force, as the "invisible power which is believed by the natives to cause all such effects as transcend their conception of the regular course of nature, and to reside in spiritual beings, whether in the spiritual part of

living man or in the ghosts of the dead, being imported by them to their names and to the various things that belong to them, such as stones, snakes, and indeed of objects of all sorts."[39]

Mana, then, is present in both people and objects, providing them with power and exceptional dynamism. It can cure disease, cause evil and misfortune, and in many ways serve as a medium of potency. "Some relic such as the bone of a dead person whose ghost is set to work is, if not necessary, very desirable for bringing his power into the charm; and a stone may have his *mana* for mischief."[40]

The concept of *mana*, and occasionally even the same word in different local variations, is known throughout the South Seas. The Maori of New Zealand used to connect it with authority and supernatural power. So did the Samoans, as well as the natives of Tahiti, Rarotonga, the Marquesas Islands, Tonga, Fiji, Mangareva, and Hawaii.[41] The Batak of Sumatra refer to it as *tondi*, and in the island group of Mentawei, natives describe this indefinable and mysterious energy as a residue of *kere*, while the Javanese call it *kesakten*. Many African tribal groups and North American Indians have similar concepts of a life-force.

We are dealing here with a presumably intangible and obscure power which, in whatever form it takes, seems to be universally accepted by preliterate peoples as existing in a world of mystery, magic, and medicine. At times this power has curative properties; at other times it can be harmful, fascinating, or even dangerous. The power itself is not visible. It is only the notion of or belief in it that is effective when the need for support finds a symbolic equivalent of strength. The supernatural efficacy of these *mana*-laden carriers transcends realistic judgments or intellectual reflection.

There are innumerable magical objects that have *mana*. Whatever the tangible aspect of the power-imbued fetish, it helps soothe anxiety, insecurity, or a sense of vulnerability, and is, as Henri Bergson put it, "a precaution against the danger man runs, as soon as he thinks at all, of thinking himself *alone*."[42]

This dynamic conception of strength or power is not arbitrary. When man is in the grip of needfulness and in search of support, its emotions ascribe various kinds of potency—healing, protective, mystical, rescuing, or, alternatively, destructive—to whatever device can furnish such a feeling, or merely prevent

anxiety. Effigies of ancestors or demons can be numbered among such devices, as can relics of saints and martyrs. All are similar to the cherished teddy bears or children's dolls, or the memorabilia of relatives or outstanding persons such as Churchill or Hitler.

Logic is eclipsed when objects held by a baby or worshipped by a religious believer are no longer literal representations of something but instead become carriers of *mana*. As such they are often treated as if they had a soul or a life-force of their own. They are, then, not merely ideational representatives but can be regarded as organisms permeated with basic strengths and capabilities. In other words, they are often employed in an attempt to master reality or, more concretely, to master anxiety by way of reassuring or even delusional fantasies.

When a child gives a name to a plaything, we tend to regard it as nothing more than the harmless abatement of temporary insecurity or unhappiness or a fear of being alone. But is this essentially different from a Melanesian native's trust in *mana*, or the conviction that magical properties exist in the bones of a dead ancestor?

A patient of mine, when leaving my consulting room, was in the habit of taking a tissue from the bathroom and, as she eventually told me, guarding it carefully until her next visit to me. There is little mystery here. All she had done was to unconsciously invent a simple, unobtrusive, and temporary fusion with me. Private rituals like this, in essence not very different from compulsive collecting, are an attempt to create artificial or illusory companions. And so attaching any sort of power or *mana*-like life-force to objects makes them special, which in turn are meant to make their owner special or different. Seen in these basic terms, collecting of objects is a distinctly individual experience.

But there are certain objects or collections that arouse shared sensations in the viewers. An early form of effecting relief from anxiety and exercising imaginary strength was skull collecting. This is an expression of sentiment with which Western man is familiar, for the Catholic church has long looked on the skulls of saints and martyrs with awe and devotion. These are more than just the corporeal residue of the actual person or even of his or her mysterious, awe-inspiring identity, and they are also more

than the tangible symbols of survival. Once we inquire into the latent meaning of skull worship and postmortem power, we have to abandon the straitjacket of logical argument or defensive reasoning.

Thought, Jan Huizinga observed, has a marked tendency "to embody itself in images."[43] Here, it is the conception of immortality that we are trying to attach to an object. Underlying this demand for a relic, and in particular a skull, is a powerful emotional experience. By keeping an ancestor's skull, the believer confers everlasting life on that person. That is to say, his spirit remains. It really means that if he can attain immortality, then in some way or other the owner of the skull can as well.

In the case of the ancestral skull, certain South Pacific tribes actually model the ancestor's image on the skull itself.[44] In the case of a saint or a martyr the skull is sometimes preserved in a reliquary which supposedly resembles his or her countenance. This is an obvious attempt to preserve or reclaim life. However, we would miss the point if we regarded this kind of habit only in terms of reclamation or preservation, or as a stab at mastery and ownership linked to possessiveness and a phallic-exhibitionistic tendency.

The accumulation of relics epitomizes what the whole process of collecting is about. People tend to attribute intrinsic power or life-substance to important parts of the body or, in an emotionally more detached spirit, to remnants of the past, like the Greek works of art Roman citizens considered highly desirable collector's items. Such endeavors often reflect a belief in transmigration of the soul. It is not essentially different from the *mana* I dealt with before. Several collectors of antiquities and tribal art have told me that the objects in their collections were silent witnesses of eternity, or, as George Ortiz put it, "evidence of infinite truth."

The dominant factor in this search for "evidence" is a guarantee of perpetuity. The objects are regarded as testimony that death is not final and the end of all existence; that one does not have to face abandonment, the dread of being left alone and, ultimately, demise and nothingness. Collecting skulls, bones, or anything belonging to ancestors or important or holy persons is a particular form of denial. It is an irrational custom; a blending of conscious dread and unconscious aggression. The skull or the

relic is unquestionable proof that the person is no longer alive, and yet this knowledge is denied by assuming that he or she still holds magical potency or secret-regenerative power.

Ritualized or institutionalized collecting illuminates elementary patterns which, whether one likes it or not, must be treated as documentary evidence of the presence of a profound state of anxiety but then warded off collectively, say, by the Church, by converting a feeling of helplessness into a manifestation of imaginative action. At the same time, we must realize that anyone in the grip of this kind of existential doubt may seek and find relief in many different ways. Thus, the solutions chosen are determined by inner conditions as well as by the prevalent sociocultural tenor. We have seen how the rudiments of these feelings are well-set in early childhood for there is no culture in which a young child can grow up without anxiety and the dread of being left out or alone. This is doubtless a key phenomenon with the deepest consequences, a fact that helps to explain why we find related ways of dealing with such fundamental feelings in many different times and places.

As we shall see later, much of contemporary collecting, even by institutions, is a continuation, however camouflaged or arcane, of what has often been observed among many preliterate peoples. The deep-seated attempts to grasp and hold—the forerunners of chase and capture—grow out of an archaic need for reassertion, because there is no one who has no submerged memory of powerlessness and early suffering.

In view of this, it may be worthwhile to consider another fundamental aspect of collecting. As I said earlier, many primitive peoples believe the head to be the seat of a person's life-force or soul. However, many tribes do not restrict this belief to the skulls and bones of their ancestors; hair, nails, teeth, genitalia, and even former belongings may also be *mana*-laden. Whatever the object, the emphasis remains on the transmigration of spiritual power or efficacy. Not too long ago, in the Sepik River region of New Guinea it used to be possible to see here and there a recently captured head. It was customary to hang such trophies at the outside of the men's community house. There they remained until an appropriate feast was organized to mark a ritual in which adolescent males were initiated. These boys with the aid of adults, usually their fathers or uncles, had taken

the heads of neighboring tribes, in preparation for becoming recognized members of the adult male society. Only after such a traditional initiation or rites of passage from boyhood to adulthood was the young man allowed to wear a particular tribal emblem, such as a pubic covering, in recognition of his new status.

We should not dismiss such institutionalized customs as savagery and bloody murder. And, in any case, manic cruelty and obsessive devotion are in no way irreconcilable. Such conventions are socially approved means of diverting unconscious and implicitly repressed drives. Head-hunting and preserving relics of a saint spring from the same experiential source. It is for this reason that I have drawn attention to the conceptualizations and practices of certain native tribes.

The Marind-anim of western New Guinea used to require that a head be taken for every newborn infant. The child needed a name, and the name had to be taken from someone else who had to die for the sake of perpetuity. The name would live on. The name had hidden power, and nobody could command power without such a transmigration, which could only be guaranteed by way of capture and murder. For that reason the Marind headhunter would first force his victim to reveal his name.[45]

Many Christian relics are the bones and particles of martyrs, some known ones, though many more died for their belief, and no name was known. Significance and, in essence, intrinsic power is inevitably linked to a name. (In much the same manner, we have come to consider a work of art with a pedigree and signed by the artist to be more valuable than an unsigned one.)

In the case of the Marind-anim this custom used to go far beyond the ceremonial. It was an attempt at guaranteeing a homeostasis of life-substance and the perpetuation of efficacy. Thus, personal name and head or skull belonged together as an entity of power. And so these people had arranged galleries of skulls, an imaginative institution to exhibit collective tribal potency. To them, this way of collecting and exhibiting fulfilled an indispensable ego-sustaining need.

Among the Bareë-Toradja of Central Sulawesi (formerly Celebes), men who had successfully participated in a head-hunting raid could wear a red-colored headdress called *ula rompo*, while

those who hunted a second time could add yellow to the head-dress, now called *udasi nambira*. The different names and colors were proof of a man's rank and courage. Someone who had gone out five times on these daring ventures was allowed to wear buffalo horns, no doubt phallic credentials. But what about the skulls? They were on display in the ghost house (*lobo*).

These head-hunting expeditions had various purposes, the most important belonging to the initiation rites of the pubescent boys, culminating in a circumcision ceremony in the course of which the youth sat on a skull during the actual operation.[46] This last instance is particularly descriptive because the entire procedure literally makes the young novice the *possessor* of the power-imbued skull. Here we must remember that the verb "possess" comes from the Latin *potis* (able) and *sedere* (to sit). I do not believe that any other demonstration of what it means to possess could be more explicit, starting with predatory expeditions and climaxing in the ritualized act of taking possession of the soul-substance or life-force of the slain victim. It is an unqualified enactment of ownership and triumph.

I choose these examples because they dramatize the association between a sense of mysterious power and certain culture-specific variations and elaborations regarding its passage. The rituals make it evident that possession—almost in the literal sense—and ownership are inextricably intertwined. The young headhunters give an unsolicited demonstration of the inner meaning of a newly achieved status, a powerful supplement to one's self-esteem, or even a new identity by way of a mysterious fusion with the *mana* of the dead victim. We recognize that the starting point of possession is visibly linked with a craving for power. This corresponds closely with some collectors' desire or even condition to own objects with a pedigree proving that they previously belonged to someone famous—as if there were a transmigration of an intrinsic force. As the headhunter's rituals make quite explicit, there is, then, a fusion of an aggressive with a passive-dependent element.

There is also, I believe, a link to certain sacramental practices. For the Orang Agung of the island of Sumatra, capturing a head was again proof of achievement and excellence. According to these peoples' concept, a skull captured by a young man would double his strength. Bringing home the head of a slain enemy

implied courage and strength and was a precondition for marriage. But there is more, for the skull served a dramatic purpose, in a practice seen elsewhere in transparent variations. It was used as a wedding cup from which the newlyweds drank palm wine.[47]

Custom apart, this is an elementary example of the interdependence of two strata for the enhancement of *mana* or life-substance and the subsequent mystical union of slayer and slain, of preservation and perpetuation of vital power. It clearly implies the principle of the Holy Sacrament in the Roman Catholic rite (to which I shall come back in the following chapter). Once again, the various elaborations, whether more explicit or in symbolic disguise, spring from man's elemental early development and become adapted and assimilated according to particular culture-defined imperatives and eventually to individual needs and vicissitudes.

One collector of my acquaintance is a modern counterpart of the Indonesian skull-cup collectors. This lady had gathered drinking cups since her adolescence. However, this was not simply an assemblage of containers, since every object in her collection had once belonged to or been used by some person of prominence, among them Voltaire, Tchaikovsky, Albert Einstein, Franklin D. Roosevelt, one of the Barrymore's, and the boxer Jack Dempsey. Notwithstanding the obvious difference between a Batak headhunter and a sophisticated Western woman, there is a subliminal nexus as to the inner motivation.

The correspondence is even more evident in another Indonesian tribe. The Wemale of the island of Ceram provide a striking example of the connection that exists among skulls, cups, and certain other objects of aesthetic appeal. (It is these equivalences that give a hint of the unconscious attributes of the "collectibles.") The skulls of the Wemales' victims were kept in the clan's sanctuary, or *pusaka* house, together with—and this is significant—sacred vessels, gongs, and Chinese porcelain cups and bowls that for centuries have found their way to the Indonesian archipelago, not as objects for home use but as part of the treasured, almost sacred holdings of a clan or village.[48] Each piece had its own history or, more to the point, a story attached to it, not unlike the lady's collection of cups used by prominent people. Among the Wemale, crockery and skulls were enshrined in

the same place, and hardly any distinction was made between them.[49]

The belief in a life-force or soul-substance or displaceable soul is obviously an incentive for the accumulation of skulls and bones. But such a collection can soon become invested with a sort of aesthetic fiction in which a beautiful artifact can take the place of a captured head. Thus, when the Dutch governor interfered with the Wemales' age-old custom of head-hunting, they turned instead to chinaware and bronze gongs, even instituting thieving raids to faraway corners of their island in order to obtain more and more of these treasures, not unlike the stealing of holy relics in medieval times (as we shall see in the next chapter). Their instinctual incentive had been moderated or, rather, adapted to the Dutch colonizers' demand, and now cups, bowls, vessels, and gongs replaced the forbidden skulls.[50]

Here is a fitting example of how raw impulses can become tamed and transformed or remolded and, from a psychoanalytic perspective, undergo secondary and often tertiary elaborations. Such developments are not at all arbitrary, and despite changes and distortions there remains a kinship with the initial, underlying concern. The *mana* attributed to symbolic substitutes had the same experiential meaning that was formerly attached to the heads of the slain victims. What counts is that the relevant sentiment, and the effective origins so vital to such notions, were hardly blurred.

We can recognize here the reverberation of the original passion and appetites. And we can extrapolate how man's initial powerlessness and his attendant cravings and insecurities eventually find extensions. Counterbalancing this uncertainty becomes of paramount significance. Thus, attaching intrinsic values and *mana* to objects one cherishes is both an expression of frustration and a striving for security by magic means.

* CHAPTER 5 *

The Headhunter's Bequest

A FUNDAMENTAL AFFINITY exists among the skulls of an ancestor, of a sacrificial victim, and of a saint or martyr who gave their life for their beliefs. All are regarded as carriers of intrinsic power, and they concretize those ideas which represent the substance of mystery and sacrament.

Texts by churchmen starting around the fourth century A.D. stressed that the remnants of saints and martyrs had *dynamis* (from the Greek *force*), and thus the ownership of relics as a reservoir of divine patronage was introduced (or more correctly reintroduced from pre-Christian religious faith) into the creed of the faithful. A pagan custom was adapted to the needs of the young Christian church, and the passions of preliterate peoples were tailored and built into the current religious credo.

There is a church in the village of San José in the Petén in Guatemala, once the home of the Maya. The church owns three human skulls, which are the center of local worship. Here the links between pagan and Christian faith are quite clear, as one of the villagers revealed. He explained that these were the skulls of holy men of the past. "My grandfather told me they were important, and his grandfather said the same thing. They were more important than the saints because the saints are made of wood. The skulls have been human beings and have been alive. They are real bones just as ours."[51]

It would be hard to link the mystical and the factual more succinctly. The trust in the efficacy of the skulls, and hence their spiritual value, was the moving influence, with the concrete existence of the skulls and bones being the logical argument. The underlying principle here is the need for illusion in search of reinforcement and guarantees of a tangible presence. Man is everywhere a prisoner of his own anxiety. This inner tyranny implies from the outset a genuine craving for security and, more than that, for being special. And so owning the remains of martyrs is not unlike possessing a skull, an ancestral bone, or any *mana*-carrying object.

Many tribes pride themselves on a large accumulation of skulls, bones, or tusks. I have already mentioned the veritable skull galleries of the Marind-anim, and other tribes in New Guinea and elsewhere also used to collect and display skulls. But no collection of skulls and other relics can compare to that of the Roman Catholic church, especially those of the Capuchin order. And then there are the catacombs of Rome and Sicily, which contain an almost endless supply of skeletons and remnants of those men and women who died for their faith.

What we have observed in Melanesia, Africa, and Central America holds for the early Christians. In their eyes too there was a magic tie between body and soul, and consequently between the mundane and the spiritual. The soul is incorporated in the body. *Reliquiae* are the material residues of the dead, and as such offer a warranty of esoteric and wonder-working power, supposedly healing and preserving life and stability and promising, most importantly, eventual salvation. Medieval Christendom practiced, and even elaborated on, the mysticism and wishful longings of ancient civilizations.

Recall the case of Paul and his rag dog Micky. Paul's belief in the efficacy of the toy helped submerge his anxiety, and with the toy at hand he learned to live with and rely on this mystery. Why then not rely on splinters or nails of the Holy Cross, or remnants of the vestments of the saints? The cathedral treasures of Milan include the shroud of Jesus Christ, the nails of the Holy Cross, and Moses' wand, while the Cathedral of S. Giovanni in Laterano in Rome counts another wand of the prophet among its rich possessions.[52] Also found among the relics in S. Giovanni in Laterano is Christ's prepuce, which has turned up in a number of other places. There is, for example, a Holy Prepuce at Charroux, near Poitiers, in France, and there are others in Coulombe near Chartres; at St. James of Compostela, in Puy, in Hildesheim in Germany, and in Antwerp.

All these relics were believed to embody some inherent presence of the holy person which remained potent and effective beyond his or her earthly life. Note the resemblance to the belief in *mana*-laden objects of preliterate peoples. The adoration or, as several churchmen in the Vatican pointed out in my conversations with them, the *veneration* of such remains has developed into a significant part of the Catholic faith. Msgr. Testori, the

priest in charge of the Custodia delle SS. Reliquie at the Vicari-
ato di Roma, the official dispensing agency of holy relics, ad-
vised me that, even if the identity of a particular martyr is un-
known, the remains nevertheless belonged to someone who had
suffered and given his life for his faith. To the true believer,
Msgr. Testori pointed out, a holy relic should be a sobering re-
minder of the devotional spirit and the vanity of earthly exis-
tence. Another priest, Msgr. C. Rogers, stressed the high-
mindedness of everyone who died for what he or she felt to be
the truth. What matters today is the spirit, Msgr. Rogers empha-
sized.

Contrary to my expectations, the office of the *custodia* is just a
couple of rooms, with a counter, a few desks, and an upright
chest with glass doors containing a few dozen jars. Some look
like apothecary jars, while others are ordinary jam jars, each
holding some bones or a small sack, possibly holding ashes or
some other fragile material. Each jar is labeled, most of them
with the name of a saint or a martyr. At the time of my visit a
German priest obtained two relics, of San Sebastian and San To-
maso, each in a small envelope with an impressive seal and doc-
umentary papers. Compared with the dramatic history of relics
and relic collectors, there was nothing at all macabre about the
transaction.

Many relics have a legend or history attached to them, which
is supposed to add to their significance and mysterious efficacy.
Even the smallest particle is believed to contain power. While
one may call it superstition or fantasy, this belief in their worth
is one reason they are so much in demand. There is no rational
explanation for it. Few subjects lend themselves better to the
study of delusional conviction and possessiveness than the col-
lecting of relics. The experiential force attached to these
remnants is like a love affair—unreasoned, wishful, and occa-
sionally manic, as we shall see.

After the early custom of building a simple altar over the
grave of a martyr had been abandoned, the corpses were ex-
humed and transported to other places. Dismemberment had al-
most always occurred, but now the division of corpses and the
dispersal of the various parts to churches in many different
places and to individual collectors became an accepted practice
that grew into "an unruly passion."[53] Again, the dread of help-

lessness and the longing for protective power found a poignant illustration under the seal of religious devotion.

When word got around that the Holy Cross had been discovered in Jerusalem, thousands wanted to share in its blessings. Splinters of the Cross flooded the market from the Middle East to Western Europe. It has been stated more than once that there was more wood supposedly belonging to the Holy Cross than all the streets of Rome could be covered with. The *pars pro toto* concept treated all the splinters as a depository of divine power, endowing the owner with a reassuring notion of superiority.

And so the remnants of saints and martyrs lost much of their original purpose. Instead of being solely objects of devout contemplation, the relics began to be used as phylacteries, "to escape the darkness of the underworld."[54] They became a means of achieving specialness and extraordinary power, as well as an accepted way of expressing one's voracity. Soon there was a regressive move to magical thinking and wishful projections about them.

There is clearly an archaistic undercurrent in equating something that belonged to a saint or, for that matter, to Jesus Christ Himself, with being or becoming part of Him. It underscores the need for a bond with the saint, which offers an illusory attempt at self-preservation. The dread of being left unprotected in this life, and the prospect that one will be exposed to the horrors of purgatory, is reminiscent of those fears infants are subject to in the early years of uncertainty and doubt, and in the sometimes macabre rituals of primitive peoples. The invocation of a remnant of a saint as intermediary evolves out of the feeling of being vulnerable and defenseless and, at the same time, out of an inherent sense of guilt because the instinctive response to vulnerability is hatred.

The relic cult and the often obsessional collection of relics was preceded by the widespread use of protective amulets.[55] Toward the end of the fourth century so many relics were brought to Constantinople that the city became the relic capital, and travelers, pilgrims, and crusaders all thronged to the city. Opportunistic merchants quickly took advantage of the pious sentiments of the visitors, and health, redemption, and divine protection were soon for sale everywhere. Appropriate holy, *mana*-laden bones and objects were summoned forth by the same kind of

mental condition the unhappy infant applies when helplessness or uncertainty threatens his or her trust.

Christianity may have supplanted paganism by that time, but the underlying need remained. Believers were reluctant to put their confidence in intangible blessings. They needed something to see and touch and put their faith in supernatural assurance. Excesses of piety and devotion, mixed in with a good measure of avarice, quickly led to the suspension of rational judgment. Zealots, along with connoisseurs, have long been the victims of their own emotions, as was the case here.

In just a few short years, relics were frequently being stolen, presumably for reasons of piety, but actually because they had become a valuable commodity to attract pious visitors to the places of worship. Whether born out of ideology, a lust for beautiful objects, naked ambition, or sociopolitical aims, there is little question that there is lying at the heart of a good deal of theft a desire for exclusivity and power as a usually manic defense against anxiety. What this meant in this case was that, if a relic really was a protection against damnation, why should not someone in a ready position to obtain one of these magic objects be solaced by its ownership? In the fierce struggle to get possession of relics that marked this period, we can see the development of a kind of acquisitiveness accompanied by a strong aura of sanctity.

We have some information about individual relic collectors from Carolingian times. One of them was Einhard, biographer of and adviser to Charlemagne and his son, Louis the Pious. Louis had provided Einhard with the bishopric of Mulinheim in the Odenwald as a privy purse, which he now wanted to enrich with holy relics. While Einhard was trying to gather relics for his "City of the Blessed," or Seligenstadt as he had renamed Mulinheim, the Venetians were smuggling the remains of St. Mark out of Alexandria. Hilduin, the emperor's chaplain, who was also eager to collect such treasures, competed with Einhard for the remains. But there is considerable evidence that possessiveness, even in the name of faith, is not far removed from corruption, and Venice became the final resting place of the skull of the saint. However, Einhard did obtain the relics of two martyrs, Marcellinus and Peter, about whom he himself wrote an extensive essay, *Translatio et Miracula SS. Marcellini et Petri*.

It is important to keep in mind the fact that in medieval life relics had a distinct economic appeal. By attracting worshippers, they brought in substantial tourist revenue.[56] There was therefore a practical reason for going after them. "A city without relics was like a man without a shadow," Hugh Honour writes.[57]

The discrepancy between demand and supply soon brought a number of enterprising traders on the scene, some in clerical garb, such as the deacon Deusdona who lived opposite S. Pietro in Vinculi, the famous Roman church, and functioned as a trustee and administrator of several rich catacombs.[58] In him, religious zeal quickly gave way to avarice, and he took to selling forged relics to naive and trusting believers. Obsessive collectors have always been open to temptation. A few hundred years later it was the sale of indulgences that took unsavory advantage of people's frail self-reliance. Now, perhaps counting more on people's naïveté, Deusdona, a veritable merchandizer in holy relics, founded a kind of syndicate for the exploitation of both the catacombs and willing believers. The difficulty of crossing the Alps did not keep the deacon from paying visits to the Imperial Court at Aix-la-Chapelle and cultivating relations there.

The burghers of Rome soon became aware of the constant outflow of their spiritual capital, particularly after some people went to look for the remains of St. Sebastian and St. Hermes and found both of their graves had been opened. Deusdona, having gained access to the inner circles of the Court at Aix-la-Chapelle, probably was able to outbid his competitors for the remains. With the consent of Pope Eugene II, part of the body of St. Sebastian had been brought to the French town of Soissons. Meanwhile, with relics on their way to becoming a good deal more than objects of devotion, Hilduin had conspired in the theft of St. Peter's body, which belonged to Einhard, while Einhard himself had devised a scheme of having them taken from a church in Rome.[59]

Medieval man triumphed when the relics of saints and martyrs could be removed without harm or authorization of the present keepers, who were then pronounced unworthy of their present treasures, thus revealing a good deal about the frailty of conscience. Gregory of Tours speaks of thieves who offered an abbey near Bourges some relics of St. Vincent that had been stolen from Orbigny. Or the monks of the abbey of Abingdon let it

be known that certain holy remains in their shrines had been taken from Glastonbury, implying that they, as their new guardians, could take better care.[60]

While the taste and choice of collectors is predominantly influenced by their personal predilection, there is little question that the ambience of the time and surroundings also affects a person's outlook. There is not too much conjecture in the assumption that this religiously tinted concern with holy relics came to some extent from Charlemagne himself. The emperor was a devout believer who made Aix-la-Chapelle, his favorite residence, one of the centers of relic worship. He recalled that when he was seven years old, a miracle had taken place before his very own eyes. The coffin with the remains of St. Germain was supposed to be moved from one place to another, but it was too heavy. At that moment, the miracle occurred: The coffin moved of its own accord. The young prince, who was watching from nearby, jumped up in disbelief and thereby lost a tooth.[61]

Even a fragmentary account such as this sheds light on the linkage between faith and danger. To the young boy, the experience was an unforgettable revelation of the supernatural forces to which he had to submit. After all, the concern with relics is rooted in insecurity and the concomitant need for reassurance. Relics became emotional currency in the face of existential anxiety and frustration, which inevitably result in hostile thoughts and aggressive fantasies, and they, in turn, spawn a dread of impending retribution. And the Church preaches eternal punishment for one's earthly sins in purgatory. Such threats, actually from within, as well as dangers from without can easily menace a person's equilibrium, to the point where delusion and fanaticism take over. The relic, like the infant's comforter or Paul's toy dog, is a technical device for those in need of tangible support, here in the form of another sustaining object. It represents the believer's unequivocal surrender to the omnipresence of the Sacrament. This was especially true at a time when the Church kept reminding the believers of their inevitable guilt feelings by preaching about the horrors awaiting the poor sinners in purgatory.

Charlemagne's childhood memory is fitting because it sharpens our awareness of the subliminal links between this awe-inspiring episode and his lifelong belief in miracles and the

ever-present threat of divine justice and retribution. We cannot ascertain to what degree the sudden loss of a tooth at the very moment the coffin moved affirmed a seven-year-old's belief in spiritual powers. Did this episode remind him of a loss of control and a need for self-preservation? Did the event increase an inner conflict over whether aggressive impulses would endanger divine protection? If we take some clues from clinical observations we understand that dreams about the loss of a tooth or teeth frequently signal concern about cannibalistic-destructive fantasies, even castration, and Charlemagne may have yearned for extrication from even unconscious culpability.[62]

As I have noted, magical objects are a hedge against a lingering sense of vulnerability or, in the case of the believer, a kind of promise of safe conduct. Thus, we can understand Charlemagne's search for protective devices, as well as a kind of supernatural potency, as a means of fostering his illusion of control over both the present and the hereafter.

Just as the call of one's faith rationalizes a rudimentary need to ward off persecutory threats, so religious beliefs turn into superstitious credulity, and, in the case of many relic collectors, into a display of crude calculation in the name of piety. Emotions of this nature are consonant with the prevailing notions of values. While the initiation and rebirth rituals of preliterate peoples demanded skulls and scalps to provide a certain guaranty of the perpetuation of the life-substance, medieval worshippers triumphed by appropriating remnants of saints and martyrs from their custodians, who did not merit their possession. Relic possession "seemed to enjoy a peculiar exemption from the common code of honesty."[63]

What we witness in this constant hustling after salvation is an amalgam of a quite primitivistic element of religious concepts and obsession with assurances of the means for salvation. It is as if there were a link between the emotional overtones of a headhunter's outlook and medieval man's existential conceptions. This is not to say that what we have here is a simple replica of ritual passion, but rather that it consists of far more profound inner determinants rooted in, as it seems, an all-pervasive existential anxiety. In other words, the question to ask is: What is the difference between the skull of an ancestor and that of a saint or martyr?

Under such conditions, outright cruelty soon took on the guise of a religious pursuit. When, in the year 1000, St. Romuald, a holy hermit, let it be known that he intended to leave his Umbrian village, the people in his parish made secret plans to take his life so that they would not be deprived of his sanctified remains.[64]

Clearly, the manic demand for holy relics did not find satisfaction entirely in spiritual pursuits. The murder of St. Romuald, and other examples like St. Elisabeth of Thuringia, offer more than a hint of how the contagion had spread. She had lived as a devout, selflessly dedicated woman helping the poor and caring for the sick. Constant exposure to people with contagious diseases eventually led to her untimely death in 1231 at the age of only twenty-three. She died in the city hospital of Marburg. The townspeople did not wait very long to obtain remnants of her blessed remains. They not only cut off her hair and removed her nails in order to obtain some corporal remnants. They also chopped off her fingers, her ears, and her nipples. It did not end here either, since the devout citizens of Marburg in their grief even ran off with pieces of her shroud.[65]

These were more than symbolic acts. They characterize the plasticity of emotions found during this period. Love and affection often merge with passionate violence, and occasionally culminate in outbursts of religious intoxication. Such excesses are an outgrowth of the same anxiety and chronic existential crises we have encountered in the headhunting rites of various primitive tribes, in the child's dread of being left alone, and in the needfulness of the never completely gratified, always searching collector.

PART THREE
THREE PSYCHOBIOGRAPHIES

*

"One Copy of Every Book!"

IN THE FOLLOWING three chapters I propose to explore the personal circumstances and life-histories of three particular individual collectors. These should illustrate certain empirical aspects, particularly in their early life events, which may help explain certain underlying factors critical for the course of their endeavors as collectors. The advantage of these three profiles is that we do not have to rely on secondary sources. Rather, the collectors themselves have left (or in the case of Mr. G. have given me) autobiographical data that provide an array of illuminating and relevant subjective perspectives about their lives. They help in the effort to understand and illustrate certain aspects in the causal criteria of the origin, course, and, indeed, compensatory significance of their passion.

The examples I have chosen to explore in comprehensive detail—and which highlight the various criteria and aspects that appear to account for the incentive to collect—are the well-known British book and manuscript collector Sir Thomas Phillipps, the famous French novelist Honoré de Balzac (an obsessional collector of bric-à-brac who in his novel *Cousin Pons* delineated with much empathy and imagination the defensive passions of the dedicated collector), and a Mr. G., whom I knew personally.

At the time of his death in 1872, Sir Thomas left what was probably the largest and most important collection of books and manuscripts ever accumulated by one individual. The collection was so large, and so significant, that to this day, more than a century after his death, the auction house of Sotheby's in London and New York has conducted some sixty sales of "The Celebrated Collection of Sir Thomas Phillipps," with a total of millions upon millions of dollars.

It should be noted here that this great collection was not limited to books and manuscripts alone. In fact, Sir Thomas, for more than fifty years, and on the most grandiose scale, acquired virtually every Babylonian cylinder seal, deed, document, codex, genealogical chart, autograph letter, cartulary and map,

besides many master drawings he could lay his hands on, in addition to the tens of thousands of manuscripts and books.

It is perhaps necessary here to stress the intellectual and historical importance of the *Bibliotheca Phillippica*, as the owner wished it to be known, because his own inspiration to accumulate it hardly derived from any lofty motives. In fact, as we shall see, at times the accumulative instinct in Sir Thomas seems to have approached, if not even passed, mania, a word which he himself used from time to time in discussing his addiction. For example, "I am going on with the old Mania of Book-buying, but not so much MSS. as Printed books," he once wrote to a fellow collector, Robert Curzon, one of the few people with whom he remained on consistently good terms for most of his life. A postscript to another letter to Curzon is even more explicit: "I am buying Printed Books because I wish to have ONE COPY OF EVERY BOOK IN THE WORLD!!!" he wrote, three years before his death.[66]

By the time Sir Thomas wrote of his ambition he was already an old man, querulous, opinionated, often mean, a hater of Roman Catholics, and completely self-centered. Only a few years earlier he had moved from the spacious country mansion Middle Hill in Gloucestershire to Thirlestaine House in Cheltenham, the large but inconvenient residence of the late Lord Northwick.

The move could not have been easy. If Thirlestaine House was uncomfortable—"booked out of one wing and ratted out of the other," his ailing wife rightfully complained of her new abode[67]—Middle Hill had by that time become totally uninhabitable. Not that Sir Thomas cared about her feelings or her discomfort. He actually moved not because Thirlestaine House was more agreeable or had more room for his collection, but in a fit of pique.

Middle Hill had been left to Phillipps in trust, and on his death would have to go to his eldest child, his daughter Henrietta. Against her father's wishes, Henrietta had eloped with James Orchard Halliwell, an outstanding Shakespeare scholar. Driven by anger, prejudice, egocentric ambition, and an unwavering hostility toward Halliwell, Phillipps was determined to prevent his library and other possessions from falling into the hands of his daughter and her husband. He therefore allowed

Middle Hill to deteriorate and become prey to marauders and decay before leaving it to the Halliwells.

Between July 1863 and March 1864, a total of 103 wagon-loads of manuscripts, books, pictures, drawings, and papers of all sorts were transported from Middle Hill to Thirlestaine House by 230 horses accompanied by 160 men.[68] Even by today's standards, the *Bibliotheca Phillippica* at that time was enormous and of incalculable value. By 1840 it contained around eleven thousand manuscripts. Sixteen years later the manuscripts alone had increased to about twenty thousand, and there were about thirty thousand printed books.[69] An exact count was never made of the collection during Phillipps's lifetime. but at his death he left behind at least sixty thousand manuscripts and around fifty thousand books.

As I have already noted, he was to some degree aware of the extent of his obsession. Sir Frederic Madden, then Keeper of Manuscripts of the British Museum, kept a diary, now also in the Bodleian Library, in which he described a visit to Middle Hill in the summer of 1854:

> The house looks more miserable and dilapidated every time I visit it, and there is not a room now that is not crowded with large boxes full of MSS. The state of things is really inconceivable. Lady P. is absent, and were I in her place, I would never return to so wretched an abode. . . . Every room is filled with heaps of papers, MSS, books, charters, packages & other things, lying in heaps under your feet, piled upon tables, beds, chairs, ladders, &c.&c. and in every room, piles of huge boxes, up to the ceiling, containing the more valuable volumes! It is quite sickening!. . . I asked him why he did not clear away the piles of papers &c. from the floor, so as to allow a path to be kept, but he only laughed and said I was not *used to it* as he was! . . . The windows of the house are never opened, and the close confined air & smell of the paper & MSS. is almost unbearable.

This vivid description is more than sufficient to give us an idea as to how Phillipps lived and collected. And Madden was not alone in his judgment. Still, one cannot help but admire a library which at that time contained, for example, a fourteenth-century copy on vellum of Valerius Maximus with annotations in Petrarch's hand (now in the library of Harvard University);

the manuscript catalogue of Horace Walpole's library at Straw-
berry Hill; and the manuscript of the letters of St. Jerome and St.
Augustine in a fifteenth-century binding (now in the Pierpont
Morgan Library).

Yet there is a difference between obsession and idealism, and
it is largely the absence of the latter that caused Madden to react
as he did. There was no sense of aesthetics in the collection, nor
is there any indication that Phillipps appeared to appreciate the
beauty of his many illuminated manuscripts. Some of them
were of astounding radiance. Nor did he admire the many out-
standing drawings by Michelangelo, Leonardo, and Rubens that
he possessed.[70]

Only by looking further into Phillipps's life-history and de-
velopment can one see how his interests and ambitions had a
certain inner logic and validity, both hidden from Madden, as
did his snobbery. Only on one of those rare occasions of self-
observation did Phillipps become aware of what he himself
called his egotism.[71] He was a willful, despotic man, plagued by
ill-temper, and with an astonishing disregard for other people's
needs and emotions. "We all are having serious thoughts that he
is going rather cracked," his second daughter, Mary, wrote to
Henrietta Halliwell, in the summer of 1843. But at that point
their father still had left nearly thirty years of uninterrupted
collecting.

At his death, Sir Thomas left behind thousands of scribbles,
letters, copies of letters, pamphlets, bills, and random annota-
tions. He seemed unable to consign to the garbage anything
with writing on it. Even with all these details we do not know
exactly where and under what circumstances young Phillipps
spent the first four years of his life. Nor do we know who looked
after him. He was probably brought up in or around Man-
chester, where his father had made his fortune. The wealthy
Phillipps père and son moved to Gloucestershire in 1796. Mid-
dle Hill, a large country house with fifty-four windows, accord-
ing to the tax bill, became the Phillippses' home for the next
sixty-eight years.

In spite of his father's wealth and acquired status, Thomas
Phillipps's childhood was marked by uncertainty. Thomas was
born out of wedlock on July 2, 1792. His mother was Hannah
Walton, a twenty-one-year-old servant of low origins. His fa-

ther, a self-made man and prosperous merchant and landowner, was fifty years old at the time of Thomas's birth. Phillipps senior, a bachelor, was apparently pleased to have an heir, as the boy was baptized as Phillipps, and not Walton. Since he was left in the care of his father, we do not know who mothered him. Hannah Walton was sent away, although they remained in contact, as we shall see later. When Thomas was six, he was brought to the house of a schoolmaster in nearby Broadway, and about two years later he entered an "Academy for the sons of Gentlemen" in Fladbury.

In 1818, when Thomas was twenty-six, his father died. In his will, he left his estates and Middle Hill in trust to his son, and subsequently to Thomas's offspring. Initially, the young heir's annual income was in the neighborhood of 8,000 pounds sterling, an enormous amount in those days. Tellingly, the old man also left an annuity of fifty pounds to Thomas's mother, who was by that time married to a Mr. Judd.

We know all this because of Thomas's inability to let go of any written material. Indeed, in a letter to his father in 1815, he asked Phillipps senior to save his correspondence. And again in 1818 he wrote: "Pray keep all my letters for I shall have great pleasure looking over them hereafter."

One wonders whether he ever looked again at those notes and letters. In any case, we are grateful for his folly, which is the principal source of his biography. The rich inventory apparently was his way of clinging to unavailable parents, and a manifestation of his search for certainty. Two small envelopes dated 1819 contain two locks of hair, marked "Father's" and "Mother's" respectively. Among his chaotic assemblage of papers, the dozen or so letters to and from Hannah Walton exhibit an unusual amount of restraint. We might view Thomas's saving of locks of hair merely as poignant, but it turns out to be a hint of his curiously warped sentimentality. Tellingly enough, he had mutilated the correspondence with his mother by cutting the words *mother* and *son* out of the letters.

In so doing, he was obviously trying to obliterate the link with that side of his lineage, as if deliberately severing the bond with his mother. At the same time, he clung to her hair and to the letters. It was like hiding a blemish, which in social terms it was, at least to him. To be sure, it was this blemish that awak-

ened his concern with genealogy and historical documents. His constant sense of uncertainty seems to have started him on his road to histrionic collecting. The question of "Where do I come from?" was thus channeled into a preoccupation with descent and origins, as shown in his initial choice of items to collect: church records, deeds, gravestone inscriptions, manuscripts, and bibliographical information, as well as books. Eventually he had so much source material of this kind that people engaged in genealogical research turned to him for information.

There can be no question as to the basically emotional focus of his collecting: "My dear [cut out]," he wrote shortly after his twenty-sixth birthday, on July 20, 1818,

> When I left Town, I went into Wiltshire & staid there three weeks, & from thence went to Cheltenham & staid one week, & when I came home, & found my Father *looking* very well, but not quite well in reality. . . . I am very angry with you for not sending me the account of your family as far as you know in addition to what you have already given me. What was the name of your Grandmother besides Sarah, and what were the names of your Grandfather's Father & Mother. What are the names of your Uncles & Aunts, & their Children, and the names of your Brothers & their Wives with their children, & your Sisters Husbands and Children. Write it down in this manner.
>
> My Father's name was James Walton & he was the son of James Walton & Grandson of <u>what name</u> He had (<u>how many</u>) Brothers & _____ Sisters & (<u>how many</u>) Uncles & Aunts, & then mention how many children they had, born & died & who they married. Or do it in the following manner, 'My Father had 5 Sons & 5 Daughters 1 Robert, 2 James, 3 Richard, 4 Isaac, 5 John . . .

His instructions continue for another two pages. It is obvious that on the one hand he was trying to cover up his ancestry on his mother's side, while on the other he was overrating his paternal descent, yet he was still desperate for every detail about his line of ancestry. His obsession with his origins was strong enough to overcome the stigma of illegitimacy. His questionnaire reveals the curiosity that was the foundation of his entire personality. After all, his life work was effectively the outcome of his anxiety about his foggy past. His motherlessness in its practical day-to-day aspects, the complicated relationship that

existed between father and son, and the attitude of Phillipps senior toward his mother are all interrelated factors which shrouded the boy's identity so much that he soon made himself the center of the universe.

Some early letters give us some insight into what was going on. The first reference to an indirect contact between Phillipps senior and Hannah occurs in a letter at the end of November 1800, when Thomas was eight:

> Mrs. Graham's compliments to Mr. Phillips [sic] and begs [indecipherable] the liberty she has taken in writing him her servant Hanah Walton who Mrs. Graham found on her return to town extremely ill. She consulted Sir Walter Farquher who advised change of air and as travelling is so expensive and the poor young woman has no house to go to she seems anxious for one to solicit you to permit her to visit Middle Hill when she gets better. I shall have no objection to take her back again at present.

On the back of the letter is a draft of Phillipps's reply, a habit the son frequently followed:

> As to the subject you write about I am very sorry to hear your servant Hanah W. is so ill as to be obliged to leave your place where she has been treated with the utmost kindness and affable condescension. . . . But Madam I am so situated amongst my relations & friends that all the female part of them woud immediately say I had shot my doors against them, and however immaculate and pure we might live yet appearances woud be so much against me that I shoud assuredly receive the public acuserers[?]. For these reasons which I think you will allow to be substantial I can in no consideration permitt her to come here.

Phillipps's relations with Hannah had evidently not always been "immaculate and pure," and we do not know why he now used this excuse. Eventually, there was direct contact between Hannah and her son, although it was always guarded and, on his part, rather pedantic. A letter of January 13, 1803, from ten-year-old Thomas to Hannah makes it clear that there had been some meetings between them: "I am very sorry I cannot come to London this Winter. I wish you had a good journey into Scotland & safe back again & I should be very glad if you would write another letter to let me know when you come back again."

In a letter to his mother later that month, we learn that his father had relented about meeting Hannah. "My Father's love to you, and begs you will bring a bottle of Soy, when you come down at Easter. I also received the gifts you was so good as to send me, the Prayer Book, Figs, and Oranges. . . . Pray, when you come down, do not forget to bring Don Quixote, for my Father wishes me to have it."

Two years later Thomas thanks his mother "for the intention of sending the books and I beg you will bring them with you when you next come to Middle Hill." Thus, there was contact between them as far as circumstances permitted. Meanwhile, Thomas had been sent to school at Rugby and was well on his way to becoming an educated, upper-middle-class Englishman. But there was already a core of self-centered stubbornness in Phillipps, which was to become a prime trait of his character. On January 6, 1807, he was looking forward to his mother's visit at Easter:

"I have not seen you a long while. When you come down, please to bring Don Quixote with you, nicely bound, and good print, that is about as large as I write now. . . . You can buy it in London, for all sorts of books can be had there I suppose. There is one of the last books, that you sent me, I do not like, it is about Confirmation; so I shall give it to you again at Easter: all the other books I like pretty well."

Sir Thomas must have overlooked the end of this letter when he reread it probably half a century later: "I could not write sooner and cannot write farther, for I have nothing else to say; So farewel, Dear Mother till I see you again. I remain Dear [cut out] Your [cut out] —T. Phillipps."

From the beginning Thomas let little stand in the way of acquiring books, although eventually his father began complaining about the bills. Like so many passionate collectors, Thomas began cataloging early: "I found this Catalogue the other day," he told Sir Frederic Madden in 1864, "made when I was 16, about the time I was at Rugby School. I fancy there are not many Boys who have had a Library of 110 Vols at the age of 16."[72] His catalogue of titles fails to reveal any special intellectual acumen. In fact, his comment implies that quantity was already more important to him than content or quality. And it certainly failed to

presage one of the most eminent collections of illuminated man-
uscripts and rare books ever put together. The letters written
during his adolescence, before he entered Oxford University,
show a warmer relationship with his mother than before, and
certainly after, his school years. Apparently, she must have
asked him what books he wanted, for he replied: "As I told you
before you may get at Middleton's Cicero in boards, price one
Guinea, with a head of Cicero in the beginning, 1st Volume. I
should be obliged to you also to get the other two books (Spec-
tator & Pope) bound different from each other. My Father is
gone to Evesham so I take the opportunity of writing to you
[January 22, 1810]."

There was also some guarded contact between mother and
son at this time, which did not meet with the senior Phillipps's
approval:

> I assure you I have not neglected you, & I would have written a
> long while before, but I did not know where you lived; you
> change about so much, that I wish you could stay in some fixed
> place, then I could write oftener. I have left Rugby now, & I go to
> Oxford in October next. My Father says it is not convenient for
> him that you should come down, & it is of no use my trying to
> prevail upon him, therefore I think it would be better for you to
> give up all thoughts of coming down here at present, & leave it to
> Providence to bring about our meeting again. We are both very
> well. Excuse this short letter as I am going out for dinner. I remain
> your [cut out].

At this point, the scope of our inquiry must narrow to the re-
lationship between Phillipps's fundamental character and his
compulsive search for historical documentation, manuscripts,
and other sources in the name of reclamation and preservation,
since he soon became the self-appointed protector and curator
of documentary material of all sorts.

Thomas matriculated at University College in Oxford when
he was nineteen, rather late by any standard. We do not know
what caused the delay. His ambition soon became obvious to his
friends, as indicated in a lively correspondence with two fellow
students. With Charles Henry Grove he shared an interest in
books and a curiosity about seals. In the case of William Riland
Bedford, his subsequent lifelong concern with genealogy and

topography surfaced. He was receiving an allowance of 300 pounds a year from his father, but neither economy nor economics was Thomas's forte, and he soon incurred large debts, despite his father's continuous admonitions: "Will not your calculations tell you that since you went last time to Oxford you have spent after the rate more than 800£ p. ann., and if this 60£ you now write for is spent also which I much fear it is, it will make it more than 1200£ p.ann. . . . I highly disapprove of your going to an auction when you have no money to pay for what you buy [June 26, 1812]."[73]

Thomas's elusive descent and rather bizarre upbringing must have been a nagging concern and preoccupation. He felt that he had to conceal from others who his mother was, and he was denied permission for free and open communication with her. This created significant differences between him and other children. There is no record that any woman had been looking after him during his early years. Whatever direction he received came from an intolerant and comparatively old bachelor father whose ideas about paternal guidance were not very clear. Indeed, in some respects, Thomas's attitude vis-à-vis his own children was, if anything, even more warped and uncomprehending. He grew up to be a stubborn, ill-tempered man whose prejudices and self-centeredness muddied nearly all his relationships. He loathed Roman Catholics and was most of the time completely oblivious to other people's feelings; with very few exceptions, he was also suspicious of everyone with whom he came in contact.

Phillipps was never a good or even interested student. Eventually, a tutor had to be engaged to help overcome his "slowness of apprehension & mediocraty of talent."[74] He interrupted his studies in Oxford to search for books, as everything was already subordinated to his passion. In the meantime he kept sending packages of books home to Middle Hill, writing to his father: "Mention every package in the order you have received them describing the appearance of each, not the number of feet, for I did not measure any of them. If you would be kind enough also to spare 10£ & enclose it in your letter."

His college friends were helpful, especially William Bedford, whose father had a lively interest in topography. Bedford took Phillipps home to meet his father, who eventually sponsored

him for membership in the Society of Antiquaries, an honor he made ample use of without showing much appreciation or gratitude. His historical and genealogical interests soon eclipsed his academic pursuits, in defiance of his father's repeated complaints of spending all his time in "Idleness, Dissipation & extravagance [April 17, 1815]."

Thomas insisted on resuscitating the past. He made contact with fellow antiquarians, offered his assistance to them, and prepared his first publication on ancient deeds. Many others followed. Eventually, he became his own printer and publisher under the imprint of Middle Hill Press. While one can argue that a publication such as *Parochial Collections for Oxfordshire* is hardly a worthwhile enterprise, it is evident that, by now, Phillipps's interest had been displaced from information about his mother's various relatives to an investigation of the pedigrees of "the most considerable persons" in the county. The focus and perspective of his pursuits were displaced but were in effect nothing more than another variation of his own existential dilemma. For example, he tried to persuade himself that he was descended from Robert, Duke of Normandy, and Leofwine, Earl of Mercia, twenty-six generations ago, and drew genealogical charts to prove his own family romance and reinforce his paranoid identity. In the same vein he also traced his ancestry to the Phillippses of Picton Castle in Pembrokeshire. Now and then he signed documents Thomas Phillipps, Esq. F.S.A. [Fellow of the Society of Antiquaries]—all a tu quoque argument against his illegitimacy.

His antiquarian interests were temporarily set aside in 1817, when he met Henrietta Molyneux, daughter of Gen. Thomas Molyneux. Henrietta was a young lady whose background offered established family connections, a fact of considerable importance to him. Thomas and Henrietta wanted to marry, but Phillipps senior insisted the marriage would not take place without a dowry of no less than 10,000 pounds. When the general could not meet this demand, Phillipps senior refused to give his consent. Thomas hounded his father with the same doggedness he would later apply to his efforts to obtain the books and manuscripts he wanted.

He tried to persuade the old man by explaining in a letter that marriage would bring to a halt his extravagance:

Since your deafness prevents our carrying on a conversation for any length of time with that calmness with which all conversations should be held . . . I confess while I live single, & have no body & no thing to be anxious for, I do not live with that prudence and economy which I should, were I in a different situation. In my present state, it is immaterial whether I live or die. But let me change that state with the person of my choice, & the cares & duties which would necessarily & immediately become incumbent upon me to support and discharge, would produce, I assure you, a very great alteration in me. It Must be a person of my own choice, otherwise there will be no affection to detain me at home, & it would be the cause of misery through life. . . . I am perfectly free from the grand causes of a man's ruin. I never gamble, & I dislike cards and betting of all kinds [November 12, 1817].

While this letter shows Thomas in a rather human light, it reveals no evidence of self-knowledge or foresight, since he never did acquire the "prudence and economy" he refers to in his letter, nor would his marriage be an exercise of the cares and duties which he alludes to. In any case, his father was not persuaded. His unbending mind was as refractory as his son's would prove to be a quarter of a century later when his daughter wanted to marry Halliwell. The young Phillipps submitted to his father, because the security of his livelihood was at stake, and that he dared not risk. Furthermore, since he was, in effect, motherless, flagrant opposition to the old man would have severed his only family tie, and that he could not do. He accommodated his father.

Nature collaborated with Thomas's hopes, since his father died only a year later. Now there were no barriers to the marriage. The courtship with Henrietta Molyneux was probably the only instance in the collector's long life when feelings of love and desire took precedence over self-absorption and acquisitiveness.

While marrying Henrietta did not bring Thomas the economic advantages his father had demanded, it did gain him the family connections and social identity that to the illegitimate son of a nouveau riche gentleman was more pertinent than additional fortune. His wedding took place about three months after his father's death.

A year after the marriage Phillipps became a Fellow of the Royal Society, which was a considerable tribute to his interests. At the same time, his father-in-law used his position and influence to get Thomas elevated to the Baronetcy, an honor bestowed on him on the occasion of Georges IV's succession to the throne in 1821. He was now Sir Thomas Phillipps, F.S.A., F.R.S. (Fellow of the Society of Antiquarians and the Royal Society). The knighthood provided him with some of the status and social acceptance his parents could not and had not given him. Notes to himself were being initialed Sir T. P. or Sir T. Phillipps, while his original letters were properly signed Thos. Phillipps or Thomas Phillipps.

Thomas's inheritance on his father's death was substantial, providing an annual income of 6,000 to 8,000 pounds, a very large sum of money in those days. Had he been less driven to collect, he and his family could have lived in the style "becoming a gentleman." However, he observed convention only to the extent that it served his inner needs. The ambiguous nature of his origins and his no doubt unusual and lonely childhood resulted in a self-centeredness that appeared as a contemptuous assertion of his superiority and subordinated everyone and everything to the tyranny of his incessant drive to amass whatever seemed to fit in his collection. Even though at the time of his marriage to Henrietta he was not yet the open monomaniac he would later become, his father had been accurate to have been concerned. Deferred payments, overdrafts, loans, unreliability, and overdue bills soon became the rule, rather than the exception, and it remained this way for the rest of his life.

But we have considerable evidence quite early on, for while he was still at the university the bursar had to remind him "that this is the fourth week of the term," and the payments due had not yet been received. The delay, the letter continues, "puts me to considerable inconvenience [May 3, 1817]." It was hardly a matter of negligence or forgetfulness. Rather, it was a precedent, as evidenced in all further commitments as far as payments, obligations, and human relations were concerned.

For Thomas's protection, his father had put his fortunes and estates, including Middle Hill, in trust for him. With the old man's death, his relationship with his mother changed to some extent. For one thing, he no longer deleted anything in the let-

ters to her, and his tone seemed more affectionate, as indicated by the following note:

> My dearest friend, I am sorry I cannot send you the spectacles, having previously given them to a friend & relation of mine [probably a reference to his father's eyeglasses, which she seems to have requested].— My father left you an annuity of 50£ Per Annum, to be paid half yearly the 1st payment is to be made this month. I expect to be in Town in a month or two & then you shall have it, if you can wait so long.— By return of Post I wish to know your age exactly. It is necessary for me to know it on account of the Legacy Duty.— Believe me with best wishes to Mr. Judd, Yours affectionately,
>
> Thomas Phillipps

This changed tenor, with its rather apologetic "if you can wait so long," disappeared in later years.

Meanwhile, Thomas's marriage to a general's daughter was a means of achieving his rightful status in society, at least the way he saw it. Henrietta represented more a symbol than a woman he loved and desired. Winning her heightened his self-esteem and provided him with a position his father could not give him. Love was never a conscious craving; it was a desire for prestige and recognition that made him court the young society woman, rather than true affection and a wish to get married, for Phillipps was apparently incapable of loving anyone.

In the light of the emotional deprivations during his entire childhood, the chronic demand for new supplies to his collection was a logical reaction of the ever-needful child. Nothing in his early development suggests any kind of attachment to any individual. Having been scarred by motherlessness, and living with a late-middle-aged bachelor father, provided no other solution to Phillipps than finding compensation in almost total self-centeredness and enjoyment in objects rather than people. Self-indulgence soon became his watchword.

Once the authority and control represented by his father was gone, he threw off all restrictions. His desire for new acquisitions knew no bounds. Now he got in touch with fellow collectors, dealers, antiquarians, and topographers, and became a constant customer of auction houses. Later, there were contacts with European and American scholars, which he clearly appre-

ciated as a sign of recognition and as a justification of his obses-
sive endeavors. The fact that he was amassing a truly unique
collection is beside the point here. What is relevant is that begin-
nings of the overspending which accompanied his manic search
for a constant stream of additions to the collection came at the
time of his father's illness and subsequent death.

In order to keep in touch with the book world, he rented a
house in London. Bills and letters show that he made purchases
from at least twenty-five book dealers in 1819 alone. He proba-
bly also bought from other sources, perhaps paying in cash.
Among those twenty-five are numerous dealers who repeatedly
asked for payment, not unlike the bursar of Oxford while he
was a student at the university.

Just two years after his father's death, Phillipps was already
in considerable debt for books, manuscripts, and transcriptions
of records. In addition, he hired several helpers to copy parish
registers, topographical drawings, and paleographical data. At
the same time, he had published by a local printer *A Catalogue of
Books at Middle Hill, Worcestershire, 1819.* This catalogue refers to
1,326 titles, but since the same book is often listed under several
different subdivisions, the actual total is presumably some-
what less than that.[75] This is just additional evidence that this
was a man who was interested predominantly in quantity, and
who was also habitually in a mess—in his house, in his habits,
his commitments, and his human relationships. Even at this
early date, his single-mindedness of purpose and his egocen-
tricity led him to exploit everyone with whom he had any
dealings.

With his father dead, and all paternal control and authority
gone, he began to make unbridled outlays for his collection,
which maneuvered him into almost immediate indebtedness.
Creditors presented their claims, but to no avail, and printers
whom he had employed were left without remuneration and, as
they often indicated to him, in desperate straits.

At this point an old remedy was prescribed by the trustees of
his estate—a change of climate, with a journey to the Swiss Alps.
His two daughters, aged three and one, were left in the care of
a nurse, while Middle Hill and the estate were put in the hands
of the trustees and General Molyneux.

He left numerous letters of instruction behind him:

If any Duns write to you in future, you must answer that I am gone abroad & you know nothing about the bills, therefore you decline interfering in the business: that I am gone abroad to save money to pay my debts of which the longest standing will be paid first, & they will be paid in their turn. . . . As to the repairs at Farm houses I beg you will not repair even the most damaged until I come home. That is the way in which a good part of my money goes, & I have been repairing & repairing without any end till at last I am resolved to repair no longer, & if the people do not choose in their houses, let them leave them. The butchers must wait another half year for their money [December 8, 1822].

If anything, the letter illustrates the constancy of his character, though hardly a very appealing one. In a sense, he created his persecutors, whom he then tried to destroy. Indeed, several tradesmen were forced to declare bankruptcy due to Phillipps's indifference to their financial needs.

Unnecessary to say, the change of climate had no effect on his obsession and self-centeredness. Throughout Phillipps's correspondence there runs a pattern of financial problems, which expands into a never-ending sequence of acrimonious letters, accusations, litigation, and, on his part, high-handed insolence. Travel was no cure for a man of his emotional condition, and even in Berne, where he and Henrietta settled for part of 1822 and 1823, he was sued by several of his creditors, including his wine merchant.[76]

Moreover, his stay on the Continent merely exacerbated matters, since he was soon making new contacts and thereby broadening the base of his purchases, all of which brought more complicated and complicating commitments. Several editions of his *Catalogus Librorum Manuscriptorum*, edited by himself and printed at his Middle Hill Press, record his acquisitions at this time, along with their provenance, giving us some information as to his suppliers during his stay on the Continent. He remained in Switzerland for some time because he had to evade his creditors back home and reduce his commitments to suppliers in Britain. However, while he and Henrietta were living in Berne, he added sixty books from a Swiss Jesuit college to his collection, and more than one hundred manuscripts. He also initiated contacts with dealers in France, Holland, Belgium, and

Germany, which he pursued after his return to Middle Hill, in the autumn of 1823.

At about this time he received a catalogue from a German theologian named Leander van Ess which listed a number of very important manuscripts, among them an eleventh-century work by SS. Jerome and Isidore of Seville from the Abbey of St. Matthias in Trier. All in all, the collection included 367 Western and seven Oriental manuscripts, 56 miniatures and illuminations, and 173 woodcuts. In addition, there was a collection of books with about 900 incunabula.

To no one's surprise, Sir Thomas could not resist buying the entire collection for the sum of 870 pounds. A lengthy letter from Doctor van Ess affirms Phillipps's unreliability to the fullest degree. While Phillipps had agreed to settle the account within a few months, van Ess clearly did not know with whom he was dealing, and it was five years before Phillipps finally paid. A letter from van Ess demonstrates the dimensions of Phillipps's aggressive self-serving manipulation:

> You bought from me my collection of manuscripts according to agreement for £320. [Later on he mentions an additional 550 pounds for incunabula and old documents.] You wrote to me 28th Jan: 1824. 'Would it be equally convenient to you to accept a Draft payable in 3 or 4 months wch. might serve all the purposes of each to you, and would not distress me to send it to you.'... But you did not honour your words: for the Bill came back with protest. . . . I was obliged to pay for charges and Damages on this Bill 34 florins. . . . It is quite beneath me, to lose further a word about this.

Letters of this tenor—and this one is hardly unique—provide us with a thorough profile of how Phillipps dealt with his creditors. Unquestionably, he was already a past master at the game of avoiding or at least postponing payment. Even while van Ess was waiting to be paid, Phillipps made other significant purchases in the Low Countries: 165 medieval manuscripts from two Benedictine cloisters, 64 additional manuscripts from three Cisternian abbeys in Belgium, and at least two collections in Holland.

His fame, or rather that of his collection, was gradually spreading, and by the late 1820s internationally known scholars

began to write to him and visit Middle Hill. As for dealers, they could not disregard his custom, despite his growing reputation as a very slow and often recalcitrant payer who only grudgingly parted with his money.

By now he had exhausted his funds to the degree that he could not even pay his own mother the current installment of her annuity. His reply to her request sounded cavalier. To him, she had become just one more creditor, although we must bear in mind the possibility that his attitude toward her may reflect the basic reaction itself: having been a motherless and unloved child, this could easily have been the ultimate source for his selfish and unempathetic conduct. And even though he was fully aware of the circumstances of his illegitimate birth, and his mother's absence, it had little influence on his conscious attitude: "I have just received your letter I am very sorry to say that I cannot pay you at present nor shall I know when until the 4th July. . . . I shall be able to give you a draft at 4 months I believe on the 4th July, but I am so pinched for want of money that I do not know what to do [June 22, 1827]."

Meanwhile, he made several journeys to the Continent searching for manuscripts and other early publications in monasteries, city archives, record offices, and salesrooms. His travel plans were just as unpredictable as his financial practices. When he departed on his travels, he still owed his mother her half-year payment of twenty-five pounds, and he had not yet paid his servants.

He visited Arras, Lille, St. Omer, and Rouen in France to do research in the town libraries, made some discoveries about manuscripts that had been stolen by a former librarian, and delivered a lecture to the Royal Society of Literature on "Observations on Some Monastic Libraries and archives in French Flanders"[77] (November 17, 1830). No doubt, he wanted to be recognized as a man of scholarly pursuits, and in that way justify his monomaniacal temperament.

He now began to spend more and more of his time traveling. While he traveled, he left his wife and children home in Middle Hill, short of money and pursued by creditors seeking payment of unsettled accounts, including items sent to him on approval, which he returned months and occasionally even years later after acrimonious exchanges of letters. Phillipps had learned in

his childhood to renounce all expectations of love and closeness, and he was now paying the world back for this, as his entire behavior makes evident. By this time, his never-ending search for manuscripts, documents, and old books—all representing vouchers of the past—was far more important than any other emotional needs.

There was not much kindliness left in his attitude toward his wife. His letters to her from London, where he now spent a good deal of his time, reflect a tone gracelessly devoid of concern and consideration: "I cannot write to you more often than I do for I have nothing to say more than that I wander every day from one Record Office to another until my business is finished, which you know is not at all interesting to you [October 22, 1831]."

A month later his caretaker, Michael Russell, tried to tell him with more tact than Phillipps could appreciate: "I think Lady Phillipps is very much chang'd lately, seems much out of spirits and appears very uncomfortable indeed ... she has so many people troubling her with one thing or other that worries her almost to death [November 22, 1831]." Twelve weeks later Lady Phillipps died at the age of thirty-seven.

Little in Phillipps's correspondence or notes reveals anything about his reaction to the loss of his wife and the mother of his daughters, if indeed he even felt any such loss. He soon returned to London, leaving his children, aged thirteen, eleven, and nine in the care of a governess. Completely frustrated by the baronet, the governess was tempted to quit on several occasions, but her affection for the motherless children must have changed her mind. She wisely kept them copying "Rolls for Papa," transcribing deeds and tracing pedigrees in the hope that their father might take some interest in them.

Not unexpectedly, Phillipps's collecting as well as his indebtedness increased after Henrietta's death. There is an endless stream of letters from booksellers and art dealers. Soon enough he is in search of another spouse. But by now his cupidity overshadows his tact and good taste. "Do you know of any Lady with 50,000£ who wants a husband. I am for sale for that price," he tells an acquaintance on April 16, 1833.[78] He is in correspondence with a Perthshire collector, W. M. Clarke. On the back of a letter from Clarke is a copy of his reply: "I am become now a

fortune hunter do you know any wealthy body who wants a husband." Clarke answered a few months later: "How goes on your matrimonial spec? I know of no person of the kind here, excepting the Dowager Duchess of Atholl who has a tremendous jointure. If you could get an introduction there, & be successful you might give me capital shooting. I should think she was mh above sixty!"

Phillipps persevered. To some, he must have appeared ludicrous. One of his lawyer's sons offered him a wife with a fortune of 100,000 pounds—against a finder's fee. Munby counted "no less than seventeen abortive negotiations with the parents of heiresses."[79] Phillipps's efforts to find a wealthy wife had nothing to do with love or attraction. Everything was governed by his all-consuming passion for adding more and more acquisitions to his already considerable collection. To him, no woman held the spell of a rare manuscript or could measure up to an old map or a fine book. A woman was desirable to him only to the extent that her material position would enable him to add to his holdings.

In the course of his constant search for origins and pedigree, he had met the wealthy family of Francis Warneford. Before he had even received a reply from Clarke, he enquired about the availability of Warneford's two daughters. But Warneford well understood Phillipps's aims and insensitivity. He answered, "I only hope [my daughters] will choose a *Gentleman* and one that is likely to make her happy." Unruffled by the man's appropriate reply, Phillipps continued his pursuit of the Warneford daughters and considered it necessary to explain to their father as follows:

> Dear Sir:
> It is an idle waste of time for 2 persons to begin making love while any obstacle remains to prevent their union. I do not choose to marry a woman without some fortune, & that is the first point I will know before I make any love at all. I have already known enough of the misery of engaging one's heart, while a stumbling block remains in the way.

While the last sentence is an obvious reference to his youthful infatuation with Henrietta Molyneux, it is at the same time an

92

unconscious reproach to the mother who disappointed him, regardless of the actual circumstances that caused the disappointment.

We can understand, although hardly be sympathetic to, the reason why Phillipps had obliterated anything resembling human affection and sensitivity from his life. His was a not unexpectable reaction, undoubtedly fostered by a lack of maternal care and the domineering stance of his bachelor father. To him, it was far safer to put all his concerns and emotions into a different sort of relationship with the past. The documents, manuscripts, and topographical and genealogical source material he collected readily substituted for human relationships, while distorting and coloring his entire sense of values and his obligations to anyone, including his own children. Nor was there any sense of guilt about the way he felt or, rather, that he had any feelings at all about the matter, character traits we tend to associate with psychopathy. Right, he was convinced, was invariably on his side, a belief that may have been bolstered by the fact that, in the child's mind, his father had preferred him to his mother.

Observing Thomas Phillipps in all his mean-spirited relationships, we are hard put to maintain an objective point of view. We must keep in mind that all his attitudes and concerns are in logical accord with his character. Arrogance and obduracy mask doubt and suspicion. There is no place for empathy or consideration of others. His letters speak for themselves. They establish a clear coherence in all his actions and affairs.

In the autumn of 1833 Phillipps's fellow collector, Richard Heber, died, leaving behind 200,000 books and 1,717 manuscripts. Obviously, Phillipps could not possibly forgo such a rich prize. Long, entangled negotiations followed the announcement that the Heber collection would be sold at auction. Now the baronet began to maneuver by seeking to delay the dates of the sales. Then he asked the auctioneers and booksellers for years of credit, and finally, after much haggling, he arrived at an agreement as to commission and dates of payment.

At the sale he acquired 428 manuscripts, among them the most important ones in Heber's collection, "merely to gratify a selfish and silly feeling, which manifests itself in carrying home

cartloads of MSS. . . and he is daily becoming a *dog in the manger*," as Sir Frederic Madden wrote in his diary. However, it should be added that Madden was not completely objective in making this comment, since Phillipps was a competitor of the British Museum, which Madden represented as the Keeper of Manuscripts at the sale.

There is no question that Phillipps, regardless of his limited knowledge and sophistication, had acquired a certain reputation and stature in the book world, and notwithstanding his unfailing bargaining and slow payment, dealers as well as scholars sought his patronage. Dealers continued to offer him material because his income was assured, and he eventually paid his bills or most of them, even if under protest.

After buying the Heber manuscripts he was approached by the London bookdealer Thomas Thorpe, who offered him "upwards of fourteen hundred Manuscripts." Thorpe provided a detailed listing of the manuscripts and arrived at a price of 11,928 pounds, 10 shillings, and 10 pence for the entire lot. Knowing his customer, he had probably incalculated Phillipps's counteroffer: "You know that I have brought myself to present poverty, through my too great zeal in the acquisition of MSS." Phillipps proposed "5000£ *without* interest, or 4000£ *with* Interest." While the transaction was finally concluded at 6,000 pounds, Phillipps was as defiant as ever about paying off the debt, and, true to his character, took eight years to live up to his commitment, contributing substantially to Thorpe's bankruptcy.

It is not easy to picture domestic life at Middle Hill at this time. We do not know what relationship, if any, he had with his three daughters during these years. Riding and shooting provided him with some modicum of relaxation. Still, the overshadowing presence of his ravenous acquisitions was visible throughout the mansion. "Books fill not only the rooms, but also the staircases and passages," reported a French visitor, Jean-Louis-Alphonse Huillard-Breholles.[80] Personal comfort, leisure time, and economic ease were constantly sacrificed to the reward of expanding the collection.

Always on the lookout for new discoveries, Phillipps began to buy up the stocks of wastepaper merchants. Let one example of what he found stand among many. In the tons of valueless ma-

terial he bought in this manner, he unearthed the main part of the early English printer William Caxton's *Ovid*. It was a remarkable find, as Sotheby's catalogue commented when the volume came up for sale in 1966, with the pages discovered, "hopelessly out of order, loose in the fragments of the binding, the remainder in loose sheets. It is a piece of almost unparalleled good luck that the work should have emerged from this lamentable condition in fine state and entirely complete."[81]

As the *Bibliotheca Phillippica* grew, so did its owner's miserliness. He even reduced his aging mother's small annuity by twenty pounds a year. It is difficult to reconstruct the relationship between mother and son in later years. There exist several receipts for the payments, and a few letters. In a letter of January 30, 1850, she addresses Thomas as "My Dearest Friend" as usual, and informs him that

> I am a little Better to Day. But at times I am very Bad as my head and Eyes are one Day Better & an other worse. But I thank the Lord that I can see at all at my age as I shall Be 80 years the next Birth Day. I thank the almighty Lord that he has speard me so long. I sincerley hope I shall live to see you once more if it is his Blessed Will. Write all this with out Glasses. . . . Write again soon & think of me.
> Yours very sincerely H. J.

Her last letter to him, dated October 29, 1850, reads "I receiv'd your kind Letter & the inclosed quite safe and am very obliged to you for the same for it was a very great help ... give my love to all." One wonders whether she ever met her granddaughters.

Phillipps was now fifty-eight. Even at this age his attitude of alienation and his egocentricity remained unchecked. A few years earlier, in 1843, his daughter Mary had written to her sister, "He is going rather cracked. He is scarecely ever in good humour now." He was angry with everyone and everything—the Pope and Catholicism in general, certain government institutions, book dealers, and various tenants of his farm. Whatever did not suit his plans and purpose was unacceptable to him. His blasphemous diatribes against the Holy Father and everything Catholic took on ludricous dimensions. He had a leaflet printed and circulated among the "Inhabitants of Broadway" stating

that "The Roman Catholics say in the Sacrament of our Lord's Supper they actually EAT the REAL BODY, and BLOOD of CHRIST, If so, are they not CANNIBALS?"

All of this is in keeping with his unceasing quarrels with authority. This can only be understood in the larger context of his animosity toward his father, but he could never allow himself the full expression of his resentment. After his father's death he had to find new targets to aim at, among them the authorities and in particular the Holy Father. There are innumerable additional examples. For instance, a few months before Mary described him as "rather cracked," the local tax collector called at Middle Hill. His affidavit describes the scene: "Sir Thomas then came up with a paddle in his hand and said to me what do you want. I replied Her Majesty's taxes—he then struck me with a paddle across my body and held the paddle up a second time and I caught it to save a second blow."[82]

This incident bespeaks the man's irritability and narrowminded behavior. It occurred about ten months after Phillipps finally remarried. An ordinary man would have been comforted and calmed by a new young wife, but the baronet was no ordinary man. He had been a widower for ten years when he found Elizabeth Manzel, who at twenty-seven was only four years older than his daughter Henrietta. Financially, the marriage did not deliver what he had hoped for a decade earlier. There were long drawn-out negotiations with Eliza's widowed mother and other relatives before the wedding took place. He finally accepted a dowry of only 3,000 pounds, plus an annual dress allowance of fifty pounds.

In the beginning, there seems to have been a measure of warmth between him and the new Lady Phillipps. He called her Vify or Wyfy, and she used to address him as Tippy, a pet name evidently derived from his initials T.P. Visitors described her gracefulness and tact. But then the space for entertaining diminished in proportion to the rapidly increasing accession of new acquisitions for the collection.

On September 8, 1857, Phillipps invited Jared Sparks, then president of Harvard University, for a second visit to Middle Hill. He warned Sparks in advance that "the Drawing Room is the only Room we live in & 3 Bed Rooms for ourselves and friends." Three years later he told his old friend Robert Curzon: "Our Drawing Room & Sitting Room is Lady Phillipps' Bou-

doir!! [December 11, 1860]." In the same letter he comments that there is "no room to dine in except in the Housekeeper's Room!" There is no question that he was well aware of the increase in his unremitting acquisitiveness.

For the first two decades of his second marriage, there was a more agreeable tenor to his relationship with his wife. There even seemed to be a measure of playfulness between them, rather surprising in a man of Phillipps's temperament and inner makeup. Thus, in a letter written from London on August 16, 1859, after the auction sale of the collection of Lord Northwick, the same man from whom he later acquired Thirlestaine House, he wrote, "My dear Wyfy, Poor Tippy ruined at the Northwick Sale!!! What a pity his careful prudent Wyfy was not with him. Could not help it! Such beautiful Pictys! But where to put them? Aye, there's the rub!"

One can read between the lines here and note a certain measure of apprehensiveness. Without doubt, in the early years of their marriage, Eliza must have been a sobering influence on his otherwise indefensible acquisitiveness. However, the tone of this note is rare indeed. It has an almost childish, apologetic ring to it and seems to reflect one of those rare flashes of insight from which he returns time and again to that ravenous craving for more and more new material.

This is demonstrated by his involvement with an adventurous forger, a Greek named Constantine Simonides. Simonides had approached the British Museum and the Bodleian Library at Oxford and offered them a number of scrolls and a variety of ancient Greek manuscripts. On close inspection, they were recognized to be ingenious fakes. When Phillipps heard about him, he extended an invitation to Simonides to visit Middle Hill. The Greek was an expert character reader, and, like many dealers, knew how to whet a client's appetite. He told Phillipps stories about his treasure trove, and how he had obtained the manuscripts in the Middle East and on Mount Athos. He soon provided the collector with a detailed description of a previously unknown manuscript by Thucydides.

Phillipps was mesmerized by the man's stories, as devoted collectors are apt to be. He immediately decided to purchase some of the manuscripts, and jotted down: "I am to have his Pythagoras, his Phocylides & 3 Diatagmata Autokrator for a certain sum [December 1853]." While several experts had warned

him about Simonides, he preferred to risk buying forgeries than to let such "jewels" get into someone else's hands.

Dr. Johann Georg Kohl, a German scholar, was visiting Middle Hill at this time. Kohl tells us that Phillipps happened to have a German newspaper clipping on Simonides, and asked him to translate the article. Even though it described the Greek as an expert forger, nothing could prevent Sir Thomas from buying twenty-two manuscripts of very questionable authenticity.[83] This outright refusal to accept anyone else's opinion or expertise is closely related to the attitude of certain types of obsessional collectors. It is the opposite of those people who dare not make any acquisition without the approval and in essence the sanction of an established authority.

Phillipps, of course, was anything but a conventional man. He could never resist from increasing his holdings. Eventually he had about sixty thousand manuscripts, in addition to his books and other documentary material. He was always accessible to scholars and fellow collectors, and his readiness to put his knowledge and experience at their disposal may have been unconsciously motivated by a desire for reconciliation with symbolic father figures. During the 1840s and 1850s, he was in correspondence with at least sixty researchers and specialists in Europe and the United States. His hospitality could be disarming, and in conspicuous contrast to the cold fury with which he sometimes tended to treat members of his family, book dealers, or his tenant farmers or anyone dependent on him.

Jared Sparks of Harvard, who visited Middle Hill in 1840, noted in his diary: "I have rarely passed so agreeable or so profitable a week. Sir Thomas Phillipps is renowned for his hospitality. . . . He devoted nearly the whole time to me, assisting me in finding manuscripts, and himself searching for such as would be to my purpose."

Another visitor, the French Abbott Jean-Baptiste Pitra, a historian of great repute who was researching the Christianization of France, reminisced: "At the end of the day, when we felt that we should have been making our apologies, we were invited by the baronet to an entertainment which he described as 'a dessert of manuscripts.' At the hour when an English table is spread with wine, fruit and rare dishes, we found displayed before our eyes a choice treat of manuscripts of Middlehill."[84]

Phillipps seems to have treated visiting scholars with a kind of filial respect, as if he were looking for praise and approval, perhaps like an obstreperous son hoping for a final acceptance and ultimate endorsement of his wayward behavior. He must have imagined himself as a generous provider of rare treats as he went about selecting "delicacies" for his honored guests, thus making a virtue out of his ineradicable greed.

In his later years, he confessed that his manuscripts were "a never failing solace in every trouble." Like his first wife, the second Lady Phillipps could not long endure his selfishness and intolerance. Not unexpectedly, his marriage suffered. At one point, her health failed, and doctors prescribed the old remedy, a trip abroad. The estimate for spending a winter on the Continent was some 250 pounds, far too large a sum for Sir Thomas to part with easily. However, as far as I can make out from his records, in that same year he spent at least 1,384 pounds 13 shillings and 6 pence on his collection, not counting bills from printers and bookbinders.

Lady Phillipps settled for a journey to the sea resort of Torquay, where she took a room in a boarding house. She wrote to complain that she did not even have enough money for groceries and dental bills. "Oh, if you would not set your heart so much on your *books*, making them an Idol, how thankful I should be!" she implored him (November 24, 1868). This was just one day after he had written to tell his old friend Robert Curzon that "I am going on with the old Mania of Book-buying."

Meanwhile his response to his wife once more reveals his unbending self-centeredness:

Dear E.

I must desire you not to send me any more of your sermons. You are evidently fallen into bad company in Torquay for you were never so absurd before. . . . Never interfere with the happiness of other people. I make no Idol of my Books more than *you* of *your Hymn* Books. Therefore write no more to me in such a strain, if you wish to retain my good Will, & then I shall continue your

affectionate
T. Phillipps

Not quite four years later Sir Thomas Phillipps died leaving the most extensive and significant library of manuscripts ever. Middle Hill went to the Halliwells, in totally uninhabitable condition. To his wife of thirty years he left 100 pounds "as a mark of my affection." The collection was given to the care of his daughter Kate and her husband, without sufficient funds to keep it properly intact. Neither the Halliwells nor any Roman Catholic were to be admitted to inspect the library.

Two Collectors: Balzac and His
Cousin Pons

O<small>N</small> F<small>EBRUARY</small> 27, 1848, Honoré de Balzac invited the young author Jules Fleury-Husson, who wrote under the pen name of Champfleury, to visit him at his new dreamhouse on the Rue Fortunée in Paris. Champfleury had long been an admirer of the famous author and had in fact even dedicated his *Feu Miette, Fantaisie d'Eté* to Balzac. It was a historic moment, for it was the day after the proclamation of the Republic.

Only twelve days earlier, Balzac had returned from one of his frequent visits to Russia, where he had stayed at the home of the recently widowed Countess Eveline de Hanska, whom he had assiduously courted for the last sixteen years. Life on her estate was luxurious, far beyond his own more or less petit bourgeois background or, for that matter, even that of his many aristocratic French friends.

His fantasy was to offer the woman he hoped to make his wife a *hôtel particulier* in Paris that would equal her beautiful manor house in Wierzchovnia, in the Ukraine. A year or so earlier, on September 28, 1846, he had bought the house on the Rue Fortunée that he wanted to give to his beloved "Louloup," the pet name he used for Eve de Hanska in the thousands of love letters he wrote over nearly two decades. Since then, he had been filling the house with rare furniture, rich carpets, chinaware, paintings, silver, and innumerable pieces of bric-à-brac.

Balzac's lavish spending and fondness for luxury was longstanding, going back to the beginning of his adult life. By this time, his passion for all sorts of decorative objects knew no bounds, and he was spending like a wild man. No author of his time depending solely on the earnings from his writings, no matter how successful, could have shouldered the cost of his collection and his extravagant lifestyle. Nonetheless, he could not resist spending still another 400,000 francs, far more than he could afford, on his dreamhouse, as he called it. He justified this

expenditure by telling himself that a grandniece of a former queen of France needed a proper home.

"I hope to become rich by the stroke of novels,"[85] he had told his sister in a letter written some twenty-five years earlier. This was a lifelong expectation, but was bound to remain unfulfilled, and, after buying and furnishing his new house, he was, as usual, very heavily in debt.

It is easy to imagine how impressed Champfleury must have been by his idol's lavishly decorated new home. Balzac spent several hours with the young author discussing the ins and outs of their profession, with particular attention to the drawback of being a novelist, rather than a dramatist. By this time Balzac was convinced that he would make his fortune in the theater, rather than through novels.

Drama and the theater were much on Balzac's mind, since three months later a new play of his, *La Marâtre* (The Step-mother), was to open at the Théâtre Historique in Paris. As usual, he was convinced that the play would be a huge success and bring in the much-needed money, which he could use to pay his always pressing debts. Also as usual, the thought the play might not be well accepted never entered his mind, since the idea of failure was something he simply could not believe.

Yes, he told Champfleury, the theater brings instant remuneration, but novels and stories do not. In the course of talking about his new home, he explained that, in his opinion, an artist should live in comfort, and even in style. To underline this pronouncement, he then proceeded to take the young writer on a tour of the home that now housed his impressive (at first glance) collection. As Champfleury was led from one lavishly furnished room to the next, he thought to himself: "This is the gallery of *Cousin Pons*, these are the paintings of *Cousin Pons*, the curios of *Cousin Pons* . . ."[86]

Champfleury's observation was by no means a leap of his imagination, since Balzac's house in the Rue Fortunée was indeed close to that of *Cousin Pons*, the central character of his recently published novel of that name. *Le Cousin Pons*, one of Balzac's last books, appearing in 1847, is the story of a failure in life of a man who is a passionately dedicated collector. While the inspiration for Pons antedates the acquisition of the house, the attitudes and activities of the man show striking similarities

102

with Balzac's fantasies, though not his habits. Moreover, the dreamhouses of Pons and his author are almost one and the same.

It is noteworthy to remember that Balzac worked on the novel and his new house at one and the same time. His story describes the passion and anguish of the inveterate collector, and the torment and courses of experience during his childhood and youth, including the coldness that denied him a mother's love. Perhaps most relevant, Pons's attitude toward the objects in his collection echoes that of Balzac himself. The author at one point in the novel describes Pons as a man "who found in those [objects] ever-renewed compensation for his failure, that, if he had been made to choose between his curiosities and the fame of Rossini—will it be believed?—Pons would have pronounced for his beloved collection."[87]

In the novel, Sylvain Pons is an aging bachelor who in his youth had been a promising violinist, even winning the Prix de Rome. However, life has not been kind to him. His only relatives look down on this unattractive and unprepossessing man, and express their contempt by haughtily distancing themselves from him. Pons is a subtenant in a house in the Marais (the same section of bourgeois Paris to which the Balzac family had moved after leaving their home in Tours, Honoré's birthplace). Here, Pons becomes friendly with another bachelor-tenant, a one-time orchestra conductor named Schmucke.

The theme of the poor relation, and of impoverished and misunderstood people, often appears in Balzac's writings. An awareness of social distinctions shines through most of his novels, while the constant references to name, fortune, and social position echo essential elements of the author's aspirations.

Cousin Pons is the unwanted and scorned relative of the cold-hearted, nouveaux riches and uninformed Camusots de Mervilles, members of the new, post-Napoleonic, Paris society, who have tried to minimize all contact with their homely and undistinguished cousin. The Camusots had become rich through France's financial and political machinations, and the rapid advance of industrialization, in the Napoleonic era. Their ostentatious parade in front of Pons during one of his infrequent visits to them, and his discomfort, clearly reflect Balzac's feelings of deprivation and neglect during his childhood and adolescence.

This mingling of graphic descriptions of the correlation between the social climate and historical events of the early nineteenth-century and his own personal history and self-image is most characteristic for Balzac's work.

Now and then the Camusots invite Pons to dine with them, a highlight in his otherwise uneventful and solitary existence. He describes these dinners with great relish to his friend Schmucke.[88] On one of these occasions, Pons brings his cousin, Madame la Présidente Camusot, a beautiful painted fan. She makes the obligatory, albeit perfunctory, gesture of appreciation, briefly shows it to her snobbish daughter, and then takes little notice of the gift. At this point, Pons, a bit put out, feels compelled to explain that the fan was painted by Watteau and once belonged to Mme. de Pompadour. Mme. Camusot, however, is not impressed, because she has never heard of Jean-Antoine Watteau.

As is frequently the case in Balzac's writings, his hero's universe is made up of thinly disguised autobiographical details. The scenery, the background, the characters, and the entire ambience inevitably connect with his own past, and with the contradictory character traits that marked his own personality. These all become part of a contemporary social drama, played out against the background of the post-Napoleonic era in France.

By the time *Cousin Pons* was published, Balzac was a famous and distinguished author, with all the doors of Paris society open to him. Had he not been constantly seeking new acquisitions to add to his collection, thereby running up enormous debts, he might very well have died a contented man who had achieved the kind of success he had only fantasized about in his childhood and adolescence. If we are to understand what was involved in the development of his highly complex character, we must delve into the disturbing emotional life that marked his formative years, since the daydreams, intricate schemes, and wild flights of imagination, which always dominated his private world, originated during that time.

Honoré de Balzac was born during Napoleon's Consulship, on May 20, 1799, in Tours, in central France. His father, Bernard-François—a self-made man, energetic, ambitious, and not without a certain flexibility as to the tide of the times—was the oldest

son of a farmer, Bernard Balssa, a name he later changed to Balzac.

The aspiring Bernard-François first became a clerk in an attorney's office, and then, "while still very young, he 'went up' to Paris, owning nothing but his hobnailed shoes, a peasant jacket, a flowered waist-coat, and three shirts of coarse material." This is recalled in the author's description of one of his heroes, César Birotteau, who, as an adolescent, leaves Tours for Paris with only his "hobnailed shoes, a pair of breeches, blue stockings, a sprigged waistcoat . . . three ample shirts of good linen, and a stout walking stick."[89]

Honoré described his father as an eccentric man, talkative, boisterous, and full of illogical theories and conceptions, although more human and certainly kinder than his cold, narcissistic mother who seemed quite indifferent to her children, perhaps with the exception of the youngest one, Henri. The father was already of grandfather age when Honoré and his two sisters, Laure and Laurence, were born. Henri was his mother's favorite, possibly because he had not been fathered by Bernard-François.

In later life, Balzac clearly took on certain character traits of his father. However, while there were quite pronounced elements of identification, especially his reiterated conviction that he was an exceptional person, it appears that here at least the son had more reason to make such a claim than the father. In addition, Bernard-François probably did not have the engaging, almost seductive nature of his son. A man with a roving eye, the father was infatuated by young ladies and much concerned with finding the key to longevity and, implicitly, potency. This soon led him to Chinese literature, since he was apparently convinced that Chinese thought and writings held the answer to everything. In his spare time, he wrote little tracts on all sorts of subjects—politics, trade, social issues—and he was incessantly trying to improve his own predicament and that of his family.

It was quite in keeping with this aim that he should have a grandiose fantasy—that his branch of the family had sprung from an early and noble stock of Gallic origins. Remember this was a family romance that Bernard-François shared with Sir Thomas Phillipps, and it was a notion that also appealed to Honoré. In this regard, it should be noted that, just as his father

attempted to trace his ancestry to the noble family of the Balzac d'Entragues, Honoré also used the pseudonym of the Marquis d'Entragues at the occasion of his first secret rendezvous with the Countess de Hanska in the town of Neuchâtel, in Switzerland.[90]

There is a principal fact we must bear in mind. Balzac's early years consisted of a series of rejections, disappointments, and loneliness. Throughout his life he kept saying, "I never had a mother." It left a lasting mark on his personality. It helps explain his many attempts and strategies aimed at providing himself with a true sense of security as opposed to his early feelings of deprivation and abandonment, which led to an almost random system of phobic defenses, especially by becoming a man of the world, a pseudo-womanizer, a carpetbagger, an obsessive collector, all in order to dilute the inner threats posed by childhood anxieties.

He was born simply Honoré Balzac.[91] His father, plain Citizen Balzac, without the "de" particle he eventually added to the name, often, and apparently jokingly, referred to the family's aristocratic antecedents. And indeed, his dogged struggle for acceptance in Tours society was crowned with a certain measure of success. Shortly before Honoré's birth, he had become a supplier to the French army, always a lucrative enterprise. Thus elevated to a solid economic status, and with it a more prominent social position in this small-town, provincial world, Bernard-François at the age of fifty-one married Laure Salambier, a nineteen-year-old Parisian girl. Marrying a girl thirty-two years his junior reflected his need to prove himself, his denial of aging, his longing for recognition, and his continual self-idealization. This last characteristic was echoed in his son's eccentricities, especially in the way Honoré went about his collecting, often intertwined with his delusional beliefs of having made extraordinary discoveries.

The considerable age difference between his parents, his mother's self-absorption and the concomitant insensitivity for other people's needs and feelings, and his father's perpetual boastfulness and grandiosity left their mark on the boy's struggle for love and attention. Vainglory was a significant element in the model the father had set for his son. And so, at the age of twenty-six, Honoré Balzac, plain Citizen Balzac, becomes

Honoré de Balzac in a letter to the Duchess Laure d'Abrantès.[92] In the next few years the article begins to appear with increasing frequency in his name, more or less in keeping with his rapid rise in Paris society.

Even though the title was a fictitious one, it was not entirely Honoré's creation because his father too had imagined himself to be a descendent of an old aristocratic family. Self-idealization was more delusional for the father than for Honoré, who, after all, had grown up with Bernard-François's preoccupation with his fictitious ancestry. Tellingly enough, while still in his twenties, Honoré wrote a few trashy stories and novels under such curious pen names as "Lord R'Hoone" or "Horace de Saint-Aubin," which seem to echo his father's fantasies.

Balzac's longing to be part of a higher social stratum derived from both the emotional deprivations throughout his childhood and the father's exhibitionistic personality. What Honoré was really hoping for was better, more caring mothering from someone who could then be elevated into an aristocratic lady. It is a theme he kept acting out in his numerous relationships with titled mistresses and describes time and again in his novels. Maternal neglect remained a festering wound with him throughout his entire life.

In Balzac's autobiographical novel *The Lily of the Valley*, the hero finds himself wishing to be the Duc d'Angoulême, for whom a party is being given. Later on in the novel, the hero refers to "the antiquity of my name, the most precious hallmark a man could possess."[93] Balzac's obsessive preoccupation with names, with social position, and with financial matters are an unmistakable natural adjunct to his propensity for dramatic exaggeration of his sense of values and priorities. He tended to elevate everything about him, people as well as goods and objects (and particularly the largely mediocre objects in his possession). This worked both ways: the objects were ennobled because he owned them, and his self-esteem, always uncertain, was enhanced because he imagined to own objects of great significance or rarity.

Honoré shares this tendency with many collectors, who also have the need to convince themselves that what they own is special, if not "the best," or "the ultimate." It is, to be sure, a form of projection that relates to their self-image. In Balzac's case it is

easy to trace the roots of this particular need. Emotionally deprived, and plagued by childhood agonies, Honoré had to learn to cope with the ignominy of hunger, illness, parental neglect, and finally devastating loneliness. Under these circumstances, he had to fortify himself with lively fantasies, idealizing himself as a person of exceptional qualities and foresight. But he also had a "Cinderella complex," in that he was convinced that one day a beautiful princess would come to his rescue.

Before we further explore the collector Balzac's personality, we must first understand more of the nondialogue between him and his parents. We only have an incomplete picture of Laure Salambier. Her family came from the same arrondissement in Paris to which the Balzacs moved twenty years later, and where Pons and his friend Schmucke led their insular existence. The Salambiers were respected merchants, and of a higher social station than the originally penniless Bernard-François. Laure's parents seem to have been more warmhearted and kinder than their daughter, according to the impression of Honoré's sister.[94]

The maternal grandmother, Sophie Salambier, was not an easy-going woman. Although she showed some affection for her oldest grandchild, she appears to have been strict and demanding with her daughter. A "Daily Time-Table for my Daughter Laure" reflects something of the severity of Honoré's mother's childhood environment: Rise at 7, clean teeth, wash hands and face, tidy bedroom between 7 and 8, breakfast and recreation between 8 and 9, writing between 9 and 10, and "useful work" between 10 and noon,[95] which referred to dressmaking, knitting, hemming, and embroidery. The force and rigor of this conditioning doubtless had its affect on Laure's personality.

There is no indication that, in all of Balzac's fifty-one years, there had ever been a single moment of true closeness and affection between him and the vain, distant, and narcissistic woman who was his mother. The extensive family correspondence, which still exists, confirms this, since it consists largely of letters from Honoré to his mother describing in the main the business of dealing with publishers, printers, and creditors, and the details of his often confusing economic affairs in general. A typical letter begins: "Dear mother, The day before yesterday I received your letter enclosing the account since May 10 according to

which you still have 614 frs. and 54 centimes, and I am answering first in regard to business [October 22, 1849]."[96]

He goes on for pages discussing nothing but financial matters, and these are mostly trivialities. He had spent several months at the Ukrainian estate of Countess Hanska, from where the letter was written. Meanwhile, he had left his financial affairs in the not-so-competent hands of his mother, who was over seventy and not very well to do. In the same letter, only five short sentences refer to her personally: "Take good care of yourself; don't spare anything. (Ah! I hope you had the heating pipes cleaned before using them for the winter for they must be cleaned every year.)" At best, these letters to his mother show no more than a sense of filial obligation and certainly no love. When he died less than a year later, his will directed Eve de Hanska to pay Mme. de Balzac a stipend for her subsistence.

Until Honoré was fifteen, the family lived in Tours, the provincial capital the man never completely abandoned. Tours was a regular setting for many of his stories and novels, which reflect an outspoken fondness for the Loire Valley and the local landscape to which he returns time and again. Despite this, it was not his parents' house in Tours that was the focus of his impressions during his earliest years.

Immediately after his birth, he was put in the care of a hired nurse in Saint Cyr-sur-Loire. His mother's explanation of this was that a brother, born exactly a year earlier, had been nursed by her and had died when he was only twenty-three days old. We do not know the cause of the baby's death, or Laure's maternal response to it. However, there is little question that being deprived from the outset of maternal love and devotion and being separated from his mother and his parents' home for the first four years of his life, constituted the basis of the predominantly obsessional defenses that persisted throughout Honoré's life.

Very little is known about the vicissitudes while he was in the care of the nurse. Sixteen months later he was joined there by his sister Laure, who was also given into the nurse's charge. There are many indications that much of Honoré's attachment to the first woman who had taken care of him was soon displaced to his sister. Her presence undoubtedly relieved some of his sad-

ness and despair, and the bond with her remained certainly the most constant, and quite possibly the least ambivalent, of any he ever had. Laure's presence guaranteed some kind of emotional continuity and belonging to him, and his lasting affection for his sister indicates a recognition of this fact. Indeed, many of his letters to her later in life read more like loveletters than correspondence between siblings. Nonetheless, this closeness did not eliminate a basic sense of solitude that remained with him throughout his life, and supplied him with his creative fantasies and astonishingly rich and detailed imaginary excursions into the world of other people. In addition, it gave him license for both his asocial way of life and his restitutive and reparative obsessions.

It should be mentioned here that it was not uncommon in French society of the Napoleonic era to give young children into the care of a nurse outside the parental home. In view of their mother's emotional detachment, the Balzac children were probably better off in the hands of a simple country woman. Nor can we discount the advantages of the brother and sister being brought up together, for they were always able to rely on each other. Spending the first years of one's life away from one's parents, and going without the emotional security provided by good-enough mothering—always a fortification against the vicissitudes of life—are more than sufficient grounds for an escape into imagination and fantasy, as well as for hopelessness and obsessional maneuvers needed to ward off frustration and mental distress.

A childhood scene recalled by Laure throws some light on young Honoré's already florid fantasy life: "For hours on end he would scratch away at a little red violin, and in his rapturous expression showed that he believed he was hearing tunes. He was astonished when I begged him to stop. 'Can't you hear how pretty it is?' he would say."[97]

Years later, after Balzac had achieved fame and success, he wrote about Pons and Schmucke, two former musicians, lonely, friendless, and prey to emotional impotence. Pons, the unsuccessful violinist turned collector extraordinaire, found solace and companionship in the objects he had collected with utmost care and discernment. Like Pons, Honoré's flights into fantasy often carried him beyond self-doubt and the disappointments

110

and suffering of his boyhood. When he was young, others had complained about the croaking of frogs, which to him sounded beautiful; later in life, he found mediocre works of art that he was convinced were outstanding examples by some of his favorite artists. Clearly, the ground for this bizarre self-deception had thus been prepared during his childhood when he simply had to take such flights of imagination.

If the initial circumstances of the two children were confusing, their traumatic and unhappy homecoming about three years later was in many ways even more so. Their mother was anything but empathetic or understanding and used to reprimand them for any misdeeds. They saw little enough of her as it was, but then there arrived a new governess, which made matters even worse, since she was just as cold and as strict with them as their mother.

A few people brought some relief. Their maternal grandparents provided a bit of warmth and understanding, and then, later on, there came a friend of the family, the "petit père Dablin," a well-meaning, considerate, and wealthy bachelor and family friend and an ever-available father figure who often came to Honoré's financial rescue.

We know what kind of healthy and healing comfort comes from a sense of being wanted and cared for. Thus, even a short visit to his grandparents' home in Paris gave young Honoré a deeply needed sense of family attachment and belonging. According to Laure, the boy cried when their grandfather died—the only tears his sister ever remembered him shedding.

In his search for a place in the world, as well as for security and inspiration, Honoré soon turned to books. He quickly became an indefatigable reader. The fantasy life as an outcome of his reading became a secret escape from, and a magical weapon against, an ever-present sense of anguish and desperation. In due time, Honoré found other escape routes. In identification with his father, he became vainglorious and exhibitionistic, at times even cynical and patronizing, and he tried to elevate himself to the aristocratic social position his father had only fantasized about.

But during those early childhood years, when true care and caring and the experience of being loved and lovable give a certain inner stability and self-regard, Honoré had almost no per-

sonal attachments and was very forlorn. An article entitled "Des Artistes," published in *La Silhouette* (1830), expresses some of his introspective understanding of this: "A man who is used to make his soul a mirror in which the entire universe is reflected lacks necessarily that kind of logic, that brand of obstinacy that we label 'character.' He is a bit of a harlot. He longs like a child for everything that strikes his fancy."[98] A statement such as this leads Maurois to the conclusion that Balzac here is asserting his prerogative to inconstancy, and I agree.[99]

Balzac's writings are studded with references to the impressions and experiences of his childhood and early adolescence; to peoples' egotism, suffering, and unstable and unreliable associations. Many of his themes reflect a childhood full of threats, ambivalent relationships, and disappointments. There seems to linger a compulsive need to return to his early circumstances, sometimes modified, at other times barely disguised at all.

His young mother was attractive, socially ambitious, and probably more than a little bored with a much older husband preoccupied with his position, and with awkward ideas about politics, religion, longevity, and his life expectations about which he concocted and published those innocuous pamphlets.

As the son later put it, he thought of his health, and what he defined as "the perfect life," as having taken refuge "in a provincial life and quiet home."[100] It is easy to visualize this narrow-minded, obsessional man with a borrowed sense of importance, married to a narcissistic woman more than a generation younger than himself who came from a Parisian middle-class family and must have seen in Bernard-François a rigid and basically insecure provincial. She sought escape from these bourgeois confines in pseudo-philosophical speculations—later expounded upon by Balzac in his novels *Louis Lambert* and *Seraphita*.

As was to be expected, the young girl from Paris turned into a disappointed housewife in Tours. Later, she had a relationship with a slightly younger local aristocrat, Jean de Margonne, by whom she had her fourth and youngest child, Henri. She was by all accounts a shallow and extravagant woman who was parsimonious and severe with her children, with the possible exception of Henri.[101] At one point, Honoré, fully aware of his mother's character, wrote to his sister, "Mme. Balzac has one foot in Paris and the other in the country, she is tired from run-

ning after wealth. . . . Papa says that our good mama is a wicked woman [January 1822]."[102]

Little is reported by brother and sister after their return "home" from Saint Cyr-sur-Loire. Their unsympathetic governess always stood between the children and their mother, although in fact it made very little difference since she was uncaring and hardly maternal anyway. Soon thereafter the two girls were sent off to a private school. The disruption of the long-established bond between Honoré and Laure must have added to the boy's sense of loneliness. Shortly before the birth of Henri, Honoré, aged eight, was sent away again, this time to the Oratorian college in Vendôme, where he remained from 1807 to 1813. He would see his mother only twice in those six years.

This boarding school was known for being very strict. The food was sparse and the heating minimal. Occasional outings were likely to resemble military forced marches, a typical example being a ten-mile walk to a local foundry or observatory starting at 4:00 in the morning. To us, such training seems much more typical of a prison than an educational institution. It is certainly not what we would consider suitable for a reflective lad more in need of care and maternal warmth than harsh discipline.

In his autobiographical novel *Louis Lambert*, Balzac describes the severity of the regimen at the school, the physical neglect, and even the sores and chilblains that developed during the cold winters. The boy felt more unloved and abandoned at the school than at Saint Cyr-sur-Loire because there was no caring sister nor a supervisory nurse. The students were not even permitted to leave school for a visit home.

Thus, Honoré's childhood had accustomed him for loneliness and neglect. As he wrote in *Louis Lambert*: "Instead of enjoying, as most schoolboys do, the sweets of *farniente*, so enticing at any age, he carried his books into the woods where he could read and meditate free from the remonstrances of his mother. . . . From this time reading became a species of hunger in Louis' soul which nothing appeased; he *devoured* books of all sorts— *feeding* indiscriminately on history, philosophy, physics, and religious works."[103]

Meditation, hunger, feeding are recurrent themes in Balzac's writings. He was never able to come to grips with his early privations and unhappiness. Incessant reading and the accumula-

tion of all kinds of knowledge gave him the vast amounts of information used so frequently and so effectively in his novels. His awareness of his isolation; his need for some tie with the outside world; his constant search for material security; his craving for objects, possessions, and people; and his enormous and constant indebtedness are in essence closely connected psychological reactions. He not only sought to acquire objects of all sorts but also collected people. In addition, there was within him a hunger for affection and for being wanted as a defense against an ever-present fear of desertion.

All of this was clearly and demonstrably rooted in those early years of uncertainty, and in the comparative vagueness of identificatory models, the unreliability of a capricious and insensitive mother, and a father whose concerns were of a higher order than coping with his children's needs. All of this considerably affected the development of Balzac's very complex character.

Balzac wrote *Louis Lambert* at the age of thirty-three while staying at Sache, the country estate of his mother's lover, Jean de Margonne. He considered this novel his most personal and possibly his best piece of writing. To today's reader it is a work of a still young and potentially promising although inexperienced writer lacking the ease and penetrating conceptualization so apparent in his later works, and especially in the *Comédie Humaine*. In a way, *Louis Lambert* belongs to those autobiographical and self-revelatory works that often serve as catalysts to young authors by opening the way for the release of more remote, often unconscious but in any case inaccessible creative powers.

The true achievement of this first novel lies in its documentation of the author's early years, since it not only makes for better acquaintance with the history of Balzac as a collector but also reveals a tortured adolescent's sense of resignation and self-absorption, together with his emerging defenses later to be expressed in arrogance and exhibitionistic displays.

The Lily of the Valley and *Louis Lambert* have always been considered the most confessional, and hence the most informative of Balzac's novels. Other works, such as *The Wild Ass's Skin*, *Père Goriot*, *Cousine Bette*, and *Facino Cane* are also personal and revealing, but they are less illuminating for the clinician than those books that offer an intriguing glimpse of his early years, of his adolescence and his pecadillos as a young adult.

Louis Lambert and Felix de Vandenesse, the young hero of *The Lily of the Valley*, both provide the key to an understanding of Sylvain Pons or, more to the point, of Honoré de Balzac. Pons lived in poverty and Balzac in constant debt; the passions of both border on mania, and their appetites feed on a fanatic need for replenishment. Both are, or can be, voracious eaters.

Louis, described as the precocious son of poor country folk, has been sent, in preparation for the priesthood, to his uncle, a curate in the Loire Valley. An intelligent lad of irresistible charm, Louis receives further education at the well-known Oratorian college at Vendôme at the expense and under the protection of the highly celebrated Madame de Stael. Out walking one day, she had "discovered" Louis, "almost in rags, and absorbed in reading." The boy is thus rescued by a "lady of quality" (a theme repeated later in the book when his bride, the Jewish heiress Pauline de Villenoix, shows her selfless devotion to him when he suffers a catatonic breakdown).

On their first encounter, Louis and Mme. de Stael engage in a brief conversation about God and mysticism. Toward the end of their exchange she declares, "He is a real seer." Indeed, his thinking is very different from that of the other pupils. However, his schoolmates consider him quite ordinary, and not at all the unusual boy Mme. de Stael thinks him to be. Only Balzac, in his role as the storyteller, knows the truth. He tells his readers: "I alone was allowed really to know [Louis's] sublime . . . divine soul." He continues: "Our intimacy was so brotherly that our school-fellows joined our two names; one never was spoken without the other."[104]

Fictitious friendships are not uncommon in Balzac's novels. Pons and Schmucke represent a similar pair. Relationships such as these are built on a strong homoerotic-identificatory bond intrinsic to the kind of defensive personality traits that commonly develop in response to early emotional deprivation. One wonders whether Balzac had any awareness of the frequency with which he refers to trust and intimacy between two men.

The emotional traumata Honoré experienced at the hands of his parents and governess as well as some of his teachers were compounded by his physical suffering at the boarding school. There he was frequently banished to the "alcove." These were confinement quarters. It was a form of isolation from the other

115

children and considered severe punishment indeed. But it gave him ample opportunity to continue unobserved his insatiable reading, at that time his only means of escape from the outside world, and the first tentative manifestation of his collecting drive. At the same time, he made his first serious attempt at writing, an essay entitled "Traité de la Volonté," which was discovered by one of the schoolmasters and subsequently destroyed. However, the same concepts were later expounded on in his novel *Seraphita* with a highly revealing example of a hallucinatory experience of male-female identity confusion and the androgynous element of human nature.

The final part of *Louis Lambert* is in keeping with Balzac's melodramatic style, especially in his early works. After Louis's sudden departure from the school, he and the narrator lose contact. Years later, in 1823, the storyteller unexpectedly meets his old friend's uncle in a coach (chance meetings are a favorite device in Balzac) and learns of Louis's unhappy fate: "My poor nephew was to be married to the richest heiress in Blois, but the day before his wedding he went mad. . . . Louis had some well-marked attacks of catalepsy. . . . He thought himself unfit for marriage." His bride, Pauline de Villenoix, insists on devoting herself to his recovery. The marriage—"a happiness we alone can comprehend," says Louis to Pauline—is never consummated.

The portraits he paints of Cousin Pons, of Raphael de Valentin, Lucién de Rubempré, Vautrin and Rastignac, and primarily of Louis Lambert, all show numerous traces of the author's personality. These characters help in our understanding of an exceptional man who found in his search for objects an avenue of self-therapy, despite his inability to adjust to the demands of his environment and to accept the terms of the world into which he was born.

Balzac had an intuitive grasp of human passion, of carnal appetites, of affects and aspirations. He knew them all. When, for example, Felix de Vandenesse reveals to the Countess Natalie de Manerville that "I have, buried within my soul, astounding memories, like those marine growths which may be seen in calm waters, and which the surges of the storm fling in fragments on the shore,"[105] This is not a mere figure of speech. He is quite aware that his emotions, although seemingly in control, are

barely repressed. We see the versatile writer dealing with anal imagery, and with an inner rage in which broken objects are flung at the outside world. He wants to undo profound anxiety by attacking, and to express his anger at the long years of hurt, of suffering and the repression of deep emotional pain.

"What poet," he writes, "will tell of the sorrows of the child whose lips suck the milk of bitterness, whose smiles are checked by the scorching fire of a stern eye? . . . What moral or physical deformity earned me my mother's coldness? Was I the offspring of duty?" He laments further: "Cut off already from all affection, I could love nothing, and Nature had made me loving! Is there an angel who collects the sighs of such ever-present feelings?"[106]

Here is the probing spirit that leads to a preoccupation with objects meant to counterbalance the traumata of a loveless, disorientating childhood. And Felix de Vandenesse's childhood could well have been a chapter in a textbook on child psychiatry. In it, we are getting a description of Honoré's own emotional conflicts and agony.

This man's younger and delicate wife becomes the story-teller's mistress. Or take *A Start in Life*. Here the Comte de Seris, a peer of France, falls in love with a younger woman whom he subsequently marries. He is emotionally dependent on her even though she refuses intimacy. The count suffers from a skin ailment, which his wife uses as her reason for rejecting him, and, while they make a pretense of having marital relations, the countess leads an independent life of glamour and luxury, not unlike that of Honoré's mother.[107]

Again, in *Droll Stories*, Balzac describes Bertha the Penitent who marries the much older Sire Imbert de Bastarnay, one of the most landed lords in the Touraine. The old man has encountered the innocent and attractive maiden Bertha de Rohan, and was "seized with so great a desire to possess her that he determined to make her his wife. . . . So immediately the night arrived when it should be lawful for him to embrace her, he got her with child so roughly that he had proof of the result two months after the marriage." Bertha lets the insensitive man enter into "the sweet garden of Venus as he would into a place taken by assault, without giving any heed to the cries of the poor inhabitants in tears, and placed a child as he would an arrow in

the dark." Bertha was only fifteen years old, and even though "she had had the profit of being a mother, the pleasures of love had been denied to her."[108]

For Balzac, Bertha is a "mirror of virtue," and this "considerably aided the little boy, who during six years occupied day and night the attention of his pretty mother, who first nourished him with her milk, and made him a lover's lieutenant, yielding to him her sweet breasts, which gnawed at, hungry, as often as he would, and was, like a lover, always there. This good mother knew no other pleasures than those of his rosy lips . . . and listened to no other music than his cries, which sounded in her ears like angels' whispers." These cries that turn into heavenly whispers are remarkably like little Honoré's scratches on his violin, which sounded to him like pretty melodies. To us, the story is dated, leaden, and ponderous, but we are not concerned here with its literary merits. The tale contrasts Bertha's devotion with his mother's frigidity; even more important, it gives us insight into his not-so-subtle incestuous fantasies of being "like a lover" to his ideal of a mother.

From this point of view, it is hardly a coincidence that as a young adult Balzac's love relationships were clear attempts to compensate for his early deprivation by acting out such instinctual gratification. He was not quite twenty-three when he started his first love affair, with the Countess Laure de Berny who was then about forty-five.

An essay by Freud deals with the phenomenon of those who see themselves as exceptional or chosen people.[109] They feel privileged or different and insist that nonconformity is their due and birthright. The ontogenetic origins of this specific self-image are that they had unusual childhoods, and that certain early experiences or conditions affected their development, the way they see themselves, their mode of behavior, and their lifestyle. Their early lives constitute a repository of emotional disturbances and experiential or physiological conditions. These are people who tend throughout their later lives to make claims for compensation, or "an accident pension," as Freud once put it. Potentially, the need to be exceptional can carry with it an insistence on a kind of eccentricity that manifests itself in more or less conspicuous and often compulsive ambition.

Honoré consistently presented himself as special and expected others to recognize his singularity. Moreover, he had a plethora of schemes, plans, and pipe dreams to further his goals in order to counteract his damaged self-esteem. It is reasonable to assume that he was testing his own potential as well as his environment. He was in a bind since his early childhood experiences had left their mark on him, so he was prepared for disillusionment and rejection. However, he also had a memory of his avenue of escape—his fantasies of grandiosity and his ostentatious behavior. His appetites and illusions were fixated at a stage when he felt unloved and even unwanted. His erratic style, his obsessive propensities—either totally immersed in his work, or squandering time and money; living on next to nothing but cup after cup of black coffee, or being a gourmandizer of enormous proportions—vividly demonstrate his underlying character structure as the affective responses to his early unfulfilled needs and his constant search for relief through a desperate, frequently delusional play for recognition and applause. His often grotesque and self-congratulatory braggadocio is conspicuously like an infant's vacillation between rage and laughter. Impulse-ridden in his decisions, starry-eyed and sentimental in his infatuation with the Countess de Hanska, sometimes vain and irritatingly pretentious, Balzac felt that his exceptionality entitled him to the temperamental outbursts and mood-swings as a manifestation of his early perception of lack of love and inadequate care.

His childhood was a chronicle of disappointments and rejections, which explains much of his behavior in his adult life. He became a "workaholic," spending as much as eighteen hours at a stretch at his desk. Then there were his outrageous debts, largely due to his ostentation and incessant acquisition of objects for his house. Quite understandably, he was predisposed to idolize older women from social strata far above his own. However, never having experienced good-enough mothering and care, all he could do was dream of love while he was incapable of ever truly loving anyone with genuinely devoted dedication, free from self-centered, narcissistic illusions.

Like his parents, he was always trying to enhance his social position. His efforts were reasonably successful, particularly as

119

his literary talents began to bring him more and more prestige. The acclaim of his books soon opened the doors to many of the most fashionable Paris salons in the 1820s and 1830s. Ambitious and resourceful, Honoré was determined to take from other women the attention denied him by his mother throughout his childhood.

His alert mind and quick wit soon captivated the Duchesse de Rauzun, the Marquise de la Bourdonnaye, and Madame Sophie Gay, and he was just thirty when he began being invited to the salon of Madame Récamier, perhaps the summit of Parisian café society at the time. The social success he was enjoying in the salons helped exaggerate his self-assertive tendencies, his dandyism, his extravagance, and, particularly, his often frenzied acquisition of more and more objects for his ever-growing collection. He now became accustomed to spending money more and more recklessly as he fell more and more in love not with his real self, but with his fantasy image, an ideal of himself.

He was already living in a very comfortable apartment at 1 Rue Cassini in Paris, which, in addition to being beautifully furnished and decorated, boasted a bathroom, a considerable luxury for a young bachelor at the time. However, his grandiosity soon threatened to engulf him as his standards went far beyond his means and, before long, his capricious self-indulgence seemed to overwhelm any sense of responsibility. In a short time he rented another room in the same house and went about furnishing it lavishly, with particular attention to carpets that André Maurois succinctly described as "thick and soft and ruinous."[110]

By this time the ambitious and talented young man from the provinces was firmly established in all quarters of Parisian society. Everybody knew about him. He was now also at home in the world of the arts, having become friendly with Delacroix, Gavarni, Dumas (père), Rossini, Merimée, Victor Hugo, and many other well-known artists and writers.

His brilliance as a conversationalist and his boundless energy must have been more than enough to offset his unsightly appearance. He has been described as being heavy-set, short, and unattractive with a gap-toothed smile—a far cry from the impressive figure known to us from Rodin's famous larger-than-life figure of him. That sculpture itself is indicative of the mental

120

image he left behind. People seemed to forget his appearance once he began to tell a story or describe one or the other event.

For many years, long before he had any indication of marrying the Countess de Hanska, he had been collecting decorative objects and bric-à-brac. His lifelong and perhaps only constant friend, Zulma Carraud, soon saw what was lacking: "I understand your eagerness to complete your little paradise; after the chinaware and the silver it needs a *female* soul, for nothing else is missing [September 10, 1832]."[111] Even at this stage, Balzac had his Tilbury (a fashionable carriage), two horses, and, of course, his debts. His fateful acquaintance with Eveline de Hanska shortly thereafter became a welcome excuse for continuing his obsessive and uncontrolled hoarding.

It should be mentioned here that all of his impulsive acquisitions would have been well within the reach of a prosperous merchant of the day, or a successful entrepreneur, or perhaps even an author of Balzac's fame and stature. The problem was that his unrestrained acquisitiveness was rooted in his identity confusion. He was unable to distinguish between the limits of what his financial condition would allow and his rich imagination, or, more to the point, the magical thinking of the lonely and deprived little boy he had been.

At this time, Balzac would, more or less periodically, indulge himself in lavish entertainment and luxuries, as if acting out the daydreams of his boyhood years of loneliness and emotional starvation. First, he would drive himself to write for fifteen to eighteen hours a day, living only on his black coffee and clad in a monkish robe. Then he would reward himself with an epicurean meal like those indulged in by the fictional Sylvain Pons. On one such occasion, he gave a dinner for the celebrated composer Gioacchino Rossini and his girlfriend, Olympe Pelissier, together with some other members of the Paris beau monde. In a letter to Eve he tells her that he had had "the choicest wines of Europe, the rarest flowers, the most wonderful food." He then adds that "the goldsmith Lecointe supplied five silver platters, three dozen forks, a fish-slice with a silver handle, and all this, having made its effect, would go straight to Mont-de-Piété [the pawnbroker]."[112]

Three months earlier the same jeweler had made Balzac a cane with a knob of gold decorated with turquoise, at a price of

700 francs. "As to my joys, they are innocent," he wrote, with conspicuously little introspection, to the countess.[113]

Balzac never understood the pathological side of these joys. In addition to his sumptuous and costly dinner parties, he comments that his "innocent" pleasures "consist in new furniture for my room, a cane which makes all Paris gossip, a divine opera-glass which my workers have had made by the optician at the Observatory; also the gold buttons on my new coat, buttons chiseled by the hand of a fairy, for the man who carries a cane worthy of Louis XIV in the 19th Century cannot wear ignoble pinchback buttons. These are little innocent toys which make me considered a millionaire. I have created the sect of 'Cannophiles' in the world of fashion, and everyone thinks me utterly frivolous. This amuses me!"[114]

What really amuses him is that he is now finally in the limelight. His self-doubt, and possibly even his unconscious feminine-receptive desires, seem to be further repressed by the reassurance he gains from his admirers, in particular those older and usually titled women to whom he felt attracted. However, he seems somehow aware of his effeminate stance. In a letter to Eve written some months earlier, he states: "The love of a poet is a bit crazy. . . . They themselves are a bit of a woman."[115] And then, in March 1835, quite proud of the popularity his flamboyant cane has gained, he tells Eve again: "You cannot imagine the popularity of this gimcrack stick of mine, which bids fair to become European."[116] His painter-friend Auguste Borget, who had just returned from a visit to Italy, had heard people in Naples and Rome talking about the cane: "All the dandies of Paris are jealous of it. . . . It appears to me that it will furnish materials for a biography; and if you were told on your travels that I have a fairy walking stick, which starts horses, builds palaces, and spits forth diamonds, don't be astonished, and laugh with me."[117]

It seems evident that the model for Balzac's manners and aspirations came from Tours, and from both his parents, although elaborated and inflated almost beyond recognition. And yet one is left with the inescapable impression of the provincial tenor in his values and appetites. Fantasy was the key to Honoré's self-image, the same fantasy that, despite some awareness of his delusions, was in effect his operative defense against those crucial years of emotional deprivation. Possessions, objects for

ostentation and appearances, the use of titles, and admiring women of status—all were essentially one and the same to him: they all can be thought of as unconscious pleas for self-assertion or part of his world of magic. They all had a phallic-narcissistic quality that provided him with a conscious sense of mastery and of being the exception. His canes, his gold buttons, the paintings, the orgies, and women obviously differed in appearance, but not in essence.

Feast and famine, vainglory and self-restraint, rational intelligence and illogical ideas and decision-making—all were closely related and reflect various facets of his personality. A handful of devoted and consistent friends went along with his temperamental and unpredictable self-deception, as well as his obsession with writing. They tried to tolerate his inconsistencies, his whims, and his paradoxes.

But who was the true Balzac? The dandy who worked for the better part of the day in a monk's cowl? The philanderer who fell in love with a woman beyond his reach whom he pursued for almost two decades? The keen observer of human frailties who was himself a lifelong prisoner of obsessional defenses? The waster of his own and other people's money?

Intricate maneuvers allowed him to cope with his self-doubt and anxiety. His zeal and dogged determination on the one hand, and his caprices and eccentricities on the other, served as a bulwark against his morbid fear of rejection and being left out and nearly forgotten. This can be seen from the many rescue themes found in his novels and in the disorder of his own affairs, from which he needed rescue time and time again.

In his early twenties he had started a series of business ventures that failed, one after the other. First, he became a publisher of French classics, doomed from the beginning since he was totally unacquainted with the publishing field. He then tried the type-foundry business, but only Madame de Berny's generosity and the fact that his sister managed to persuade their mother to lend him 85,000 francs prevented him from going bankrupt. His confusion about obligations and expenditures was endless. Within a few years he owed about 100,000 francs. This time his cousin Charles Sédillot came to his rescue by settling with the creditors. Hyacynthe de Latouche, fourteen years his senior, helped by signing notes to various dealers, thereby abetting his

passion for adding to his collection.[118] At the same time, Balzac told another of his protectors, the General Baron de Pommereul, that his name and honor were saved by his mother's sacrifice and his father's kindness.[119]

With a clean slate once more, Honoré decided to settle down and begin his career as a fully committed writer. By this time he was already well on his way to becoming a highly acclaimed author. The first edition of *Le Dernier Chouan* appeared in March 1828. It more or less established his reputation, but he received only 1,000 francs for it, hardly enough to cover his running expenses, let alone his debts, which had again risen to almost 100,000 francs. His ability to ignore seemingly unsupportable outside pressures and demands while pursuing his obsessions is a familiar psychological manifestation: he was able to erect invisible walls between contradictory acts and emotions, thus distorting the underlying significance of his behavior.

Clinically we describe such phenomena as a mechanism of isolation designed to cope with anything liable to cause anxiety or discomfort. Honoré was a master at it. His continuous acquisitions offer one example, his various business ventures and far-fetched entrepreneurial attempts another. The correlation is evident. There is neither any planning nor perspective: his knowledge of works of art or porcelain is limited, at best. And his experience in commercial enterprises is nonexistent. His relationship with women reflects much the same attitude, which never corresponded to any sense of reality.

His compulsions are well documented in his own writings. In fact, he retold his experiences in so many versions and elaborations, and so often, that we can understand his character and emotional conflicts without passing judgment. In *Illusions Perdues*, for example, Lucien Chardon, a poverty-stricken and idealistic young poet from the village of L'Houmeau, changes his name to Lucien de Rubempré when he is introduced to the leading light of the high society of the provincial town of Angoulème, Madame de Bargeton. They fall in love and soon become lovers. This is but one variation of his own encounter with the Countess Berny. As he writes: "Mme. de Bargeton was thirty-six years old and her husband fifty-eight. The disparity in age was all the more startling since M. de Bargeton looked like

a man of seventy, whereas his wife looked scarcely half her age."[120]

As mentioned before, when Honoré was twenty-six, he made the acquaintance of the Duchess Laure d'Abrantès, renowned for her love affair with the Austrian Prince Metternich, by whom she had a son. Even though Honoré was still involved with the Countess Berny, he was soon in a well-publicized relationship with the duchess. This was followed shortly thereafter by an affair with the Marquise de Castries. All three women were appreciably older than he. His choices of mistresses is not surprising.

Balzac can broadly be described as suffering from manic-depressive manifestations correlated with obsessional defenses. Childhood and adolescence confronted him not only with a series of rejections and a variety of traumatic events but early on required him to renounce every kind of emotional support. As a result, he had only his sister Laure and a few casual friends. The root of his state of mind is found in his repeated statement: "I never had a mother," which not surprisingly blossomed into a profound unconscious ambivalence toward women, and latent homosexuality.

Can he row effectively against the stream of his obsessive pressure? Evidently, he cannot. At the end of 1835 he founded an intellectual journal, the *Chronique de Paris*, wining and dining his distinguished contributors, and in the process incurring even more debts. He yearned to be the center of intellectual fervor, but it was not to be. Like his earlier commercial enterprises, the publication of the journal was doomed from the start and had to be discontinued.

This is but another example of Balzac's conflict with reality, a condition that affected the entire nature of his existence. An exchange in *The Wild Ass's Skin* sheds much light on the inner features of his mental functioning. The young hero, Raphael de Valentin, has lost his last sou in a gambling den and is about to commit suicide. Dazed, he wanders through the streets of Paris and enters the shop of an antiquaire. The dealer offers the young man a reprieve in the form of a talisman, a wild ass's skin. The old man lectures him: "Moderation has kept my mind and body unruffled," and finally puts the salient question to Raphael: "Is

not knowledge the secret of wisdom? And what is folly but a riotous expenditure of Will and Power?" Now comes Raphael's fatal decision:

"'Very good then, a life of riotous excess for me!'

'Young man, beware!' cried the other with incredible vehemence."[121]

This dialogue clearly echoes the conflict in Honoré between conscience and abandon, restraint and self-indulgence. He is constantly struggling with unresolved, regressive crosscurrents which carry him back and forth between the narcissistic wound dealt him by his indifferent, uncaring mother, and his fantasy of the concerned, generous, and understanding woman, the kind of woman he describes in the person of Mme. de Stael in *Louis Lambert* or what he projects onto Eveline de Hanska.

Honoré labored on all fronts to compensate for the lack of maternal love. He kept searching for attention and acclaim. He sought the love of older and socially more prominent women. His friendships with eminent artists were, in essence, complementary attempts to transform self-doubt into grandiosity (as his descriptions of his dinner parties or the admiration of his canes or buttons shows). His collecting is another variant of the same condition; his need for self-aggrandizement, which tended to ignore decorum, subtlety, obligations, and debts.

The pace of material consumption was accelerated by Balzac's discovery that he enjoyed traveling. He had been to Neuchâtel in Switzerland for his first secret rendezvous with the Countess de Hanska, who as an admirer of his writings had been in correspondence with the author. He had also been to Munich and Vienna. Now he visited Italy and Switzerland, Sardinia, Holland, Saxony, and the Ukraine, always frantically driven by the same inner forces that made him a gourmandizer, a dandy, and an obsessional buyer of usually mediocre decorative and art objects.

In 1837, when he should have been devoting his time and energies to his *Chronique de Paris*, he took a trip to Italy. There he learned by chance about some ancient silver mines in Sardinia, going back to Roman times. He decided he would like to investigate the mines, and saw a business opportunity. So he set out on an almost Don Quixote-like journey, without any research or preparation, and completely ignorant about the conditions and

circumstances on the island. En route he sent a note to Zulma Carraud that the journey was a failure and he is one illusion poorer.

When he finally landed on the island, it turned out to be what he had vaguely anticipated it would be—an illusion. The Genoese entrepreneur who had told him about the mines had already acquired the concession to exploit them, and they ultimately proved to be highly profitable, although not for Honoré, of course. And so he left Sardinia as he arrived—without any preparation, without any knowledge of mineralogy or economic conditions, indeed quite similar to the way he used to acquire his works of art. He came back tired, empty-handed, and disappointed, but immediately ripe for another undertaking.

Living in Paris was too demanding, he explained to Eve shortly after his return from his Sardinian venture. In the village of Ville d'Avray, only ten minutes away, he would build a small but ideal house, "Les Jardies." He bought the land and designed the house, which would be richly decorated with carpets, expensive furniture, and bronzes. In order not to disturb this fine composition, the staircases would be outside the building. And the land was sloped, so it would be perfect for a pineapple plantation.

One of his companions, Léon Gozlan, remembered seeing some of Balzac's scribbles on the bare walls of the building: "'Here a casing of Parian marble—Here a pedestal of a column of cedarwood—Here a ceiling painted by Eugène Delacroix—Here doors in the manner of Trianon. Here a mosaic parquet floor made of all the rare woods from the islands.' These marvels never existed but as notes made in charcoal."[122] It should come as no surprise that the house collapsed. The unevenness of the property not only rendered it unsuitable for construction but made it dangerous as well, for Honoré fell and was incapacitated for several weeks.[123]

Optimism and a belief in one's self and one's abilities are useful and supportive personality traits. However, it is also necessary to take into account what has been learned from past experience. Did Balzac refuse to look to his past, or to recognize that his distortions and exaggerations always repeated the make-believe games of his childhood, such as his hearing fine music instead of the scratching of his violin? All his actions were but

remarkable illustrations of his primary fixation to masochism, to the emotional deprivations and disillusionment of his childhood. "Les Jardies" was just one of his many doomed undertakings.

His behavior bears all the earmarks of a traumatized child who, as an adult, finds ways of instinctual expressions that, compulsively reenact the disappointments of his formative years, and is often unable to differentiate between illusion and reality. In keeping with these characteristics, Honoré attempted to look at himself with a certain measure of amusement. He could laugh at himself, and was amused when his friend Gozlan added to the notes on the empty walls of another room: "Here a painting by Raphael, exceedingly expensive and one which has never been seen."[124]

In the autumn of 1840, Balzac moved back to Paris. "Les Jardies" had cost him close to 100,000 francs, bringing his debt at the time to more than a quarter million francs.

Given the distressing experiences of a loveless childhood, we understand that his optimism and almost blind trust were tantamount to a massive denial of nearly constant anguish and loneliness. Inevitably, that in concert with his bragging behavior was his way of mastering hopelessness and self-doubt. Toward the same ends he also believed in clairvoyants and spiritualism, and had an almost childlike faith in his signet ring called "Bedouck," given to him by a well-known Arabist, Baron von Hammer-Purgstall, who claimed it had once belonged to no one less than the Prophet himself. Then there were his canes, obvious phallic representations even to those skeptical of psychoanalytic interpretations.

The early times of loneliness and continued emotional distress had been the initial setting for his flight into imagination and inventiveness, not simply restricted to his literary creativity. He was a dreamer as his entire lifestyle, his business ventures, his houses, his eating habits, and, of course, his impulsive acquisitions of works of art show time and again. They all were obsessional defenses meant to ward off his desperate needs for reassurance and tangible support as proof of his own worth and eminence.

In September 1847, Balzac visits Eveline de Hanska for the first time at her estate in Wierzchovnia, in the Ukraine. His en-

thusiasm is limitless: "Exactly like the Louvre," he exaggerates although the mansion is not small by any standard.

Does his rhetoric echo desperation? Is he trying to establish his uniqueness by magnifying whatever seems significant and meaningful to him at the moment? Was he in love with Eve or the Countess de Hanska, or with the grandniece of a former queen of France? Or was it the kind of attachment where love is essentially motivated by a deep-rooted need for closeness and support, and as a defense against that ever-present doubt a child tries to undo when he projects idealized concepts onto real people?

At times, Balzac himself is aware of his dilemma. Early in his relationship with Laure d'Abrantès, for example, he describes himself with a kind of candor and self-knowledge linked with his overall attempts to isolate the opposing tendencies within him. His self-knowledge is bold and yet on target:

> In my five feet two inches I contain all possible inconsistencies, all contrasts, and those who consider me vain, lavish, obstinate, flighty, incoherent, foppish, negligent, lazy, unpurposeful, thoughtless, inconstant, talkative, tactless, uncouth, unpolished, restive, of uneven moods could point equally with good reason to those who would say I am economical, modest, courageous, tenacious, energetic, neglected, working, constant, taciturn, full of finesse, polite, always gay. Someone who calls me a coward will be no more mistaken than the one who calls me extremely brave, in a word knowledgeable or ignorant, very talented or inapt; nothing astounds me more than myself. In the end I believe that I am but an instrument played on by circumstances.[125]

This is no poor insight for a young man of twenty-six. His self-portrait reveals a bold and yet rational character sketch, unromantic and stern, although perhaps not entirely unaffected.

Did Honoré ever overcome his intense feeling of loneliness? Did he ever abandon the image of himself as "the most melancholy man, the most unhappy among all the ill-fortunate ones?"[126] All too often an irrational approach is taken to deny his depressive moods: "Now my plate is empty," he laments to his sister, "it is not gilded, the table-cloth is faded, the food insipid. I am hungry and nothing is offered to still my greed! What do I want. . . . Ortolans, because I have but two passions,

love and fame, and till now nothing has been satisfactory, and nothing ever will," he concludes in disillusionment.[127]

The point I am making here is that he is essentially very depressed, and to remedy this ever-present threat he has found a variety of obsessive devices. He is often despairing and because of it also insatiable, much like Cousin Pons. Did he see himself as ugly as he described Pons? Did he feel, like Pons, that he was a freak from birth? Did he find himself guilty of selfishness? Was he really "a man with a great soul, a sensitive nature"? Was "'success with the fair' out of the question" for him?[128]

Balzac tells his readers that "Pons contracted the unlucky habit of dining out," and that "the demands of digestion upon the human economy produce an internal wrestling-bout of human forces which rivals the highest degree of amorous pleasure." But here he is really talking about his own conflicts and impulses, his own passions and appetites for he is torn between pregenital oral concerns and mature genitality and a fulfilling love relationship. However, he knows that he is not his own free agent for he loved his objects, his paintings, his carpets, his porcelain "as a man might love a fair mistress," he senses correctly.[129]

His cupidity and extravagance are consistent with his mood-swings and the ambivalent tendencies in which monklike puritanical self-denial and overwork alternate with periods of self-indulgence and times of grandiosity. His letters to Eve, always full of sentimentality as well as constant chatter about his finances, tell us a good deal about his despair: "My need for you is like a hunger," he writes.[130] But this hunger sprang from far more tortuous depths than Eve could ever fathom.

Honoré spent ten weeks of the summer of 1843 in St. Petersburg and returned home more than ever determined to secure his alliance with the countess, although there were legal obstacles as well as her own hesitation to consider. The thought of marrying her provided him with a sound incentive for putting his affairs in order, and he seemed to make a more realistic effort to reduce his debts. For a time he seemed more purposeful in his pursuits, and perhaps life was even a bit less turbulent for him. Strains and crises did not appear quite as acute as heretofore. The reluctance of Eve, now widowed, to marry was dimin-

ishing. She had even given Honoré a substantial amount of money—"trésor louloup," he affectionately called it—to invest for her.

In the spring of 1844, *Modeste Mignon* was published, further reducing the author's debts. In the autumn, Eve, after having settled her affairs at home, decided to leave Russia and stay for a while in Saxony. Several months later, in the spring of 1845, she finally gave Honoré permission to visit her in Dresden. She and her seventeen-year-old daughter Anna had been joined by the young Polish Count Georges Mniszech, who had fallen in love with Anna.

The four traveled together through Germany, Holland, Belgium, and Alsace. They must have had a good time. They called themselves *Saltimbanques*, or buffoons, and gave each other nicknames. Honoré ordered two canes from his jeweler Froment-Meurice as a tangible confirmation of the bond between the two men who were in love with the two Hanska ladies.[131] There is little mystery in the significance of this gesture, since it constitutes yet another instance of the recurrent covert homosexual trace in Balzac's personality.

This was to all appearances the most genuinely carefree time in Honoré's life. One would have to make this assumption if only during this period he was able to exercise a certain measure of self-restraint over his spending. Nevertheless, in Rotterdam, he bought some antiques and was tempted to acquire an armoire.

But ultimately and hardly unexpectedly, his struggle failed. His resolve had been sincere, but he was incapable of living forever without this means of discharging tension. What had been a folly for most of his adult life had now become a passion. In the autumn of 1845, the *Saltimbanques* embarked at Toulon for a journey to Naples. En route, Honoré visited several antique dealers in Marseilles, particularly one named Lazard. A bill of sale dated November 13, 1845, lists a soup toureen, three sauce boats, ninety-four plates, twelve round dishes, nine long dishes, two large vases, a clock in gilded copper, and a set of coral jewelry.[132] A month later, when the shipment arrived in Paris, he complained to Lazard that three of the plates had been broken.

On February 18, 1846, he describes to Eve his latest discovery:

I have the portrait of Maria Leczinska [Eve's great-aunt]. It is not by Coypel, but made in his studio by a pupil, Lancret, one believes, one has to be a connoisseur to doubt it is a Coypel, it is an excellent family portrait. . . . The frame is worth 75 to 80 francs to a dealer, and I only paid 130 fr. altogether. I could never lose money on this, according to Chevard; but among 3,000 paintings, I discovered a marvellous portrait (Holbein, Bronzino, Schidone are accused of this jewel without any proof). The frame can be sold for 100 fr., and I bought it for 120. Chenavard told me: 'Nobody could paint this picture today. . . . M. Ingres couldn't do it; and one would ask a hundred louis, and wouldn't be able to produce such a solid piece of work, even if one's name were Decamps. It is not a great masterpiece, not a work which will be known; but it will hold its own in a room among masterpieces, buy.' Here it is worth 120 fr., in Poland it will be worth 1200.[133]

Balzac later elevates the portrait to a Holbein, lists it in his "Inventory of Personal Property" of the Rue Fortunée of 1848.

In the same inventory, Balzac, always full of noble aspirations, also attributes a portrait of a woman to Allori, usually known as Bronzino.[134] Twenty-six other paintings are attributed to such masters as Domenichino, Palma Vecchio, and Giorgione. A reading of *Cousin Pons* indicates that the collection at the "Musée Pons" contained sixty-seven pictures, among them many works by the most outstanding masters, in addition to nearly two thousand other objects—clocks, porcelain, bric-à-brac. It is quite evident by now that Pons was in many ways a portrait of the true Balzac, behaving as the author would were he not held back by admittedly minimal self-restraint. Pons, or rather his collection, reflects the genuine proportions of Balzac's fantasy world.

In the winter of 1848, he once again visited the de Hanska estate, and after leaving, stopped off at a number of antique shops on his way back to Paris. In Dresden he made some substantial purchases from the dealer Louis Wolf, and in Mainz he visited the antiquaire Schwab, before arriving in Paris just a week before the outbreak of the February revolution.

On the day the revolution broke out, he wrote Wolf that he wanted his credit extended, referring to the special circum-

stances that existed ("l'état actuel des évenements'). Schwab, he assures Wolf, had given him a whole year's credit.[135] However, when the shipment arrived partly damaged, he tells Wolf that he has never had complications of this kind with dealers before,[136] as if he had forgotten his complaint to Lazard. Meanwhile, he orders other objects from Wolf but informs him at the same time that he cannot remunerate him before the end of the year.[137]

If Honoré tended to act out so many of his conflicts in his haphazard acquisitions, he showed another side of his character in the manipulation of his debts. He had yet to yield to his monetary limitations, even though he seemed painfully aware of them. In portraying Sylvain Pons, however, he could overstep those boundaries and buy to his heart's content.

The prospect of marrying the countess provided more fuel for his delusions. Secure in the knowledge that a bond with the woman he believed he loved was now assured, another man would probably have been content. Instead, this made Balzac even more of a slave to folly and ambition. In announcing his marriage to the Countess de Hanska, he writes to Zulma Carraud:

> This union is, I believe, the compensation God held in store for me for all the adversities . . . the years of labor—I feel the happiness of youth, the flowery of springtime; I am going to have the most brilliant summer, the sweetest of autumns . . . I, the maltreated child, the misunderstood worker, often crushed under physical and moral misery. Ah! I shall not forget your motherliness, your divine sympathy with the sufferers.[138]

Is he as happy and fulfilled as he sounds? Now he buys the house in the Rue Fortunée and proceeds to spend hundreds of thousands of francs in furnishing it lavishly. He tells Eve that all of this is being done out of his concern for her, and that she needs and deserves the proper surroundings. However, one needs little insight that he is actually serving his own fantasies and emotional needs by submitting to his perpetual craving for new supplies and constant replenishment. When he writes to Eve, now back in Wierzchovnia, that he is creating an abode for her where she can receive her cousin, the Princess de Ligne, one can recognize his identification with her.

In September 1847, after completing *Cousin Pons*, he departs for the Ukraine. Again he is overcome by the wealth of the vast estate, where he spends four months with Eve. But coming home forces him to face reality once again. No sooner is he in Paris than the king, Louis-Philippe, abdicates and the monarchy is abandoned. Honoré watches the street fights and the ransacking of the Tuileries. Mixing with the rioters who were breaking into the palace, he carries home some decorations and draperies from the throne room, as well as some notebooks of one of the emperor's children.[139]

The following September, Balzac returns once more to Wierzchovnia, this time to stay for a year and a half. He and Eve are finally married on March 14, 1850, and at the end of April they depart for Paris, via Dresden, where he makes still more purchases. Balzac will die of peritonitis just four months after the wedding, but not before adding the true crown jewel of his collection and his most treasured gem to his "jewel box" in the Rue Fortunée: the grandniece of a former queen of France.

Ventures of Passion:
The Vicissitudes of Martin G.

Looking back to the nineteenth-century and earlier, one is bound to find gaps in any inquiry into the trends of collecting and the personal manifestations under certain historical and socioeconomic conditions. Nor do encounters with contemporary collectors contribute many more answers to the tantalizing questions concerning the ultimate incentive: what is it that collectors are seeking? Even the dramatic candor and revelations in primary observation of a collector in action tend to grow hazy and incomplete.

Still, proximity does permit one to examine a collector's endeavors and patterns of behavior more closely. Thus we get an intimation of subjective incentives and objective aims. We see an individual style of expressing interest and enthusiasm, or, say, agitation or impulsiveness, or studious research and thorough knowledge. At times, one can observe a particular collector's approach, which is rather like seeing an almost choreographed passion play—moving from infectious appeal and enticement, through temptation (occasionally raising notions of sin and desire) to the ultimate pleasure in obtaining the treasured object.

We recognize one trait shared by all true collectors—that there is simply no saturation point. There may be a shift in taste, or a change in area of interest and aims. There may be deeper knowledge and enlightenment, or resolutions to call a halt to erratic acquisition or to stop being a victim to impulsiveness or nonrational decision-making. I have often heard self-criticism and seen a tendency of self-censorship among collectors, but none of it contributed to more conclusive insight.

Any devoted collector longs for new supplies not unlike the body needs replenishment or an addict longs for another drink or drug or the compulsive gambler is unable to resist the gaming table or the races. This is far from saying that the motives behind the collector's needs are antisocial or a version of dis-

ease. Rather, that we are concerned with an almost irrepressible passion. This is, as I have said before, the basic condition to all collecting, regardless whether the person prefers the rare and exceptional or the ordinary and mediocre, for the true nature of the drive, the inner pressures, are in some sense irreducible and have nothing to do with any external standards or judgment.

By whatever means a collector goes about his gathering of additions to his possessions—discreetly, prudently, ostentatiously as one can occasionally observe at auctions or pedantically after much research and soul-searching—the objects' grip on their owner can be described and understood only in terms of an emotional experience that appears to demand a more or less perpetual supply. The objects thus represent but a modicum of fulfillment.

This pattern makes it clear why one must think only in terms of a modicum of fulfillment. The basic need for replenishment and good feeling is suspended temporarily by a new discovery or a new addition to one's holdings. The elation over a successful find or acquisition is bound to pass sooner or later. Once the object has been incorporated into the collection and the initial affective sensation, the joy, the pride, the novelty have worn off, the unconscious memory of early longings reemerges in accordance with the mental processes of the return of the repressed. Time and again external reality is being tested, and the characteristic restlessness sets in until another pleasure-giving object has been found.

Martin G. was one of those unrepentant collectors who had occasionally resolved that he would "kick the habit" and no longer succumb to the collecting "bug," not unlike the chain-smoker who tends to vacillate between more reality-oriented ego functioning and the suspension of mature, unambivalent control.

It was only in retrospect that Mr. G. could fathom the role collecting played in his current life. His two senior business partners relied on his acumen and thoroughness. One of them compared him to a resourceful inventor, full of new ideas and penetrating suggestions, while Martin saw himself more as an artist or, almost facetiously, a talented cook. His self-image, he thought, was more correct, since the artist retreats into his studio, essentially to hold a dialogue with himself, while the

kitchen, less separate from the rest of the house, is the domain of the cook.

Several rooms in Martin's home were reserved for his collection together with his extensive library, predominantly devoted to Oriental art and history. Invisible walls separated his living quarters, his office, and his avocation. He was a private man without strong emotional ties. Despite his success he was not at home in business circles, and, even when he was with like-minded collectors and scholars, he seemed to value his privacy and appeared not very approachable. While he worked hard and long hours, often well into the night, he saw his true challenge in his collection. Indeed, he used to refer to himself as "an underdeveloped intellectual," because his ideal self was that of an academic, and not an entrepreneur. In both his business and his collecting, he always aimed for excellence.

Such characteristics are never isolated, and we are right to expect consistency. A pattern is reflected in a person's values, as well as in his aims, interests, and cravings. Martin G. took the trouble to excel in his work and gradually came to rank among the best with his collection.

The interplay between the passion of possession and the emotional support deriving from magically imbued objects is, as we have seen in a variety of examples, a recapitulation of old longings for attachment, which in turn provides a sense of security and a feeling of mastery. And even though the possessions are only external tokens, their significance in the collector's experience represents a salient distinction between the connoisseur and the collector. A connoisseur may cherish or admire an object, but receives little emotional support from its ownership. In other words, there is no affective attachment to the object. Thus, a majolica dish, say, may be an interesting or unusual example to a specialist or an antiquaire. He may admire it as a rare specimen and point out its unusual colors or perfect condition. However, he does not need to own the object and can live without it. The committed collector, on the other hand, cannot. A dealer is used to part with an object, but the collector cannot give it up. Hans Peter Kraus, the late bookdealer, provided a succinct description of this difference: "Once a Kraus book, always a Kraus book," he remarked to me with convincing self-confidence. Thus, to him a sale was no loss, as it would be to the

dedicated collector. The special and often personal effort involved in obtaining anything warranting collection and subsequently disposing of it is not perceived by the dealer as deprivation. In experiential terms, the dealer is the dispenser or supplier of magic objects. While ownership of the article in question may add to the collector's *mana* (in other words, representing a narcissistic supply) the self-assured dealer adds nimbus to the object.

Martin G. usually preferred objects with a provenance, a particular history, with the name of the previous owner or owners and the dealers who had handled the specimens. He was a diligent man, quite in charge of himself, and for complex reasons seemingly too balanced a person to idolize or even animatize objects. "They don't have a soul, do they?" he once remarked. Still, he was inclined to rationalize his preference for objects "with a history" by hinting at some sentiment of distinction and prestige.

It is true that a list of previous owners or of exhibitions in which an object has been shown or of publications in which it has been cited or reproduced sometimes reads like a family tree of a peer, or is on a par with those of racehorses, as Horace Walpole once remarked. To some collectors, it is like a borrowed lineage or genealogy, the more so when some of their objects are treated as evidence of their status or specialness. However, neither Martin nor many of his fellow collectors would willingly accept my argument of a hidden link with such basic affects.

In the years of his focus on things Asiatic, Martin's interest had shifted from Japanese prints and netsukes (those ingeniously conceived buttons in ivory, wood, even stone and metal), to porcelain and paintings, and more recently to early Chinese bronzes. He still held on to many of his earlier acquisitions since he was never quite prepared to part with something he owned. Over the last few years, he had made several major additions in terms of quality, rarity, and provenance by which, he explained, he was paying tribute to the past.

There was a kind of pattern to the course of his interest. He went from marginal and in the beginning extraneous acquisitions to discerning selectivity and competitive procurement. All this is characteristic of most discriminating collectors.

Despite a measure of restraint, Martin G. was an affable man, willing to show me his rooms filled with Oriental objects, leaving the impression of a small, private museum. Since I had scant knowledge of his area of specialization, he drew my attention to some clearly outstanding and to him exciting specimens. He explained many details, especially with regard to the bronzes, pointing out how they had been cast. He made some elucidating comments about the various designs, and how they compared with other examples from the same area and period. There was more than a hint of pride in his descriptions, and, in the case of several remarkable specimens, sheer pleasure of possession.

At this point the objects in one's collection are, strictly speaking, no longer foreign bodies. Instead, there is now a magical link to them for the owner tends to experience his possessions as mute but nevertheless demonstrative expositors of himself. Or, in the case of provenance, he sees himself as the appreciative and worthy successor, if not the heir, to an illustrious predecessor. By attributing elements such as rarity, merit, beauty, or superiority to a jar or a bowl, Martin G. not only conveyed his admiration for early Chinese art and craftsmanship but also betrayed his dedication to and emotional dependence on this craving.

As a rule, showing one's collection is an intrinsic part of a collector's way of self-expression. There are exceptions, such as an acquaintance of mine who will show his latest acquisition but nothing else, or Count Antoine Seilern who would discourage visitors unless they could prove a particular scholarly or aesthetic interest. These are facets of a psychological style of exhibitionism in reverse. Others display some part of their collection as evidence of their taste or foresight, like people who explain that they bought "their" Jackson Pollocks or vintage automobile or tribal art with the courage of their own conviction before museums had provided them credibility. There are, of course, all possible nuances of such performances. But all they establish is an attempt to infer exceptionality.

Few collectors are consciously aware of the inner processes aimed at maintaining, if not fortifying, an ideal self by letting the objects speak for them or, not infrequently, borrowing a particular identity because they help support a narcissistic expansion.

What was Martin G.'s guiding impulse in collecting? The manner in which he explained and commented on many of his objects, and here and there their meaning and history, contained a measure of self-display. He repeatedly stressed their uniqueness, their unblemished condition, and the proof of true craftsmanship. His rather large house abounded in all kinds of Orientalia—Chinese and Japanese paintings and decorative objects, and sculptures from India, Nepal, Cambodia, and Hindu-Buddhist Java. He still kept his collection of netsukes, even though he was no longer adding to it. He liked to reminisce about certain pieces and told here and there a story such as his good fortune in obtaining this or that piece, about obstacles, blunders, and discoveries. Occasionally he had just blind luck, he admitted, all the while watching my reaction to the objects as well as to his various remarks. He then volunteered that he had to curb his desire for high-quality items because they had become too expensive, largely due to the activities of new Japanese collectors. It was hard to say whether the resolution he expressed in this regard was truly meant. If so, he would indeed be an exception among collectors.

A while ago he had received an invitation to the home of a prominent Oriental fellow collector, an elderly gentleman with a predilection for archaic Chinese bronze vessels. In the course of the visit, the man showed Martin a particularly fine wine jar (*ku*) from the Shang dynasty (1766–1122 B.C.). Eventually, Martin could reconstruct the approximate price the man had paid for the jar and, even though it was high, it seemed to Martin a wise purchase on all accounts. Specimens of such quality and elegance are scarce, the older collector explained, and known in only two or three collections. Meanwhile, the man sounded as if he had to defend the acquisition. Dedicated and erudite collectors, being somewhat aware of the underlying nature of affect and the conflicts with respect to their decisions, often feel a need to justify themselves.

After this visit, Martin G. suddenly found himself at a crossroads in his collecting endeavors. He felt that he now had to look for comparable pieces. Having been treated as an equal by a highly respected and knowledgeable senior collector, he had to persuade himself that he was indeed his equal.

Martin readily found justifications for improving his collection, regardless of his previous resolution to stop accumulating more objects. He reminded himself that his success as a businessman had been due to his calmness and equanimity. Yet the other collector's specimens had left him in a state of reverie. Was he envious? Was he resentful? Did the man's outstanding examples mobilize, or rather remobilize, ancient and largely hidden feelings of insufficiency which had to be undone by way of competition?

There could not be any doubt that the true meaning of his reaction went back to far earlier, intrapsychic conflicts which lay at the bottom of this recent experience. While a good part of the desire of possessions is a continuation of early reparative needs, there are now overlays and a fusion with other aims. The older collector's display of such rare and desirable specimens had reactivated early feelings of insufficiency, which had in effect been largely responsible for Martin G.'s dogged perseverance in his business life. In his infatuation with the objects in his collection, he led a separate and almost romantic existence, simultaneous with his day-to-day obligations but in contrast to them, as if part of his critical faculties had been put aside.

I have seen this kind of response in several collectors. It is akin to that of the intoxicated gambler in the casino or the excited buyer carried away by the auction-room fever. Unconscious demands for mastery and possession are fused with a hunting instinct and, to some extent, competitive-aggressive aims. Occasionally, the aggressive provocation may be turned against oneself, for example by outbidding a competitor, often only to enhance one's self-esteem and not for the love of the object. Such individuals may keep on bidding for objects at far higher prices than they would ever have considered if they were under less emotional pressure.

In Martin G.'s case, another collector's admirable possessions had had a mortifying effect against which he felt he had to stand guard. When a better or more desirable object is found in someone else's possession by a collector, complicated emotions arise—admiration, envy, a notion of anxiety, distress, feelings of inferiority or, in extreme cases, rage—no one of which excludes any of the others. There is a logic to such various responses: in-

sofar as these objects are magic-laden they imply that the owner is endowed with greater power than you. This leads to a feeling of potential subjugation and subsequently to a need for reaffirmation by way of symbolic equivalents. And because of their unconscious link with the instinct for self-preservation, such needs must not be frustrated.

J. Paul Getty shared Martin G.'s predicament. His diaries of an "incurably hooked collector" provide abundant proof of this:

> In 1960, I was once again determined to reform.
>
> July 15: I think I should stop buying pictures. I have enough invested in them. I am also stopping my buying of Graeco-Roman marbles and bronzes. I'm through buying French furniture. My mind is set. I am not going to change it.
>
> The best laid schemes . . .
>
> Unfortunately, that was the year that the Snyders-Boeckhurst *The Pantry* and Bonnard's *Woman in the Nude* were made available for sale. Set mind or not, I was unable to resist. The following year, Peter Paul Rubens' breathtakingly luminescent *Diana and Her Nymphs Departing for the Hunt* was offered to me. Again, I couldn't resist . . .
>
> Sorry as I am to make the admission, I am not only an addict. As the foregoing record—and the history of my art collecting activities between 1965 and 1975 prove, when it comes to collecting, I am also a chronic prevaricator.[140]

In Martin G.'s case, the events followed swiftly. Shortly after his visit to the collector of Chinese bronzes, a museum curator mentioned some rumor of a mysteriously important archaeological discovery at an unspecified area on the Chinese mainland. There was a hint of some outstanding Bronze Age discoveries, and a few weeks later there was talk in the art market of bronze vessels and jewelry from the same find.

At first Martin G. did not seriously consider following up on this kind of hearsay information, especially with so few facts and details to hand. Intimations of new discoveries have been tempting collectors for many centuries. Old graves and extensive burial sites have attracted plunderers at least since Roman times. The remains of old settlements or tombs have furnished some of the most exquisite examples of ancient art and crafts-

manship. However, the vast majority of rumors about such finds usually come to nothing. And yet, regardless of his doubts, the story he had heard had indeed fueled Martin's imagination. To ease his incredulity, he spent several nights at home weighing the pros and cons in his own mind.

Even if the rumor actually turned out to be true, did he need to improve on his current holdings? That was about the first question he asked himself. But he was also quite aware of his ambivalence. And then: could he afford to acquire another group of significant objects? However, one or even a few choice objects from the find would unquestionably enhance the prominence of his collection as a whole. Moreover, the expense involved would be justified because the value of the objects was bound to increase, he reasoned with himself.

This is the kind of self-searching uncertainty that accompanies many a collector's attitude. Martin G. argued back and forth with himself as if he were pleading his case before a jury. The actual issue is the conflict between an inner demon and the pangs of conscience.

Martin was not blind to his own bias. We must keep in mind that the entire course of his thinking and his current turmoil derived from a comparison of his own collection with that of another older collector. Seeing and admiring somebody else's possessions may arouse competitive and at the same time admiring feelings which do not necessarily exclude frustration, if not despondency. Under the circumstances, the older man's impressive objects reawakened in Martin early doubts and a sense of inadequacy. Now, he argued with himself, he had to come to a decision: he could either succumb to this irritating deeper and not entirely conscious sense of inferiority, or he could act and live out his competitive fantasies.

It was in view of these acute mixed emotions that Martin finally decided to investigate the rumor. He followed a habitual practice of inner accountancy of debits and credits by which he tried to overcome his momentary predicament. This marked the beginning of what turned out to be a long and quite extraordinary odyssey. It was a solitary and nearly cloak-and-dagger undertaking in which the stakes in emotion, time, and effort were considerable. However, insofar as he was now being driven to find reaffirmation, he took up the challenge.

His first stop was Hong Kong, since he was traveling there for business negotiations anyway. He had many important commercial contacts in that curious outpost and knew several local art dealers as well as middlemen. He also was reasonably sure that if there was any truth to the fact of the recent discoveries, the quite reliable bush telegraph would have some more conclusive information. Although there were no clandestine excavations in the Republic of China, as there were elsewhere in Southeast Asia and Latin America, it was always possible that a few select objects might have made their way from the mainland into the Crown Colony. In practice, he thought, the ties of old family connections and obligations were still strong, despite the teachings and philosophy of Mao.[141]

Within a few hours of his arrival, he was in touch with a number of different people he believed might be able to help him. He dispatched a go-between to a runner from whom he had bought a few fine objects on a previous visit, and he had spoken to a well-established and reliable local dealer in Oriental art whose erudition and extensive experience was beyond question. He had also contacted a certain Mr. Lee, an enigmatic sort of middleman but an inexhaustible source of local information, sometimes reliable and sometimes not.

It was this man who invited him to one of those obligatory meals that many Chinese prefer as a prelude to significant negotiations of any kind. Martin took it as a good omen and accepted. Having known the man for several years, he believed that he could distinguish between his persiflage and his factual and often worthwhile information. Or so he told himself.

Dinner lasted well into the night. The two men discussed Martin's collection as well as other collections in Hong Kong, in Europe and the United Kingdom, and in the United States. They spoke of travels, visitors, and political issues. Finally, and as it seemed almost casually, the rumors about the recent excavations came up in their conversation.

Now Mr. Lee became politely effusive, and Martin G. was quick to note that Mr. Lee's replies to many of the probing questions were somewhat evasive and contained few, if any, hard facts. Nevertheless, Mr. Lee's attempt to sidestep certain inquiries told Martin more than some of the direct answers he received. There was one piece of information that Mr. Lee did

provide, and that was the news that a certain Professor Y., a distinguished Orientalist, and the very man Martin intended to consult on the matter, had also arrived in Hong Kong.

What we have to this point is the buildup of Martin G.'s involvement in the chase after the newly discovered objects, the anxiety-arousing deliberation, and the first and ever-so-slight anticipation that his quest might be successful.

The next morning, he tried to get in touch with the professor but the man had left his hotel at an early hour, and Martin was told that he would not be expected until the late afternoon. He now felt at loose ends. Looking for clues to where Professor Y. might be, all of a sudden Martin felt confused and even anxious. The suggestion of the alleged new finds was too powerful to remain secret. While he was about to contact another dealer, the telephone operator in his hotel gave him a message from Mr. Lee, who wanted to see him at his earliest convenience.

When Mr. Lee arrived a few hours later, he produced some snapshots of a few objects which he said were from the new excavation, adding that they were due in Hong Kong shortly. Even though the photographs were by no means of professional quality, the objects reproduced looked very promising. However, as Martin G., along with most collectors, knew, judging the quality and importance of objects from simple photographs is risky at best. One of the photographs showed a *fang yi*, bronze urn, of apparently unusual shape and intricate designs, but hard to decipher. Still, there was enough indication of fine workmanship. Martin was instantly reminded of several specimens in collections in Scandinavia, in Taiwan, and in the United States.

Nevertheless, now that he had seen the snapshots, he was really suspended between doubt and excitement. If the objects turned out to be genuine, he thought, he might spend his last penny on them, since it would be the opportunity of a lifetime. On the other hand, a mistake would not only be costly, but, even worse, could seriously embarrass him, because there are no secrets in the small world of collectors.

Would there be any chance to consult with experts such as Professor Y. before he made a commitment? His initial enthusiasm became tempered with some sobering thought. Would he be able to obtain a few small metal samples for spectroscopic and possibly thermoluminescent tests? And even though Martin

was convinced of Mr. Lee's reliability, the man's expertise was hardly the last word in this field. More than once he had sold a motley group of genuine and forged objects—not with malice but simply out of ignorance. These were some of the questions that ran through Martin G.'s mind.

Mr. Lee added that these objects had been discovered in Hunan Province on what had been an ancient temple site. His informants had told him that some of these bronzes had changed hands before government representatives had arrived on the scene, and official archaeologists had taken over. The few examples that had found their way out would soon be arriving in Hong Kong.

A perplexing tale indeed, Martin thought. But it was not atypical in cases of clandestine origin, and not only in the Far East. Martin's resolve not to acquire any more objects—a promise to himself that he was incapable of keeping—was only a matter of time, as almost all collectors are aware. Self-restraint is not common among dedicated collectors, as J. Paul Getty made quite explicit. However, few collectors are aware of their unconscious motivations, and even temporary abstinence, is usually more than they can bear. Martin's temporary curtailment of further acquisitions became almost unendurable once he began to see certain gaps in his own collection, especially in the light of another one.

The incidental details in such cases may vary considerably. All sorts of circumstances and events can trigger feelings of envy, inadequacy, or self-doubt in a collector. What counts here is that Martin G. could not remain indifferent, essentially because the recent experience had rekindled old conflicts and anxieties. Almost before he had any conscious awareness, he was once again enmeshed in an internal crisis that echoed earlier times in his life.

There is a mysterious lure in such states of diffuse anxious expectation. It is rooted in an emotional and surely eroticized force, outside of one's rational control. There is an element of winning or losing, getting or yielding. It is an inner plight collectors as well as gamblers experience repeatedly, and in some instance even ritualistically. At this particular moment, Martin G. was unable to get himself out of this predicament. He

changed his travel plans and decided to stay on for a few more days, if only to gather more information.

One hears occasionally about a sixth sense in the determined, inveterate collector. There are those who pride themselves on never having come back from a journey, even a casual one, without one or the other discovery. "Serendipity leads collectors into the mysterious extra-sensory world where telepathy, clairvoyance, and premonition are commonplace," Wilmarth Lewis, known among his friends as "Lefty," related from his own experience in discovering all possible documents by and about Horace Walpole (now in the Yale University Library). "Making all allowances for the collector's tendency to dress up his discoveries and to forget the times when these occult impulses led to nothing, there remains a good deal that cannot be accounted for by the five senses," he observed.[142]

Indeed, Martin G. himself had been lucky on a few occasions. Once, he found a very fine Sung celadon bowl with sensitive flower designs in a secondhand store in a small town in Holland. Another time he walked into a bric-à-brac shop where the shopkeeper had shown him a drawer full of old tiles. "Middle East," he mumbled. But Martin knew better. He bought the whole lot, which he immediately recognized to be rare and delicate terracotta tiles depicting scenes with men and animals, from about the first century of the Han period (206 B.C. to A.D. 221).

Martin G. was not an amateur. He kept up to date on the pertinent literature and most of the major museum collections. Over the previous few years, he had bought with care and increasing knowledge. He liked to explain his infatuation as a kind of guardianship. This is a spurious rationalization one hears now and then from certain collectors whose obsessional motives seem to require an apparently acceptable explanation. Martin G., like many collectors (particularly, it seems, of antiquities and medieval and tribal works of art), tried to reinforce his dedication with a rather partisan a priori picture of himself as only a temporary safe-keeper of the objects in his collection. This is a transparent attempt to camouflage the emotional commitment anyone makes to collecting, and the deeper links that account for the habit.

147

Early bronzes had a special emotional claim on Martin. He had studied the differences in form, types of the often compelling variations of iconographic details, and their chronological development. In fact he had once bought a much admired *ting*, an archaic food vessel, from Mr. Lee. It was one of the most outstanding examples of the middle Shang period (about the fifteenth century B.C.)—an object of rare elegance and precision. Now, while talking to Mr. Lee, he could not forget how well this piece had held up. It had been shown in several exhibitions and reproduced in a major publication. The photographs Mr. Lee had just shown him, poor though they were, promised some extraordinary objects, better than anything in the Royal collection in Stockholm, in the Freer Gallery in Washington, or anywhere outside of China, for that matter or perhaps not even there . . .

Several days after this overture by Mr. Lee, when nothing more had been heard from him, Martin got restless. Few collectors have the ability to wait patiently once an object they truly cherish is near at hand. Waiting usually tempers hopes and expectations, and the tension of suspense is hard to bear. This is in line with childhood anxieties, such as the dread of being left alone and unprotected, which require instant gratification. The impatience of many collectors is usually due to those unresolved childhood frustrations. Martin's restlessness was also kindled by a lingering suspicion that he might be the victim of a hoax. Nevertheless, he decided not to return to the States, for the moment. "I couldn't help myself," he confessed, revealing a sense of ineffectualness, the exact opposite of what he had hoped to achieve, almost with the aid of those magical new objects.

These emotional fluctuations are germane to collectors like Martin G. Very often, it is the actual obtaining of the sought-after object that counterbalances the inner and ever-present dread of running out of tangible support. Only a message from Mr. Lee was necessary to put Martin in a different mood. On the telephone, the dealer mentioned some more photographs and also murmured something about a few sketches of newly found specimens. A few hours later they met once more, and the sketches were produced. They proved to be rough but readable, and seemed to support the likelihood of a most unusual find.

148

True, Martin quickly spotted certain stylistic variations from well-known pieces of the same type, but this did not suggest that the new discoveries were copies or forgeries. Rather, to the contrary, since Martin knew that forgers usually follow the rules, preferring to stick to fine examples of a particular type of object and eschewing variations that may inadvertently reveal the fake.

There were only two possibilities, Martin told himself: either he was being tested by accomplished and unscrupulous frauds, or he was very close to the source of a major discovery. A tantalizing sense of excitement was by this time overriding his earlier doubts—a distinctive trait that marks the obsessional collector.

At this very moment, a prominent international dealer suddenly arrived in Hong Kong. This was the same dealer who had supplied Martin's collector friend with some of his most important bronzes. Could this man have heard about the excavations? The dealer would hardly waste his time in Hong Kong, Martin reasoned, if there were any question as to the authenticity of the find. And then there was Professor Y.'s presence. Martin still had not got hold of him. In one respect this was reassuring, but at the same time the arrival of a potential competitor hit him like a physical blow. In the midst of what he felt to be confusion and menace, it never occurred to him that these men were collaborating. This dawned on him only much later.

.

Martin G.'s association with the Far East was not coincidental, nor was it entirely romantic. His first encounter with the Orient came when, as a young college professor, he had received a postgraduate fellowship in economics. One of his publications drew the attention of an industrial firm, which offered him a position far more alluring than any he could then find in academia. It was the beginning of a rewarding career that involved frequent travels in the Far East and in Southeast Asia. Industrious and efficient, he was so successful that he eventually accepted an even more challenging position. He explained the strong appeal of Oriental art as a welcome relief from the rigors and responsibilities of his work. At the end of the day, he felt the need for aesthetic and spiritual relief.

Martin G. had been born during the interval between the two world wars to a socially and economically well-situated family. His brother, four years his senior, was a sports fan with little inclination for learning and education. He later became the manager of a local department store, much to their ambitious mother's dismay. Because he was a better student, Martin regarded himself as being better than his brother. The brother and a couple of his classmates used to tease Martin, calling him a sissy and a mama's boy. He remembered two dramatic clashes in which his father had taken his brother's side, and he had retreated to another room to be comforted by his mother.

The mother was an amateur painter whose work had been shown in several local church benefit exhibitions. Martin had always thought that her still-life paintings inspired his early love for flowers and butterflies. As a child he had made a collection of pressed flowers as a Christmas gift for his mother. When asked what he wanted to be, his usual reply was a gardener or botanist, largely because this had his mother's approval, but also because it set him apart from his unimaginative brother.

Everything changed at the time of World War II, when Martin's father joined the armed forces. Unlike his brother, Martin did well in school; also unlike his brother, he had few friends. He was something of a loner. He was twelve when the family learned that his father had been lost on a mission in Southeast Asia. The consequences were critical in more ways than one. Because his father had been away for more than a year, it took a while for the full impact of his death to hit Martin. His mother's behavior changed immediately and perceptibly. She became moody and, at times, impulsive. Their financial condition deteriorated. The brother helped by leaving school and getting a job as a plumber's assistant. When the war was over, Martin earned a college scholarship and determined to pursue a career in economics.

He married a college classmate shortly after accepting a promising position in the business world. His wife had a natural assertiveness and sociability, and she responded instinctively to his newfound appreciation of Far Eastern art and culture. They combined a somewhat belated honeymoon with a business trip to Taiwan and Japan, and there they acquired various decora-

tive items for their new home. A few months after their return, his wife was injured in a tragic car accident that confined her to a wheelchair for the rest of her life. She asked Martin for a divorce, but he refused.

Thus, the beginning of their marriage coincided with Martin's early years of serious collecting. He sometimes referred to this as a time of preparation, of "going to school again." So far, his enjoyment of Oriental art had nothing of the intoxication he eventually found irresistible. Together, he and his wife visited museums, made the acquaintance of other collectors as well as some scholars, and improved their knowledge through diligent reading. All this infused a kind of tenderness and pathetic sensitivity into their relationship. Even so, Martin could hardly hide his sexual frustration.

It was about this time that he heard of the death of an eminent scholar-collector who had owned some rare bronzes. He inquired as to the fate of these objects and learned that the executors were organizing a sale by public auction. This seemed to intensify his interest and, after thinking it over, he later concluded that this is when his true collecting instinct emerged. He found himself with a burning desire to obtain some art works of established merit and provenance. The distinction of the objects in the sale was beyond question. He and his wife discussed how to proceed, and began to pay attention to the rumors and gossip that are quite common in the small community of specialized collectors and experts in any field.

Various strains were at work here. Martin's early interest in aesthetics had been stimulated by seeing his mother paint, he thought. Also, and probably more importantly, he wanted to underline a greater closeness to her, thereby stressing his being different from his stronger older brother, who used to bully him. His business acumen and skill were yet another triumph, insofar as he had superseded both his brother and his dead father in this regard. In this context it was not without relevance that he had achieved his successes in the same geographic area where his father had lost his life, a fact of which he had been only dimly aware before our conversations. In addition, as his attachment to his wife turned from love to companionship, he found himself spending more and more of his time and atten-

151

tion on Far Eastern art and artifacts. Now the death of this re-
spected collector and the disposal of his belongings marked a
turning point in Martin's life.

There can be no argument about one's appreciation of a mas-
terpiece. However, when a collector puts greater emphasis on a
name or a pedigree than on the object itself, this involves other
indicative factors. It separates the object from its initial meaning
and underlines different hierarchies. Thus, when an object gains
in significance or value simply because of its history such as its
pedigree or other propensities, it sheds light on deeper needs of
the owner (namely, needs for reassurance such as those felt by
primitive man when ancestral skulls and bones provide magic
support).

In Martin G.'s case, it was not the pedigree of the late collec-
tor's bronzes that drew his attention. Rather, it was the fact that
here were some outstanding examples the likes of which could
not easily be obtained. For Martin the circumstances were some-
what different. He was in a conflict brought on by his wife's
nearly total physical dependence. He was in need of new incen-
tives. In the beginning, under the impact of the accident, select-
ing objects and collecting had helped eliminate (or so he saw it)
the straits on their relationship and given them new, construc-
tive ideals. It was a quite conscious means of coping with their
frustration. Collecting soon became a dominant feature of their
lives, and, as far as Martin was concerned, quickly developed
from a pastime to a tantalizing passion.

The convergence of the death of the prominent collector and
the condition of Martin's marriage owing to his wife's physical
state seemed to sanction Martin's reenforced dedication. He re-
called the time of his father's death, remembering that, initially,
he had felt almost numb about it and could only empathize with
his mother's grief. It was her bereavement that gave the event a
pathetic poignancy. How could he help? But also, were there
grounds for self-pity? He had a vague comprehension of a sym-
bolic equation between his father's death in the Orient, his
mother's emotional withdrawal, and his awareness that he had
little to lean on. It was at this time that he found himself prey to
uncertainty and, simultaneously, resolved to find protection
from further harm and "to make good."

These are only fragments from a complex life-history. What is relevant here are the echoes of stress and lingering anxiety which made discharge of tension imperative. Martin did not intend to find this relief through further and more significant acquisitions. However, under such circumstances, one's affects tend to fluctuate, and behavior can easily be overruled by unconscious needs for triumph, canceling out notions of uncertainty and disorientation.

At the time of these events Martin was still a young man, in view of his achievements and standing in business. The collector who had just died was considerably older than Martin, and he too had had a notable career in industry. As a result, Martin felt a certain bond, and he now mourned the sincerely admired older man. In a deeper sense, he had represented the father whose absence Martin had begun to miss during the later years of his adolescence.

Now Martin considered to bid on one or even more of the objects, thinking of them as signs of a posthumous bond, not being aware that his feelings about these objects contained some residue of the cult of holy relics or that this was analogous to animistic beliefs in transmigration of power, even *mana* (which, as I have shown before, govern preliterate peoples' concern with ancestral bones). Here Martin inadvertently followed their example and joined those collectors who, due to underlying conflicts, look for an *imprimatur* which, in essence, guarantees approval and consent. One may assume that such habits reveal remnants of old, unconscious ambivalence and primitive aggressive wishes in well-rationalized disguise.

Let me pursue this point a bit further. Concern with provenance and pedigree of collected objects is understandable as well as historically valid. But this does not mean that such inclinations do not rest on magic thinking and irrational emotions. The same holds true for a preference for unblemished or perfect objects, like a mint-condition coin or an uncut first edition of a desirable book.

However, when preference becomes obsessional insistence, and perfection or previous ownership replaces all other considerations, we are looking at several phenomena: the obsession with perfection may be connected with irrational fears or be a

153

manifestation of hostile-destructive defenses, or it may cushion an unconscious fear of one's own imperfections. Or take the example of the pedigree. Previous ownership, as Walter Benjamin recognized, provides the owner with an identificatory solidarity with the past as if the previous owner's or owners' magic had been incorporated in the object.

As I have discussed earlier, objects imbued with such irrational attributes serve essentially the same purpose as the head of St. Mark or the toe of St. Anthony or a piece of the Holy prepuce or a nail of the Holy Cross. They are essentially meant to put the collector's uneasiness about his appetites to rest.

.

These events occurred more than a decade before Martin G. came to Hong Kong. He had acquired some outstanding specimens which had belonged to his much-admired deceased collector-friend. Meanwhile, with diligence, fine taste, and substantial knowledge he had built a remarkable collection and achieved a position of esteem among the cognoscenti in his field. He had become a generous lender to exhibitions, and his house was open to scholars and students with whom he liked to exchange views about their shared interest. Yes, he was flattered when he was complimented, or his name appeared in scholarly publications. Recognition and acclaim infuse a renewed belief in one's special qualities and can enhance anyone's self-image, especially that of a devoted collector. I have yet to meet a collector without a measure of guilt, conscious or unconscious, about his "frivolities," as one man put it.

Martin G.'s Hong Kong sojourn was actually part of a business routine, this time worked out and scheduled as a result of rumors about the recent exciting discoveries in mainland China. Martin used to insist on separating his business activities from his collecting. But this is not to say that they were watertight compartments. Indeed a Hong Kong banker with whom he had quite frequent dealings, was an equally devoted collector (in his case, of fine examples of Chinese calligraphy).

At this time, Martin G. was surprised to find how absorbed he had become in this particular treasure hunt. His tension during his dealings with Mr. Lee reminded him of a child on Christmas Eve. He met Mr. Lee again, this time at the dealer's apartment.

When he arrived, a man-servant showed him into an almost empty room, sparsely furnished with a table, a few chairs, and a couple of standing lamps. For a short while he sat there alone, not knowing what to expect. At one point he thought he heard voices in another room, but it was the puzzling silence that primarily added to his tension. Then Mr. Lee appeared, poised and seemingly portentous. The shipment, he said somewhat defensively, had arrived. And then, with a vexing kind of hesitation, he added that, unfortunately, what he had received was not the objects shown in the photographs. Those were promised at a later date. He could not apologize enough, he said, with genuine regret.

Martin felt an impotent rage. Could he believe the man? Was he being sincere? Although there was no evidence of betrayal or falsehood, Martin was exasperated, almost ready to jettison the entire venture which, he felt, had now got out of hand. At the moment, the obvious possibility of a conspiracy crossed his mind. After all, craftiness and foul play have been known for millennia in the world of art and antiquities.[143] The mere fact of the collector's obsessional need gives the ingenious dealer a kind of shamanistic power as provider of magical supply.

Without being able to articulate the various elements of his predicament, Martin saw himself in a labyrinth between yearning and common sense. For the sake of some old Chinese pots and pans, he had allowed himself to be maneuvered into a position of gullibility and uncritical trust. He was even more confused when Mr. Lee explained that he now had to take him to another place, a grocery store in Kowloon, where a few of the objects could be seen.

It is worth recalling for a moment the onset of this venture. Martin had seen some outstanding and alluring bronze containers in a well-known private collection. He had learned of the discovery of similar or even superior vessels. He experienced frustration, even a measure of anger, which in turn gave way to feelings of self-doubt and inferiority, a personal shortcoming that he felt compelled to correct. Was his inadequacy now proven by this blunder? he might have asked himself (if he had been fully aware of the melee within him). Gradually, and quite innocently, he had slipped into a passive-masochistic impasse that threatened to drown his usual commonsense perspective.

155

Torn between his still-not-abandoned hope of owning an un-
questioned masterpiece, and the self-condemnation that was
part of his dilemma, he was only half aware of his wish to excel
by obtaining such treasures for his collection.

Mr. Lee was no Pied Piper. It was Martin's own monomania
that at this juncture made him follow Mr. Lee to Kowloon, on
the other side of Hong Kong Harbor. It was a typically dark,
sweet-smelling grocery store in one of the city's innumerable
mazelike alleys. Here they were greeted by the shopkeeper, who
first addressed Mr. Lee in Chinese and then made a few polite
remarks to Martin in halting English. Another man appeared
from the back of the store, and the conversation continued in
Chinese. The whole scenario, Martin felt, was like a conclave
from which he had been excluded. They all then proceeded to a
dimly lit storage room, filled with bags and baskets. One of the
men removed a large basket, lifted another out of the way, and
brought out a tea chest. While the grocer removed a few layers
of cottony paper from whatever it was covering, the Chinese pa-
laver continued. The setting was reminiscent of a ritual dis-
robement, Martin thought. The unwrapping of the bundle, he
said later, had the air of a secret-society ritual. Since he knew
that he was not going to see the objects in the original photo-
graphs, the response was not overwhelming. However, on ob-
serving Mr. Lee's evident captivation with what was going on,
his spirits rose once again. The dealer had not deceived him, he
told himself. If there had been any deception, they both had
been duped.

The entire experience was the more mystifying to Martin G.,
because he felt like a young child again who cannot follow the
talk among grown-ups and does not quite understand their ges-
tures and actions. However, he still retained enough of his com-
posure and objectivity to be able to describe later on all the de-
tails of what had gone on in those few frenetic moments. He
kept trying to remind himself that in the end it was all just a
fascinating game. Then he began to see himself as a coward in-
volved in a dubious transaction, quite contrary to his customary
business ethics. In the peculiar atmosphere of secrecy, intrigue,
and restiveness in the room, he tended to confuse the roles and
forgot whose game it was. He had always considered himself
rational, level-headed, and astute. Now, he felt green, blunder-

ing, and overwhelmed by a nagging sense of bewilderment, "as if there were no way out," to recall an oft-quoted Chinese phrase.

What strikes the listener in Martin G.'s account is his perseverance and indomitable determination, which seems more like that of an obdurate child than of an adult business executive. What had led him to this dubious undertaking? Had his overwhelming desire to own objects better than those of his fellow collectors threatened his self-image? Or should one see his behavior within the frame of his life experience and a new search for some serious purpose after the tragedy that had affected his marriage? All of a sudden he found himself in the midst of, and essentially in collusion with, smugglers and tomb-robbers.

The grocer handed Mr. Lee two small objects, which had to be taken to the light in order to be clearly seen and examined. Now Martin got a glimpse of what appeared to be a pair of superbly cast *tai kou*, the Chinese name for buckles or dress hooks, with delicate gold inlays. They were doubtless of an early, and probably archaic period—if they were authentic, Martin thought. He found himself trembling. He could feel his heart pounding in tremors of triumph. Holding the hooks in his hand, he almost physically felt his doubts and misgivings vanish. His uneasiness gave way to a new moral and emotional lift. Had he really made the "once in a lifetime" discovery, the evidence of magic that every true collector dreams of? While all these thoughts were racing through his mind, he realized that he had almost forgotten even to examine the *fang yi* or *p'an* (water vessel) he had been looking forward to seeing.

The buckles were "dazzling," to use Martin's own word. He saw evidence of rare skill in the masterful casting of what under his magnifying glass appeared to be fantastic animals, possibly dragons or birdmen. He traced the peculiar arrangement of interlaced foliage and geometric decorations entwined with figures he could not decipher at the moment. Iconographically, the two pieces seemed related to early Eastern Zhou (seventh to sixth centuries B.C.) designs. The exquisite patina would eventually provide proof under radiographic examination, he thought immediately. As he closely checked the objects he stopped suddenly and looked up, startled. Anyone watching him would probably have described his handling of the pieces

more like fondling, since he had been so carried away by his enthusiasm. However, he had suddenly recalled something he had learned years ago—that fine copies had been made, and patinas forged during the Sung era (tenth to thirteenth centuries A.D.).[144] Could the hooks actually be early forgeries?

Trying to hide his confusion, he gestured to Mr. Lee that it was time to terminate the visit. He must have been quite guarded in his demeanor, since Mr. Lee at that point had no notion of what Martin thought or felt about the objects. No one had mentioned a price nor was there any reference to a place of origin. There was no discussion as to evidence of ownership, let alone of authenticity, although such issues were surely not of the grocer's concern. Did he wish to consider the *tai kou*? Mr. Lee asked.

A quick appraisal of the situation told Martin that this was no time for long deliberation, let alone for later consultation with Professor Y. Moreover, what did the professor know about these particular finds? An old sensation recurred, an awareness of many collectors. He felt embarrassed. He would not dare offend Mr. Lee. The man had given him an exceptional opportunity. He would never offer him another object if he showed ingratitude by turning down this chance. He now felt like a best-loved child, a sentiment unmistakably revealing much of the psychological condition of the collector.

Martin remembered that several years before he had acquired an early Chinese bronze from a European antiquaire. After a few weeks he had changed his mind and asked to return it. When he handed the well-wrapped piece to the dealer's secretary, she did not even open the package. All she did was hand him an envelope with a check for the returned object. While Martin had been received on this occasion with impeccable courtesy, he was never again to be shown an object of more than average quality by that particular dealer. Or, at another time, a dealer had shown him a fine bowl which he liked but wanted to think about. He asked the man whether he could reserve it for a week, and the dealer agreed. When Martin returned a few days later in order to finalize the purchase, he was told by a salesman that there had been a misunderstanding. The bowl had previously been offered to another collector who had now decided to obtain it. Martin never set foot again in the gallery.

Looking at such vignettes as a whole, one is soon aware that the relationship between collector and dealer is different from any customary buyer-seller contact because of an apparently more complex interplay, largely due to the intrinsic power that accrues to the dispenser of magic provisions. This predicament is one of the most potent assets of the successful dealer, whose role is often closely akin to that of physician, priest, or shaman.

For the moment, the only reply Martin allowed himself was that he would prefer to examine the hooks in the more comfortable and relaxed surroundings of Mr. Lee's premises. They left the dingy back room of the grocery store and went out to the alley. To Martin it had been a magic place where a dream had come true. It took him a few moments to regain his composure. In retrospect, he understood that he had been disconcerted partly because of the fact that the objects that had been offered were to him unfamiliar ones. From the snapshots that had been shown, he had formed a mental picture of what he was going to see and possibly acquire. Dedicated collectors delight in anticipating objects that they might be able to obtain. In his own mind, Martin had already rearranged one of his display cases in which he would show his new vessel or vessels. One of the photographs shown to him had been that of a *fang yi*, or bronze urn, reminiscent of one of the very finest examples in a famous European collection.

Now he felt obliged to make an immediate decision about the *tai kou*. All he knew was that he had either seen two very special variants of a well-known type of artifact, or two very clever pastiches, or possibly copies, made hundreds of years ago, probably during the Sung period. Thus, they would only be some eight hundred years old, and did not go back nearly two or three millennia. Wherever Martin looked, there emerged a series of arguments pro and con. It was as if he were conversing with an invisible alter ego.

I have encountered these silent soliloquies with surprising frequency among those collectors who have little capacity to resist temptation—a struggle in which it seems that an inner counterpart to one's self instinctively recognizes the menace entailed in an ungovernable desire. We saw it earlier in the case of Paul and his secret language with his toy dogs. There is also the report of Cardinal Mazarin's well-known "conversation" with his

159

paintings shortly before his death.[145] These monologues articulate the collector's powerful emotional commitment by implying that the *object* is in some respects *subject*.

We see the same seemingly extraneous force in Martin G.'s reaction to the buckles. There is both need and anxiety. On the one hand, he desperately wants the two hooks for the satisfaction of owning them and the curious pleasure of having found and almost discovered them in the underground market. On the other hand, he is also perturbed because, first, he may be buying fakes—even eight-hundred-year-old fakes—and, second, he might lose these rare specimens to another collector if he hesitates too long to make up his mind about them. How is he to decide what course to follow? Recognizing his uncertainty, he became angry with himself because he began to understand his bewilderment as a refusal of responsibility.

Mr. Lee may have sensed something of this conflict. When they arrived at his home, Martin was ushered into a room that served as a photographic studio. Here Mr. Lee put first one and then the other part of the buckle under a strong magnifying glass. He squinted in satisfaction at what he saw, and invited Martin to take a look himself. When he noticed Mr. Lee's apparently genuine expression of delight, his own doubts vanished. He felt transformed, as if released from an almost physical pressure.

Luxuriating in his refound self-confidence, he embarked on a new course in his thinking. The *tai kou* were unquestionably genuine. He was ready for bigger game now that his uncertainty had disappeared. Was he determined to court another bout of anxiety? Did the strain itself have an irresistible attraction? Was he ready for another masochistic exposure? Martin would not have admitted then that this was like a need for self-punishment. Nevertheless, he acknowledged later, at the time of our encounter, that once he had felt the relief, he was ready to face still more stress. "I didn't want to leave one stone unturned," since he had already gone that far, he implied.

The following morning, he suggested to Mr. Lee that they both might have been led astray, and that the superior objects from the find might already have been bought by the important dealer who was also in Hong Kong, or even by Professor Y., acting on behalf of an anonymous buyer. Still hesitant, Martin

telephoned the hotel where the professor was staying, only to hear that he was on his way to the airport. Immediately his doubts returned. Why couldn't he reach him? And the professor's inaccessibility became another stumbling block.

Thereupon he decided to telephone another of his acquaintances, a well-known dealer in Taipei. In guarded language he hinted at the reason for his extended stay in Hong Kong. He was clear-minded enough to realize that in the small world of Oriental art the whereabouts 'of a leading authority such as Professor Y. could be traced very quickly. The dealer could tell him nothing other than the name of the university where the man was expected to arrive at any moment. However, he volunteered that he also had heard of the unusual pieces recently brought out of mainland China.

Being so close to what seemed to be a rich strike had not simply increased the intensity of Martin G.'s passion. It also seemed to have brought out an inordinate yearning for more possessions as if he had been looking, though not consciously, for more irrational anxieties.

Mr. Lee remained confident about the *tai kou* and in his modest way persuaded Martin to finalize the purchase. And Martin, now in a state of competitive elation, admitted that no other acquisition had brought out so many facets of unexplained and unexpected emotions.

It was only months later that he understood the concurrence between the state of his homelife and the self-balancing effort of his Hong Kong venture. He recognized that the presence or departure of the professor gave, or did not give, a sophisticated business executive a plausible rationale for chasing after some rare and to him magical objects. Whatever he inferred from Professor Y.'s expertise was due to his readiness both to believe and to be deceived. He was used to having his reliance on people betrayed—if not by them, then by events. His father had been absent, and even before his death he had sided with Martin's brother. His mother was, in effect, absent once they were informed about his father's death. And Martin had prematurely lost any fulfilling intimacy with his young wife.

He began to understand that his all-absorbing involvement with finding and collecting rare works of art was hardly less than a flight to escape from repeated disillusion. It was his

answer to an urgent need for replenishment, if not an essential guaranty of life and continuation. It is evident how and why Martin G. was compelled to collect by a deep and turbulent hunger for retrieval and healing with the aid of tangible things as a protective shield against disillusionment.

The actual course of events following the Hong Kong episode makes no difference with respect to the motivating factors. It should only be a reminder that, inevitably, the collected objects remain just that—objects. They may elicit feelings, but they have no life. And so it is the search—successful or not—that ever promises hope, suspense, excitement, and even danger. The quest is never-ending. It is, as one can see time and again, bound to repeat itself, while the ultimate pleasure always remains a mirage.

PART FOUR
EXCURSIONS INTO HISTORY

*

Renaissance and Reconnaissance

IN OUR SEARCH for the roots of the collecting habit, we have focused on individual experience and have seen the need for attachment and clinging to objects as a primary incentive for the accumulation of tangible possessions. For the individual collector this concentration on objects can become a way of life, as I tried to show in the three profiles sketched in the previous chapters.

But while the fundamental motive is based on the individual's history and essential events, the type and style of selecting and collecting is effectively guided by the prevailing culture pattern, the mood and values of the time. Indeed, many collections in all their diversities are a visible testimony to the substance and standards of the particular era, even though the sentiment of one generation may not simply fade away during the next.

Take the case of Cosimo de Medici III (1642–1723), an eighteenth-century zealot. He had a special yearning for holy relics, which was a throwback to medieval times. From this point of view, he can be taken as an example how certain earlier traditions and beliefs (in his case, in religious benefits) filtered into the so-called Age of Enlightenment. Collecting holy relics at this time had in effect anachronistic overtones. Inconsistencies such as this example put into question any attempts to make strict delineations and compartmentalization into exact phases or periods.

Any student of history will agree how misleading it can be to draw historical demarcation lines. While there are always prevalent trends[146]—political, intellectual, social, cultural—it would be naive to think of the Dark Ages or the Middle Ages or the Renaissance as definable periods of sophistication with demonstrable differences, be it from a technological, ideological, aesthetic, or economic point of view. The appellations we devise are in fact little more than attempts to set apart dominant features and states of progression and change.

The dynamic nature of sociocultural development and corresponding technological advances do not entirely justify the historian's attempt to set up more or less circumscribed chronological phases. We use these historical divisions for our own benefit, just as we attempt to divide child development into dominant, organ-specific stages. But we are quite able to see that, for example, oral or anal or phallic elements help constitute character traits in the adult personality, in the same way as medieval ideologies can still be found today, even in a highly rationally functioning and industrially focused society.

What counts are crucial events: catastrophes such as wars or epidemics. Take the Black Death during the middle of the fourteenth century, which generated new outlooks, changed intellectual trends, caused shifts in priorities. Nor can different tastes and interests rely on uniform acceptance. It is mainly for that reason that I cite Cosimo as an example of a person who lived with one foot in one era and with the other in a different one.

Or take another case: More than two centuries before the time of King Louis XI (1423–1483), Aristotle's philosophy was introduced at the relatively new University of Paris. Aristotelianism, the credo of reason and the basic principle of knowledge, was fundamental to rational study and the exploration of logic. However, since it was essentially atheistical and thus implicitly a threat to Christian teaching, it was condemned and banned before it could further endanger the spiritual instructions of the Church.

We need hardly look for other examples in order to describe the existence of regressive trends and advancing movements side by side. They are part and parcel of the historical process. There is no question that the ingredients of verifiable changes and transformation are not dictated by any single force or circumstance, by expansion and political outlook, or by manifestations of popular movements, or by emerging spiritual, cultural-economic developments. And there are different and often highly effective causes, such as famine or epidemics or other catastrophes, that vitally contribute to shifts and changes in the lifestyle of an entire era. Also, we must not forget that there are great inventions, like the mechanical clock in the fourteenth century or the introduction of the use of eyeglasses a century or so earlier or, possibly more important, the use of movable type. It

all demonstrates a trend of an increasingly more penetrating influence of realism and at the same time a potentially greater complexity of external stimuli and a more intricate stimulus-response pattern.

I just mentioned the invention of the mechanical clock, one of the major technological advances of the fourteenth century, which we owe to Giovanni de' Dondi (1318–1379?). Dondi was a physician, architect, clockmaker, and, last but not least, dedicated collector. He belonged to the circle of Petrarch (1304–1374) and was actually his doctor, although not one of those "godless physicians" so vehemently attacked by the humanists. For Petrarch was a romantic. If he was a champion of the technical progress Dondi represented, it was only because he was a champion of the momentous movement that forged the dramatic conquest of the past. It was idealistic humanism that started to ring in the advent of the Renaissance. Petrarch stood between the traditional preachings of Catholic beliefs and the gradually advancing ideas of a rational conception of being as represented by the Aristotelians, who in turn had been influenced by Islamic philosophy.

The Church, it must be remembered, was in turmoil, and divided as never before. There was one Pope in Rome, who was considered a heretic. The other Pope was in Avignon, which remained the seat of the Curia until 1377. And for a short while there was even a third Holy Father in Pisa. This schism reflected the power struggle that was going on not only within the Church but in effect against all ecclesiastical teachings. It was one expression of the spiritual change and the increasing realism as also exemplified by the installment of town clocks or church clocks, which gave people a greater awareness of time. It all indicated a change in conceptual trends and shifts in priorities.

The creation of numerous universities during the thirteenth and fourteenth centuries is but another proof of the growing influence of the new consciousness and intellectual approach, of which Petrarchian humanism was one of the most significant and vociferous manifestations.

As far as Western Europe was concerned, the first few decades of the fourteenth century constituted a time of torment and suffering. There were two years of severe famine, from 1315

to 1317, especially in France, the Low Countries, and the British Isles. The whole period was accompanied by deep economic depression. This in turn was responsible for social upheavals and a religious and intellectual crisis that threatened to unglue the unifying power and claims of Rome. "So many people died every day," wrote the Abbot of St. Martin at Tournai, "that the air seemed putrefied."[147]

It took many years for Western Europe to master the disastrous consequences of hunger, illness, and hopelessness and as far as the lower classes were concerned, oppression and exploitation. It was in consequence of these years of continued trauma and suffering that the ecclesiastical and sociocultural mold underwent fundamental changes. Such critical and potentially explosive experiences tend to undermine any sense of reliance and criteria of security.

Then, about three decades later, came the worst epidemic in human memory, the plague, which began to spread throughout Europe, with lasting consequences for the whole structure of human existence by hastening a new world view in social, religious, and ideological terms. To many the Black Death was nothing less than a sign of God's wrath. The horrifying effects of the plague helped dismantle the influence and traditional power the Church had appropriated. According to all accounts, Western Europe's population was reduced by one-third to one-half. The illness killed prince and pauper alike. For eighteen months, about eight hundred people a day died in Paris alone. There is a great deal of evidence that the illness eroded the entire mood and moral fiber of the times. "Brother was forsaken by brother, nephew by uncle, brother by sister and oftentimes husband by wife," Boccaccio, who was an eyewitness to the plague, recounts at the beginning of his *Decameron*.[148] All moral rules, ethical codes, and traditional loyalties evaporated under the constant shadow of illness and death. Mass psychoses as expressed in group flagellations, pogroms, witch-hunts, and sexual bestiality became daily occurrences. The emotional climate of the time seems to have mobilized everybody's hysterical extroversion.

The Black Death hit France during the middle of the fourteenth century. Largely because of the war with England, the country had been torn apart. In 1345 the English had beaten the French in the battle of Crécy. At the time, Jean de Berry (1340–

1416), the third son of the future king of France, was six years old.

While Boccaccio had eloquently depicted much of the desperate social scene in his *Decameron* (speaking of parents abandoning their own children under the impact of the plague), Jean had remained in the good care of his mother and grandmother. Nonetheless, he had undergone the ravages and desperation of the times. Even before the war with England, France had been immersed in internal unrest. By all standards the Duke of Normandy's family was poor. The duke himself was with the army. Jean's mother, Bonne de Luxembourg, had to borrow money to feed and dress her nine children.[149] Much help and care came from the queen, Jeanne de Bourgogne, who seemed have a special affection for her grandson Jean. But the pestilence took its toll. In 1349, at the height of the Black Death, both mother and grandmother fell victim to it, and Jean found himself motherless at the age of nine.

Here is a telling example how a trauma of this emotional dimension leaves a lasting mark on a person's entire development and inner coherence. Jean de Berry became one of the foremost collectors of his time. In fact, one of his biographers, the late Millard Meiss, described him and his brothers as "the most remarkable fraternal group of collectors in history."[150]

Jean was the most prominent of the brothers insofar as eye, selectivity, influence, and fame are concerned. And not unlike many dedicated collectors, he seems to have been essentially a lonely man, restless, dynamic, and enlightened. He was constantly moving, from one of his residences—no mean feat considering that he had ten or twelve of them. Meiss characterized him as a "wealthy nomad," a trait that can be observed among many collectors who seem to be in constant search of new acquisitions. Jean de Berry had three sons. None of them survived him, and after the death of the last one, also named Jean, in 1397, he began (to us as observers, not at all unexpectedly) to collect on an even larger scale.

Famous for the many paintings and illuminations he commissioned, and especially for his prayer books, the *Très Riches Heures*, his collection resembled in some ways that of his great-grandnephew, King Louis XI. They both had a great deal of affection for animals, and in particular for dogs. They were both

also devoted collectors of holy relics (always a clue to a power-
ful sense of insecurity and dread of ultimate damnation). In
1384, Pope Clement VII gave Jean some fragments of the nails of
the Holy Cross. He was also the proud owner of the chalice
from which Christ had taken wine at the last supper, had a piece
of the Crown of Thorns, and a head of one of the Innocents.

Here is striking evidence for the close relationship between
the reliance on the possession of holy relics supposed to magi-
cally protect the owner against the threat of suffering in purga-
tory *and* my argument that fright is a determining factor for all
kinds of collecting. Whatever the individual collector selects,
any "thing" is ultimately destined to constitute an unconscious
prophylactic device to assist the owner in mastering a feeling of
threat and to control a sense of helpless frustration.

Thus, Jean de Berry was not only an avid collector of Chris-
tian relics. He was well recognized for his predilection for aes-
thetically specially appealing objects. His library contained
about three hundred exquisitely illustrated books, and his col-
lection of precious stones, gems, seals, and cameos as well as
medals had largely been supplied by Florentine dealers. One of
his most important suppliers was the jewel designer Antoine
Machin or, rather, Antonio Mancini, who worked in Paris as
well as dealing from his Florence residence, which suggests to
us how Florentine culture blossomed at the French court.

Jean de Berry was among the first collectors whose enthusi-
asm and infatuation could not be confined to a single area,
which is always indicative of a less rigid and less monomaniacal
approach. In fact, he could be described as a forerunner of the
Wunderkammer or curio cabinet collectors, about two centuries
later (to be discussed in the following chapter). But if, because of
his imaginative involvement with all sorts of objects, Jean de
Berry can be called a curio collector, he not only did it in grand
style, he also had an edge on the fashion by several generations.
It should be recognized that, while he stood at the threshold of
an era which developed a more concrete sense of reality, Jean de
Berry was still a barely modified true believer, as his frantic as-
sembling of holy relics suggests. Nevertheless, he had an indi-
vidual, discriminating mind and, while still prey to the pieties of
the fourteenth century, he made a conspicuous effort to look at
the world in a more "modern" way. It should be recalled that he
was, after all, a contemporary of the early humanists. Had he

lived among them in Florence or Padua, instead of in France, he would probably have been counted among the followers of Petrarch, since he was a distinctly forward-looking man.

I mean to suggest here that certain collectors' concerns toward the end of the Middle Ages were closely interwoven with the modes of intellectual orientation resulting from the ills of their time. Quite conceivably, individual and cultural elements interact and have a cumulative effect. And here existential anxiety and disillusionment as one consequence of the plague helped pave the way to turn away from the Church in search of other sources of inspiration. "The epoch of Humanism put in place of a closed medieval world image (*Weltanschauung*) a completely and fundamentally different perspective of God, the world but especially of man himself," concluded the Swiss historian Walser.[151]

For example, both Jean de Berry and King Louis XI kept a kind of private zoo, possibly as an essential part of new sentiments and broadened interests, which stressed observation and the quest for greater knowledge. Such knowledge provided a more reliable basis for the understanding of natural phenomena; even so these were still conceived of as being confined within the boundaries of a divine plan. Thus, it may be said that while the primacy of the Church of the Popes was on the decline, the style and spirit of collecting at the time reveal new interests, especially for the past, for the world of the forefathers, in other words for antiquity and, almost imperceptibly, a changing world view.

At the time of Jean de Berry there was a growing popularity of gems and cameos, witnesses of the Greek and Roman cultures. They were a pictorial representation not simply of the talent of fine stone-carving during earlier centuries. They represented the inescapable conclusion of artisans' accomplishments long before the Christian era. And yet, even while collecting these treasures of antiquity, Jean de Berry continued to be on the lookout for holy relics and to believe in the tales and legends attached to them, underscoring the importance of unrealistic (i.e., magical) projection, which determined these objects' function.

The notion of an overall transformation from belief in miracles and mysteries to the discriminating study of man, animals, and natural phenomena presents a new avenue for the collector.

One might say that it initiated the collection of evidence—evidence of the achievement of past generations; evidence of natural phenomena; and most tellingly evidence "of what the human body was like, as shown in the illustrations of Guido da Vigevano (ca. 1280–1345) in his *Anothomia per figuras designata*."[152]

In addition, technical advances began to facilitate travel. Specimens of all kinds from foreign lands and unknown civilizations opened new vistas to the curious, perhaps less so in the Italian states than in France and eventually in the Northern countries. With the advent of the Renaissance, man was beginning to lose his innocence.

This was not only a time of physical scarcity but also one of spiritual famine and socioeconomic transformations, changing values and ideals, although these were predominantly confined to a progressive intellectual elite. This change appears in a variety of symbolic expressions, although the more systematic study of human anatomy is the most suggestive sign of a shifting mood and intellectual climate. But the arts, especially painting and poetry, are equally witness to the gradual change toward the objectification of the universe.

Take for example the time between the 1420s and the 1530s. During that hundred years we see a conspicuous shift away from religious themes in paintings. There was a gradual change in favor of secular topics from about 5 percent to 20 percent, although such statistics are hardly reliable because they are often used to prove doubtful hypotheses.[153]

In any event, it is not surprising to find Petrarch among the collectors of Roman coins and medals, since it was chiefly he who stimulated his contemporaries' pride in their Roman ancestry. Such pursuits were much more than just idle pastime since they constituted but one aspect of the new search for tangible facts, rather than the long-held belief in (nothing but) doctrinal teachings of the Church. The thrust was in the direction of reason and more evidential information, as exemplified by what Lewis Mumford has called "the key machine of the modern industrial age." He was speaking of the clock, "the foremost machine in modern technics."[154]

As I have mentioned, Petrarch saw the intellectual merit in antiquarian studies, and he encouraged a group of his young disciples to pay special attention to old Roman specimens. He

had close friends who shared his pleasure in ancient coins. His adviser in old age and the executor of his will, Lombardo della Seta, followed the master's example and collected antiquities, as did his doctor-friend, Giovanni de' Dondi. Considering the wide span of his interests, Dondi was doubtless a man of great erudition with by all accounts genuine visual curiosity. "I have trained myself to look carefully at everything marvellous," he had written, "to reflect on what I see and never to allow myself to become unduly amazed."[155] He was not only famous as a clockmaker. He was also an antiquarian and astronomer, besides being a physician, who described his work with the same meticulous precision with which his clocks functioned.[156]

Dondi was another true forerunner of the later *Wunderkammer* collectors, for even at this early period he attempted to find a kind of order for the objects he was collecting. Dondi was actually some two hundred years ahead of the time when collectors divided their possessions into *naturalia* and *artificialia*, natural or artificial (man-made) specimens. According to Dondi's order, the *mirabilia* of the universe were juxtaposed with the *miracula*. In other words, there were finite marvels, in addition to miracles. Like other humanists such as Brunelleschi and Donatello, during his visit to Rome he was not drawn to churches and other holy places. Instead, he explored archaeological sites and acquired antiquities as an affirmation of a rich past of which he was deeply in awe.

These fourteenth-century collectors were no ordinary men. Petrarch himself had been brought by his family up to Avignon, where he spent most of his youth in the environment of the Papal Court, his father being an exile from Florence. But the popes from Rome and Avignon, involved as they were in feuds and schisms, had lost much of their aura of sanctity, and Petrarch's "enthusiasm for the ancient world [became] greater than for the saints," in the perceptive remark of Jacob Burckhardt.[157] Christian devotion no longer had to outweigh antiquarian interests, and the burgeoning trend toward visible or tangible evidence showed that at least the intelligentsia was looking for natural phenomena rather than reverting to theological explanations.

This was quite in keeping with the humanists' dedication to their Latin ancestry. It may be that Filippo Brunelleschi (1377–

1446), as a promising young architect, painter, and sculptor, was somewhat of an eccentric when he went to Rome not as a pilgrim but as an enthusiastic collector in search of antiquities. He wanted to find inspiration and affirmation in his cultural heritage. This enthusiasm for archaeological finds was entirely in step with Petrarch's Florentine followers, for the master had been perfectly correct when he prophesied in his *Africa* that "our grandsons will be able to walk back into the radiance of the past."

By today's standards a journey from Florence to Rome is no complicated undertaking. But at the turn of the fourteenth century (and even later) Italy was divided into warring city states. In Brunelleschi's case, his Roman venture seems to have been a blend of sincere devotion and sentimental journey. If we can rely on a description left by one of his younger friends, his biographer Antonio Manetti, the architect left Florence in the company of Donatello (1386–1466) who, although still a teenager, belonged to the circle of his admirers.

In order to finance their voyage, Brunelleschi sold some property he had inherited. "Neither of them had family problems," Manetti recorded, "since they had neither wife nor children . . . They were generally called *quelli del tesoro* (the treasure hunters) as it was believed that they spent and looked for treasures. They said: the treasure hunters search here today and there tomorrow. Actually they sometimes, though rarely, found some silver or gold medals, carved stones, chalcedony, carnelians, cameos, and like objects."[158]

The two young friends' inspired exploration of the Roman ruins and monuments and their collecting of artifacts constituted a sincere and passionate dialogue with the past, and their stay in Rome left a discernable imprint on their later art and conceptions. "Brunelleschi's command of ancient Roman architecture and Donatello's mastery of the antique presuppose a painstaking study of what was left of ancient Rome," Roberto Weiss concluded.[159]

Nor were they alone in this genuine response to classical Rome. They were soon joined by others, among them Lorenzo Ghiberti, the sculptor, but most importantly by their slightly younger contemporary, Cosimo de' Medici (1389–1464). It was a closely knit group of forward-looking, enthusiastic third-gen-

eration humanists. Collecting antiquities, sculptures, and coins and medals as well as manuscripts became a subjective as well as objective experience among the members of the group.

The curiosity for the past was but an expression of embracing a different future. It should be seen as evidence for a possibly unconscious rebellion against the spiritual straitjacket of ecclesiastical dogmas. It revealed the same kind of intellectual appetite that had brought Giovanni de' Dondi to Rome in 1375, about a quarter of a century before them.

These Roman ventures were much more than exercises in sight-seeing or even in discovering or obtaining collectable items. This kind of collecting must be seen in the light of a pronounced desire to learn and understand more about one's heritage and in essence more about one's self *in the world*. (I might mention here in passing that much of this kind of interest in the past is but a sublimated way of asking the age-old question, "Where do I come from?")

For the humanists their past or their universe was no longer a matter of mystery or of blind acceptance. There was a lively curiosity and an incessant search for illumination, in the same way that young adolescents who collect butterflies or postal stamps discover more about nature or the world at large. All these men shared a strong and, I believe, basic desire to acquire a fund of knowledge through visible and tangible objects from antiquity as a requisite for romanticizing their Roman forefathers above the credo of the Church. In their idealized vision of the Rome of Caesar and Cicero, they created a subjective rationale that helped them repudiate their present reality as dominated by feuding popes and the rulers of the many city-states of the Italian peninsula.

One of the enthusiasts in the circle of Cosimo de' Medici was a somewhat controversial but nevertheless remarkable man by the name of Poggio Bracciolini (1380–1459). He had many of the characteristics and the habits of the tireless aficionado. His predominant concern was old manuscripts and literary sources. In many respects he was a fifteenth-century (though more civil and civilized) predecessor of Sir Thomas Phillipps. Moreover, not unlike Dondi, he was one of the forerunners of the *virtuosi* or *dilettanti*, largely motivated by an essentially narcissistic curiosity though in the disguise of intellectual inquisitiveness.

In all events, Poggio Bracciolini became one of the most notable bibliophiles of the Renaissance, in addition to being a collector of Greek and Roman sculpture, old coins, medals, and gems (if this indeed was all he collected). Already known by his late teens as one of the best copyists of ancient manuscripts, he became a self-made man of humble origins who started to earn his keep as a scribe. Because he was a prolific correspondent, and as many of his letters are still preserved, we know quite a bit about his activities, his circle of friends, the way he gathered his treasures, and the variety of his interests.

Poggio, as he is usually referred to, came from a hill village near Arezzo. There, in Terranova, his father was a small farmer who supplemented his income by dispensing medicinals. Poggio pictured his early childhood as pleasant and carefree, though this must have been a somewhat distorted sentiment since it is known that he had to earn his keep by child labor before the onus of poverty and debt forced his mother to leave the village. In apparent imaginative idealization he later referred to Terranova as a *castellum splendidum*.

His father was evidently neither a good provider nor reliable. By the time Poggio was eight his family was destitute, had to sell the property in the village, and move to Arezzo. In order to help his parents feed his three younger siblings he had to work as a farmhand. Somehow he must have kept up his education, since a few years later, at the age of sixteen or seventeen, he worked as a copyist in Florence. Moreover, he studied to receive the prestigious degree of *notario*. By the time he was twenty-two years old he could add to his name the title of "ser" in this status-conscious society.

Poggio was doubtless a very ambitious young man who was soon moving in Florence's intellectual circles. This came about because he had the same animus as some of the Florentine collectors who were infatuated with old books, which had to be copied for their libraries, and Poggio's ability, learning, and enthusiasm had come to their attention. Among these men was Coluccio Salutati, scholar, writer, and teacher, but first and foremost "the spiritual heir of the great master" Petrarch, and a fatherly friend, Niccolò Niccoli, a well-to-do member of the Florentine aristocracy, who spent most of his fortune in building up an important library. In addition to his passion for books and

old inscriptions, Poggio was a devoted student of Cicero's writings. Salutati and to some extent Niccoli and the young Poggio soon grew close, possibly because the young *notario* was in search of an intellectual father since his own unscrupulous father, deserting his whole family, provided neither the outward sustenance nor the model Poggio had been looking for.[160]

Poggio was not in need of too much help. In the atmosphere of the early fifteenth century, the young man's enthusiasm for classical literature, for epigraphic texts and original inscriptions, was well received and supported among the influential and responsive humanists who were also among some of the leading citizens of the city republic. All this Poggio shared with one of his fatherly protectors, Coluccio Salutati.

Cicero's eloquence and oratory mastery had become something of a paragon, a living connection with a rhapsodized past. The identification with that aspect of Roman culture was a logical outcome of these humanists' urge to collect, and Poggio was indeed an acutely conscious representative of those who saw themselves as the true heirs of their Roman ancestry. He began to search for old documents and hitherto unknown texts of Cicero. In a short time he was to become one of the most successful discoverers of old manuscripts, which to the fifteenth-century humanists were sacrosanct ancient records.

Through the network of his well-positioned Florentine patrons, Poggio found employment with the Roman curia, eventually advancing to the influential office of papal secretary, always with the principal aim of making more and more discoveries for his collection. The Vatican was a treasure trove of rare or hitherto unknown ancient texts, and he copied many of them with what was by this time his well-known calligraphic skill. Besides, he made copies of the inscriptions on Roman stones and sent the material up north to his mentor Salutati. Poggio's position and prestige in Vatican circles advanced quite rapidly, and he soon became a member of the papal entourage. Nevertheless, Florence remained his spiritual home.

Was it his close identification with Salutati and the Florentine humanists that brought about the dedication that enabled him to make discovery after discovery? His enthusiasm in inscriptions and epigraphy may at times have carried him away. It would seem so, at least according to Leonardo Bruni, a contem-

porary who was also papal secretary and a friend of Salutati. Bruni described his colleague as romantic, carefree, not too reliable, and occasionally inconsiderate, though likable. Poggio was also something of a charmer, and it would appear that this combination of character traits helped him to obtain many desirable items for his own collection.[161]

I have observed similar personality traits among other self-serving collectors who, regardless of their truly genuine enthusiasm, can sometimes be tempted to acts of dishonesty and, owing to a certain lack of self-criticism, fall victim to their uncontrollable, largely unconscious longings. In this connection I may refer to an incident when Poggio, as a member of the Pope's inner circle, spent some time in Bologna. During this sojourn he seized the opportunity to visit his beloved Florence. Florence, it must be remembered, was at the time not only the center of Renaissance culture, of the study of antiquity, and, as far as the elite was concerned, of *decorum* (a concept borrowed from Cicero),[162] but it was also, in more economic terms, a major center of cloth manufacture. On leaving the city-state, Poggio managed to smuggle out a large piece of expensive cloth under the very noses of the frontier guards.[163]

Were it not for the fact that the papal secretary Poggio Bracciolini used similar techniques to obtain valuable manuscripts, such an incident would be of little more than anecdotal interest. However, it was a deliberate, well-calculated move used some years later when he discovered a storehouse of hitherto unknown Latin texts under the dust and debris in the library of the old monastery at Einsiedeln in Switzerland. And since his dedication was stronger than his moral codes, he could prevail upon the monks to let him browse at will. At the bottom of the monastery's library, "housed in a dingy, dirty dungeon ... he found Lucretius's *De rerum natura*, a history of Ammianus Marcellinus, a book on cookery by Quintilian."[164] Poggio later rationalized his appropriation as an act of merely a rescue operation and an affirmation of the bond that existed between the Latin ancestry and present humanist fervor, whereupon some of the finds promptly disappeared up his sleeves.[165]

I am using this example in order to illustrate a personality trait that can be understood in terms of an infant's self-centered demand with an outspoken indifference to moral values. I

would not describe it as common thievery, since Poggio unquestionably believed his own intellectualized interpretation of the event, founded as it were in his idealistic commitments as a rescuer. Indeed, those manuscripts would probably have disappeared or disintegrated since they were virtually buried and unprotected among the many other and presumably irrelevant documents in the dungeons of the monastic library. To all appearances Poggio was a man of formidable charm and, considering his history, of great persuasiveness. I have heard arguments about one's mission as a rescuer from several dedicated collectors and dealers in antiquities as well as from unscrupulous grave-robbers and burglars when valuable but unprotected objects could be obtained through bribery, inveiglement, or sheer deception.

Without denigrating Poggio's enthusiasm and achievements, one can hardly underrate the skill and talents of a man who knew how to outwit such authorities as the Florence border guards or the Swiss monks who were the gullible custodians of the Latin manuscripts. It is possible to think of men such as Poggio as people who know how to mobilize aggression in the guise of charm and allurement. It is easy to see that Poggio the collector would probably have defended himself on the grounds that his subterfuge saved, after all, important historical documents from ruin; that he did what he did as a savior in the service of his scholarly and antiquarian pursuits. I have heard similar arguments from other collectors or archaeologists. One cannot always refute their own perspective. However, accepting their explanation differs from understanding the inner nature and unconscious meaning of their action. In view of their personality, their habits are under the sway of, if not motivated by, a drivenness arising from aggressive-possessive impulses and imperatives. Thus, in psychoanalytic terms it is an obsessional, repetitive attempt at testing one's magic: their ability to mobilize their personal magnetism works to their advantage. Here is an obvious link between the Don Juan and the persuasive collector.

By the time of the historical Council of Constance, from 1414 to 1418, Poggio had become one of the anti-Pope John XXIII's private secretaries. In that position he had easy access to abbeys and monasteries. True to his obsessive character, rather than

wasting his time in drawn-out disputes and arguments, he traveled further north hunting for more documents and new treasures. And in the course of these endeavors he made enormous finds in the monastery of St. Gall. He left the place with no less than two wagon-loads full of old manuscripts, after explaining to the monks that he only wanted to copy these treasures, since he was one of the best copyists of his time. Whether it was the ignorance or innocence of the monks or, once again, the papal secretary's powers of persuasion, they let him have his booty against a simple receipt.[166]

He also visited the monasteries of Langres, Cluny, Basle, and Cologne, and while he was not by far as successful as he had been at St. Gall, he still managed to unearth more Ciceronian orations and a number of ancient maps of the city of Rome.[167] Only the abbot of the well-known monastery at Fulda was disinclined to succumb to Poggio's entreaties to part with the manuscripts he found there.

In August 1430, Poggio accompanied the Pope to Grottaferrata and explored the entire district, visiting many of the old villas in the vicinity, quite a few of which were still "filled with various bits of ornaments and fragments of statues. . . . At Grottaferrata there was a villa which must have been Cicero's," he concluded in a letter to his fatherly friend Niccolò Niccoli.[168]

Poggio was now fifty. He was established and well known, and yet still in need of an ideal father. He knew not only about Cicero's country villa but also of his collection of statues. And so, like Cicero, he too acquired a country villa. Not surprisingly, he chose no other location than Terranova, the hill village he liked to refer to as *castellum splendidum*, which he and his pauperized family had to leave under pressure because his own father was a fugitive debtor when Poggio was a young boy. Now he returned, not only in an exalted position in the Church but later as a chancellor of the city-state of Florence. The poor boy from the provinces came back as an urban patrician who wielded power and was a paragon of classical learning and education. It is quite likely that many of the actions in his career, in his social ambitions and his endeavors as an outstanding collector, were motivated by early wishful fantasies of a high station, so that as a middle-aged man, now a member of the Florentine

elite, he could reestablish himself in his home village, the successful son of an impoverished runaway.

Poggio apparently thought of himself as an antiquarian with scholarly ideals. Even though his primary concern was with Greek and Roman texts, his enthusiasm for the plastic arts was hardly less fervent. And here he knew how to make use of his high office. On one occasion he tried to persuade papal envoys in Greece to supply him with fine examples of ancient sculpture.[169]

However, when one of his scouts in the Greek Islands offered him an entire collection of statues that had presumably been discovered in a cave in the island of Rhodes, he was not immediately carried away and became suspicious.[170] Another of his suppliers was a "Master Franciscus," or Fra Francesco da Pistoia, who had already obtained for him three marble heads of Juno, Minerva, and Bacchus and further wrote to him about nearly "a hundred undamaged marble statues in marvelously beautiful workmanship." Unfortunately, after having promised Poggio the sculptures, he also offered them to Lorenzo de' Medici, who, being by far the richer collector, got away with the prize.

One recognizes in Poggio not simply an ardor for antiquities as witnesses of a glorious past with which he and many of his fellow humanists tried to identify, but also an unrelenting obsessiveness that has almost a childlike quality. For example, in 1457, at the age of seventy-seven, he received word about some manuscripts of Livy which had been found in a monastery in Denmark. He immediately tried to persuade the newly appointed Bishop of Bergen to make the discovery available to him. In his manic state he had already worked out a convenient route for transporting the manuscripts via Bruges and Geneva to Florence, where he was now residing after leaving the Roman curia. Two cardinals would serve as intermediaries, he noted, and he was quite prepared to bear all the expenses.[171] Clearly, like many collectors, even in his advanced age he was engrossed by a never-ending need for new acquisitions.

What sort of a man was Poggio Bracciolini? Documents such as his own writings and his vast correspondence are implicitly and explicitly revealing as to his aims and ambitions. One can

sympathize with his tribulations and sense the enormous energy involved in his acquisitiveness. In Poggio we find a frenzy, a dynamism, which is not too unusual in collectors of his disposition.

An epicurean who liked to display his collection, Poggio lived in his villa in Terranova in the way becoming a very successful man. The villa had been decorated in the style of Cicero, with a number of Greek and Roman statues. At the villa he received many men of position and renown who were supposed to admire what the poor boy from this very village had managed to acquire. One of his visitors was Lorenzo de' Medici; another was Donatello, by that time considered an expert on antique works of art. "Donatellus vidit et summa laudavit," he wrote to Niccolò Niccoli.[172]

Of major interest in Poggio's personality is his flamboyant effort to resurrect "what still remained of the ancient Rome," in Weiss's words.[173] His dynamism was certainly rooted in an attempt to overcome an initial source of insecurity caused by an unreliable father. He found substitute fathers in sponsors like Salutati and Niccoli—Salutati as the acknowledged heir of Petrarch, and Niccoli as "unquestionably the most important Italian art collector of the early 15th Century."[174]

Aside from his personal need to find a new identity by way of attaching himself to mentors who were intrigued by his charm and resourcefulness, he was also seeking some kind of spiritual heritage. This he shared with the intellectual vanguard of his time, as men such as Giovanni de' Dondi had foreseen: marvelling at the world instead of accepting the traditional axioms of the Roman Catholic church.

In a letter to Battista Guarino, Poggio described his success in the monastery of St. Gall. There we find a most revealing comment: "When Mother Nature gave the human race mind and reason, two wonderful guides to a righteous and happy life, she could think of nothing finer to give."[175]

This, written when he was the anti-Pope's secretary, crystallizes how little credit one of the most influential churchmen of his time gave to divine providence, and how much a collector's taste can be under the spell of the spirit of his era.

The Age of Curiosity

O NE WOULD BE hard put to deal with the predominant lean-
ings of all the humanists at the time of Poggio Bracciolini whose
taste and antiquarian interests also aroused a desire to own old
sculpture or epigraphic texts or whatever might relate to the hu-
manist world. However, there were a few who seem to have
gone beyond antiquities and contemporary works of art. One of
them was Sigismondo Tizio, a man with a preference for Etrus-
can objects, although his attention was also directed toward
"natural curiosities." While others concentrated exclusively on
Roman remains, a man like Tizio seems to have been well ahead
of his time.

Remarkably, Poggio, whether consciously or not, also seems
to have had ideas not too far removed from this. Poggio did not
just collect statues and manuscripts. "He was not satisfied with
merely giving a description of what he saw," Weiss wrote. "In-
stead he chose to question and seek answers from the old
remains."[176]

What all this seems to tell us is that such men were guided by
a new spirit of inquisitiveness and an intellectual curiosity that
was soon to define many collectors' concerns and preoccupa-
tions. For the first time, man dared to ask: Where did all this
come from? Such questions are solidly embedded in childhood
emotions, although now on a higher (or sublimated) plane.
There comes a time when children want to know where they
come from and are no longer satisfied with hearing about the
stork. At this point, generalizations have little appeal for chil-
dren, since they are actually curious about their parents' sexual-
ity.

Men like Poggio must have felt quite ready to leave tradi-
tional taboos behind. They helped usher in a passion for
remnants of the past, which in turn led to investigations of the
true roots of being. The next few centuries saw the passing of
miracles and marvels. Collectors leaned toward a distinction be-
tween man-made and natural specimens (*artificialia* and *natu-*

ralia) in their possessions. Rational observation made its presence felt.

This intellectual transformation gave collections a different complexion. In the beginning there was a subtle change of mood that could be distinguished in many respects and on a variety of levels. A thirst for knowledge lay behind the humanists' speculations about the Roman and Greek past, and Arabic and Hebrew history. The collecting of old manuscripts and Roman and Etruscan antiquities was more than a replacement for traditional expressions of piety. It was almost a new kind of religion, or at least an "almost religious veneration for even the crumbs of Antiquity."[177]

Needless to say, there are various aspects to such phenomena. Regardless of whether we look at antiquarian interests, or science, or travel and exploration, they all carried the mark of the times. If curiosity prevailed it was clearly in the spirit Burckhardt had observed.

The rapid advance in navigation stemming largely from the Hispano-Arab cartographers and the invention of the compass brought demonstrable proof of other cultures and hitherto unknown foreign goods. If the "romantic" search had been started in Rome (by Tuscan explorers), travel to strange countries brought marvelous revelations of the things and people beyond the seas. It is quite evident that humanism, the many discoveries and inventions of the time, and the gradual disintegration of the late medieval social structure all cross-fertilized one another; that the ever-expanding spheres of knowledge and exploration gravitated toward each other. It is within this ambiance of search, of discovery, of engineering and navigational advances that the newly awakened curiosity must be placed.

Petrarch's mentorship had a strong influence on later generations, not only on the Salutatis and Bracciolinis. The appeal of Greek and Roman coins, which had become "modern" collectors' items, grew and grew. And it was more than a matter of just owning various kinds of coins. Iconographically, these coins also contributed greatly to the enrichment of historical information.[178]

By putting the accent on information, I want to draw attention to the increasing secular approach of this period to learning and factual knowledge. The humanists' interest in and admiration

for the classical past and concern with the laws of nature were only some of the indications that the doctrinaire demands of the Church were falling by the wayside. Realism was in the ascent even if the humanists' idealization of antiquity was here and there befogged by sentimentality and the ambivalence with respect to the teachings of Rome.

One of those dogmatic papal dictates was the Bull of 1300 by which Boniface VIII explicitly prohibited the disemboweling of corpses. The Bull was aimed mainly at the thriving trade in holy relics. It had become a habit to return from the Holy Land with the bones of Crusaders who had died during their pilgrimage.[179] By boiling their bodies, the bones could be brought back to Europe after the flesh had been removed. It had grown into a habit that was, after all, not so very different from the customs of many of the native tribes of Oceania. The papal edict tried to call a halt to it.

Even more important, this interdiction also applied to dissections and autopsies carried out by students of anatomy. In other words, the Church was trying to discourage the study of anatomy. Early accomplishments in this field are rather obscure. Physicians tended to rely on Galen, although this Greek doctor's work (he died in Rome at the beginning of the third century) was unfamiliar to anatomists until a translation appeared in 1322. Despite the Church's position, Mondino de' Luzzi (1275?–1326) performed dissections of cadavers at the University of Bologna, and published his results in 1316—yet another example of how factual knowledge was deemed more important than conformity with Church-imposed prohibitions. Mondino's *Anatomy* quickly became standard reading for students of medicine.

The trend toward rational observation and discovery was neither uniform nor undeviating. It coexisted with traditional or even regressive pursuits. Medicine was still a mélange of magical procedures and gradually advancing physiological and anatomical knowledge. Chemistry was still intertwined with alchemy. Astronomy encroached upon astrology. Superstition and reason made heterodox partners but managed to reconcile their divergent leanings.

"The difficulty was not that there was no difference between natural philosophy and mystic science," Boas explains, "but

rather that men saw that each rational science had its magical, occult or supernatural counterpart."[180]

The overall motivation was a new consciousness accompanied by a still simple but genuine and diverse curiosity that extended in many directions: digging and measuring in Rome; traveling to hitherto unknown countries; learning about strange peoples, their customs and their goods; and challenging the traditional pieties by making discoveries about the basic principles of anatomical structure. All of this indicated a gradual shift in outlook stimulating a different worldview. Fifty years after Mondino, for example, a French surgeon from the University at Montpellier, Guy de Chauliac, published a *Cyrurgia Magna*.

In our effort to understand the gradually unfolding drift of collectors' interests or, rather, the mode of expression of their preference, one must be aware of the potent effect of the mood and temperament of the time. The process of seeing and demystifying as part of the early Renaissance mentality extended its influence on most enterprises and concerns in many ways. The Church sent missionaries to the Far East. Merchants and travelers such as the Polo brothers expressed in action, if not in thought, the critical shift in values and expectations.

The emerging pattern shows a simultaneity of changes. The great interest in the Latin past is but one example. The increasing influence of Hispano-Arabic mathematics and its effect on navigation expanded the itineraries of tradesmen and led to new shipping facilities and enterprises.

Travelers returned with new goods and astonishing tales. True, the earlier accounts by Crusaders and pilgrims to the Holy Land had told of the journey through Asia Minor, and some traders and missionaries had even pushed further, to India, to the Malay Archipelago, and to Cathay, as China was called at the time. One of these was Odorico de Pordonore, who came back to Europe with much surprising information about East Asia.

Throughout the second half of the thirteenth century and during the fourteenth and fifteenth centuries, more and more unexpected and startling goods filtered into Europe and could not fail to tempt and inspire scientists, artists, and collectors alike. In the inventory of Jean de Berry, for example, there appears "porcelaine," counted among the rarities. He also had narwhal horns, ostrich eggs, and Oriental perfumes.

186

Travel books played a major role in whetting the appetites of collectors. One such book was Sir John Mandeville's *Travels*, dating to the second half of the fourteenth century.[181] It is an articulate, lively concoction of factual data mixed with the quasi-utopian fantasies of the author. It is doubtless meant to be entertaining, and it did have a conspicuously wide appeal. By the end of the fifteenth century the work had appeared in at least seven languages. Highly successful because of the enthusiastic curiosity of the time, the book consists of a series of far-fetched and garbled tales that Mandeville had distilled in Gulliver-like fashion from Pliny and other early travelers such as that zealous missionary to Asia, Odorico de Pordonore.

It is quite obvious that spellbinding tales about distant lands and hitherto unknown goods and customs were welcomed by the early humanists' less erudite contemporaries. Curiosity and inquisitiveness went hand in hand with the increasingly impressive mercantile ventures, originally led by Venetian and Genoese traders, although rather soon followed by the Portuguese, Spaniards, Dutch, and English.

This gradually enlarging mise en scène of discoveries, of experimentation and inventions, was nothing less than an attempt to substitute empirical observation and knowledge for long-standing beliefs in magical powers and practices. Theological debates were enlisted to marshal arguments conveying the latent conflict between traditional Christian teachings and enlightenment, between faith in magic and empirical truth.

The spirit attending this ambiguity is an eloquent expression of what Heer has described as the "two-tiered theological structure" relating to the supernatural world as it is impinged on by concrete data and tangible objects of reality.[182] The change from magico-religious speculation to the excitement of learning and exploration—in other words, the advance of a secular movement and the effective investigation of the perceivable world—was very exciting to collectors. Moreover, this development was soon to be helped by another major cultural achievement, the invention of the printing press.

Even though emphasis was first placed on the scriptures and religious texts, soon books with wood-block prints began to appear which featured naturalistically depicted animals, plants, flowers, birds, and insects, sometimes incorrect in proportion and symmetry but informative and inspiring nonetheless. New

books on anatomy, botany, physiology, and stereometry indicate which way the wind was blowing. There was, for example, a *Fasciculo di Medicinae* of 1493 which showed a female body with the reproductive organs,[183] and a *Herbal* by the Greek physician and botanist Dioscorides. The illustrations in the various new books and translations differed as to accuracy and verisimilitude. The same was true for the depictions of animals, although there was conspicuously less interest in zoological illustrations than in plants and flowers because of their medicinal properties, the implication being that man's well-being was no longer entirely left to fate and prayer.

It all demonstrates an overall trend of putting more emphasis on the study of human nature and a deliberate awareness of the real world. Along with the experience of commercial travel, of new discoveries, and of factual information, there is a corresponding burgeoning of curiosity and inquisitiveness. In its initial concern this development is only relevant as it is clearly echoed in the increasing impetus for further research and for more than hearsay evidence, as in Mandeville's wild tales. However, it contains within it typical elements that are to become of all-absorbing moment in later years, and even among today's collectors, in that the ever richer sources of supply support greater differentiation and specialization among collectors' interests as a mark of individual expression. I shall come back to this at a later point.

The rapidly expanding trade and travel routes over land, and more and more by sea, brought radical changes in the international exchange of goods. There had been effectively two combined sea-and-land routes to the Far East, one through the Red Sea via Cairo and Alexandria, and a second northern route through the Persian Gulf, Aleppo, and Constantinople. Venice was the European trade center until Vasco da Gama discovered the new sea route around the Cape of Good Hope, which would soon revolutionize the transoceanic exchange of goods and eventually shift both commerce and cultural activities to the north—to Antwerp, to Amsterdam, and also by land to Augsburg and Nuremberg.

The lively attention directed more and more toward strange objects and hitherto unknown or very rare products, and not only antiquities or old manuscripts, soon developed in collec-

tors new tastes for things like silks, gemstones, and exotic jewelry. It also inspired new trends in luxurious extravagance[184] and promoted opportunities for changing patterns in visual discrimination.

It must, of course, be stressed that this development was not really conscious nor uniform, as the examples of Cosimo de' Medici III or of Luther's protector, Frederick the Wise of Saxony, with his 17,433 (by actual count) holy bones and a corpse of one of the Innocents, prove. Frederick was, after all, a contemporary of men like Albrecht Dürer, Verrochio, and Verrochio's pupil, Leonardo da Vinci, all of whom, along with many other artists, had pursued anatomical studies. They had been under the influence of humanist anatomical and medical texts, again as part of the broad process of ideological transformation and the expanding frontier of knowledge.[185]

The scenario then, within wide variations, is the potent and in some ways quite novel attitude toward knowledge, but not knowledge per se. It was knowledge correlated with method and an intellectual delight in classification and order. No longer did the aficionados talk of *miracula* and *mirabilia*. Instead they divided objects into *antiquitas, artificialia*, and *naturalia*. Such initial attempts at organizing categories were probably meant to assist the early collectors of all kinds of specimens to divide their possessions into different sections.

The comparatively sudden wave of collecting in the encyclopedic manner that became prominent toward the close of the sixteenth century was no doubt stimulated by the discovery of hitherto unknown objects from other continents. The curio cabinet, or *Wunderkammer*, was supposed to represent the miracles of the world. The paintings and cabinets of the period provide fine documentary evidence of this sometimes bewildering display of all kinds of examples, of *naturalia* as well as specimens of the material culture of recently discovered civilizations. It marked an attempt to create an allegorical cosmos that would permit the viewers to take pleasure in a fanciful, and much condensed, view of a good part of the entire universe. If the collections of Petrarch and his followers tried to evoke the traditions of the past, the curio collectors and their followers, the *virtuosi*, attempted to compose a metaphorical representation of facets of the world at large.[186]

There is at least one other clue as to what must have moved people to gather all sorts of rare or unknown things, or drawn their attention to shells, plants, butterflies, and antiquities and paintings alike. It was a fascination with the discoveries of new territories. Indeed, many of the paintings of curio-cabinets show a globe, as a symbolic representative or a substitute for the real earth.

This fascination with the observable world was not entirely anchored in the domain of discoveries and the new developments in anatomy, astronomy, and scientific cartography. Much of the force behind these various activities resulted from a decline in religious censorship. The fact that Mondino de' Luzzi did not hesitate to dissect cadavers in order to study anatomy, quite contrary to the papal edict of 1300, not only demonstrates the spirit of scientific inquiry but also is an illuminating example of receding church authority, preceding the Reformation. In this connection, works such as Leonardo's anatomical treatises or Berengario da Carpi's (c. 1460–c.1530) enchantingly titled *A Short but very Clear and Fruitful Introduction to the Anatomy of the Human Body, Published by Request of his Students*[187] represent a convincing link between the gradual abandonment of what Tawney called "the spiritual blindness"[188] of the church and the increasingly strong appetite for new knowledge.

It should be noted at this point that even encyclopedic collections are representative of their owner's individual approach and slant. One of the most telling contemporary descriptions of the curio-cabinet refers to it as the *Vernunfft-Kammer*, or the Room (or Cabinet) of Reason.[189] Such a designation clearly reveals an owner's ideological bent, seeming to imply that occultism, fantasy, and allegory were to be replaced by visible and tangible records and reality. Other collectors have preferred a title like *theatrum mundi*, or World Theater, to explain their particular outlook. The title of one of the earliest publications on collecting, Samuel Quiccheberg's *Theatrum sapientiae* of 1565, draws direct attention to the need for knowledge since every object in the book is carefully documented as to time and place by the author.

A good number of the objects commonly found in these early curio-cabinets could also have been found in Jean de Berry's vast collection. While he may have enjoyed their beauty and sig-

nificance, the sixteenth-century collector was as interested in their classification as in their aesthetic value.

This shift in concept and outlook is well articulated by two men of almost megalomaniacal ambition, Archduke Ferdinand II (1520–1595), younger brother of the Emperor Maximilian II, and his nephew, Emperor Rudolf II (1552–1612). Ferdinand had married a wealthy commoner and established himself in his castle in Ambras, in Tyrol. His collection was, according to von Schlosser, "much better and more judiciously" organized than that of most of his contemporary fellow collectors.[190] This passionate dedication was demonstrated in a most impressive volume describing part of his holdings and containing 125 etchings, which appeared six years after his death.[191]

The collection ranged from the most exquisite bronze sculpture by Giovanni da Bologna and perhaps the most sensitive of all of Cellini's works, the famous saltcellar (now in the Kunsthistorische Museum in Vienna), to stuffed birds, sharks' teeth, elephant tusks, a piece of the rope Judas used to hang himself, and an enormous assortment of armor, weapons, and harnesses, especially equipment that had once belonged to famous contemporaries. (Did the archduke feel that this last group had part of their "soul" attached to them, just as other collectors value a pedigree?) In addition, Ferdinand had a passion for musical instruments, clocks, and intricate locks, and also owned a collection of ethnographic specimens now in the Vienna Völkerkunde-Museum.

It should be noted that such a large collection did not have to be a matter of cupidity or a wealthy hoarder's demonstration of possessiveness, particularly in the sixteenth century, when new trade routes helped to speed everything up, and bigger was usually considered better. It may simply have assuaged the curiosity of an eminent and dedicated collector in search of a kind of panoramic view of the intelligible universe—an inclination certainly in step with the spirit of the times.

Ferdinand's ambitions were shared, perhaps imitated, and eventually doubtless outdone by his nephew Rudolf II, Holy Roman Emperor, although possibly contrary to his own inclination. Whether Rudolf saw in Ferdinand, his father's younger brother, a model for himself is difficult to say, particularly since Rudolf had spent seven very significant years of his adoles-

cence, from the age of twelve to nineteen, under the tutelage and guidance of another relative, Philip II of Spain.[192] Philip, one of the most discerning collectors among the Hapsburgs, had many works by Titian, Veronese, Hieronymus Bosch, and many other outstanding artists in his collection. Without doubt Rudolf must have been affected by both the quality and quantity of Philip's collection.

Whether or not he was in need of any particular inspiration, however, is another question. Collecting had long been a family tradition among the Hapsburgs, although Ferdinand and Rudolf II certainly were the most avid collectors, at least in the northern branch of the family. Collecting on a large scale became a huge source of delight to both men, although somewhat more, perhaps, for the elder of the two, since Rudolf's interests became increasingly eccentric with advancing age.

Of the two, Rudolf was the more intriguing and possibly the more manifestly obsessed collector. Over the years he surrounded himself with some of the leading scientists, painters, sculptors, and instrument makers of his time. They were joined by alchemists, astrologers, even Kabbalists. His court reflected not only his own complex personality but the signal ideological turmoil of the late Renaissance. Educated as a devout Roman Catholic, with all the vestiges of the past, Rudolf was nevertheless open to new and searching concepts, and he was not unsympathetic to the modifying arguments of the Reformation. At the same time, the presence of alchemists and Kabbalists at his court demonstrates a certain ambivalence in the emperor's character.

But then he brought one of the most outstanding astronomers of his time to the Hradschin, his court in Prague. The Dane Tycho de Brahe (1546–1601) became the Imperial Mathematicus, with a castle at his disposal and the appropriate staff.[193] Shortly thereafter another famous astronomer, Johannes Kepler (1571–1630), also joined the Imperial Court, taking Tycho's position after his death in 1601. In addition, well-known clock and instrument makers built intricate gadgets for the emperor while war was threatening and their minds and energy could have been focused on military equipment instead. There was already a rebellion in Hungary, and the first signs of the turmoil that would arise out of the Thirty Years' War were clearly visible.

This was the same war that would eventually bring to Prague Swedish troops who would carry off with them a major part of Rudolf's treasures.

The emperor's quest for all kinds of objects took up most of his time and almost all his attention. He used numerous agents to acquire paintings, clocks, fossils, animals, minerals, and, in his own words, "res quasdam nobis curiosas," or anything that would arouse his curiosity.[194] It is not easy to determine the initial basis for his collecting mania. It is a well-known fact that he gradually retreated more and more from the world, closeting himself in the private apartments of his castle. His emotional commitment to his collection is evident in many anecdotes about him. When, after extended negotiations with the ducal court at Modena for a relief by Giovanni da Bologna, he finally received the much-longed-for work and carried it to his rooms with a kind of victorious expression, saying "Now it is mine!"[195] And while he quickly dismissed his advisers and ministers who came with urgent messages and requests, he spent a good deal of time with his instrument makers at the turning-lathe. Meanwhile, his coffers ran empty.

These are not accidents. Such behavior has all the earmarks of typical anal-obsessive character traits. In the emperor's case they seem to have been an attempt to ward off feelings of depression, a condition that is not too unusual among manic collectors. We cannot call them addicts. Their compulsion does seem to be triggered by an ever-threatening dread of not having or not getting, and the objects acquired—in Rudolf's case, it didn't seem to matter much, as witness his order for *anything* that would arouse his curiosity—work like a protective or reassuring device, as if they incorporated some form of magic.

Rudolf's records attest to his complex personality, which was possibly of a progressive paranoid type that clearly affected his actions, or, rather, lack of action (as in his refusal to function as the head of the Holy Roman Empire and instead hide behind the walls of his Prague citadel). Nevertheless, the course he pursued in terms of his interests and his vast collection was strongly colored by the spiritual movements that existed at the threshold of the seventeenth century. While Rudolf had his educational roots in the militantly Catholic culture of Spain, his

emotional leanings were clearly sprinkled with Protestant ideas. Moreover, there was the apparent ambiguity that existed between factual scientific research and thaumaturgic entrancement. But he was far from alone in this. Even his Imperial Mathematician Tycho de Brahe, the most prominent astronomer of his time, had not cut himself off from a belief in astrology and alchemy as approaches to finding the truth.

In this ambiguous ideological climate, the Hradschin was a highly desirable retreat not only for outstanding artists, scientists, and instrument makers but also for swindlers and quacks. However alive it may have been in cultural terms, Prague was more the seat of a willful, capricious, and arbitrary head of state than the vibrant international center of Northern Europe at the turn of the seventeenth century.

As Rudolf's collection grew, his statesmanship waned. While his ministers waited in vain for an urgent audience, the emperor remained absorbed in alchemical experiments and Kabbalistic rites, or became entranced with a new object just added to his collection. In this regard, he asked one of his official envoys to acquire for him "treasures, metals, precious stones, and all hidden secrets in the whole of nature," rather than assume his obligations as head of the Empire.[196] His aunt, the Archduchess Maria of Styria, knew of his all-consuming and uncontrollable mania. "Anything the Emperor learns about, he believes he has to have," she commented.[197]

Regardless of the financial burden involved, Rudolf patronized some of the leading artists of the day, whom he virtually tied to his Court. Bartholomaeus Spranger and Arcimboldo were among the Court painters, with Spranger also acting as Rudolf's emissary and bringing the sculptor Adriaan de Vries, a pupil of Giovanni da Bologna, to Prague. One might ask whether Spranger's painting nude women in the most lascivious poses (a quite prevalent theme at that time) pleased his Imperial patron. If this was so—and it seems conceivable because the pictures of a contemporary, Hans van Aachen, use closely related themes—it may provide a clue to Rudolf's undoubtedly complex psychological makeup. Such paintings, or rather their themes, would no doubt have been of interest to a man tormented by recurrent depression and, one might venture to add, pronounced psychosexual conflicts.

Regardless of his position as emperor, and what one might call his obligation to produce an heir to the throne, he never submitted to the political pressure and married. It has been reported that he had various ladies far beneath his status whom he liked to tease, to pinch, and perhaps to abuse. However, he spent most of his time with his chosen companions, with his animals, with his collection, or with his artists, instrument makers, and craftsmen.

Was Rudolf a melancholic voyeur? Was it a coincidence that a man, searching and open-minded, yet withdrawn and in need of reassurance of all kinds, wore a bezoar stone on his body? One of his physicians had suggested he wear such a stone, which is actually a rocklike material found in the stomach of certain animals. Bezoar stones were supposed to possess magical properties and, implicitly, medicinal powers.

One can perhaps conclude that the emperor employed a strategy not infrequently found among obsessional collectors, who in their essential loneliness need a daily "fix" or feel a pressing demand for constant replenishment. Rudolf was looking for help in all directions. He sought magical answers but also liked to share in the activities of the clockmakers, whose work was precise and concrete. He wanted "the whole of nature" in his collection, a logical request for a man living on the threshold between rational thought and mysticism.

As he isolated himself more and more in his Prague retreat, there is reason to suppose that his intermittent depression turned into a state of chronic melancholia. His self-centered concerns finally became more than his Empire could endure, and he was finally deposed by his younger brother Matthias. But in spite of his evidently progressive seclusion, his achievement as a collector on a grand scale is documentary evidence of the cultural transformation of the sixteenth century. The shift in style from Renaissance to Baroque belonged on a wider stage than the arts alone.

There are no stated criteria for collecting, but Rudolf II's encyclopedic *Wunderkammer* or curio-cabinet was probably one of the most ambitious ever put together. While in many respects he had cut himself off from the outside world, this did little to slow down his activities as an ever-ready gatherer of anything collectable.

195

By and large, the sixteenth century was a time of ever-expanding dimensions. Goods and people traveled farther, although not faster, than two centuries earlier.[198] While the Mediterranean civilizations dominated the previous centuries, economic and cultural expansion shifted the main centers of activity to the Holy Roman Empire, and more specifically to the Netherlands and Austria-Hungary, and Rudolf profited from these sociocultural realities in his collecting.

The emperor may have helped in providing the standard for the type of collecting that captured the fancy of his own time and the next few generations. Rarity cabinets, curio-cabinets, and *Wunderkammern* all reflect and emphasize the remarkable cultural diffusion of the post-Renaissance era. When Dondi spoke of the marvels to be found locally, the people of the Baroque period were infatuated with Oriental and American artifacts, as well as with antiquities, coins, and medals. But they were equally interested in what has been described as *naturalia*.

For example, the well-known Basle patrician Felix Platter (1536–1614), rector of the university and a noted physician, had a large collection of herbs, aquatic plants, and shells, in addition to the musical instruments and antiquities he had purchased about 1556, at the time of his medical studies at Montpellier, in southern France. He also collected drawings relating to his interest in plants and flowers and had acquired a number of his countryman Conrad Gessner's (1516–1565) famous botanical sketches, considered to be the basis of up-to-date horticulture, after the latter's death in 1565.[199]

While Renaissance collectors, especially those of the humanist group, had shown their profound interest in Roman and pre-Roman antiquities, sixteenth-century collectors broadened their areas of curiosity. The collection of antiquities, of works of art, of curios and *naturalia*, it must be repeated, was in its infancy during the fifteenth century, but got much more creative and illuminating, and certainly more systematic, attention during the next two centuries.

Before coming back to this matter, I should call attention to a parallel and intellectually closely related movement, that of diligent and ambitious anatomical studies. These had started with Mondino's work in Bologna, but found their culmination, tellingly enough, during the sixteenth century with Andreas

Vesalius's *De Humani corporis fabrica*, published in Platter's hometown of Basle in 1543. Basle had become the center of printing and book publishing. While Mondino had prepared the ground in Italy, Vesalius taught in Paris and at the University of Louvain, in the Netherlands. It was yet another indication of the rising importance of the north as a cultural, as well as an economic, center.

Man was in search of himself and the mystery of the human body, or, in Vesalius's term, the *fabric* of the body, and on a larger scale in search of documentary evidence of everything that existed in nature. What for a loner such as Rudolf had become the main focus, if not the solution, of an undoubtedly affective disorder was soon to be a trend.

This tendency to search for "things" and the resonance coupled with intense inquisitiveness and the possession of collections began to draw attention in many different quarters. Barely two decades after Rudolf's death, etiquette books made mention of the increasing interest in tangible examples of antiquity, of gems, coins, medals, and other specimens of archaeological artifacts. Then there were the *naturalia* and *artificialia*, in addition to items from what until then had been totally unknown cultures, from the Far East, from the Americas, from sub-Saharan Africa.

I shall come back later to this "trendy" perspective, which magnified in some respect an attempt to find concrete answers to an increasingly more complex world, especially in times of the rapid progress that had started during the sixteenth century.

It was men like Rudolf II who must have persuaded such a perceptive observer as the Oxford scholar Robert Burton (1577–1640), librarian of the college of Christ Church, to gain some understanding of the function of collecting. He wrote: "There be those so much taken with Michael Angelo's, Raphael de Urbino's, Francesco Francia's pieces, and many of those Italian and Dutch painters, which were excellent in their ages; and esteem of it as a most pleasing sight to view those neat architectures, devices, escutcheons, coats of arms, read such books, to peruse old coins of several sorts in a fair gallery; artificial works, perspective glasses, old relics, roman antiquities, variety of colours."

Burton made these observations in his *Anatomy of Melancholy*, which originally appeared in 1621 but was reissued four more

times before the author's death nineteen years later. Steeped in classical literature, Burton continued:

> When Achilles was tormented and sad for the loss of his dear friend Patroclus, his mother Thetis brought him a most elaborate and curious buckler made by vulcan, in which were engraven sun, moon, stars, planets, sea, land, men fighting, running, riding, women scolding, hills, dales, towns, castles, brooks, rivers, trees etc., with many pretty landskips and perspective pieces: with sight of which he was infinitely delighted, and much eased of grief. Who will not be affected so in like case, or to see those well-furnished cloisters and galleries of the Roman cardinals, so richly stored with all modern pictures, old statues and antiquities? . . . Or in some prince's cabinets, like that of the great duke's in Florence, of Felix Platerus in Basil, or noblemen's houses, to see such variety of attires, faces, so many, so rare, and such exquisite pieces, of men, burds, beasts, etc. to see those excellent landskips . . . pleasant pieces of perspective, Indian pictures made of feathers, China works, frames, thaumaturgical motions, exotic toys, etc. who is he that is now wholly overcome with idleness, or otherwise involved in a labyrinth of worldly cares, troubles, and discontents, that will not be much lightened in his mind.[200]

Burton understood that the obsessional motivation of collectors was not just a matter of leisure and luxury, but that its connection with depression, lack of affection, scoptophilic tendencies, and escape from "worldly cares" signified splits and conflicts in their personalities.

On the other hand, the authors of the etiquette books were conspicuously less sensible than the Oxford scholar. While Burton recognized some of the etiological factors involved in collecting, the authors of the current descriptions of curio-cabinets or, for that matter, of etiquette books were only vaguely aware of collecting as a substitute device. It is fascinating to realize that the fame of some collectors must have traveled all over Western Europe and even across the Channel, since Burton was quite aware of the interests of the Medicis and also knew of the collection of men such as Doctor Platter in Basle, among others.

To be sure, this lively concern with Greek and Roman sculpture, and with old books or botanical specimens, was very inspiring and undoubtedly came to the attention of a good many

people, possibly arousing feelings of envy and rivalry among them. Trends always involve competition and imitation because they become a vehicle for self-definition. There is both a desire for some form of expression of an individual kind and at the same time there is a propensity for sharing in a current drift and identification with others. Such movements are always part of fashion and trendiness. One of the leading and to today's generation most entertaining seventeenth-century publications, Henry Peacham's etiquette book of 1634, entitled *The Compleat Gentleman*, takes note of this.[201]

Thus Peacham tells his readers of "the pleasure of *statues, inscriptions and coynes* [which] is best knowne to such as have beene abroad in France, Spaine, and Italy, where the Gardens and Galleries of great men are beautified and set forth admiration with these kinds of ornaments. . . . Such as are skilled in them, are by the Italians termed Virtuosi."[202] Peacham seems to refer here to the popularization of collecting and the spreading recognition of aesthetic pleasure, which is not the same thing as the often escapist zeal of the monomaniacal collector. However, it is equally different from the sixteenth century's more enquiring mind, which tended to focus on method and order and *"On the Hidden Causes of Things,"* according to the telling title of the French physiologist Jean Fernel's sixteenth-century publication.

While only a few generations earlier collecting had been the concern of a comparatively small fraternity of noblemen, intellectuals, and artists, as Peacham indicates, it had gradually become a trend and a leisure activity that should be familiar to, if not practiced by, any gentleman. The concept of a *virtuoso* or *amateur* or *dilettanti* conveys the profound change that had taken place since the humanists' enthusiastic discovery of old inscriptions, old manuscripts, and all sorts of artifacts from ancient Rome and Greece.

One may reasonably agree that such shifts from the sixteenth to the seventeenth century represent reactions to, rather than causes of, an elementary process. When behavior books begin to elaborate on the social value of collecting as such, we can regard this as a reliable indication of a change in intellectual tone, as well as a change in cultural climate.

It may be a bit more than speculation that the relic collectors at the time of the Crusades, as well as the latter-day hoarders of

holy bones, were motivated by a struggle to achieve peace of mind. The humanist collectors then turned to another sort of relic. Antiquities should be regarded as a kind of token, since to the humanists they were an indication of the revival of pre-Christian ideals. Turning to these mementos of classical Rome was thus an indirect indictment of the Roman Catholic church. To the humanists such antiquities and ancient manuscripts they collected answered an emotional need that was not fulfilled by the Church at the time of the early Renaissance.

The seventeenth century, however, presents a conspicuously more complex and perhaps more advanced spectacle. The social, political, economic, and, last but not least, religious forces had undergone considerable change. Spain had lost her predominance. Protestantism had made its striking impact. Europe's northern region, predominantly the Low Countries and England, were now of key importance, not only in a world trade but also as major cultural centers.

Much of the mood of the time emanates from the lively and often engaging annotations of John Evelyn (1620–1706), the famous English diarist who spent several years of his early adulthood on the Continent. In Paris as well as elsewhere he paid visits to various collectors, something that he obviously delighted in. For example, Evelyn made notes on a visit he made to a Monsieur Perishot. He was quite impressed. He describes Perishot as

> one of the greatest Vertuosas in France for his Collection of Pictures, Achates, Medaills, & Flowers, especially Tulips & Anemoneys: the Chiefe of his Payntings were a Sebastian of Titian: from him we went to a Monsieur Frenes, who shewd us also many rare drawings, a rape of Helens in black Chalke; many excellent things of Sneiders, all nakeds; some Julios, & Mich. Angelo: a Madona of Passegna, somethings of Parmensis and other Masters [1 March 1644].[203]

Evelyn's notes reflect what kind of things his well-to-do bourgeois contemporaries were collecting. Seven years after his first stay in the French capital, he comments on his visit to the "Collection of one Monsieur Poignant, which for a variety of *Achates, Chrystals, Onyxes, Porcelain, Medails, Statues, Relievos, Paintings, Tailes douces* and Antiquities might compare with the Italian Vir-

tuosos."[204] Descriptions such as these are crucial because they give us an idea of the fashions of the time and what the prevailing styles in collecting were in the days of Louis XIV.

It is instructive to observe that what was for the humanists initially a revelation of life, of nature, of hitherto unknown cultures and customs, quite soon developed into an undeniable fascination with the object itself, while paintings, sculpture, and other works of art were soon found to be inspiring and in essence a rich source of stimulation. It is conceivable that the almost religious commitment of men such as Jean de Berry or even the insatiable acquisitiveness of a Rudolf II could not be repeated a hundred or two hundred years later. By the time curio collecting became de rigueur among the affluent, the basic motivation had been colored by the realistic climate of science, the concern with classification and comparison.

We are not questioning here the initial intent, the unconscious desire for security and firm orientation. But when, at a certain time in history, collecting becomes a matter of fashion, it is all too evident that what once was a deeply emotional, and perhaps even revolutionary, endeavor for a few, had gradually shifted into a romantic outlet for the many.

In August 1641 we find John Evelyn in Holland. He toured several towns and visited museums and collectors, always as a keen, open-eyed observer. At the University Museum at Leyden he saw "naturall curiosities; especially all sorts of Skeletons, from the Whale & Eliphant, to the Fly, and the Spider, which last is a very delicat piece of Art, as well as Nature."[205] The museum also owned "an hand of a Meermaide presented by Prince Mauritz."[206] Examples of this type must have had a particular appeal because we know that another astute Dutch collector, the well-known Amsterdam pharmacist Jan Jacobz. Swammerdam, prided himself on another such hand, in addition to a unicorn, 1,900 shells, and an impressive number of other rare objects.[207]

Swammerdam was not one of the Amsterdam patricians, some of whom used to collect because this was an element of modernity in seventeenth-century Dutch society. We will have more to say about him in the next chapter. He was rather a well-to-do burgher and an enthusiastic garnerer of rare specimens. "The visitor of such a collection would not compliment the owner for his refined choice but for his universal interest (curi-

ositas).["208] It is noteworthy that a collection of this kind stressing *naturalia* reflects a Protestant-scientific outlook concentrating on tangible reality. Essentially, the aesthetic feature was minimized, if not excluded, in favor of scientific verifiability and observation.

"It is my aim to establish a universal inventory of the most curious natural rarities," stated the German collector Johann Daniel Major.[209] Indeed, in retrospect there seems to be little romance left in descriptions such as "rerum tam artificiosarum, quam naturalium, tam antiquarum, quam recentium, tam exoticarum."[210] This sounds like a defensive veneer of reason compared with the acquisitive enthusiasm of a Poggio Bracciolini or the craving for constant replenishment of a Jean de Berry or Rudolf II. But this does not mean that collectors in the Netherlands, in England, and in Germany lacked enthusiasm or didn't exhibit a narcissistic pride in their collections (as the next chapter will demonstrate). In fact, they couldn't escape envy and criticism.

In 1696 Mary Astell wrote in quite a censorious manner how this sort of collector

> trafficks to all places, and has his Correspondents in every part of the World; yet his Merchandizes serve not to promote our Luxury, nor increase our Trade, and neither enrich the Nation, nor himself. A Box or two of *Pebbles* or *Shells*, and a dozen of *Wasps, Spiders* and *Caterpillars* are his Cargoe. He values a Camelion, or a Salamander's Egg, above all the sugars and Spices of the *West* and *East Indies*. . . . He visits Mines, Colepits, and Quarries frequently, but not for that sordid end that other Men usually, do, vis. gain; but for the sake of the fossile Shells and Teeth that are sometimes found there. . . .
>
> To what purpose is it, that these Gentlemen ransack all parts both of *Earth* and *Sea* to procure these Triffles?[211]

Today, we would try to convince Mrs. Astell of the lofty motives of these gentlemen. We would point out that, whether their rationale was study or curiosity or merely possessiveness, they followed a trend that began in Petrarch's time and continued with artists, scholars, and patrons such as the Medicis before it became the concern of any gentleman.

Once Western Europe reached the Reformation, some of the romantic dedication of the early collectors was curtailed. Intel-

lectual individualism seemed to contain affective fascination. More strength was drawn from orderly observation and knowledge than borrowing support from magico-religious sources. Everyone fell under the spell of an attempt at a "civilized compromise." But then one ought to ask where the difference lies between the gentlemen who ransacked "all parts of both earth and sea," as Mrs. Astell put it, and the generals of the Roman army who ransacked Greece, Sicily, and Asia Minor?

These are variations embedded in the cultural mold and in the prevailing spirit of the era. The purpose of collecting, we would try to explain to Mrs. Astell today, is to cope with a deep sense of uneasiness, if not self-doubt, and a need for orientation. Certain people—collectors—can find no better answer than the notion of being special by demonstrating what they possess or have found or, in the religious believer's experience, of being blessed.

A greater sophistication and more widespread and better organized communication system helped change taste and perspectives. The early Renaissance marked the initial step in the modern approach to collecting; the Baroque era and the Age of Enlightenment speeded things up, provided new and different viewpoints to the habit and a vast array of different specimens to collect, and new aspirations for the committed collector.

As time passed, the focus shifted and expanded. Less inhibited curiosity allowed for greater discernment and widened criteria allowing, perhaps, for a greater differentiation in aim and the experiential process of acquisition. It made the collecting habit both more complex and possibly more dynamic, of course, but what remained constant is the fact that it is inextricably bound up with an inner need for ever new supplies for the enhancement of the self.

In Praise of Plenty:
Collecting During Holland's
Golden Age

THERE IS NO RECORD of exactly how many people in the young Dutch Republic of the seventeenth century collected. Some chronicles seem to indicate that nearly everybody became a prospective collector. The recently won freedom from decades of oppression and insecurity thanks to the ruthless rule of Spanish despots had ushered in a period of zest and feverish animation. Along with the prosperity due to their bold seafaring undertakings and the ever-increasing competitiveness in international mercantile trade provided a successful base for these burghers to express their enthusiasm for life and their forward-looking enjoyment of worldly pursuits. One way of expressing this enthusiasm, regardless of their Calvinist piety, was demonstrated by the Dutch people's out-and-out love for earthly goods.

Officially peace had come only after a treaty was signed in 1648, known as the Peace of Westphalia. But the foundations of a nation were laid earlier, during the 1580s, when the core of the Dutch Republic and the inception of both the economic expansion and a growing awareness of a distinct cultural selfhood can be traced to the time of William of Orange and the Union of Utrecht in 1579. It was then that political forces split the Low Countries into a southern Catholic domain consisting of Flanders and most of Brabant and the largely urbanized northern region, the so-called Seven Provinces, which leaned essentially toward Protestantism.

This was the time when, with much emphasis on predominantly Protestant ethics, Dutch civilization started to blossom. Commercial, maritime, and agricultural successes were joined by the new political identity, and the overall effect began to threaten and eventually diminish the preeminence of the neighboring trading centers to the south, Antwerp, Bruges, and

Ghent. Amsterdam became the heart of the northern province and its cultural and economic activities, quite openly and successfully competing with Venice.

Townspeople and peasants alike became patrons of the arts, mainly of painters and draftsmen while there seemed to be less passion for sculptural works, as Huizinga already found.[212] Still, these people's exhilaration after many decades of brutal tyranny and ever-present insecurity continued for the better part of the seventeenth century. The courage and moral character they showed during the decades of Spanish rule and occupancy carried the seeds for an unrestrained cultural and intellectual transformation. The entire country seemed to feel revitalized and ready to participate in genuinely relishing the new freedom.

For example, so many of Dutch seventeenth-century paintings give us a blissful, even euphoric description of a sense of well-being, thematically and psychologically. Jan Steen's peasants are merry and truly relaxed, at times even lustful and frivolous; Piet van Ostade's paintings provide us with a lively idea of rural everyday life; many still-life pictures reflect opulence and often the visible enjoyment of culinary plenitude; the paintings of buildings—solemn churches by Saenredam, or townscapes by Berckheyde—echo the indispensable Calvinist restraint, while the numerous portrait paintings seem to have been part at least of the prosperous people's house decoration and interiors. As Schama remarks: "It was common for burgher families to own works of art."[213] But then Huizinga reminds us that even when people collected they had a different approach from ours:

> The collector was not a collector in the modern sense of the word. He was far more concerned to own works of every genre than of every great master. The average buyer greatly preferred possessing a country scene, a landscape, a seascape, an allegory and above all his own portrait to owning a Van Goyen, Steen, Hals or Porcellis. There were, of course, exceptions to this rule.[214]

Acquiring decorative objects of all sorts seems to have been part of the recently emerging way of life among Holland's burghers of the seventeenth century, after the collective trauma of the Spanish reign of terror.

This was, I suspect, a phenomenon under the influence of the young nation's newly found prosperity and commercial prominence, and quite possibly as a result of it, part of shifting values.

And along with the changing fashionable trend there was much emphasis on comfort and good living.

The oft-quoted British diarist John Evelyn, in the course of his Grand Tour, was an eyewitness to it. He paid a visit to the Low Countries, stopping off in Rotterdam, Delft, Amsterdam, and several other towns in the Netherlands. Evelyn was twenty at the time and ready to be surprised. He left a lively account of his journey which gives us a colorful description of the burghers' everyday life during the middle of the seventeenth century, the height of the Golden Age. One gets the impression of solid prosperity and the genuine contentment of the people with their simple bourgeois wants. No sooner had Evelyn arrived in Rotterdam in mid-August 1641, he was moved by the entire atmosphere of what he saw. He was taken with the evident abundance he found and the overall uplifting tenor of everything he came across. While in Rotterdam, he notes, that he paid a visit to an

> annual marte or faire, so furnished with pictures (especially Landskips and Drolleries, as they call these clounish representations) that I was amaz'd. Some of these I bought and sent to England. The reason of this store of pictures and their cheapnesse proceedes from their want of land to employ their stock, so as tis an ordinary thing to find a common Farmer lay out two or three thousand pounds in this com'odity. Their houses are full of them, and they vend them at their faires to very great gaines. Here I first saw an Elephant, who was extremely well disciplined and obedient. It was a beast of a monstrous size, yet as flexible and nimble in the joints, contrary to the vulgar tradition, as could be imagined from so prodigious a bulk. . . . I was also shown a Pelican, or *onocratulas* of Pliny.[215]

A few days later, we find the young traveler in Amsterdam, where he takes special notice of the impressive streets and patrician buildings. Moreover he admires "the multitude of vessels which continually ride before this Citty, which is certainly the most busie concourse of mortalls now upon the whole earth."[216]

Evelyn's remarks touch upon Holland's phenomenal economic expansion emerging as a world power within the first forty years of independence from the yoke of Spain's despotic regime of religious and political terror. It had caused intermit-

tent unrest among the Dutch people. Exorbitant taxation, religious persecution, and a series of poor harvests led to a popular revolt and bloody riots all through the Netherlands. By the summer of 1556, the unrest had spread from Brabant to the Northern Provinces, and a raging mob swept through the streets of Antwerp and Ghent, and soon reached Haarlem and Amsterdam.

In order to understand what had sparked this frenzied passion, we must extend our perspective and examine the Dutch people's reaction to the decades of Spanish suppression. Philip II of Spain, who had become king upon the death of his father Charles V, had sent the Duke of Alba to the Low Countries to crush the revolt. Vested with the king's authority, the duke instituted a rule of terror and demoralization in order to put down the rebellion. There were no concessions, whether political or religious. But neither the duke nor his successor, Don Luis de Requesens, could maintain order. The rebellion, with Prince William of Orange (better known as William the Silent) as the head of the uprising, continued to spread. Soon the Dutch, always systematic and well-organized, were attacking their oppressors from both within the country and without, from the sea.

By 1579 five of the Northern Provinces had separated themselves from Spanish rule and established the Union of Utrecht under the leadership of Prince William, thus consolidating the northern part of the Netherlands and making this territory the focal point of the fight for freedom. But other tests awaited these people, not the least of which was the assassination of their leader, in 1584. Again the Dutch were exposed to the ravages of war and destruction. Finally, four years later, the supposedly invincible Spanish Armada was defeated, luckily with the aid of a tempest in the North Sea. And now, at long last, after much intrigue, suffering, and bloodshed, the Dutch were free. The country had dearly paid for sovereignty and stability.

There can be little question that the decades of foreign rule and suppression, of war and famine, had taught the strong-willed burghers the value of visible and tangible earthly possessions. And possessions have, as we have seen in earlier chapters, a reparative, even healing, capacity. The hard-won sense of security and stability, now linked to the Calvinist- and Mennon-

ite-Puritan ethic of industry and thrift, soon ushered in a century of incomparable achievements, of extraordinarily fertile artistic creativity, of aesthetic perspectives and a broad cultural and scientific advance. In just a few years, a nation of peasants and fishermen was transformed into a thriving community of urbanized merchants and enterprising seafarers. This state of well-being offered the Dutch the opportunity to ameliorate the traumata of the decades of strain and distress. From this point of view the vogue of obtaining paintings, all kinds of works of art, and decorative objects, to which Evelyn refers, appears to be a reactive response after the many years of suffering. His sketches of the bustling activity and affluence he found in Amsterdam, in Rotterdam, in Delft communicate the ambience of this unique period in Holland's history.

It does not require much insight to recognize in such an emotional expression a compensatory need. Lewis Mumford saw "a tendency to seek relief from remembered horror in unbridled drinking and fornicating, and to swing from a harsh facing of reality into an over-indulgent escapism," after people had been exposed to death and destruction.[217]

After such traumatic experiences, rational pursuits are often put aside, although one cannot say that irrationality is the inevitable consequence. On the contrary, the Dutch gravitated to exploration and that dynamic activity which so impressed the twenty-year-old Evelyn. The emotional effects of the newfound liberation spread like wildfire. It is conceivable that after the defeat of their oppressors they were now looking themselves for mastery, which they found in their various enterprises in the physical world. The diminished external pressure led to an ever-increasing sophistication in the spheres of thought, of cultural pursuits and learning. The transformation of the Zeitgeist encouraged new aims and new intellectual perspectives, and brought about a new scale of values. The universe promised more and more surprises. The curiosa that now began to flood the country offered evidence of the existence of what hitherto had belonged to the universe of fiction and fairy tale, and much of the earlier world of miracles began to crumble. The new discoveries opened new avenues for changing beliefs and ideologies.

At such moments in history, the promise of transformation elicits new and different signifiers, and new and different objec-

tives. Together with prosperity and a growing commitment to individual liberties, there appeared a distinct shift in values, and collecting soon became one of the phenomena of change in terms of inner and outer reality. In historical reconstruction, I believe, the widespread inclination to collect all kinds of objects as well as works of art constituted a continuing attempt at reintegrating contentment with tangible, concrete "things" after decades of deprivation and frustrated longing for security and "the good life." One only has to take a careful look at the so-called Vanitas pictures, allegorical paintings of the era, in order to appreciate the rich imagery and sign language, which the people understood. One of the frequently appearing objects is, for example, the hourglass, a reminder of the limit of earthly existence, like the pipe and tobacco that were supposed to remind us of ethereal airiness, of worldly irretrievability calling attention to the limits of life and the ultimate truth. We also find shells from foreign seas, strange weapons, and previously unknown fruits and vegetables like the coconut. Then there are specimens from Asia, Africa, the Americas, glasses and chinaware, maps and instruments. I must draw attention to the fact that many of these and other objects depicted in these paintings come right out of the curio-cabinet.

As I have shown in the two previous chapters, we can trace the fascination with this aspect of collecting back to the Renaissance, which started to provide man with a different and broader perspective of the human condition. In a more basic sense, it gave permission to *look* and *explore*, rather than to simply believe and put one's faith in the preachings of the Church. Men like Petrarch and Jean de Berry were, because of their social prestige as well as their temperament, representatives of a vanguard that soon attracted disciples, followers, and imitators, the usual course in the dissemination of cultural innovations. What had started among the aristocrats, first in Italy and to some degree in France, soon became something to be copied and imitated by the "patricians lately waxed rich, who sometimes also derived fine-sounding titles from a manor they had purchased."[218] Collecting, then, took a markedly significant position in the pursuits and envy of the burghers who followed in the footsteps of their paragons.

Certainly not everybody became a collector, especially in the strict sense of the concept. Dedicated collectors are always a

small minority of the population. Others, often in doubt of their identity, may simply follow their example. Dutch collectors found their model in the southern Netherlands, which at the time was effectively a separate country.

Flanders and Brabant had had a well-to-do middle class when Antwerp, Bruges, and Ghent were the trade centers of northwestern Europe. Moreover, during the sixteenth and early seventeenth centuries, these towns were the hub of northern European cultural activity, under the guidance of their governor, one of the most outstanding female collectors of all time, Margaret of Savoy, daughter of Emperor Maximilian I and Mary of Burgundy.[219]

Margaret, married three times and finally widowed at the age of twenty-four, had been installed as her father's representative in the Netherlands. A very competent and able woman, she was also highly literate and a discriminate collector of works of art and artifacts of the first rank. She had a superb library of illuminated books and manuscripts, and paintings by the then leading artists in her domain, among them Rogier van der Weyden, Mabuse (Jan Gossaert), Jan van Eyck, Hieronymus Bosch, and Dirk Bouts.

No wonder, then, that her subjects were so impressed by her example that we soon hear of extensive private collections among the Flemish and Brabant high bourgeoisie, among them the painter Peter Paul Rubens and his in-laws, the Brants and Fourments, both families of great wealth and respectability.[220] However, it was not the respect for the Court and other dignitaries which sparked the collecting craze. It was essentially an affirmation of mastery after so many years of foreign rule.

There were already coin and medal collectors. For instance, by the beginning of the seventeenth century, Barent ten Broeke, a physician in the town of Enkhuizen, had a reputation for his encyclopedic collection of *artefacta* and *naturafacta*, along with ethnographic objects from Africa and the Far East, "Chinese porcelain, Italian majolica, Spanish and Portuguese earthenware, French ceramics (probably the so-called 'Palissy') and even Dutch porcelain dishes and cups."[221]

Another collection not too different from that of ten Broeke (better known under his Latinized name of Bernardus Paladanus) belonged to none other than Rembrandt. Again, we possess

an inventory of his entire collection, made up at the time the painter had to declare bankruptcy in 1656, when Amsterdam authorities directed that one be made for the sale of his belongings. "The Trustee of the insolvent estate of Rembrandt van Rijn, art painter . . . ," begins the announcement.

I question whether an artist's collection offers an indication of the habitual collector's cause or basic incentive. No artist, particularly so gifted a painter as Rembrandt, needs or seeks fulfillment in what he collects since that fulfillment is implicit in his own creations. But we know from contemporary artists' collections that they provide animation and inspiration, or may even sway his barely conscious susceptibilities, long before the artist himself is fully aware of the source. Rembrandt, like other artists, frequently sought inspiration in the past. We know, for example, that he owned a group of antique sculptures, among them the busts of Homer, Aristotle, and Socrates, which are shown in his well-known painting in the Metropolitan Museum in New York. Other Rembrandt paintings depict weapons and armor of which, according to his own inventory list, he had some two thousand examples of such objects. He also collected feathers of various exotic birds, as well as stuffed birds and ethnographic specimens from Asia and the Americas. And then there were fossils, minerals, and coins, besides porcelain from China and Japan and a vast collection of prints and Italian, German, and Dutch paintings.

Not every Dutch collection of the seventeenth century showed such a vivid inquisitive mind as revealed in Rembrandt's diverse possessions. But as an Amsterdam citizen, he was well situated right in the middle of the cultural and commercial activities in the Low Countries. Amsterdam had gradually taken over the role of international trading center previously overshadowed by the Flemish port of Antwerp. The emotional overtones in Protestant Holland after the defeat of the Spaniards were marked by elation and a taste for a carefree, comfortable existence. There was a distinct public-spirited, I suspect even frantic, spark of optimism.

The Dutch expressed their optimism and forward-looking mood by redesigning and developing their towns, not without obvious pride and pleasure. They improved the canals and their transport system. One only has to take a walk along the canals

in order to recognize the lasting impact of seventeenth-century city planning and architecture on Dutch towns. But this atmosphere did not stop outside of their houses. The many interiors Dutch painters left us are a testimony to even the unassuming burghers' delight in decorating their houses. There was a constant demand for paintings, and I agree with Huizinga that it was in this ambience that "many a mere owner was transformed into a collector with a gallery of his own—not only among the very rich. In this way, the emphasis gradually shifted from enjoyment of good likenesses towards the sheer love of art and beauty."[222]

Historical events followed each other in rapid succession. After so many years of occupation and enslavement, the peoples' prospects changed dramatically. Evelyn visited the university at Leiden and "the famous printer, Elzevir's printing house [Elsevier—still in existence at the end of the twentieth century] and shop, renowned for the politeness of the character and editions for what he has published through Europe. Hence to the physics-garden, well stored with exotic plants," and later to the anatomy school.[223] The young traveler convinced himself of Holland's rapid scientific advances, of new technical skills, of the merchants' exploratory journeys, and the attendant reports about new lands beyond the seas. Evelyn noticed the "extraordinary industrie" in Amsterdam overtaking Antwerp in all respects. Only half a century earlier the Flemish town had been northwestern Europe's cultural center. The Florentine historian Guicciardini counted then about three hundred painters and etchers in Antwerp, an impressive proportion of the entire population. One must keep in mind that there were only a hundred seventy-nine bakers and seventy-eight butchers in the city.[224]

Now Antwerp, as the result of the political struggle and the determination of the Northerners, had ceded her cultural as well as mercantile predominance to Amsterdam. Antwerp had been a truly international center, especially between southern Europe and Germany and the Baltics, and many merchants who visited the town bought not only paintings and sculptures but also books, maps, and curiosa during their sojourn in Flanders. And besides Antwerp there were Bruges and Ghent, towns that were hardly less lively and creative than Antwerp as far as the production of works of art was concerned. In fact, they were to

Antwerp what Haarlem and Leiden were to Amsterdam at the time of young Evelyn's visit.

Thus, what had been hatched in the South quickly came to maturity in the North. We must keep in mind that the psycho-social dynamics which these environmental conditions of zest, of advance and prosperity bring to the fore, help stimulate mental climates which further encourage new intellectual endeavors. As I said already, visitors to Antwerp acquired not only paintings and books but also curiosa, items sailors had brought back from their travels to other lands.

We hear quite similar accounts about the hustle and bustle in Amsterdam. The inventory of Rembrandt's collection is a manifestation of the rich and varied supply of "collectibles" at that time.

The mode in relating to the new tangible changes and achievements is also well reflected in the activities of a man such as Jacob Swammerdam, whom I mentioned in the previous chapter. We don't know whether his initial incentive was that of an obsessional collector or, rather, of a detached and scientifically oriented man, a systematizer. In any case he adapted his inclination to the prevailing opportunities and left us a rather characteristic example of an alert and perceptive burgher of his time. He earned his keep as an Amsterdam apothecary.

Ailing sailors returning from their voyages to strange lands came to Swammerdam for medication and advice. In exchange for providing them with his pharmacological knowledge and medicinals he used to ask not for remuneration but for obscure objects and strange specimens these voyagers had brought from all corners of the globe. In this manner he built a famous collection of curiosa which he had well organized and catalogued according to the then customary divisions.

Swammderdam's *Konst-Kamer* (curio-cabinet) and rarity collection in many ways reflected the brisk activity in and around Amsterdam's harbor. The catalogue of his collection, a kind of private museum, was compiled by his son Jan, a to-this-day famous entomologist. It suggests something of the alertness and intellectual opportunities under the exhilarating atmosphere of the era. After his death in 1679, the collection was offered for sale. In all, it contained twenty-six curio-cabinets which had been divided into four categories: "Items from mines" (*berg-*

213

werken), "growing things" (*groeiende zaken*), "animals," and "works of art," the latter including a considerable number of ethnographic objects.[225]

The same year another collector, the famous marine painter Jan van de Capelle, also died. Although only an amateur, van de Capelle was one of Holland's outstanding marine painters. But his actual profession was that of an astute and highly successful merchant. On his death, he left seven town-houses in Amsterdam to his children, in addition to forty-four bags of gold ducats, several barrels full of gold and silver, and a substantial amount of cash—13,000 florins, to be exact. Unlike Rembrandt and Swammerdam, he did not collect in an encyclopedic manner. Rather, he had what one might assume, a collection that reflected a solidly established taste and the preferences of a comfortable burgher of his time. His inventory listed 197 paintings, among them a Dürer, a Holbein, several works by Rubens, a Poussin, and no less than 7,210 drawings, of which 891 were his own and 516 were by Rembrandt. Both the painter and his father had their portrait painted by Rembrandt, quite a common practice among well-to-do burghers of the period.[226] In fact, I agree with Schama that the "most grandiose high-life interiors as we see them in the paintings by Metsu and de Hooch" are placed in the shade by the opulence of furnishings and decorations of the Dutch patricians.[227] We hear for example of the bedroom of the wealthy Amsterdam widow van Erp, decorated with twelve paintings, or one of her side chambers with gold-stamped leather hangings and fifteen paintings or a reception room with a large landscape and yet another twelve paintings besides numerous embellishments such as oriental carpets and mirrors.[228] Even the servants' room had seven paintings.

To be sure, Swammerdam's collection was conspicuously different. The emphasis was hardly on aesthetics nor on taste. Nevertheless, people with an inclination to learn about the unknown and find an opportunity to gather rare or exceptional specimens of any sort take pride in procuring examples of special interest. Irrespective of their scholarly or scientific aims, they bring into focus the plain enjoyment of possessions as well as a sense of mastery by exploring opportunities to add to their assets.

People such as Swammerdam, no doubt, had different ideas than overdecorating their houses with paintings and ornaments. What seems worthwhile mentioning is that the fact of finding gradually quite divergent themes and outlooks among collectors demonstrates an increasingly greater differentiation of individuals, of attitudes, and tastes. It also gives evidence that about the time of the late sixteenth century collections became more focused, and the more distinct environmental stimulus is clearly reflected in the collections that were characteristically personal.

A collection such as the curio-cabinet of a seventeenth-century Dutch apothecary is indicative of the effect of the new cultural and socioeconomic circumstances in the northern Netherlands. As the result of the new freedom people soon learned to enjoy a new vitality. Swammerdam serves but as one example of the kind of thought, of new values and action that people started to relish.

We do not know why the apothecary began to look for curiosa, ultimately building up one of the most representative collections of this kind. But we can assume that internal and external circumstances allowed him to respond to his inclinations and use his collecting of strange and unknown objects as a desirable vehicle to express his individual, possibly obsessional, inclinations. In other words, collections of curiosa revealed personality traits with a preoccupation for organization, orderliness, even exactitude. It tells us more about the collector's need for mastery. That is to say that the setting of curio-cabinets is evidence for a growing secular perspective dividing his holdings into *fossilia* and *metallica, vegetabilia, animalia*, and artefacts, and a large group of what he labeled *exotica*. As private museums of this kind were already fashionable enough, there appeared guides and handbooks in print advising collectors how to arrange their possessions.

There is a hint here of what later became a major pursuit of collectors—a categorizing and organizing tendency of making subdivisions of their holdings. Divisions such as *Naturalia* and *Artificialia* are very frequent in early catalogues. And we start to encounter such terms as *Repositorium Naturae et Artis* (Repository of Nature and Art) and *Mundus Sensibilis* and *Mundus Intelligibilis* (World of the Senses and of Knowledge).

Categories as such have a realistic as well as psychological function. They aid the owner's efficiency but at the same time tell us about a person's attempt to envisage his or her life in a codified or ritualized fashion by using this technique in order to be in charge if not in control or to dominate. These are examples of symbolic action still observable to this day and especially frequent among collectors who tend obsessively to collect series or limit their holdings scrupulously to particular periods or areas or themes; for example, certain coin or stamp collectors get intense pleasure from finding the one coin or the one stamp that will complete a series in their possession. Or I met a young Dutch collector of eggcups determined to limit his holdings to this particular theme. But then he took pride in showing me the greatest variety of eggcups from all parts of the world imaginable.

I am emphasizing this tendency here because it preoccupied many a collector at the time of the Renaissance and post-Renaissance. As we have seen, the popularity of the curio-cabinet or *Wunderkammer* during this period of cultural development in Europe relates to greater emancipation from devout belief in a world ordained and intoxicated by the Church. With their new-found freedom of thought and action, people were looking for evidence of a tangible and real, rather than mysterious, universe. Just as a child arrives at a stage when he or she has an urge to find out where babies come from, so did people of the sixteenth and seventeenth centuries with much inquisitiveness seek to expand their intellectual horizon. This liberalization of thought and advance in scholarly and scientific pursuits lay behind the impressive determination for enlightenment, not only in the Netherlands but much of Europe (even though the Low Countries were in the forefront of this development, possibly resulting from so many decades of experiencing acute personal fears and persecution besides the overall political suppression and control).

These factors deserve some emphasis here because they cannot but affect a peoples' worldview and behavioral responses. There is a distinct correlation between the emotional states evoked by threats and insecurity, and clinging to factual data and knowledge and collecting objects. Nor was it coincidental

that, at the same time, Dutch physicians studied and taught anatomy, exploring as it were the tangible inner world.

The Dutch now represented the nouveaux riches of Europe. There was no question as to the country's social and economic stability at a time when their former oppressor, Spain, was in decline, and the Dutch people's commercial and expansionist activities, and the concomitant prosperity, triggered a fervor and an overall intensity that could not help but lead to certain excesses. The portrayal of the markets, of the activities in the harbors, of some houses foreign visitors described, extended further. One of such excesses was the tulipomania, which shall be discussed shortly.

In their search for a new self-definition and direction, and lacking inspiring forebears or a court, or an aristocracy that would set the prevailing style, some people sought inspiration beyond the country's boundaries. As one example I may refer to two young Amsterdam collectors, the Reijnst brothers. Their father had died when they were still in their adolescence. At the time he had been governor-general of the recently colonized Dutch territories in the East Indies. His two sons, Gerrit and Jan, while still in their early twenties, became involved in the family business, an import and trading company of impressive proportions. Jan, the younger of the two, settled in Venice as the representative of the firm, directing its affairs with particular astuteness. Although Venice was no longer Europe's economic capital, to many it still stood for elegance and classic taste, perhaps not dissimilar to the shift in Paris's current position after having been seen for several centuries as the cultural center of the Western world.

Jan quickly turned into an Italophile and became infatuated with the Italian, or more correctly the Venetian, way of life. As a great admirer of Italian culture, he had an outspoken predilection for Roman and Greek antiquities,[229] and unquestionably preferred them to contemporary Dutch art. And when the Venetian Doge Andrea Vendramin died in 1629 and his famous collection became available, the Reijnst brothers bought (presumably with the assistance of an adviser to Louis XIV of France, the well-known painter Nicolas Régnier) a large part of the Museo Andreae Vendrameno en bloc.

217

Two years before the doge's death, a seventeen-volume catalogue had been printed which described the contents of his museum. It was a considerable part of this collection, which consisted of hundreds of paintings, sculptures, and antiquities, that the Reijnst brothers now brought to their recently acquired mansion at the distinguished address of 209 Keizersgracht in Amsterdam. The house quickly became a kind of cultural gathering place, well-known to European connoisseurs. Visitors to Amsterdam considered it an honor to be invited to see the collection, and some of them described it in the most laudatory terms.[230]

A German visitor, Christian Knorr von Rosenroth, found the house palatial and the collection encyclopedic, since the Reijnsts had by this time added to their original purchase art objects, coins, gems, shells, and other *naturalia*, as they were called.[231] A Dutchman, Melchior Fokkens, compared the house to "a King's Palace . . . [with] Roman and Indian decorations and rarities."[232] Among the many works of art in the collection were paintings by Bassano, Titian, Andrea del Sarto, and Veronese, and at least ninety-eight antique sculptures. Interestingly enough, the brothers had bought only a few works by Dutch masters, and even these belonged to the Italianizing School of Utrecht.

Jan seems to have been the more active collector of the two brothers, spending a good part of his time in Venice where he belonged to the most fashionable circles of the local smart set.[233] He also represented the Dutch Republic at the Court of Louis XIV, who eventually knighted him. He died in Venice at the early age of forty-four.

One wonders if Gerrit and Jan Reijnst, influenced as they were by their commercial connection with Venice, were inclined to display the social graces of the Venetian patricians in their hometown. Their preference for Italianate taste is beyond question. Italian paintings, with their often greater flair for color and complex movement, as well as their different subject matter, obviously had more appeal for them than Dutch works, which were thematically sometimes more sensual but less flamboyant.

What motivated these two urbane young merchants to acquire an art collection of such high repute? As the sons of a former governor-general of the East India Company, their social status was impeccable, and they certainly had no reason for

seeking to establish a new public image. They were enterpris-
ing, cosmopolitan, "enlightened amateurs, gifted, with flair, and
not afraid of big prices," in Lugt's succinct description of them
to F. H. Taylor.[234] Acquiring a large part of the ready-made col-
lection and bringing it lock, stock, and barrel from Venice to the
Netherlands almost seems like a bravura act designed to im-
press the Amsterdam *burgerij*.

While they must have had a reason to distinguish themselves
from the mainstream, it is difficult to trace their immediate aim
in buying a collection in this fashion. Whatever their motivation,
there is little question of their preeminence in the international
art circuit. Only a month before Jan Reijnst died in Venice in
1646, Carlo Ridolfi had dedicated the first volume of his *Mara-
viglie dell'Arte* to the "Illustrissimi Signori Fratelli Reinst." Re-
gardless of whether the author intended to express his admira-
tion for the brothers or just wanted to retain their goodwill, the
dedication clearly offers an indication of their prominence in the
international art world.

As an example of a way of collecting, the wholesale acquisi-
tion made by the Reijnst brothers may have some kind of special
meaning, though one does not want to speculate on their intent.
Clearly, the Vendramin collection had proven its distinction. It
was famous because of its quality as well as because of the name
of its previous owner. Did it represent a solution to a dilemma?
Did it confirm a feeling of superiority the brothers had about
their compatriots? Or did Andrea Vendramin provide them
with a father image, since they had lost their own father during
puberty and had been orphaned at the ages of sixteen and four-
teen, respectively? And finally, did the brothers perhaps feel
that, by owning many of the Vendramin treasures, they were
only following in the footsteps of the historical and economic
development of Europe? We know that by this time Venice had
lost much of its position and prestige to Amsterdam, sometimes
called the "Venice of the North" because of its closeness to the
sea and the fact that both cities have canals.[235] It is possible that
to the brothers the Vendramin treasures could have seemed
much like laurels brought home from battle, like the Greek
works of art which had been carried back to Rome in triumph.

The Reijnst collection shared the fate of so many others. For
twelve years after Jan's death, Gerrit carried on the fraternal

pursuit until he was drowned in the Keizersgracht in 1658. Two years later, his widow sold twenty-four Italian paintings and twelve antique statues for the price of 80,000 guilders to the Dutch government. The government then offered them as a gift to Charles II of England. Gerrit's son Joan seems to have sold various other objects in the collection, and in 1673 the well-known Amsterdam art dealer Gerrit Uylenburgh arranged for an auction sale of Italian paintings, among them probably several from the Reijnst collection. Today, many of their holdings have disappeared, while others have found their way to England, Germany, and the United States. Some have remained in the Netherlands and now belong to the Museum van Oudheden (Museum of Antiquities) in Leiden.

The vogue of collecting something or other soon had affected almost the entire country. The Reijnsts got their immediate incentive from the Italians, quite conceivably identifying more specifically with the established Venetian aristocracy, perhaps thereby borrowing the illusion of being of different and possibly better status than their Dutch compatriots.

Others like Swammerdam were under the spell of the new enlightenment, especially in cities such as Amsterdam, a major port that offered all sorts of opportunities for discovering curiosa and choosing a collecting field.[236] Still, all the different kinds of collecting during this period can be seen as living examples with the reassuring function of having and holding something, and as proof of power and control. To the Dutch of the era, the world was full of novelties. Rembrandt's occasional use of feathers, strange birds, chinoiserie, and antiquities in his paintings and drawings reveals the interest in and stimulation of hitherto unknown items. We must remember that using items of this kind was distinctly modern, and that, for example, Chinese pottery, especially of the Wan-Li and Kang-H'si period, was highly en vogue. Works by Breughel de Velour, Jan van Kessel, Frans Francken II or Willem van Haecht, to mention only a few artists, also reveal a fascination with collecting as such and with the opulence of uncommon and often perplexing things.[237]

In this sociocultural setting, it may be instructive to examine what might be considered a peculiar sideshow of the era. Many of the new goods were brought north via the Mediterranean and the Middle East. First they were exhibited rarities, like the ele-

phant John Evelyn found so impressive in Rotterdam, or shown in collections, which often contained "shell creatures" or "outlandish fruits" or strange flowers. Among those flowers was the tulip, which was destined to play a particular role in Dutch socioeconomic history. Here, as so often happens, curiosity and the scientific exploration of observable phenomena overlapped.

As far as is known, the tulip was first introduced into Holland from Persia or Turkey at about the middle of the sixteenth century. It was originally brought to the court of Emperor Ferdinand I in Vienna by the Imperial Ambassador to the Turkish court of Suleiman the Magnificent. The diplomat, Ogier Ghiselin de Busbecq, was of Dutch origin. At about the same time, the flower came to the attention of the ever-alert Venetians, who began marketing it in Western Europe. As early as 1565, and thus remarkably soon after its introduction considering the pace of communication in those days, the Swiss botanist Conrad Gessner gave an informative description of the flower, which he had seen growing in two Augsburg gardens, one of them belonging to the Fugger family and the other to the Hewarts, both international merchant bankers. While the information we have is quite scanty, it seems evident that, as so often happens, the Imperial Court and some aristocratic families had been instrumental in setting a trend. Gradually, the tulip, partly because of its shape, partly because of its fascinating variations in colors and stripes, became the most sought-after flower in Western Europe.

Along with the systematic study of plants and flowers there came a growing interest in botanical gardens and herbariums. One of the outstanding men involved in the scientific study of plants and herbal remedies was Carolus Clusius, or Charles de l'Ecluse, who had been in the employ of the Emperor Rudolf II in Vienna and Prague. He was the overseer of the Imperial medicinal herb gardens and had for a while joined Rudolf II's entourage in Prague. Clusius devised a detailed classification of plants in his *Rariorum Plantarum Historia* of 1601 and later accepted an invitation to join the faculty at the new University of Leiden, where he was attached to the medical school as a professor.

One anecdote about Clusius sheds some light on the tenor of the times. He began to develop new and beautiful variations of

the tulip, but his enthusiasm for this project soon waned because his bulbs were being stolen during the night. Whether this thievery was due to some amateur's zeal or to the steadily increasing commercial value of the bulbs is impossible to say at this time, but such thefts are obviously reminiscent of cattle rustling or pilfering works or art.

As the bulbs grew more and more valuable, many people became horticulturalists and began to raise them, and many more became collectors of, or speculators in, the bulbs. Tulips quickly became a national pastime on a truly immense scale, and no account of collecting in the Netherlands of the seventeenth century can afford to neglect the apparently irresistible spell of the tulip.[238]

Anyone who studies collecting and collectors soon learns that economic factors usually have an enormous influence on fads and fashions of the day. The economist N. W. Posthumus credits the tulip craze to the proximity of Amsterdam as a world trading center to the tulip fields, the so-called Bollenstreek, around nearby Haarlem and Alkmaar.[239] Another influence was the fact that the price was not always paid in cash, as we shall see shortly.[240]

The craze reached its height about a year after a devastating plague epidemic resulted in the death of thousands of people in the Netherlands, especially in the area around Haarlem. History tells us of the anarchic effect of the Black Death during the early Renaissance. A recurrent threat for more than three centuries, the plague carried with it the potential to cause enormous anxiety among the population, always followed by a search for, and clinging to, some form of magic relief. While the Dutch infatuation with the tulip began before this particular epidemic, there was now no protection against the breakdown of inner checks, resulting in an almost manic frenzy, and in no time at all the upper classes, ordinary city dwellers, and peasants alike engaged in a mad competition for tulips.

Readers may not agree that the *tulipomania* was somehow a form of collecting. But, in a stricter sense, much of what pertains to the infatuation with collecting bears on the behavior and overenthusiasm that involved the attitudes during the tulip craze. There was, for example, a very rare and according to some reports most beautiful specimen of the *Semper augustus*, with fire-red and white stripes on a blue base. A tulip collector,

Nicolaas van Wassenaar, bought one in 1623 for 1,000 florins, an enormous amount in terms of buying power at the time. However, after the transaction had been finalized, the previous owner noticed that there were two tiny bulbs just developing on the stalk, and felt that he had cheated himself out of another 200 florins. The next year the same tulip fetched 200 florins more, and by 1625 a bid of 3,000 florins for the flower was turned down.

This brief account serves to illustrate how a fashionable fad quickly developed into a passionate affective mania. By this time tulips were being treated like rare treasures and had turned into showy status symbols. Here is another concrete instance of what can occur because of changing psychosocial conditions. There is little question that the material success achieved by the Dutch during this dynamic period had placed an undue emphasis on both possessions and possessiveness. After years of deprivation and chronic anxiety, a new mood had arisen out of the echoes of the past and the empirical evidence of plenty.

There is no question about the manic overtones of the tulip craze. Clearly the newly won freedom of the Dutch had affected their traditional moderation. Many tulip collectors turned into speculators as prices skyrocketed, and the exercise of thrift seemed suspended. Tulips of the rarer sort were weighted and sold exactly like gold, and the transactions were frequently validated by public notaries.[241]

We can get a glimpse of the spirit of the times in the case of the famous landscape painter Jan van Goyen. He had originally dealt in real estate but then became a tulip enthusiast. In January 1637 he bought ten bulbs from the burgomaster of the Hague, Albert Claesz. van Ravensteijn, another tulip collector, and a week later he bought another forty bulbs as well as a group of cheaper ones by the pound for a total of 900 florins. However, two paintings were also included in the transaction, one by himself and the other by [Salomon?] Ruijsdael. To put this deal in the proper perspective, it should be noted that the price for an average-sized ox at the time was approximately 120 florins.[242]

The extent of the commitment van Goyen had made in buying the bulbs is indicated by the fact that four years later he still had not paid off the debt. In fact, he lived for another fifteen years

without ever getting out of debt. And this was by no means an exceptional case.

The *tulipomania* eventually subsided. It seems to have been an outgrowth of a period of undreamed-of material well-being, which led to irrational actions, of which the boiler-shop atmosphere of collecting and speculating is a striking manifestation. In such times, material success adds to the dynamic interplay of a strong desire to give proof of one's prosperity and comfort, and to use "collectibles" for those purposes.

It is apparent that the admiration for the object not only gives reassurance to the owner. It enhances his self-image. It also provides protection against the insecurities of the past. It is easy to see how quickly the collecting "bug" could spread in a period when the whole country felt the quickened pulse of life and everyone tried to partake in the frenzied activity. In such times people are almost destined to seek some tangible evidence of reassurance against renewed vulnerability. And after the many difficult decades it was now collecting and the embellishment of their towns and their houses, not their churches, that became the rage in the course of Holland's Golden Age.

PART FIVE

IN SEARCH OF PLEASURE

*

Ways and Means

THE PREVIOUS two chapters focused on historical periods that witnessed not only essential changes in Western man's perspective and his awareness of his manifest destiny but also the advance of rationalism and concomitantly the gradually diminishing impact of the preachings and dogmas of Latin Christendom. The schism in the Church was part of the breakdown of medieval culture due to changing social conditions and increasingly heterodox ideas.

However, probably nothing had a deeper and more lasting impact on medieval man than the collective trauma caused by the outbreak of plague or Black Death, first reported in 1347, when Petrarch was forty-three years old and at the height of his influence. Such a dramatic experience could not help but affect his ideology and worldview. We have already spoken of Petrarch's influence on rational thinking in an earlier chapter and noted that, regardless of the dramatic changes in the fabric of life in western Europe, it is finally the humanism of Petrarch and Dante which must stand as the preeminent source of *rinascita*—the Italian word for Renaissance referring to *rebirth*.

Ever since the trecento people tended more and more to search for the source of man's past and particularly for evidence of his Latin origins and ultimately his Greek heritage. Their inquiries reflected the intellectual and experiential leap from medieval ecclesiastical thinking to the enthusiastic exploration of the material world, including learning about the past and, as a result, developing a tendency to idealize antiquity. But this creative expansion was not restricted to a curiosity about history and mere intellectual inquiry. There was at the same time a practical side expressed in the vital pleasure taken in the possession of worldly goods and, to begin with in Italy, an astounding advance of urban development, of city culture and sophistication, even luxury.

There is no question that promising young artists like Donatello and Brunelleschi were deeply influenced by the mod-

ern spirit of the era. As I have already mentioned, they went to Rome as the "treasure hunters," looking for archaeological specimens. An instance such as this illustrates how the new humanist worldview—the rediscovery not only of classical Rome but more tellingly of Nature as such—influenced the desire to expand learning and broaden the intellectual horizon of collectors and hobbyists alike.

But there were many other examples as well. Poggio Bracciolini (1380–1459), for one, provides us with a fine example of a true collector, motivated by forward-looking thought and intellect. Unlike Brunelleschi and Donatello, he was anything but a casual treasure hunter. So possessed was he in his habit that he thought nothing of stealing rare documents or of deceiving unsuspecting monks in order to get hold of valuable manuscripts that were often moldering away in the vaults of the monasteries.

So much for the strategies and moral values of a dedicated collector at the time of the early Renaissance. This was by no means impulsive behavior. It was, rather, determined, carefully planned, and unambivalently goal-directed. However, we should at least contrast Poggio's approach with the values of the Church, or his limits of honesty and integrity, prompted by his impelling passion.

Nor was he alone in his passion. Men like Thomas Phillipps or Cardinal Mazarin, who had their own rationales and habits of collecting, were probably equally predisposed. They all represent a personality type that is driven by the need to own and to be in control, and simply unable to wait or to tolerate frustration. While their modus operandi was influenced by the period and circumstances in which they flourished, there is sufficient evidence that they lived according to their own moral and psychological codes.

Balzac, another prototype, was well aware of such individual differences in collecting patterns, for while he himself was a nearly irrepressible accumulator, often with the idea of profit in mind, his brainchild, Sylvain Pons, represents an almost complete opposite type—one who made no concessions to impulsivity. This does not mean that different avenues of pursuit can easily be translated into different psychological configurations. It does imply, however, that both the manifest attitude and the unconscious forces responsible for the active drive to collect reflect much more than mere techniques of gathering and a yearn-

ing for accumulation. They involve a clearly individual stamp and inner experience, sometimes romantic and idealistic, as in the examples of Donatello and Brunelleschi, and at other times truly disciplined or systematic or scholarly.

Whatever their overt conduct, I am not in agreement with certain psychoanalytic propositions according to which "cupidity and collecting mania ... have their correlating determinants in the infantile attitude toward feces."[243] This, I believe, is too confining a point of view. It is a homogenization on the basis of appearances and genetic phases instead of seeing the phenomenon in its immediate experiential context.

If one attempts to trace the individual development of collectors, it soon becomes evident that the actual cause of their habit and the role of this inclination cannot be limited to a particular phase-determined character trait. As I have shown earlier, this is not an elementary matter, since there are in most instances deeper and more involved sources for the often surprisingly powerful passion for a particular kind of object or, more to the point, for the habit as such.

From this point of view it would seem instructive to note that, in observing the manifest attitudes of different collectors it soon becomes evident that their individual behavior reveals quite similar needs but vastly different approaches in making their acquisitions. Thus, in keeping with their own specific ego constellations, different people are bound to take their own pathways with respect to their collecting techniques and preferences.

Basically these collectors' impulses are not irrational because, regardless of the striking differences in character and lifestyles, the development of their passions can most of the time be plausibly reconstructed from their personal histories. I was surprised to learn from the many collectors I had an opportunity to interview that beneath their longing for possessions there was often a memory of early traumata or disillusionment, which then shifted the need for people to a narcissistic need for substitution functioning as their equivalent—in other words, a self-indulgence with objects. More specifically, this usually took the form of a chronic longing for objects rather than for people. People were, so it seemed, potentially unreliable.

A shell collector of my acquaintance once showed me a Golden Cowrie shell. To be more exact, he did not simply show it to me as other shell collectors might do when they point out

a careful arrangement of, say, different examples of one particu-
lar variety of shell, thereby revealing their inclination toward
observation and method—indeed, a behavior trait that can
be interpreted as a "successful repression of coprophilia."[244]
Rather, this man, a confirmed bachelor, presented the shell like
some delicate work of art or jewelry, and placed it on a taste-
fully selected blue velvet cushion. Such details reveal more of a
collector's personality. No impulse buyer would be inclined to
display his or her objects in as solemn a fashion. Here, the man
was expressing more than his mere pleasure in having finally
obtained this specimen of considerable rarity and beauty, out-
standing with respect to brightness of color and resplendent lus-
ter, as he eloquently explained.

"I fell in love with it," he commented with visible pride. "I
could not resist it. It took me years before it became available. It
used to belong to a scientist of note, and only sometime after his
death could I persuade the family to let me have it."

As the man kept saying, he had known about the shell for a
number of years and had hankered after it ever since he first
saw it. It had made him restless and it had caused what has been
described as a *sentiment d'incomplétude*, an incapacity to feel
complete without possessing it. He then went on to comment
about its perfect shape and ideal color. "A masterpiece of na-
ture," he kept reassuring me. There were no blemishes, not even
a small chip. And while he was speaking in these enthralled
terms he could not suppress a transparent comparison.

"It's like a body you find beautiful beyond description. You
want it all for yourself." At this point he took the shell, on its
blue velvet cushion, back to its proper abode, a drawer where it
was protected against the light. However, this did not occur
until I had followed what had obviously become a traditional
rite: I had to express my admiration of the shell for the collector.

Such an incident is instructive. It is not hard to recognize that
situations of this kind are occasionally unconsciously calculated
in order to elicit the acclaim of the observer. The man's enchant-
ment was clearly transposed from the plane of sensuality to a
kind of triumphant overvaluation often observed among young
lovers. Indeed, excesses of passion such as this show anthropo-
morphizing residues and are bound to cross the threshold of
objectivity.[245]

There was no doubt that the shell was very beautiful, and that the man had made material sacrifices in order to obtain this rare specimen, a habit not at all uncommon among devoted collectors. But was his obviously romanticizing exaltation limited to this one specimen? The analogy with the body was revealing and close to the essential focus: He had to have it. He had to touch it. It had to be *his*.

In connection with this, I was reminded of another shell collector, an eighteenth-century Peruvian adventurer who was living for a while in Paris. He got permission to inspect the well-known collection of the Countess de Praslin-Rochechouart. She graciously presented him with some rare shells, probably duplicats of ones she already owned. Yet he still helped "himself to three others which he had not seen before despite the owner's protest that she did not give away precious specimens for nothing, and, as if this were not insult enough, he broke three more, supposedly unique."[246]

Whatever the aesthetic or historical or occult value of a collected specimen, emotional echoes are rooted in past experiences reawakening a delusional reaction either to a person (remember: the collector had referred to a body) or an object (or the proverbial security blanket or a doll), irrespective of its quality. What we observe here is an expression corresponding to the belief in amulets or magical relics or, for that matter, to longed-for toys when their presence remedied states of anxiety. We saw this in little Paul's toy dogs. We hear about it from certain fanatics such as the Cardinal Albrecht of Brandenburg, a contemporary of Martin Luther, who owned enough holy relics to buy himself 39,245,120 years of indulgences and salvation. There is, then, a sense of relief and hence a subjective exaggeration or overestimation of value, an almost quantitative-capitalistic contrivance for redemption.

In the shell collector's case, his reference to a body was like an involuntary confession, since the symbolic equation had little to do with the shell's conchological rarity or exceptional quality. Remarks of this kind, even in the form of a puckish aside, should not go unnoticed. It is not at all uncommon for the attitude of a devoted collector toward his objects is similar in many ways to a lover's passion and, further, that overvaluation is, after all, a well-known trait among lovers and collectors alike.

231

One must be aware of the fact that the emotion is detached from the outside world and narcissistically invested in the collected object.[247]

There is no denying that the symbolic equivalence here tells us much of the inner nature of the man's experience. His beautiful object really means that he is not alone. If we think of the traumatic events in so many collectors' early lives, it is easy to see how affection has been displaced to "things," rather than to people who have proven not to be reliable.

I remind my readers of the late Mario Praz who once described to me something that occurred while he was around London. He was looking into a bookshop and his attention was suddenly drawn to a chandelier. (He also spoke of this incident in a fine passage in his *House of Life*.)[248] "When I saw it I fell so deeply in love with it that, if it had been for sale, I would have done anything in the world to acquire it."[249]

Here the source of satisfaction, even of deep love, appears to derive from something other than devotion to a loved person or, rather, from a stable emotional involvement. Instead early frustrations or traumata have led to what George Steiner has aptly called a "malign emptiness," with respect to people, and we find a pronounced sensitivity to and idealization of objects.[250] Chandeliers and other decorative objects or shells or even exquisite works of art are appreciated not just for their aesthetic excellence.

Professor Praz's collection was famous for its high quality of Empire furniture and abundance of elegant decorative examples, but as his personal history implies, early sensitivity, largely prompted by the consequences of his congenital impairment, encouraged compensatory gratification: since his body was imperfect, he chose to acquire and surround himself with impeccable objects.

Other collectors would readily confirm to what degree time and affect can be attached to those tokens of one's involvement. The noted book and manuscript dealer, the late Hans Kraus, once told me about a similar phenomenon in connection with his early captivation by postal stamps and, later, rare books and manuscripts—rather than attractive young ladies. For him rare books became a lifelong craving and fascination, and discovering or obtaining them remained his ambition. This he correctly

understood to be "a mistress of another kind, safer and more exciting" than the real thing.[251]

Keeping this observation in mind, I thought of the Goncourt brothers, two French writers, who warned that "those who believe themselves to be in love ruin themselves for their passion: whether for woman or thing, for art objects alive or inanimate [September 12, 1868]."[252] But then Jules de Goncourt, the younger of the two, died of syphilis in consequence of his sexual encounters at the age of thirty-nine, two years after the diary entry. The brothers' affection for each other had many homoerotic overtones. Nonetheless, women in their lives had only a casual and noncommittal meaning, as if their temporary presence would merely highlight the lasting fraternal closeness.

Kraus had been made aware of similar dangers: "for better or for worse, father had put the fear of syphilis into me," he noted. This was quite a realistic warning at the time before the miracle drugs of antibiotics would separate every young man's romantic affairs from the haunting image of hazardous contagion. Such a threat itself would almost certainly tend to make people satisfy their sexual longings through other than amorous encounters. In this regard, Kraus told me how he would pursue the owner of certain rare books and how he would approach him year after year, and wine and dine him, and offer him other desirable books in exchange or replace it with other objects for the books he coveted. And he painted these adventures in what were almost rhapsodic tones.

To be sure, in our particular context, diverting one's affections or, in psychoanalytic terms, splitting the ego between sexual and desexualized interests, does not imply an irreconcilable conflict. Books, shells, chandeliers, or cookie jars, for that matter, may be objects an avowed collector cannot do without, yet they do not necessarily constitute an opposite stimulant to the physiological impulse of sexual relations. However, there is no denying that the love for objects so emphatically expressed by Praz is inevitably interlinked with a preexisting narcissistic clinging to tangible possessions.

In reality the range of nuances and variations in the pleasure taken in whatever one assembles or even hoards is indeed infinite, especially among those collectors who are so entranced by their possessions that all other emotions are shunted into the

background. When the second Lady Phillipps complained that she had been "booked" out of one room and "ratted" out of another, she expressed quite graphically the idea that marital bliss had been sacrificed at the expense of her husband's self-centered character. Obviously, she had forgotten that Sir Thomas had been "in the market," as he wrote, for a substantial dowry, rather than a wife; and that his sole purpose in marrying a second time was to satisfy even more his progressively obsessive need for new acquisitions.

There is no doubt that there is an infantile component in the behavior of a man of Thomas Phillipps's character, where collectibles (in psychoanalytic definition we would think of them as narcissistic supplies) are meant to ward off a deep sense of anguish and avert a recurrence of childhood feelings of mystification, loneliness, and rage. Even wealthy collectors such as J. Paul Getty or the Empress Catherine the Great have let us know how powerfully their reactions were ruled by emotions when it came to making new acquisitions. "Reality considerations are abandoned and the impelling aim . . . is the pursuit for and the *acquisition of an object,*" observed M. M. Segal tellingly enough, not in connection with some collectors' manic pursuit of new objects but for immediate sexual gratification,[253] as in the case of another collector previously mentioned, the Don Juan.

Keeping in mind that those intense needs are rooted in an early sense of abandonment or of literally being out of touch and then longing for something tangible, the inner drivenness to guarantee possession (in experiential terms we should speak of *re*-possession) is sometimes uncontrollable.

Among collectors, it is not at all uncommon to hear people refer to certain objects in anthropomorphizing or animistic terms. Jacques Kerchache, a French collector and a dealer in African and Oceanic art, once remarked to me in reference to a representative sculpture from Zaïre that he did not care for it because it had "no soul." Although I myself saw some artistic merit in the figure, I immediately understood what he had in mind.

My main concern here is not with the emotional experience one or the other object may arouse in a person. Rather, I am using this vivid example in order to exemplify how a discriminating collector's response leans on the recall of pleasurable

memories, possibly from early childhood. In such an instance, the visual experience of the sculpture should be captivating enough to magically evoke the illusion of a live creature.

Magic is closely akin to such emotional reactions. In observing magic acts and rituals in preliterate societies, we soon become aware that their psychological plot aims essentially at the self-assertion of the magician by turning insecurity and doubt into its opposite (i.e., fantasies of control, superiority, and excellence).

Similarly, "collectibles" are, strictly speaking, implements that are meant to enhance or restore a narcissistically injured person's sense of self. This seems to be the principle that appeals to the unconscious pleasurable memory traces of many collectors. It touches pretty closely on what is, to the outsider, often quite curious behavior.

It is the recurrence of this experience which has led many observers to describe the collector's quest as a compulsion to repeat. It is a trait known to every collector. After all, whatever the objects in his possession, they all represent a special moment of search and the excitement every find elicits. One man told me that he had never returned from a journey without having discovered a worthwhile object, be it in a rummage sale or under a heap of bric-à-brac, as when a rare Oriental vase appeared among broken or damaged late Victorian porcelain, or as a Dutch acquaintance, Loed van Bussel, described to me a fine seventeenth-century Benin ivory carving that had been miscatalogued in a country sale as a comparatively ordinary piece of Japanese carving.

There is no question about the fact that nearly every collector has a hungry eye or, as my late friend Paul Wallraf, collector par excellence, put it: he would "manger avec ses yeux"—eat with his eyes—an expressive description of the visual experience I have spoken about throughout this book, which is the essentially oral-incorporative longing for a continuous flow of new additions to one's collection.

If we look at the behavior of many collectors with respect to discoveries or purchases, one soon becomes aware that they often tend to follow a certain pattern. For example, one of my informants owned a specialized library of travel books and guide books, among them a number of unique and much

sought-after volumes. Many of them were discovered in out-of-the-way antiquarian bookshops, which he visits and explores quite systematically at more or less regular intervals. Unlike those who rely on contacts and scouts, he insists on making the finds himself.

His love for travel books, he told me, is a direct outgrowth of his experiences during the first seven or eight years of his life, when he accompanied his parents on their tours of the American continent to appear in variety acts. His constant concern was where they would go next and who would take care of him while his parents were working. He remembered alternating between the anticipation of seeing another town and the apprehension of being left with a strange new sitter.

Eventually his parents gave him a number of picture books and postcards and photographs of the places they had visited, and these gave him some sense of continuity. But, he stressed, and not without pride, the turning point came when he began to help his father in reading maps to find the right road or a better road before his father could do so. This gave him more than the feeling of superiority. It was a real triumph, he said. Besides, knowing the destination—and actually seeing the place on the map—helped alleviate some of his fears and uncertainties.

By assuming total responsibility for his quite unique collection, he maintained this kind of control. His insistence on finding the books himself was but a repetition of what had given him this initial sense of skill and mastery. In other words, not only was he collecting travel guides and maps, which had first provided him with a sense of greater security, but he also felt compelled to repeat those moments of elation when he found the best road by himself. Now, as an adult man discovering yet another book or map or even another bookshop, but, revealingly, without anyone's help, the same sense of triumph (over his father) returned over and over again.[254]

This example should be contrasted with that of a woman with fine taste and a more-than-average knowledge of medieval history. In this connection, she had developed a predilection for select examples of early tapestries and put together a beautiful group of rare specimens, often in direct competition with major museums. Only under exceptional circumstances would she acquire a piece without consulting a professional acquaintance or

connoisseur even though she had a better eye than most of them. When other people's opinions reinforced her own, and the preliminary judges had approved an item, she would turn to a scholarly expert for final advice.

In view of her own expertise, she hardly needed any other opinion, so that it became clear to me that she required something more than agreement with her initial choice and judgment. Every acquisition obviously triggered emotional upheaval that was excessive in terms of the new piece or its cost, especially in view of her financial independence. She acknowledged that she needed someone else's encouragement to mitigate her intrinsic apprehension and, ultimately, guilt in making new purchases.

But why guilt? One of her often repeated rhetorical questions caught my attention: "How can I permit myself?" she was always asking when she was considering another purchase.

In this case, the conflict and turmoil represented a repeated return to old modes of behavior, which centered around her persistent envy of four older brothers who, she had always felt, had been wanted by her parents, while she was not. As the youngest child and only girl she had never felt "good enough." She sought relief from this chronic feeling of unworthiness and envy, which was followed by self-reproach. Placing the onus of release from inhibition and decision-making on experts seemed to arrest her guilt feelings. Her perpetual struggle between self-indulgence and an awareness of at times grandiose fantasies generated hours of histrionics before she could make up her mind. Her behavior revealed the various facets of her ambivalence. She really did find those tapestries beautiful examples of craftsmanship, even though her longing for possession and having them reproduced or exhibited involved early fantasies the dynamic meaning of which were linked to her hope that she was now "as good as" her brothers.

By calling on professionals in loco parentis she tried to transform envy and possessiveness into specialness and, with the help of her collection, attention and desirability. One could also say that it was a borrowed sense of acceptability. But does such behavior truly alter the basic intent? While I was not in a position to ask this lady personal questions, her conduct was at times so extreme that she could barely conceal the inner rage

which motivated her possessiveness, seeking relief from her conflict by employing judges as guarantors against her unconscious fear of retribution because she had given way to her desires.

She is not alone. While the elements in her approach contrast with those of collectors who insist on making purchases or, rather, the discoveries themselves, others lean on dealers who, like the experts in the lady's case, function as arbiters and act as if they had the power to release their customers from their unconscious guilt feelings. This is not because purchasing a collectable item is a culpable act, but that the object represents the fulfilment of a forbidden wish.

When collectors idealize one or the other supplier they may indeed feel that they have been singled out like best-loved children. It is not at all unusual to hear a collector say: "I always get first crack from John," as if he was finally receiving the love and favored position he had wished for ever since his early years of turmoil and disappointments. Collector-dealer relationships often feature a finely tuned interplay between the needful collector-acquisitor and the astute and, indeed, empathetic dealer-provider. The notion of being the preferred customer, or in emotional terms the best-loved child, appears then as a source of relief and assurance while revealing an infantilized aspect in the collector's personality.

It is in the light of such variations in behavioral styles that we should consider some other personalities. Sylvain Pons and Lady Charlotte Schreiber shared, at least superficially, several characteristics. With outstanding intuition Balzac sketched Pons as a man of remarkable energy, determination, and knowledge. In addition, Pons shared with Lady Schreiber an ultimate satisfaction in discovering bargains.

Born Lady Charlotte Elizabeth Bertie, she began keeping a diary in 1822 at the age of ten. However, her celebrated collection of ceramics, now one of the prized possessions of the Victoria and Albert Museum in London, was not begun until 1869, when she was already a grandmother. She grew up as a poor little rich girl. "When my mother was born her father was 68, and he died in 1818 when she was six years old," wrote her son, of her first marriage, Montague Guest. Three years after her father's death, Lady Charlotte's mother married a cousin, a diffi-

cult alcoholic, whom the child detested. One gets the impression of a forlorn and sometimes depressed girl who "led rather a lonely life and was thrown very much on her own resources."[255]

Such a view is in keeping with our wider and more comprehensive picture of the woman. Both her sons were noted collectors. "She was fired with the spirit of collecting from seeing my brother and me returning from our trips abroad laden with china and curiosities of all sorts." Her son of her first marriage, Montague J. Guest, writes. "She had always had within her the spirit of the collector and connoisseur. . . . She hunted high and low, through England and abroad; France, Holland, Germany, Spain, Italy, Turkey, all were ransacked; she left no stone unturned, no difficulty, discomfort, fatigue, or hardship of travel daunted her."[256]

Often her search was crowned with success, although her diaries recount the stories of the many inevitable dead ends familiar to any collector. However, skill in carrying out her venture had become imperative, as set forth in many detailed entries. On August 17, 1869, she wrote:

> In train before 6. At Amsterdam about 11. Put up at Brack's Doelen. Set off immediately 'en chasse.' First to van Houtum's in the same street. Very little in our way; one or two Chelsea cows, sheep, etc., at high prices. Our purchases of him in the course of our stay consisted only of a small purple enamel pot and cover, 10/-. A Chelsea Pug (tail replaced), 10/- . . . Derby biscuit group (arm replaced), £1.10. Good Chelsea Derby figure of a youth sacrificing a goat (head replaced), 10/-. . . . After van Houtum's we had a grand 'Chasse' at Ganz's, and a rather successful one, though not to be compared to that of two years ago when we pulled down from his rafters one or two fine Bristol jugs. At Ganz's we have found two excellent Chelsea jardinieres painted with flowers, which he sold us as old Dresden, for £1.15. Our next best haul was with Speyers, St. Anthony, Breestraat; from him we made several purchases, some of them likely to be good. Two groups of Derby-Chelsea figures, man and girl in bocage of leaves, good condition, only two figures wanting, 'Proposal' and 'Acceptance' (?). £15.[257]

Then followed visits to five other dealers, after which she and her husband proceeded to The Hague to make additional pur-

chases. Their next stops were Gouda, Utrecht, and Rotterdam and then "up again by cockcrow the next morning."

This lonely, defensively rigid girl had turned into an impressively astute woman, energetic, single-minded, and often better informed than her suppliers. Her resolute stance sounds like an echo of early fights for survival, and the residue of a childhood with two younger, mentally deficient brothers. There had been constant friction, mainly with her alcoholic stepfather.

Her approach, though uncommon for a woman of the Victorian era, was consistent and revealing. She goes "en chasse"; she goes ransacking; she hauls or pulls down from a dealer's rafters some jugs that strike her fancy. The relevance lies in the entire fabric of her thrust. Her son recalled an incident he had heard from Sir Joseph Duveen, the well-known art dealer. Duveen was on his way to an isolated village in an inaccessible part of the Netherlands. It could be reached only through a difficult journey by carriage. Nevertheless, in view of some rare objects owned by one of the local inhabitants, he undertook the expedition. Shortly before reaching his destination he saw another carriage coming in the opposite direction. While passing he caught a glimpse of Lady Schreiber, "only to find that she had snatched the prize, which she was carrying off with her."[258]

There is no question that this is a modified version of the successful hunt or the chase and capturing the trophy; in Lady Charlotte's case, I see her mode of action as an attempt to prove her dominance vis-à-vis her stepfather, and also to enhance her self-esteem. At its simplest, it can be a fleeting impulse, like bringing home a souvenir. At its most committed, it assumes the proportions of a kind of aggression with masculine potential, if not dominance or an all-consuming, sensuous activity surpassing rational ends.

Habituated collectors of Lady Charlotte's behavior, impassioned and not easily deterred, feel peculiarly driven to follow a certain pattern, making their rounds weekly or daily but usually with a certain regularity. "I must find something or I'll get mad," commented a young man infatuated with military insignia.

It would probably be more correct to call such a man a hoarder for he delighted in the masses he brought together. The only limit he had set himself was the price. He would not go beyond a fixed amount. He represents the opposite of the care-

ful, even though eccentric type of which Charles Ricketts, the English designer, epitomizes possibly one of the most outstanding examples.

Long before I embarked on this study I had read excerpts of his letters and journals.[259] "You would not think that Old Master drawings would be at home with a birdcage ... each object, being in itself perfect, added its lustre to the whole," wrote his friend Cecil Lewis. Ricketts and his companion C. H. Shannon were genuinely dedicated to finding objects of art, all selected with an almost unique sense of quality and vision distinguishing between the often quite subtle difference between true artistry from good craftsmanship. But then their actual living quarters reflected "almost poverty-stricken puritan simplicity," showing the same intentional discipline with which they pursued their acquisitions. This involves a narcissistic attempt to keep decision-making in strict control and, unlike many collectors, to be on top of one's affects. The collection assembled in other rooms seemed like an "indulgence in luxury ... arranged in perfect taste." Ricketts, who was the more influential of the two, "had skimped and saved on daily expense in order to amass his magnificent collection [now in the British Museum]. ... If you had an Old Master drawing worth £50,000.00, then surely you could afford a car? But you could not. You walked or went by bus: and it was by doing this for a lifetime that you had what you had."

Ricketts's temperament contrasts sharply with the appetites of George Gustave Heye. Heye's self-centered behavior is very illuminating for the understanding of another collector's practices. His aims and objectives were doubtless ruled by his primitive-compulsive boldness, largely expressed in his insistence to pursue everything that was Native American Indian. His tenacity had many elements in common with Lady Schreiber. He was unconventional, a nonconformist, and of unequaled dynamism, and often manic. He too started his collection at a mature age— but then with a vengeance. Was he trying to catch up with the excitement that was lacking in his youth? Or had his inclination merely remained dormant until some external event triggered this yearning?

Heye was omniverous and monomaniacal. Why he focused his attention on Native American Indian objects is unclear, although any collector's preference is influenced by a variety of

circumstances. In Lady Charlotte's case, her sons' collection stimulated her interest. Often it can simply be a trendy fashion, as at the time the Ladies Six in Amsterdam mentioned to me that "Our family always collected modern," and indeed, when the Six's bought their Rembrandts and Saenredams they were among the most avant-garde collectors of their time buying "modern masters." Or Martin G.'s area of choice was determined by his father's death in the Far East.

Often people's preference is linked to their professional occupation. I have met physicians who collected old apothecary jars, and surgeons with collections of very impressive historical surgical instruments. Miss Freud was kind enough to show me her father's Greek and Roman collection, an offshoot of both his idealization of classical antiquity as well as his psychoanalytic work by delving into his patients' distant past, which he used to compare with making discoveries by digging for remote, deeply hidden archaeological specimens. According to Peter Gay, "Freud's . . . collecting of antiquities reveals residues in adult life of [no less] anal enjoyments."[260]

In Heye's case I am inclined to attach much significance to his collecting habit as such rather than to the specific area that became, apparently almost accidentally, the focus of his activities.

Heye was a huge man, standing six foot four and weighing around 220 pounds. He was renowned for his voracious appetite, and smoked innumerable king-size cigars. I recall that the late Sam Lothrop, the outstanding Central-American archaeologist , once described him as having been born with a cigar in his mouth. These particulars seem to hint at something of a very basic bodily narcissism. Everything he did or was reflected largeness, and here and there even grossness.

His vast collection was eventually established as the Museum of the American Indian in Upper Manhattan, in New York City (the museum was later relocated to Ellis Island). It contains approximately four million items, ranging from common flints and potsherds to a great number of superb masterpieces of Native American Indian art.

What we can put together of Heye's personality sounds more like a novelist's invention than a portrait of an actual person. Some saw him as a collector of note; others as a ruthless, compulsive scavenger, and even a looter of precious works of art.

His approach had the earmarks of some kind of drunken revelry. The methods he employed with such impressive results attest to his uncompromising perseverance. One can view his collection as the outcome of creative dedication or devout ecstasy, or as the result of the hunger of a megalomaniacal narcissist, considering his oral habits. Still, owing to his compulsive temperament, he created a monument to himself which is also a major cultural contribution.

It is doubtful that Heye thought of himself as a man whose destiny was to rescue Native American Indian art. "I doubt whether his goal was anything more than to own the biggest damned hobby collection in the world," a scholar commented. "George had absolutely no sense of sin. He didn't give a hang about Indians individually," said another.[261]

If these characterizations are correct—and there is no doubt that they accurately depict some aspects of the man's habits and personality—Heye did not hesitate to foist his neurotic presence on others regardless of circumstances and environment.

René Gimpel, the noted Parisian art dealer, remembered the famous bibliophile Gallimard and his collection of nineteenth-century woodcuts. After the death of any engraver of repute, he would appear like a vulture at the premises of the deceased: "I'd rush round to his widow or see his family and buy the complete works. I've made good use of my opportunities," he proudly commented. Gimpel was impressed by the sheer lack of any sense of guilt, not unlike the young Don Juan's simulated amorous protestations or Heye's remarkable lack of conscience. Gallimard's eyes would sparkle when he related such tales. "What a book could be written on the cruelty of the collector," was Gimpel's perceptive comment.[262]

Heye was probably cut from similar cloth, his successful collecting apparently resulting from a conglomeration of horse sense, good luck, and tenacity. I do not know what early experiences laid the ground for his monomania. He told of one incident that acted as a sort of catalyst. While working in Arizona as a young man of twenty three, he saw an Indian woman biting a piece of deerskin she had on her lap. She was apparently killing the lice that had infested her husband's skin shirt. Heye bought the shirt, the first item of his Indian collection. "The collecting bug seized me and I was lost," he wrote at a later date.[263]

The "bug" became progressively evident, not surprisingly emerging as a substitute for emotional involvements. His wealth enabled him to cultivate his greed and possessiveness without any pangs of guilt or regard for other people's feelings. His collecting habits echo Thomas Phillipps's crudeness and total self-centeredness. Heye's ruthlessness destroyed at least two of his three marriages, and both his children committed suicide.

Little illustrates a man's disposition better than his rituals. Once a year Heye purchased a new automobile and raced across the United States from coast to coast. Here and there he would stop, "look up the local mortician and weekly-newspaper editor, and ask for word of people lately deceased, or soon likely to become so, whose possessions might include an Indian collection." On these trips Heye also visited Indian reservations. "George would be fretful and hard to live with," a former staff member remarked, "until he'd bought every last dirty dishcloth and discarded shoe and shipped them back to New York. He felt that he couldn't conscientiously leave a reservation until its entire population was practically naked."[264]

His unrelenting obsession shows a solid measure of ambivalence toward the Indians. By stripping them "practically naked" he carried home his badges of victory. Heye once suggested to one of his associates, that he "would make a killing by doing some more [excavating] work," and the man contentedly agreed. "And that's just what we made—a killing. Worlds and worlds of pots, fifteen hundred years old, and skeletons, shell beads, gaming stones."[265] Remarks such as these reveal an essential element of the affective components of the man's ruthlessness, quite at variance with Judeo-Christian ethics. The aggressive-narcissistic aspirations of these actions are not so far removed from those of the headhunters of Borneo or New Guinea.

As the acquired object brings with it additional support and hence narcissistic enhancement, envy and brute sadistic instincts play a large part in the perpetual search for personal triumph in order to ward off one's susceptibility to helplessness and frustration.[266] Heye's explicit vocabulary and actions imply a notion of this complex interdependence of hidden rage, destructiveness, and obsessional control. His suggestion of "making a killing" is at least a symbolic correlate to both the

headhunter's endeavors and the unconscious rage caused, as we have seen, by the baby's helplessness and his need to cling. It is then that fear and anger come to the child's aid in his maneuver at self-rescue, as I described in Paul's attachment to his rag dog Micky.

As the acquired object brings with it relief from doubt and frustration, there also comes a better notion of successful action. This reduces tension and is experienced as a sense of joy. Thus, in the case of many collectors, jealousy and a competitive spirit play a large part in this restless search for personal triumph.

In this connection, it is unequivocally more pertinent to consider the struggle between an involuntary and passionate craving for possessions on the one hand and, on the other, social pressure, lack of conscience, and embarrassing fears. This conflict puts many people in a double bind. The question is, then: How and to what extent do the restraining injunctions alter tension and the discharge of the compulsion? Or, perhaps more frequently: How does the longing lead to behavior or temptations that the collector himself, were he able to view them objectively and reasonably, would acknowledge are contrary to expectations of decency and consideration?

The Peruvian shell collector's feelings of resentment and envy when exposed to a truly unique collection expressed themselves in the form of thievery and rage. Heye's attitude was not less brutally impulsive than Verres's strong-arm tactics in Sicily. And quite similar sentiments moved Christina of Sweden when she ordered her troops to ransack Prague in the autumn of 1648, and brought five shiploads of the Emperor Rudolf II's art treasures to Sweden. Her covetousness, in many ways a reaction to her *kyphosis* (hunchback), was known throughout Europe, and her quest to satisfy her vanity and eccentric demands transcended any moral expectations.

These vignettes give ample evidence of the occasionally curious roads some collectors travel in order to pursue their aims. Nowhere is this more apparent than in the auction rooms, where the tense and occasionally electric atmosphere can bring to the fore the play of human emotions among those who actively participate.

All auction sales follow certain prescribed procedures, which form a clearly delineated, ritualistic pattern. In Great Britain particularly, the calm and seemingly dispassionate conduct of

the auctioneer stands in sharp contrast to the tension found among some of the bidders. And it is instructive to observe the bidders' behavior. Fear, covetousness, greed—all combine to build an occasionally hysterical fever arising not only out of the urge to possess. There is also the contagion of the frenzy and the direct challenge of competition.

In this sphere of one-upmanship, unconscious impulses of rivalry, fear of failure, and feelings of inferiority may often be counteracted by deceptive, and, indeed, self-deceptive, forms of ambition and manic extroversion. This atmosphere in the salesroom, not unlike that of a poker game, frequently tends to incite unconscious cravings for possession, triumph, and trophy-gathering that culminate in the crescendo of not only carrying away the prize but oftentimes also of attracting attention and even applause. Was it the intention of some collectors to put themselves on the stage?

But the majority of collectors do not attend auctions, and not many of those who do exhibit extremes of behavior. Still, the circumstances may be persuasive enough to bring otherwise less overt character traits to the fore. The atmosphere of rivalry and intrigue, the chance of immediate rewards, and the prospect of acquisition of objects someone else once owned and so provided with a pedigree, all help to create an environment in which decision-making can become quite independent of a bidder's better judgment.

I remember that, on one occasion, a few days before an auction sale, a young, well-informed collector of old medals gave me an illuminating description of the historical and aesthetic elements, the rarity and variations in design of some pieces included in the sale. He also gauged their true market value, and after some calculations and careful consideration, he informed me that he had decided to bid on two special items in the sale the importance of which nobody else would fathom. And, he added, under no circumstances would he go beyond a certain price.

On the day of the sale I saw him once again, and once more he repeated his resolve not to exceed his carefully established and realistic limit. Somewhat later I saw him again in the salesroom.

Shortly after the first and less important items had been sold, a middle-aged man entered the room. His presence seemed to

cause a stir among a few of the people at the sale. A bit later the first medal my friend had wanted was offered. After a few hesitant moments he nodded at the auctioneer. There were several other bidders, and soon the price had reached the high estimate in the catalogue although it was still below the limit the collector had set for himself. For a few moments there was no other bid. But just before the auctioneer's hammer went down, the newcomer signaled a further bid.

Now a chase began, with each denying the other the triumph. It soon became apparent that whoever finally got the medal would win only a Pyrrhic victory. As is all too common at auctions, the collector had abandoned his resolve and had not unexpectedly made a higher bid than the medal was worth. What is more, he also had abandoned his rational self. Indeed, the very climate of the salesroom environment has impelled many collectors to abandon logical decision and self-restraint in favor of competition and, not inconceivably, exhibitionistic grandeur. In this case, I believe, the collector gave in to his possessive instinct. This in turn triggered a fugue state, brought on by fear of a narcissistic humiliation in case he had to suffer defeat at the hands of a competitor.

Or did the medal become more desirable merely because someone else wanted it? And, possibly, did the medal, rare and exceptional as it was, actually become a love object?

The event itself ended pitiably. Later, at home with his booty, the collector started to cry and shudder like a helpless young boy, confused and guilt-ridden, full of self-reproach, angst, and torment. It was a kind of ex-post-factum self-punishment.

This is a concrete illustration of a characteristic superego decompensation in a particular social and public milieu. But as this milieu supports narcissistic action for self-enhancing aims, it also tends to induce alterations in autonomy and critical judgment. The collector wanted to show "them." He also had the self-deceptive conviction that he alone knew, better than his symbolic fathers or brothers, or the fraternity in the auction room, the true worth of the medal, and that he had made a discovery and, by implication, deserved the trophy.[267]

The charged atmosphere of the gambling casino and the auction room tends to create a protohypnotic ambience among those in attendance. As a result, judgment and perception can be blunted or reduced, and it is at this time that the passive-recep-

tive longing of the gambler or the object hunger of the collector succumbs to the potentially mesmerizing effect of the room itself. Characteristically, people tend to be "carried away," as the self-explanatory expression implies.

This leads me to examine one remaining aspect of collectors' conduct in the salesroom setting. I happened to be present when I had the chance to witness the exact opposite of the abandonment of one's ordinary critical powers. In this case, an ambitious collector's skillfully composed scheme made him the winner in a contest for a very desirable specimen. Again, a rather large group of aficionados had gathered for an auction of papyri and manuscripts, some of them known, reproduced, and exhibited at various occasions. Other items had recently been discovered, and a couple of them had surprised the connoisseurs. Such conditions often help to start rumors and can be striking manifestations of stratagems of cupidity. The skeptics take cover. Others may research the state of the parchment or paper, the color and the script. But in view of our question the items as such are of little concern.

The sale took place in a London auction room. There was no empty seat, and several of the leading dealers and collectors had taken the more prestigious seats around the cloth-covered table in front of the auctioneer's desk. The sale began punctually as is customary. One man with a well-known and exemplary collection had seated himself in relaxed fashion at the table. His gestures and body movements indicated that he was settling down for the length of the auction as he arranged himself comfortably with the catalogue in front of him, and a couple of morning newspapers and a shopping bag beside his chair.

The first few items that were offered he ignored. Then one manuscript seemed to draw more than average attention from the audience. He was one of the bidders but abstained shortly before the hammer came down. He participated once again for one of the following items but eventually seemed to hesitate and finally pulled out of the competition. During the next few offerings he began glancing through the morning papers, helped himself to a candy, and made a production out of getting something out of his shopping bag by bending down rather demonstratively to his bag. There remained a few other lots before the last and most important items, namely, those recently discov-

ered illuminated pages that had evoked so much discussion in the book world. At this moment, perhaps coincidentally, the shopping bag fell on its side causing a moment of commotion; and while the auctioneer, as it seemed, unperturbed by the distraction, invited an opening bid on one of the important items, which was followed by the customary few seconds of silence, the collector stood up, assembled his newspapers, took the catalogue and shopping bag, and worked his way back to the entrance and seemingly out of the salesroom.

Everyone in the room had seen what the man had done, and everyone was convinced of his lack of interest in the pages being offered. This added to the uncertainty of the faint-hearted because almost all the likely buyers were well aware of his expertise in this area. And before his potential rivals had a chance to compose themselves, the hammer had come down, and the manuscript had been sold. The price was reasonably low.

Meanwhile, the collector had vanished or so it seemed. But no. Instead, he had taken a place at the entrance from which he could be seen by the auctioneer but barely be observed by the audience. He got his reward, and he could be proud not only of it but of his strategy.

In looking over this entire scenario, it is striking to consider how well orchestrated the man's procedures had been. He had studied the manuscripts thoroughly and had convinced himself of their authenticity. He knew he wanted them. He also knew how to produce signals that added to his competitors' insecurity, as well as to the auctioneer's.[268] Implicitly, he fully understood that rational thought and even knowledge would give way to uncertainty and doubt given the proper stimulus.

The practical proof of how correct his maneuver had been was in his success. He had counted on the all-pervasive internal tension and the need for evidential support that mark the collectors' ego constellation. He also knew that his apparent lack of enthusiasm would evoke uneasiness or insecurity in others, and lead to his good fortune. A seasoned collector himself, he was well aware of both the appetite but also how to conceal it.

There are, of course, many other avenues collectors, and especially experienced ones, know in order to satisfy their ambitions. Here it has been my intention to sketch some profiles of

conduct. They shed light on a few characteristic ways people travel to satisfy their unconscious needs of these magic objects. Like holy relics, "collectibles" seem endowed with extraordinary qualities that help dispel old self-doubts and fears of vulnerability because they recede behind sentiments of pride and accomplishment.

1. Peter Bull with some of his teddy bears. Photo: Topham Picture Source, U.K.

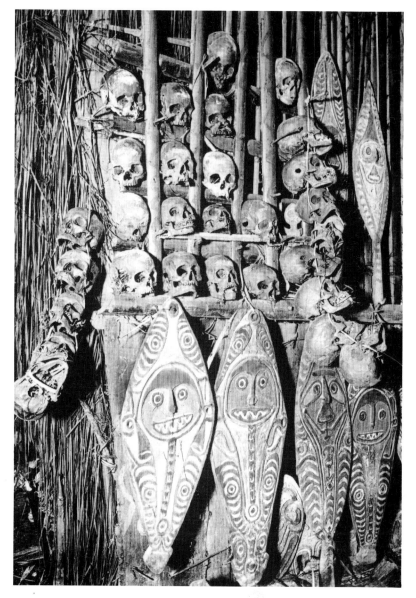

2. A Skull rack in the possession of a village chief of Dubu Diama of Urama, Papua, New Guinea. Photo: Frank Hurley; reproduced by permission of the National Library of Australia.

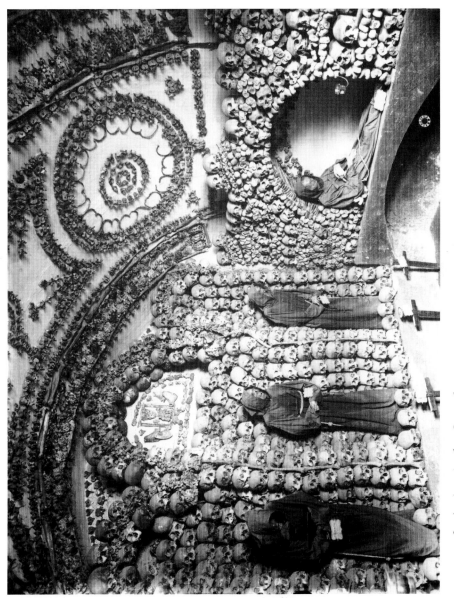

3. A view in the Capuchin cemetery in Rome; photo Fratelli Alinari, Florence.

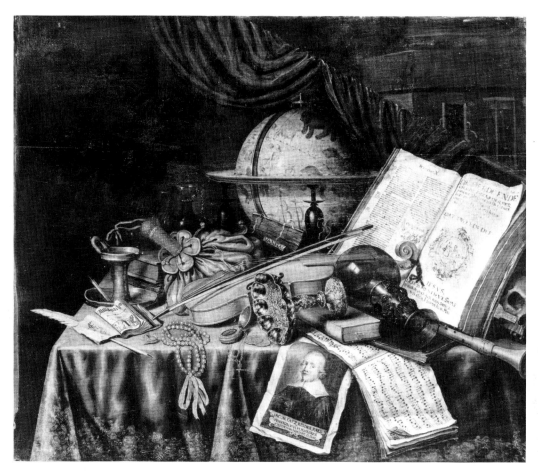

4. *Vanitas*, by Edwaert Collier (about 1662); Dutch. Vanitas paintings of the seventeenth century were inspired by the prevailing religious concepts trying to show the ultimate triviality of earthly goods and possessions. Those objects of ostentation and pride are frequently found in curio cabinets. With permission of the Metropolitan Museum of Art, New York.

ale et ce te donna grant auiferat
de toy retraiæ. Et prens garde
enchacant aquelle main le cerf
que tu chaceras se desfournera
enfupant ou adestre ou a sene
stre car il est de certain que en
faufant ses rufes il se desstone
voulentiers avne main z celle
ou il se desfonne mainz rent
cout se iour comunement.
¶ Ces deur chofes que re tay
dites comment grant auifent
en chacant ce st de faure les
brisees pendans et amon
auifment aquelle mainiz
se desfouument. Car se tes
chiens chacent se contre ongle

ce st adur se reuers par ou ilz
feront ales tu se faras par les
brisees pendans et sibonment
auisement de retraire ses chies
pour desfaure la rufe. Vus
nous dirons coment sen doit
relaissier du cerf ce que sen
chace. Quant sen enuoye
ses chiens au rues sen pdoit
enuoies tel qui aut congnoif
fance du cop des sauges chiens
et la caufe si est que silouent
venir aucune partie des chies
chacant combien que tous
ceulx que sen auoit laisse
couue my feussent ne z ge
m'eufe gaure de chiens et q

5. Illuminated manuscript illustration of huntsmen chasing a stag, from *Le Livre du Roi Modus*, second half of the fifteenth century, northern France. Formerly in the Phillipps Collection. Collection of the J. Pierpont Morgan Library, New York, M. 820, f. 12.

6. Gilt silver and ivory bookcover, attached to a wooden board, twelfth to fifteenth centuries, probably from the Church of the Holy Apostles, Cologne. Formerly in the Phillipps Collection. Collection of the J. Pierpont Morgan Library, New York, M. 651, front binding.

7. Visit with a merchant in curios, by Cornelis De Man (1621–1706).
Oil on canvas 64½ × 51½ cm. Archives Musée Dapper, Paris.

8. Medical paraphernalia and instruments. Photo: Christie's, London.

9. Some of Robert Opie's mugs; photo by Robert Opie, 1993.

10. Interior of a collector's living room displaying a variety of New Guinea sculptures. Anonymous collection, U.S.A.

11. Art Deco living room in Andy Warhol's townhouse, with paintings by Roy Lichtenstein, Cy Twombly, Man Ray; sculptures and furniture by Renoir, Jean Arp, Pierre Legrain, Emil-Jacques Ruhlmann, Jean-Michel Frank. Courtesy Sotheby's.

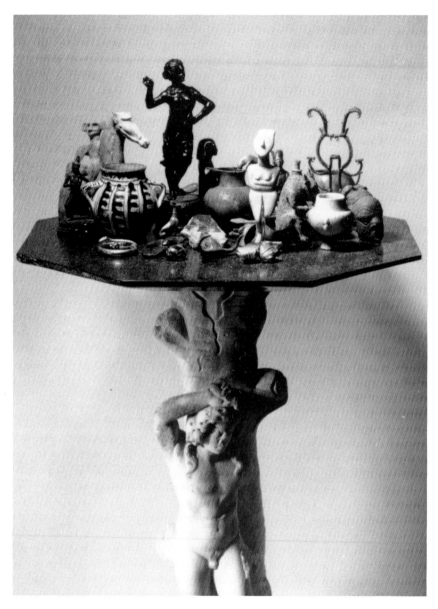

12. Objects from the George Ortiz Collection. This composition of prehistoric, Chinese, Egyptian, Bronze Age, Archaic Greek, Cycladic, African, Medieval, and Renaissance sculptures was "especially created by the collector for Werner Muensterberger and this book," and mounted on a Roman stand, 2nd century A.D.
Photo: Patrick Goetelen.

The Promise of Pleasure

THE PURPOSE OF the present book was to arrive at a better understanding of the phenomenon of collecting. I have not been dealing here with collecting as an isolated manifestation. As in clinical work I wanted rather to arrive at a deeper insight into a variety of characteristic elements of certain processes in the human experience. More specifically, I wanted to examine collectors' motivations and the dynamics of their undertakings. I was looking for convincing insight into what constitutes the impelling factors of their passion, their commitment, and the nature of their occasionally baffling conduct in response to their wishful longings.

Not surprisingly, the various profiles and vignettes presented here illustrate quite different personalities from disparate eras and walks of life, with different aims, styles, and preferences. But styles and preferences are surface deflections or, in psychoanalytic parlance, secondary elaborations, in most cases influenced by one's environment, social and cultural, and more often than not by the prevailing values and dominant traits of the living generation.

But then there are different attitudes in response to a variety of stimuli, as for example, Lady Schreiber's infatuation with porcelain after her sons showed her the chinaware they had garnered in the course of their journeys, or in Lord Bath's case where collecting, even though in a different field than the one his ancestors had pursued for about five centuries, is considered a family obligation. Or take John Steinbeck's amusing and quite down-to-earth mockery: "If the battered, cracked and broken stuff our ancestors tried to get rid of now brings so much money, think what a 1954 Oldsmobile, or a 1960 toastmaster will bring. . . . I guess the truth is that I simply like junk."[269]

In listening to collectors' descriptions of their habit, one soon becomes aware of the force of the causative circumstances that seek satisfaction. Obtaining one or another object is a prerequisite of finding relief from what one lady described as "unbear-

able restlessness." It is more than an impulse. Rather, I see it as an in essence defensive move, initially with the aim of turning disillusionment and helplessness into an animated, purposeful venture. If collecting is kept within these bounds it is by no means an unhealthy ego defense. It is a device to tolerate frustration and a way of converting a sense of passive irritation, if not anger, into challenge and accomplishment.

Collecting is not simply a response to certain manifest stimuli, as a rare coin collector of my acquaintance claimed because he remembered when he first found a penny and shortly thereafter began hoarding old coins, even before he entered school. There are many similar examples, of course. However, further exploration showed with amazing frequency that the inclination itself was an undeniable reaction to earlier states of frustration. This appears, at least temporarily, to dominate a person's behavior and, in a more definable way, has a curious double function because acquisition acts as both a palliative and a stimulant. After the collector has found a new object or made another acquisition, it seems to serve as an acknowledgment of his worth, at least consciously and for a while. Meantime he no longer feels haunted by self-doubt.

I began my study by restricting myself to the observation of contemporary collectors whom I could meet. Many allowed extensive interviews. (There were even several who had heard about my project and got in touch with me in order to be interviewed. A porcelain collector of note called me on the telephone and started the conversation by saying: "I *must* be in your book!") They all gave me their reasons. However, enquiring now and then how their collection had begun, they arrived surprisingly often at almost forgotten memories of butterflies, of postal stamps and baseball cards, of matchboxes and candy wrappers; and the gifted actor, the late Peter Bull, showed me and told me in detail about his well-known collection of teddy bears.[270]

It suggested to me that there was an affective core and a causal link which entail a predisposition to collect; that the primary motivation, due to an underlying experience of hurt or unsafety and the subsequent recurrence of moodiness or depression, needs the object as an antidote in order to regain one's equilibrium and self-composure.

It was in the course of those informal meetings with collectors that I became aware how frequently they recalled acute states of fright or injury or impending danger when some object—a doll, a picture book, a special pillow, all of which were tangible, came to their rescue. People who grew up in England during the Second World War told me how they were taken to and spent some time in air-raid shelters clinging to an old toy or, in one case, to a favorite cup, evidently aiding the illusion not only of being protected but also, quite literally, in touch. I learned from others of the illness or loss of a parent, or of having been handed over to child-minders, as Balzac kept repeating throughout his life while complaining about his mother's coldness and distance.

These examples sound like paradigms of preludes of spontaneous self-rescue with the illusory help of an object to which magic power is attributed. The basic experience of not being safe and protected—under such circumstances still more traumatic because even the adults, presumably reliable protectors, showed panic or anxiety—forces the child to find avenues of self-rescue and, with the support of the objects, the illusion of a private, reassuring world.

Observing the habitual nature of many collectors' routines led me to a greater awareness of their intrinsic need, which is often more like a compulsion, provoked time and again by an almost perpetual urge to restabilize the ego. Whether subtle or ostentatious this need seems to be evoked by traumatic occurrences, in many cases long forgotten, that call for counterphobic measures.

Seen from this angle, I have occasionally used the concept of "technique," which is exercised in order to counterbalance doubts and anxiety and a recurrence of early frustrations at not being able to cope. Whatever I have learned from dedicated collectors has a chronic tone. It is imperative to remain aware that the object, seen in its dynamic dimensions, has more than one function. It fulfils a collector's aim for satiation; it helps the illusion of being singled-out, and, by reducing tension and anxiety, it restores stability and a sense of self-assertion: "I can get it" or "I am the best-loved child." In its wider connection, it is simply the promise and capability of obtainment, which can bring pleasure because it can exorcize the anxious restlessness so many collectors are familiar with.

Obtainment in whatever way—bought, found, or even acquired by scheming or tricky means or thievery—works like a mood regulator and provides the owner with a potential sense of success or triumph, and occasionally of grandeur, as is the case with the winner at the gaming table or the astute buyer in the auction room. This is anything but complacency because most collectors are aware of the temporality of their ingrained longing for magic security.

The dynamics of these repetitive states of neediness due to infantile trauma have been well described by Rycroft: "An infantile traumatic experience is one which was not represented in the shell of the child's immediate future nor in his general scheme of the nature of reality," he wrote. "It is something which makes the bottom fall out of his world and which compels him either to recognize precociously the uncertainty and insecurity of the human condition, in which case he will grow up wise and unhappy but not ill, or to institute defences to enable him to deny that the disillusioning disaster has really occurred."[271]

Collecting is one of those defenses that promise temporary relief and bring new vitality because every new object effectively gives the notion of fantasized omnipotence—remembering the shell collector who in so many words confided in me how the beautiful cowrie (as well as other fine items in his collection) replaced people and kept it in a drawer hidden from the outside world. Even such casual remarks indicate how the ownership of objects and the pride and pleasure in their possession has more than one function: the object becomes a countermeasure to insecurity and thus a protective narcissistic shield. It also conveys the owner's covert need to hear pronouncements of praise and admiration: "Admire the shell, which is me," he is really saying by displaying his collection.

But this is not very different from a remedy that has an instant effect on a child's grief when he feels left alone, and no help or soothing touch is forthcoming—it is the magic of the soft doll which will make the anxiety disappear. Or take the collector of holy relics: in order to counter future threats of damnation and the dread of burning in purgatory, his hoard of tens of thousands of holy bones and other relics would protect him against the threats and dangers of ultimate suffering. His persecutory

delusions are supposed to explain his frenetic need to amass and exhibit his relics.

This, it seems to me, is of critical significance. Even though most collectors are aware of the temporality of their existence, this form of collecting or in the case of the two German church-men during Luther's time, their type of amassing relics and ex-hibiting them, not only provided the owners with a potential sense of relief but also bestowed a particular distinction. The ethologist Konrad Lorenz described this inclination to display as *triumph ceremony*.[272] While the concept pertains also to man, in this case it is largely a defensive maneuver caused by self-doubt or fragile self-esteem. As we have seen, the objects in a collection are meant to substitute for close touch with a real person who was not available when needed by the baby.

Here I should like to paraphrase an old statement by D. W. Winnicott: possessiveness, when it appears as a symptom, is al-ways a secondary phenomenon, implying anxiety.[273] During early childhood, when there is much need for touch and warmth and the knowledge of being wanted, lack of it results in deep insecurity, in greediness, in oral erotism and castration fear. These conditions often account for a flawed relationship with the outside world and end in finding more reassurance in objects than a close bond with people, who cannot be trusted.

However, in the narcissistic stimulus-producing display of which men throughout history have given us, one finds evi-dence of a special kind of relationship between the collector and his environment. Have many collectors, in their focus on quite basic need fulfilment, abandoned their lasting trust in people, thus giving preference to objects and possessions? From this point of view, the collector's boasting appears to be a display of grievance in disguise. A collector's possessions not only serve his or her own gratification but also function for retaliatory pur-poses. Remember Balzac, who wrote to his future wife how all of Paris envied his walking stick and gold buttons; and even she herself, as the grandniece of a former queen of France, was but the crown jewel he hoped to include in his collection.

This is not too surprising a conclusion. We have seen, after all, that much of the collector's basic defense is not only having and holding and being in possession, but also using his objects as a culturally acceptable device for reasserting himself. He thus

turns his basic sensitivity, his disillusionment and frustration, into acts of triumph and braggadocio, quite like Don Juan, who had constantly to prove to himself that he was desirable and making people aware of his conquests. His adventures were not born out of love for these conquests but were rather evidence to let the world know that, regardless of his early sense of not being wanted, he could have any maiden of his choice; and also there were inanimate substitutes that came his way and demonstrated to the world what his mother or caretakers did not recognize: that he is special and is entitled to these objects.

And so it is with collectors as well. The objects they cherish are inanimate substitutes for reassurance and care. Perhaps even more telling, these objects prove, both to the collector and to the world, that he or she is special and worthy of them.

* Notes *

1. Hugh Trevor-Roper, *Princes and Artists* (London: Thames and Hudson, 1976), p. 125.

2. Walter Benjamin, *Illuminations* (1931; rpt., London: Fontana, 1973), p. 60.

3. Benjamin, *Illuminations*, p. 60.

4. Benjamin, *Illuminations*, p. 60.

5. Benjamin, *Illuminations*.

6. This coincides with an observation made by E. R. Dodds: "The Greek had always felt the experience of passion as something mysterious and frightening, the experience of a force that was in him, possessing him, rather than possessed by him. The very word *pathos* testifies to that: like its Latin equivalent *passio*, it means something that 'happens to' a man, something of which he is the passive victim." See *The Greeks and the Irrational* (1951; rpt., Boston: Beacon Press, 1957), p. 185.

7. See H. Kohut, *The Analysis of the Self* (New York: International Universities Press, 1971), pp. 44–47.

8. See William Fagg, *African Tribal Images: The Katherine White Reswick Collection* (Cleveland: Cleveland Museum of Art, 1968), p. vii.

9. Fagg, *African Tribal Images*, p. vii.

10. D. W. Winnicott, *The Child and the Family* (London: Tavistock, 1957), p. 29.

11. See W. Muensterberger, "Psyche and Environment: Sociocultural Variations in Separation and Individuation," *Psychoanalytic Quarterly* 38 (1969): 191–216.

12. Otto Fenichel, *The Psychoanalytic Theory of Neurosis* (New York: W. W. Norton, 1945), p. 283; see also Karl Abraham, *Selected Papers on Psychoanalysis* (1927; rpt., London: Hogarth Press, 1948), esp. "A Short Study of the Development of the Libido."

13. Sigmund Freud, "Beyond the Pleasure Principle" (1920), in Freud, *Standard Edition* (hereafter, *S. E.*), vol. 18 (London: Hogarth Press, 1955), pp. 14–16.

14. Walter Benjamin, *Schriften*, 2 vols. (Frankfurt: Suhrkamp Verlag, 1955), 1:416.

15. In a somewhat different though related context André Green refers to delusional neoreality. See Green, *On Private Madness* (Madison, Conn.: International Universities Press, 1986), p. 108.

16. D. W. Winnicott, *Playing and Reality* (New York: Basic Books, 1971), p. 89.

17. E. Panofsky, "Abbot Suger of St. Denis," in Panofsky, *Meaning in the Visual Arts* (1955; rept., London: Penguin, 1970), p. 162.

18. See W. Muensterberger, "Between Reality and Fantasy," in S. Grolnik, L. Barkin, and W. Muensterberger, eds., *Between Reality and Fantasy* (New York: Jason Aronson, 1978), pp. 3–13.

19. Here I am reminded of a perceptive observation by Joyce McDougall: "Such children run the risk later in life of living as though they were 'not entirely real.' They may then feel that they do not understand the world around them; they come away from others with nothing—in other words, 'empty.' This kind of split in psychic reality may well predispose people to addictive ways of dealing with the feelings of unreality and emptiness. In place of the transitional object of infancy, with its capacity for soothing the self, the child within the adult may continue to seek transitory objects—drugs, sexual rituals, other people, or endless compulsive pursuits that bring only temporary relief." See J. McDougall, *Theaters of the Mind* (New York: Basic Books, 1985), p. 77.

20. Benjamin, *Illuminations*, p. 61.

21. Personal communication, March 14, 1973.

22. Susan Isaacs, *Social Development in Young Children*, 5th ed. (London: George Routledge, 1946), p. 287.

23. I owe the reference to Professor Sachs's former student and successor, Dr. Agnes Mongan, formerly of the Fogg Museum, Harvard University, Cambridge, Mass.

24. See Green, *On Private Madness*, p. 251.

25. Mario Praz, *The House of Life* (London: Methuen, 1964), pp. 110, 62f. See also p. 2.

26. Praz, *The House of Life*, p. 25f.

27. Praz, *The House of Life*, p. 10.

28. Praz, *The House of Life*, p. 13.

29. Praz, *The House of Life*, p. 205.

30. See Sigmund Freud, "Some Character-Types Met with in Psycho-Analytic Work I: The 'Exceptions'" (1916), in Freud, *S. E.* (1957), 14:315

31. A number of collectors have expressed similar sentiments such as "I simply must have it," or "I couldn't do without it." Remarks such as these illuminate an attempt of a narcissistic merging with the desired object. As child observation demonstrates, the object becomes subjectified and gives the owner-collector a momentary experience of satisfaction because it seems to restore a sense of omnipotence. These phenomena are reminiscent of the delusion that plays such a decisive role in the psychodynamics of fetishism.

32. A. F. Laurens and K. Pomian, eds., *L'Anticomanie* (Paris: Editions de l'École des Hautes Études, 1992).

33. See F. H. Taylor, *The Taste of Angels* (Boston: Little, Brown, 1948), p. 528.

34. Cf. O. Vessberg, *Studien zur Kunstgeschichte der Römischen Republik* (Lund: Acta Instituti Romani regni Suediae, 1941), pp. 26ff.; G. M. A. Richter, *Three Critical Periods in Greek Sculpture* (Oxford: Clarendon Press, 1951), pp. 38ff.

35. See Strabo, *The Geography of Strabo*, trans. H. L. Jones (Cambridge: Harvard University Press, 1927), 4:202ff.

36. Cicero, *The Verrine Orations*, trans. L. H. G. Greenwood (Cambridge: Harvard University Press, 1928).

37. Cicero, *The Verrine Orations*, 2.4.17–38 (p. 327f.).

38. L. Friedländer, *Roman Life and Manners Under the Early Empire*, 4 vols. (7th ed., 1908; rpt., London: Routledge and Kegan Paul, 1965), 2:232f.

39. R. H. Codrington, *The Melanesians* (Oxford: Clarendon Press, 1891), p. 191.

40. Codrington, *The Melanesians*, p. 203.

41. See Edward Tregear, *The Maori-Polynesian Comparative Dictionary* (Christchurch, N.Z.: Whitcombe and Tombs, n.d.), p. 203

42. Henri Bergson, *The Two Sources of Morality and Religion* (New York: Henry Holt, 1935), pp. 112f.

43. See Jan Huizinga, *The Waning of the Middle Ages* (1919; English ed., New York: Doubleday, 1956), p. 151. In the original Dutch text Huizinga's meaning is more intricate: "De gansche inhoud van het gedachtenleven wil uitgedrukt worden in verbeeldingen." *Herfstij der Middeleeuwen* (Haarlem: H. D. Tjeenk Willink and Zoon, 1919), p. 242.

44. In some areas of Melanesia and Polynesia, about a year after a relative's death the skull is exhumed and cleaned; the lower jaw is fixed to the upper one and carefully decorated by covering it with a layer of clay mixed with resin. Sometimes cowrie and other shells are placed in the eye sockets to heighten the human likeness.

45. See Paul Wirz, *Die Marind-anim von Holländisch-Süd-Neu-Guinea* (Hamburg: Kommissions-Verlag Friederichsen, 1925), vol. 2, part 3, pp. 49–62.

46. A. C. Kruijt, "Het Koppensnellen der Toradja's van Midden-Celebes," in *Verslagen en Mededelingen, afd. Letterkunde*, 4de reeks [4th series], III, Nederlandsche Akademie van Wetenschappen, 1899, p. 164f.

47. See F. W. Funke, *Orang Agung*, vol. 1 (Leiden: E. J. Brill, 1958), p. 77.

48. The etymological relation between *cup* (English), *kop* (Dutch),

coupe (French), *coppa* (Italian), and head is evident. The common root is the Latin *caput*.

49. See A. E. Jensen, *Die Drei Ströme* (Leipzig: Harrassowitz, 1948), pp. 65–70.

50. See J. F. F. Riedel, *De Sluik- en Kroesharige Rassen tusschen Selebes en Papua* (The Hague: Nijhoff, 1886), pp. 104–106.

51. R. E. Reina, "The Ritual of the Skulls," in *University Museum of Pennsylvania Expedition*, 4 (1962), no. 4:26–35.

52. The basic information can be found in Hippolyte Delehaye, *Les origines du culte des martyrs*, 2d ed. (Brussels: Société des Bollandistes, 1933); see also Bernhard Kötting, *Peregrenatio Religiosa* (Münster: Regensberg, 1950), and Carl Meyer, *Der Aberglaube des Mittelalters* (Basel: Felix Schneider, 1884). For the Milan treasures, see *Distinto raggauglio dell' ottavo maraviglia del mondo* (Milan, 1739).

53. Delehaye, *Origines du culte*, p. 60.

54. Kötting, *Peregrenatio Religiosa*, p. 333 n. 206.

55. *Amulet* derives probably from the Latin *amoletum*, a means of defense. See Pliny, *Natural History*.

56. See M. Bondois, *La translation des Saints Marcellin et Pierre. Étude sur Einhard et sa vie politique* (Paris, 1906); P. J. Geary, *Furta Sacra*, 2d ed. (Princeton: Princeton University Press, 1990), pp. 45, 118.

57. Hugh Honour, *Venice* (London: Fontana-Collins, 1965), p. 33.

58. *Monumenta Germaniae Historica*, Scriptorum, vol. 15, part 1 (Hanover: Bibliopolii Hahniani, 1887), pp. 240f., 329f. See also P. J. Geary, *Furta Sacra*, p. 467.

59. Ibid., vol. 4 , part 1, pp. 238–264 (*Translatio et Miracula SS. Marcellini et Petri*).

60. J. Armitage Robinson, *The Times of St. Dunstan* (Oxford: Clarendon Press, 1923), pp. 71–80.

61. *Monumenta Germaniae Historica*, vol. 15, part 1, pp. 240f., p.329f. (*Translationibus et Miraculis Sancti Germani*).

62. Abraham, "A Short Study of the Development of the Libido," p. 493 (see also chapt. 1, n. 11).

63. Robinson, *The Times of St. Dunstan*, p. 73.

64. See H. Fichtenau, "Zum Reliquienwesen im früheren Mittelalter," in *Mitteilungen des Instituts für Oesterreichische Geschichtsforschung* 60 (1952): 75.

65. There is a well-known early description by Caesarius von Heisterbach, a so-called *libellus* which deals with the circumstances in detail. For further reference see A. Huyskens, *Quellenstudien zur Geschichte der Heiligen Elisabeth* (Marburg: Verlag Elwerth, 1908); E. Busse-Wilson, *Das Leben der Heiligen Elisabeth* (Munich: C. H. Beck,

1931), p. 278f. See also Huizinga, *Herfstij der Middeleeuwen*, p. 273, part 2.

66. Unless otherwise indicated, all the quotations in this chapter are taken from the original Phillipps letters in the possession of the Robinson Trust and deposited in the Bodleian Library, Oxford, England. This chapter relies on this correspondence and on A. N. L. Munby's extensive *Phillipps Studies*, 5 vols. (Cambridge: Cambridge University Press, 1951–1960). I also had the privilege of a number of conversations and discussions with the late Tim Munby.

67. See Munby 2:91.

68. Munby 4:133.

69. Munby 4:86, 166.

70. The Leonardo drawing together with five Rubens drawings were acquired by the late Count Antoine Seilern, who was kind enough to show them to me.

71. Copy of a letter to Lady Steele-Graves of August 11, 1863.

72. See Munby 3:1f.

73. There are striking parallels between Thomas Phillipps and another book collector, Richard Heber, who was nineteen years his senior. Heber's mother died when he was only one week old, and he grew up partly in the care of a paternal aunt. At the age of ten he was severely ill. Like Phillipps, he too received his education in a private school, but did exceedingly well, unlike Thomas. Heber's impressive precocity is reflected in a letter to his father shortly before he fell ill: "I send you a line as I promised. . . . Caractatus is a very scarce book but I believe it is at Mr. Betham's sale where I would be much obliged to you to go, there being the very best Editions of the Classics of all sizes. His auction is to be very soon at Messrs. Southerbys [sic] Covent Garden [April 30, 1784]."

His father obliged. Seven years later Heber was a student at Oxford and buying books and prints, about which his father soon complained, as he did in a number of other letters, although their tone is conspicuously different from that of old Phillipps's letters: "The Charge of Ten Guineas which you mention for *Prints* is I think a very unnecessary article of Expense and I hope I see no more of the like extravagant complexion. . . . It grieves me to observe that indirect breach of Your Word and promise." Quoted from the collection of the Heber Correspondence in the Bodleian Library, Oxford.

74. See Munby 2:9.

75. See Munby 3:13.

76. See Munby 2:23.

77. See Munby 3:38–41.

78. See Munby 2:28.

79. See Munby 2:28.

80. See Munby 4:33.

81. Catalogue of *The Celebrated Collection of Manuscripts Formed by Sir Thomas Phillipps*, Property of the Trustees of the Robinson Trust, Sotheby's, London (June 27, 1966).

82. See Munby 2:63.

83. Johann Georg Kohl, *Vom Markt und aus der Zelle* (Hannover, 1868).

84. See Munby 4:32–36.

85. H. de Balzac, "J'ai l'espoir de devenir riche à coups de romans," in *Lettres à sa Famille*, ed. W. S. Hastings (Paris: Albin Michel, 1950), p. 52

86. See Donald Adamson, *The Genesis of "Le Cousin Pons"* (London: Oxford University Press, 1966), p. 121, quoting from Champfleury, *Grand Figures d'hier et d'aujourd'hui* (Paris, 1861), p. 84f. See also H. J. Hunt, *Honoré de Balzac* (London: Athlone Press, 1957), pp. 71–75. *Le Cousin Pons*, one of Balzac's last novels, had appeared as part of the series *Les Parents Pauvres* and was first published in the *Musée Literaire du Siècle*, and then again between March and May 1847 in *Le Constitutionnel* (see Adamson, *Genesis*, pp. 44f.), the title of the latter publication being *Le Cousin Pons ou Les Deux Musiciens*.

My quotations from the various writings of Balzac have been double-checked. They rely on the English edition, *The Works of Honoré de Balzac*, trans. E. Marriage, 36 vols. (New York: Society of English and French Literature, 1900), and *Oeuvres complètes* (édition nouvelle), ed. Marcel Bouteron, 28 vols. (Paris: Pléïade, 1956–1963).

87. Honoré de Balzac, *Cousin Pons*, see *Works* 22:27f., and *Oeuvres* 6:53. My quotations from Balzac's writings are from *The Works of Honoré de Balzac* and *Oeuvres complètes*.

88. In an earlier version of the novel Balzac paid even more attention to the details and finesse of those dinners: "Pons was a gourmandizer. His poverty and his craving for bric-à-brac restricted him to a diet so repugnant to his sensitive palate that, as a bachelor, he had solved the problem from the start by dining out every evening. . . . Now when the stomach gets such schooling, the moral person is affected, is corrupted by the high degree of culinary knowledge thus acquired" (*Cousin Pons*, in *Works* 22:27–29, and *Oeuvres* 6:533.

89. *César Birotteau*, in *Works* 27:22, and *Oeuvres* 5:341.

90. Honoré de Balzac, *Lettres a l'Etrangère*, ed. A. C. J. de Spoelberch de Lovenjoul and M. J. Bouteron, 5 vols. (Paris: Calmann-Levy, 1899–1950), 1:24f., 41.

91. His birth certificate of May 21, 1799, reads: "Un enfant male par

le citoyen Bernard-François Balzac . . . lequel me declare que ledit enfant s'appelle Honoré Balzac." See G. Hanotaux and G. Vicaire, *La Jeunesse de Balzac* (1903; rpt., Paris: Librairie des Amateurs, 1921), p. 123.

92. Balzac, *Correspondance*, ed. Roger Pierrot, 5 vols. (Paris: Editions Garnier Frères, 1960–1969), 1:271 (July 22, 1825).

93. Honoré de Balzac, *The Lily of the Valley*, in *Works* 17:17, 37, and *Oeuvres* 8:770f.

94. Laure Surville, *Balzac, sa vie et ses oeuvres* (Paris: Jaccottet, Bourdillat, 1858). This is one of the best sources of insight into Balzac's life and personality.

95. André Maurois, *Prometheus: The Life of Balzac* (1965; rpt. New York: Harper and Row, 1966), p. 22.

96. Balzac, *Correspondance* 5.

97. Surville, *Balzac*, pp. 18–20.

98. Balzac, "Des Artistes," *La Silhouette* (April, 1830).

99. Maurois, *Prometheus*, p. 24f.

100. Balzac, *The Lily of the Valley*, in *Works* 17:37, and *Oeuvres* 8:770f.

101. M. Fargeaud and R. Pierrot, "Henri le trop aimé," in *L'Année Balzacienne* (1961), pp. 44–46.

102. Balzac, *Correspondance* 1:132.

103. Honoré de Balzac, *Louis Lambert*, in *Works* 4:146 (italics added), and *Oeuvres* 10:354.

104. Balzac, *Louis Lambert*, in *Works* 4:151–64, and *Oeuvres* 10:359–70.

105. Balzac, *The Lily of the Valley*, in *Works* 17:2, *Oeuvres*, 8:770f.

106. Ibid., in *Works* 17:37f., and *Oeuvres* 8:770f.

107. Balzac, *A Start in Life*, in *Works* 11:160f., and *Oeuvres* 1:615f.

108. Honoré de Balzac, *Droll Stories*, 2 vols. (London, 1899), 2:80ff., and *Oeuvres* 11:819.

109. "Some Character-Types Met with in Psycho-Analytic Work I: The 'Exceptions'" (1916), in *S. E.* 14:309–15.

110. Maurois, *Prometheus*, p. 187.

111. Honoré de Balzac, *Correspondance inéditée avec Zulma Carraud*, ed. Marcel Bouteron (Paris: Arneaud Colin, 1935), p. 77. The French text puts it more succinctly: "parceque votre âme est faussée, parceque vous répudiez la vraie gloire pour la gloriole . . ."

112. Balzac, *Lettres à l'Etrangère* 1:200, 217.

113. Balzac, *Lettres à l'Etrangère* 1:205.

114. Mary Frances Sandars, *Honoré de Balzac*, London, pp. 178f.

115. Balzac, *Lettres à l'Etrangère* 1:126.

116. Balzac, *Lettres à l'Etrangère* 1:236–41 (March 11, 1835).

117. Maurois, *Prometheus*, p. 328.

118. Maurois, *Prometheus*, p. 127.

119. Balzac, *Correspondance* 1:336.

120. Balzac, *Oeuvres* 4:496.

121. Balzac, *The Wild Ass's Skin*, in *Works* 1:32f., and *Oeuvres* 9:41.

122. Léon Gozlan, *Balzac en pantoufles*, 3d ed. (Paris: Michel Lévy, 1865), p. 31f.

123. Balzac, *Correspondance inéditée avec Zulma Carraud*, p. 306.

124. Gozlan, *Balzac en pantoufles*, p. 45f.

125. Balzac, *Correspondance* 1:269f.

126. Balzac, *Correspondance* 1:111f.

127. Balzac, *Correspondance* 1:113.

128. Balzac, *Le Cousin Pons*, in *Works* 22:7–15, and *Oeuvres* 6:532–37.

129. Ibid.

130. Balzac, *Lettres à l'Etrangère* 3:336 (July 28, 1846).

131. Balzac, *Lettres à l'Etrangère* 3:11 n. 2.

132. Balzac, *Correspondance* 5:57 n. 2.

133. Balzac, *Correspondance* 5:64.

134. Balzac, *Lettres à l'Etrangère* 3:176, 214, 216, 222f. (February 18, 1846).

135. Balzac, *Correspondance* 5:281–84.

136. Balzac, *Correspondance* 5:297.

137. Ibid.

138. Balzac, *Correspondance* 5:743–46.

139. Champfleury, *Note sur M. de Balzac* (see Maurois, *Prometheus*, p. 518).

140. J. Paul Getty, *As I See It* (London: W. H. Allen, 1976), pp. 277ff.

141. These events took place during the time of the Mao Tse-tung (Mao Zedong) regime in China.

142. Wilmarth Lewis, *Collector's Progress* (London: Constable, 1952), p. 221.

143. Karl E. Meyer, *The Plundered Past* (1973; rpt., New York: Penguin Books, 1977).

144. See S. J. Fleming, "Bronze Technology in China," in Fleming, *Ancient Chinese Bronzes* (London: Eskenazi, 1975), p. 14.

145. See Comte de Brienne, *Memoires* (Paris, 1828), quoted by F. H. Taylor, *The Taste of Angels*, p. 334f.

146. For a comprehensive overview see Jean Gimpel, *The Medieval Machine* (London: Victor Gollancz, 1977).

147. See J. Glennisson and J. Day, eds., *Textes et documents d'histoire du moyen age, XIVe–XVe siècles* (Paris: S.E.D.E.S.), p. 8f.

148. G. Boccaccio, *Il Decameron*, trans. J. M. Rigg (New York, E. P. Dutton, 1930), p. 8f.

149. Françoise Lehoux, *Jean de France, Duc de Berri*, vol. 1 (Paris: Éditions A. et J. Picard, 1966), p. 12f.

150. Millard Meiss, *French Painting in the Time of Jean de Berry*, 2 vols. (London and New York: Phaidon, 1967), p. 31.

151. Ernst Walser, *Gesammelte Studien zur Geistesgeschichte der Renaissance*, ed. Werner Kaegi (Basel: Benno Schwabe, 1933), p. 99.

152. See especially William S. Heckscher, *Rembrandt's Anatomy of Dr. Nicolaas Tulp* (New York: New York University Press), 1958, p. 85.

153. Peter Burke, *Tradition and Innovation in Renaissance Italy* (1972; rpt., London: Fontana/Collins, 1974), p. 235.

154. Lewis Mumford, *Technics and Civilization* (New York: Harcourt Brace, 1939), p. 14f.

155. Dondi's correspondence and manuscripts are in the Biblioteca Marciana in Venice; see *Ms. Lat. XIV 223 (4340)*. See also S. A. Bedini and F. R. Maddison, "Mechanical Universe: The Astrarium of Giovanni de' Dondi," in *Transactions of the American Philosophical Society* 56, part 5, p. 966.

156. Roberto Weiss, *The Renaissance Discovery of Classical Antiquity* (1969; rpt., Oxford: Basil Blackwell, 1973), pp. 49–53.

157. Jacob Burckhardt, *The Civilization of the Renaissance in Italy* (2d. ed., 1868), ed. Irene Gordan (New York: New American Library, 1960), p. 190.

158. Antonio di Tuccio Manetti, *The Life of Brunelleschi*, ed. Howard Saalman (University Park: Pennsylvania State University Press, 1970), p. 54f. See also C. von Fabriczy, *Filippo Brunelleschi* (Stuttgart: J. G. Cotta'sche Verlagsbuchhandlung, 1892), p. 92.

159. Weiss, *The Renaissance Discovery of Classical Antiquity*, p. 63. According to Weiss, the journey to Rome has recently been questioned, largely because their friendship underwent some changes in subsequent years. The doubts are based on their eventual alienation.

160. Salutati, *Epistolario di Coluccio Salutati*, ed. F. Novati (Roma, 1896), 3:655. See also B. L. Ullman, *The Humanism of Coluccio Salutate* (Padua, 1963).

161. See especially Weiss, *The Renaissance Discovery of Classical Antiquity*, pp. 63–68.

162. See Burke, *Tradition and Innovation in Renaissance Italy*, p. 174.

163. See Walser, *Gesammelte Studien*, p. 24f. Also T. de Tonellis, ed., *Poggii Epistolae* (Florence, 1832), 1:16.

164. Christopher Hibbert, *The Rise and Fall of the House of Medici* (1974; rpt., London: Penguin, 1979), p. 45.

165. Walser, *Gesammelte Studien*, p. 60.

166. Letter to Guarinus Veronensis dated December 15, 1416. See Phyllis W. G. Gordan, *Two Renaissance Bookhunters* (New York: Columbia University Press, 1974), p. 193f.

167. Walser, *Gesammelte Studien*, p. 55 nn. 2 and 3.

168. Dated Rome, September 27, 1430. See for this and the following letter Gordan, *Two Renaissance Bookhunters*, pp. 166–69.

169. *Poggii Epistolae* 1:322. Cf. Gordan, *Two Renaissance Bookhunters*, p. 146f.

170. *Poggii Epistolae* 1:331. See also Walser, *Gesammelte Studien*, p. 148.

171. Walser, *Gesammelte Studien*, p. 304.

172. See Gordan, *Two Renaissance Bookhunters*, p. 166f.

173. See Weiss, *The Renaissance Discovery of Classical Antiquity*, p. 63.

174. See Joseph Alsop, "Art Collecting: The Renaissance and Antiquity," *Times Literary Supplement*, August 4, 1978, p. 892.

175. See Gordan, *Two Renaissance Bookhunters*, p. 166f.

176. See Weiss, *The Renaissance Discovery of Classical Antiquity*, p. 185.

177. Weiss, *The Renaissance Discovery of Classical Antiquity*, p. 29.

178. Weiss, *The Renaissance Discovery of Classical Antiquity*, pp. 167–79.

179. Marie Boas, *The Scientific Renaissance 1450–1630* (1962; rpt., London: Fontana/Collins, 1970), p. 121. According to Boas's view the edict was given because of the practice to have the bones of Crusaders and pilgrims laid to rest in their homeland. But it was equally responsible "for the many subterfuges such as robbing gallows" for the purpose of anatomical dissection.

180. Boas, *The Scientific Renaissance*, p. 156.

181. See *Mandeville's Travels*, ed. and trans. Malcolm Letts, 2 vols. (London: Hakluyt Society, 1953).

182. See Friedrich Heer, *The Medieval World* (1961; rpt., New York: Mentor, 1963), p. 272.

183. See Boas, *The Scientific Renaissance*, pp. 120, 45–48.

184. See Walter Minchinton, "Patterns and Structure of Demand 1500–1750," in Carlo M. Cipolla, ed., *The Fontana Economic History of Europe, the Sixteenth and Seventeenth Century* (Glasgow: Collins, 1974), p. 168.

185. Many artists of the period and later started their training in painting and sculpture with anatomical studies. However, Leonardo insisted on his own dissecting. He wrote: "I have dissected more than ten [later he amended it to thirty] human bodies, destroying all the members, and removing even the smallest particles of the flesh which surrounded these veins. . . . And as one single body did not suffice for so long a time, it was necessary to proceed by stages with so many bodies as would render my knowledge complete; and this I repeated twice in order to discover the difference." See E. MacCurdy, *The Note-*

books of Leonardo da Vinci (New York: George Braziller, 1956), p. 166. Also J. Playfair McMurrich, *Leonardo da Vinci, the Anatomist* (Baltimore: Williams and Wilkins, 1930), p. 14.

186. See for a comprehensive discussion R. W. Scheller, "Rembrandt en de Encyclopedische Kunstkamer," in *Oud-Holland* (n.d.).

187. Boas, *The Scientific Renaissance*, p. 130.

188. R. H. Tawney, *Religion and the Rise of Capitalism* (1922; rpt., London: Penguin, 1964), p. 176.

189. See F. S. Wurffbain, *Dissertatio de Technophysiotameis von Kunst- und Naturalienkammern*. Altdorf: Henricus Meyer, 1704.

190. Julius von Schlosser, *Die Kunst- und Wunderkammern der Spätrenaissance* (Leipzig: Klinkhardt and Biermann, 1908). Von Schlosser's work is still the most comprehensive study of these collections. See also Alphons Lhotsky, *Geschichte der Sammlungen* (Vienna: Festschrift des Kunsthistorischen Museums, 1941–1945).

191. Von Schlosser, *Die Kunst- und Wunderkammern der Spätrenaissance*, p. 44.

192. See E. Mayer-Löwenschwerdt, *Der Aufenthalt der Erzherzöge Rudolf und Ernst in Spanien, 1564–1571* (Vienna, 1927).

193. Arthur Koestler, *The Sleepwalkers* (1959; rpt., London: Penguin, 1968), p. 300.

194. See letter to François Thomas Perrenot de Granville (February 28, 1605), in *Jahrbuch der Kunsthistorischen Sammlungen des allerhöchsten Kaiserhauses*, vol 19 (Vienna, 1889), nr. 16534.

195. See H. Zimmermann, Kunstgeschichtliche Charakterbilder, "Rudolf II and die Prager Kunstkammer," *Jahrbuch der Kunsthistorischen Sammlungen des Allerhöchsten Kaiserhauses* vol. 25 (Vienna, 1893).

196. See R. J. W. Evans, *Rudolf II and His World* (Oxford: Clarendon Press, 1973), p. 217 n. 7.

197. See Gertrude von Schwarzenfeld, *Rudolf II, Der Saturnische Kaiser* (Munich: D. W. Callway, 1960), p. 94. (I was unable to check this quotation.)

198. See Fernand Braudel, *The Mediterranean and the Mediterranean World in the Age of Philip II* (1966; rpt., New York: Harper and Row, 1972), p. 369.

199. Elisabeth Landolt, "Late Humanistic Art and Collecting in Basle," in *Apollo* (December 1976): 467–75).

200. Robert Burton, *The Anatomy of Melancholy* (Second Part), ed. Holbrook Jackson (1651; rpt., London: J. M. Dent, 1977), p. 86f.

201. Henry Peacham, *The Compleat Gentleman* (London: Francis Constable, 1634), p. 104f. Quotations are from a facsimile edition (Oxford: Clarendon Press, 1906).

202. Ibid.

203. John Evelyn, *The Diary of John Evelyn*, ed. E. S. de Beer (London: Oxford University Press, 1959), p. 66.

204. *The Diary of John Evelyn*, p. 303.

205. *The Diary of John Evelyn*, p. 68.

206. See David Murray, *Museums, Their History and Their Use*, 3 vols. (Glasgow: James MacLehose, 1904), 1:30f. Quoted from an English edition of 1691.

207. See A. Schierbeek, *Jan Swammerdam* (Lochem: De Tijdstroom, 1946), p. 14f.

208. See Scheller, "Rembrandt," p. 105.

209. Johann Daniel Major, *Unvorgreiffliches Bedencken von Kunst- und Naturalien-Kammern insgemein* (Kiel, 1662).

210. Museum Spenerianum (Leipzig, 1693), quoted after Murray, *Museums, Their History and Their Use* 3:185.

211. Quoted after W. E. Houghton, Jr., "The English Virtuoso in the Seventeenth Century," in *Journal of the History of Ideas* 3 (1942):53.

212. J. H. Huizinga, *Dutch Civilization in the 17th Century* (London: Collins, 1968), p. 77

213. S. Schama, *The Embarrassment of Riches* (New York: Knopf, 1987), p. 318.

214. Huizinga, *Dutch Civilization in the 17th Century*, p. 79.

215. *The Diary of John Evelyn*, p. 21f.

216. *The Diary of John Evelyn*, p. 26 n. 1.

217. L. Mumford, *The Condition of Man* (New York: Harcourt, Brace, 1944), p. 181f.

218. P. Geyl, *The Netherlands in the Seventeenth Century*, vol. 1, 1609–1648 (London: Ernest Benn, 1961), p. 247f.

219. E. Tremayne, *The First Governess of the Netherlands, Margaret of Austria* (New York: G. P. Putnam, 1908).

220. J. Denucé, *De Konstkamers van Antwerpen in de XVIe en XVIIe eeuwen* (Antwerp: De Sikkel, 1932).

221. T. H. Lunsingh Scheurleer, "Over Verzamelaars en Verzamelingen" (n.d.), pp. 12–14.

222. Huizinga, *Dutch Civilization in the 17th Century*, p. 79.

223. *The Diary of John Evelyn*, p. 28.

224. H. Floerke, *Studien zur Niederländischen Kunst- und Kulturgeschichte* (Munich and Leipzig: G. Müller, 1905), p. 154.

225. J. Schierbeek, *Jan Swammerdam*, p. 9.

226. A. Bredius, "De Schilder Johannes van de Capelle" *Oud-Holland* 10 (1892).

227. Schama, *The Embarrassment of Riches*, p. 313f.

228. G. Leonhardt, *Het Huis Bartoletti en zijn Bewoners* (Amsterdam, 1979), quoted after Schama, *The Embarrassment of Riches*, p. 313f.

229. See Arnoldus Buchelius, *Res Pictoriae*, in G. J. Hoogewerff and J. Q. van Regteren Altena, eds., *Quellenstudien zur Holländischen Kunstgeschichte*, vol. 15 (Gravenhage, 1928), pp. 96–100.

230. See Elisabeth Reynst, "Sammlung Gerrit und Jan Reijnst" (typescript), Amsterdam: Rijksmuseum, 1964. I acknowledge with thanks the kind cooperation and suggestions of Drs. E. Haverkamp-Begemann, A. Logan, and J. W. Niemeijer.

231. See *Jaarboek Amstelodamum*, vol. 14 (1916), pp. 239–45.

232. *Beschrijvinge der wijdt-vermaarde koopstad Amstelredamum* (1662).

233. F. Lugt, "Italiaansche Kunstwerken in Nederlandsche Verzamelingen in vroegere tijden," in *Oud-Holland* 53 (1936):115f.

234. Personal note to F. H. Taylor quoted in his *The Taste of Angels*, p. 238.

235. See also Peter Burke, *Venice and Amsterdam* (London: Temple Smith, 1974).

236. See Scheller, "Rembrandt en de encyclopedische Kunstkamer," p. 197.

237. See J. Denucé, *De Kunstkamers van Antwerpen*; L. J. Bol, *De Bekoring van het kleine*, Stichting Openbaar Kunstbezit (no year); M. Winner, "Gemalte Kunsttheorie," in *Jahrbuch der Berliner Museen*, 4 (1962):151–85; and S. Speth-Holterhoff, *Les Peintres Flamands de Cabinets d'Amateurs au XVIIe siècle* (Amsterdam and Brussels: Elsevier, 1957).

238. For the most extensive description see E. H. Krelage, *Bloemenspeculatie in Nederland* (Amsterdam: P. N. van Kampen en Zoon, 1942), pp. 15–112. Also W. Blunt, *Tulipomania* (London: King Penguin, 1950), id. *The Art of Botanical Illustration* (London: Collins, 1950, rpt. 1971), pp. 75–77.

239. N. W. Posthumus, "De Speculatie in Tulpen in de Jaren 1636–1637," in *Economisch-Historisch Jaarboek* 12 (1926): 3–9.

240. A. Meldola, *Tulpen und Staatspapiere* (Hamburg: Hoffmann and Campe, 1830), pp. 5–16.

241. Krelage, *Bloemenspeculatie in Nederland*, p. 63f; Posthumus, "De Speculatie in Tulpen," pp. 10–12.

242. Meldola, *Tulpen und Staatspapiere*, p. 8, after A. Munting, *Waare Oeffening der Planten* (Amsterdam, 1672).

243. See Fenichel, *The Psychoanalytic Theory of Neurosis*, p. 283.

244. Karl Abraham, "Contributions to the Theory of the Anal Character" (1921), in *Selected Papers* (London: Hogarth Press, 1948), p. 371.

245. The Armenian magnate Calouste Gulbenkian refused visitors to his collection in his Paris mansion in the Avenue d'Iena. "Would I admit a stranger to my harem?" he used to reply. See Kenneth Clark's introduction to Douglas Cooper, ed., *Great Private Collections* (New

York: Macmillan, 1963), p. 15. Also Maurice Rheims, *Art on the Market* (1959; rpt., London: Weidenfeld and Nicolson, 1961), p. 17f.

246. S. P. Dance, *Shell Collecting* (London, Faber and Faber, 1966), p. 86f.

247. Sigmund Freud, "Psycho-Analytic Notes on an Autobiographical Account of a Case of Paranoia" (1911), in *S. E.* (1958), 12:68–70.

248. Praz, *The House of Life*.

249. Praz, *The House of Life*, p. 62f.

250. George Steiner, "A Note on Language and Psycho-Analysis," *International Revue of Psycho-Analysis* 3 (1976): 253–58.

251. H. P. Kraus, *A Rare Book Saga* (London: André Deutsch, 1979), p. 32.

252. E. and J. de Goncourt, *Journal*, vol. 1 (Paris: Flammarion, 1935), p. 177.

253. Morey M. Segal, "Impulsive Sexuality: Some Clinical and Theoretical Observations," *International Journal of Psycho-Analysis* 44 (1963): 407–18 (italics added).

254. Needless to add, there was an issue of Oedipal rivalry. My informant's disposition suggests that collecting travel guides is a secondary revision of his inclination as such.

255. Lady Charlotte Schreiber, *Lady Charlotte Schreiber's Journals*, ed. Montague Guest, 2 vols. (London: John Lane, the Bodley Head, 1911), 1:6f.

256. Schreiber, *Journals*, 1:xxv f. Lady Schreiber used to buy paintings before she became a collector of chinaware, fans, etc. Curiously enough she acquired paintings without ever having set foot in a museum. I owe this information to Mr. Francis Russell.

257. Gerald Reitlinger refers to this group in his *The Economics of Taste* (1963; rpt., New York: Holt, Rinehart and Winston, 1965), p. 554. A similar pair was sold in 1930 for £3,250.00.

258. Schreiber, *Journal*, 1:xxvi.

259. Charles Ricketts, *Self-Portrait: Letters and Journals of Charles Ricketts*, ed. Cecil Lewis (London: Peter Davies, 1939), pp. viii f.

260. Peter Gay, *Freud: A Life for Our Time* (New York: Norton, 1988), p. 170.

261. I owe a major part of my account to K. Wallace's "Slim-Shin's Monument," in *The New Yorker* (November 19, 1960): 104–46.

262. René Gimpel, *Diary of an Art Dealer* (1963; rpt., New York: Farrar, Straus and Giroux, 1966), p. 23.

263. Wallace, "Slim-Shin's Monument," pp. 121, 110.

264. Wallace, "Slim-Shin's Monument," p. 115.

265. Wallace, "Slim-Shin's Monument," p. 134.

266. Edward Bibring, "The Mechanisms of Depression," in Phyllis

Greenacre, ed., *Affective Disorders* (New York: International Universities Press, 1953), pp. 13–48.

267. For a lively description of auction-room scenes see Stowers Johnson, *Collector's Luck* (London: Phoenix House, 1968), pp. 56–78.

268. Cf. John Herbert, *Inside Christie's* (London: Hodder and Stoughton, 1990), pp. 100–12.

269. John Steinbeck, *Travels with Charley* (1962; rpt., New York: Bantam, 1976), p. 43f.

270. See Peter Bull, *Bear with Me* (London: Hutchinson, 1969).

271. Charles Rycroft, *Anxiety and Neurosis* (London: Allen Lane, 1968), p. 32

272. Lorenz refers to *Imponiergeschehen* in animal behavior. The English translation of *triumph ceremony* does not have exactly the same meaning. See Konrad Lorenz, *Das Sogenannte Böse: Zur Naturgeschichte der Aggression* (Vienna: Dr. G. Borothra-Schoeler Verlag, 1963); *On Aggression* (London: Methuen, 1967), pp. 156–60.

273. D. W. Winnicott, "Appetite and Emotional Disorder" (1936), in *Collected Papers* (New York: Basic Books, 1958), p. 33. Winnicott referred to *greediness*.

* Bibliography *

Abraham, Karl. *Selected Papers on Psycho-Analysis* (3d ed., 1927). London: Hogarth Press, 1948.

──────. "Contributions to the Theory of the Anal Character" (1921). In Abraham, *Selected Papers*.

──────. "A Short Study of the Development of the Libido." In Abraham, *Selected Papers*.

Adamson, Donald. *The Genesis of "Le Cousin Pons."* London: Oxford University Press, 1966.

Alsop, Joseph. "Art Collecting: The Renaissance and Antiquity," *Times Literary Supplement*, August 4, 1978.

Aston, Margaret. *The Fifteenth Century: The Prospect of Europe*. London: Thames and Hudson, 1968.

Baart, Willem. "Catalogus van een extra uytmuntend Kabinet van allerley soorten van ongemeen gepolyste hoorens en doublet-schelpen ... coraal en zeegewassen petrificata ... benevens een kabinet van vreemde opgezette vogels, in en uytlandsche gediertens in liquor ... verzameld en nagelaten door Willem Baart." Amsterdam, 1762.

Bak, R. C. "Fetishism." *Journal of the American Psychoanalytic Association* 1 (1968).

──────. "The Phallic Woman: The Ubiquitous Fantasy in Perversions." *Psychoanalytic Study of the Child* 23: 1–36.

Balzac, Honoré de. *Correspondance*. Edited by Roger Pierrot. 5 vols. Paris: Editions Garnier Frères, 1960–1969.

──────. *Correspondance avec Zulma Carraud*. Edited by M. Bouteron. Paris: Gallimard, 1951.

──────. *Correspondance inédittée avec Zulma Carraud*. Edited by Marcel Bouteron. Paris: Arneaud Colin, 1935.

──────. *Droll Stories*. 2 vols. London, 1899.

──────*Honoré de Balzac: Letters to His Family, 1809–1850*. Edited by Walter Scott Hastings. Princeton: Princeton University Press, 1984.

──────. *Lettres à l'Etrangère*. Edited by A. C. J. de Spoelberch de Lovenjoul and M. J. Bouteron. 5 vols. Paris: Calmann-Lévy, 1899–1950.

──────. *Lettres à sa Famille*. Edited by W. S. Hastings. Paris: Albin Michel, 1950.

──────. H. *Oeuvres complètes*. Edited by Marcel Bouteron. New ed. 28 vols. Paris: Pléïade, 1956–1963.

──────. *The Works of Honoré de Balzac*. Translated by E. Marriage. 36 vols. New York: Society for English and French Literature, 1900.

Barge, J. A. J. *De oudste Inventaris der oudste Academische Anatomy in Nederland*. Leiden: Brill, 1934.

Barker, Nicolas. *Bibliotheca Lindesiana*. London: Bernard Quaritch, 1977.

Baudelot de Dairval, Ch. César. *De l'utilité des voyages et de l'avantage que la recherche des antiquez procure aux savants*. Paris: Aubouin and Emery, 1686.

Bedini, S. A. and F. R. Maddison. "Mechanical Universe: The Astrarium of Giovanni de' Dondi." *Transactions of the American Philosophical Society* 56, part 5.

Behrman, S. N. *Duveen*. London: Hamish Hamilton, 1952.

Bellemo, V. *Jacopo e Giovanni de' Dondi dell' Orologio*. Chioggia, 1894.

Benjamin, Walter. *Illuminations* (1931). London: Fontana, 1973.

――――. *Schriften*. 2 vols. Frankfurt a. M.: Suhrkamp Verlag, 1955.

Bentley, J. *Restless Bones*. London: Constable, 1985.

Bergson, Henri. *The Two Sources of Morality and Religion*. New York: Henry Holt, 1935.

Bettenson, H., ed. *Documents of the Early Christian Church*. 1943 (n. p.).

Beurdeley, Michel. *The Chinese Collector Through the Centuries*. Rutland, Vt.: Charles E. Tuttle, 1966.

Bibring, Edward. "The Mechanisms of Depression." In Phyllis Greenacre, ed., *Affective Disorders*. New York: International Universities Press, 1953.

Bille, C. *De Tempel der Kunst van het Kabinet van den Heer Braamcamp*. Amsterdam: J. H. de Bussy, 1961.

Bisticci, V. da. *Vite di uomini illustri del secolo XV*. P. d' Ancona and E. Aeschlimann, eds. Milan, 1951.

Bittmann, Karl. *Ludwig XI und Karl der Kühne: Die Memoiren des Phillippe de Commynes als Historische Quelle*, vol. 1. Göttingen, 1964.

Black, Max. *Models and Metaphors: Studies in Language and Philosophy*. Ithaca, N.Y.: Cornell University Press, 1962.

Blumenthal, Walter. *Bookman's Bedlam*. New Brunswick, N. J.: Rutgers University Press, 1955.

Blunt, W. *The Art of Botanical Illustration* (1950). London: Collins, 1971.

――――*Tulipomania*. London: King Penguin, 1950.

Boas, Marie. *The Scientific Renaissance 1450–1630* (1962). London: Fontana/Collins, 1970.

Boccaccio, G. *Il Decameron*. Translated by J. M. Rigg. New York: E. P. Dutton, 1930.

Bogeng, G. Q. E. *Die Grossen Bibliophilen*. 2 vols. Leipzig, 1922.

L. J. Bol. *De Bekoring van het kleine*. Stichting Openbaar Kunstbezit (no year).

Bondois, M. *La translation des Saints Marcellin et Pierre*. Paris, 1906.

Bonnaffé, Edward. *Les Collectioneurs de l'ancienne France* (1867). Paris, 1869.

Borenius, T. *The Picture Gallery of Andrea Vendramin*. London, 1923.

Boussard, J. *The Civilization of Charlemagne*. London: Weidenfeld and Nicolson, 1968.

Bouteron, Marcel. *Études Balzaciennes*. Paris: Jouve, 1954.

Bovill, E. W. *The Golden Trade of the Moors*. London: Oxford University Press, 1958.

Braudel, Fernand. *The Mediterranean and the Mediterranean World in the Age of Philip II* (1966). New York: Harper and Row, 1972.

Bredius, A. "Archiefsprokkelingen. Inventaris van de vermogende verzamelaar Hans Brouwer." *Oud-Holland* 57 (1939).

———. "De Schilder Johannes van de Capelle." *Oud-Holland* 10 (1892).

Bredius, A., H. Brugmans, G. Kalff et al. *Amsterdam in de 17e eeuw*, ed. P. J. Blok. 3 vols. Gravenhage: Van Stockum, 1879–1904.

Bruck, Robert. *Friedrich der Weise als Förderer der Kunst*. Strassburg: J. H. E. Heilz, 1903.

Buchelius, Arnoldus. *Res Pictoriae*. In G. J. Hoogewerff and J. Q. van Regteren Altena, eds., *Quellenstudien zur Holländischen Kunstgeschichte*, vol. 15. Gravenhage: Nijhoff, 1928.

Bull, Peter. *Bear with Me*. London: Hutchinson, 1969.

Burckhardt, Jacob. *The Civilization of the Renaissance in Italy* (2d ed., 1868). Edited by Irene Gordan. New York: New American Library, 1960.

Burke, Peter. *Tradition and Innovation in Renaissance Italy* (1972). London: Fontana/Collins, 1974.

———. *Venice and Amsterdam*. London: Temple Smith, 1974.

Burton, Robert. *The Anatomy of Melancholy* (1651), Second Part. Edited by Holbrook Jackson. London: J. M. Dent, 1977.

Busse-Wilson, Elisabeth. *Das Leben der Heiligen Elisabeth*. Munich: C. H. Beck, 1931

Cabanne, Pierre. *Roman des Grand Collectioneurs*. Paris: Plon, 1961.

Cabrol, F., and H. Leckreg, eds. *Dictionnaire d'archéologie Chrétienne et de liturgie*. Paris, 1947.

Casson, Stanley. "The Popularity of Greek Archaic Art." *American Magazine of Art* 30 (1937).

Chambers, D. C. *The Imperial Age of Venice, 1380–1580*. London, 1970.

Champfleury, *Grand Figures d'hier et d'aujourd'hui*. Paris, 1861.

Chapeau, G., "Les Grandes Reliques de Charroux," *Bulletin de la Societé des antiquaires de l'Ouest* (1928).

Cholmondeley, R. H. *The Heber Letters, 1783–1832*. London: Batchworth, 1950.

Cicero, M. T. *The Verrine Orations*. Translated by L. H. G. Greenwood. Cambridge: Harvard University Press, 1928.

Cipolla, C. M., ed. *The Fontana Economic History of Europe, the Sixteenth and Seventeenth Century*. Glasgow: Collins, 1974.

Clark, Kenneth. *Leonardo da Vinci*. London: Cambridge University Press, 1939.

Codrington, R. H. *The Melanesians*. Oxford: Clarendon Press, 1891.

Coke, Desmond. *Confessions of an Incurable Collector*. London: Chapman and Hall, 1928.

Cole, Arthur H. *The Great Mirror of Folly: An Economic-Bibliographical Study*. Publication no. 6 of the Kress Library of Business and Economy. Boston: Harvard Graduate School of Business Administration, 1949.

Connell, Evan S., Jr. *The Connoisseur*. New York: Knopf, 1974.

Constable, W. G. *Art Collecting in the United States of America*. London: Thomas Nelson, 1964.

Cooper, Douglas, ed. *Great Private Collections*. New York: Macmillan, 1963.

Coquery C. *La Découverte de l'Afrique*. Paris: Juillard, 1965.

de Cosnac, L. G. de. *Les Richesses du Palais Mazarin (Inventory of 1661)*. Paris, 1884.

Coulton, G. G. *Medieval Panorama*. London: Cambridge University Press, 1938.

Curtius, Ernst Robert. *Balzac*. 2d ed. Bern: A. Francke, A. G. Verlag, 1951.

Dance, S. P. *Shell Collecting*. London, Faber and Faber, 1966.

Darlington, H. S. "The Meaning of Head Hunting." *Psychoanalytic Review* 26 (1939).

De Bury, Richard. *Philobiblon*. Oxford: Shakespeare Head Press, 1960.

Delehaye, Hippolyte. *Les origines du culte des martyrs*. 2d ed. Brussels: Société des Bollandistes, 1933.

DeMolen, Richard L., ed. *The Meaning of the Renaissance and Reformation*. Boston: Houghton Mifflin, 1974.

Denucé, Jean. *Art-Export in the 17th Century in Antwerp: The Firm Forchondt*. Antwerp: De Sikkel, 1931.

———. *De Konstkamers van Antwerpen in de XVIe en XVIIe eeuwen*. Antwerp: De Sikkel, 1932.

———. *L'Afrique de XVIe siècle et la Commerce Anversois*. Antwerp: De Sikkel, 1937.

Dibdin, T. F. *A Bibliographical Antiquarian and Picturesque Tour in France and Germany*. 3 vols. London, 1821.

———. *Bibliotheca Spenceriana*. 4 vols. London, 1814–1815.

Dietrichs, Albrecht. *Reliquienkult im Altertum*. Giessen, 1909.

Distinto ragguaglio dell' ottavo maraviglia del mondo. Milan, 1739.

Dodds, E. R. *The Greeks and the Irrational* (1951). Boston: Beacon Press, 1957.

Dornseiff, Franz. "Der Märtyrer: Name und Bewertung." *Archiv für Religionswissenschaft* 22 (1923–24).

Downs, R. E. "Head-Hunting in Indonesia." *Bijdragen tot de Taal-, Land-en Volkenkunde* 111 (1955).

d'Eaubonne, Françoise. *Honoré de Balzac*. Geneva: Editions Minerva, 1969.

Eccles, Lord. *On Collecting*. London: Longmans, 1968.

Edey, Winthrop. *French Clocks*. New York: Walker, 1967.

Elliott, J. H. *The Old World and the New, 1492–1650*. Cambridge: Cambridge University Press, 1970.

Engel, H. "The Life of Albert Seba." *Svenske linnésällsk Årsskr* 20 (1937).

Erikson, Erik H. *Childhood and Society*. New York: W. W. Norton, 1950.

――――. *Young Man Luther*. New York: W. W. Norton, 1958.

Eudel, Paul. *Collections et Collectioneurs*. Paris, 1885.

Evans, I. H. N. *The Religion of the Tempasuk Dusuns of North Borneo*. London: Cambridge University Press, 1953.

Evans, R. J. W. *Rudolf II and His World*. Oxford: Clarendon Press, 1973.

Evelyn, John. *The Diary of John Evelyn*. Edited by E. S. de Beer. London: Oxford University Press, 1959.

Fabriczy, Cornel von. *Filippo Brunelleschi*. Stuttgart: J. G. Cotta'sche Verlagsbuchhandlung, 1892.

Fagg, William. *African Tribal Images: The Katherine White Reswick Collection*. Cleveland: Cleveland Museum of Art, 1968.

Fargeaud M. and R. Pierrot. "Henri le trop aimé," *L'Année Balzacienne* (1961).

Fenichel, Otto. *The Psychoanalytic Theory of Neurosis*. New York: W. W. Norton, 1945.

Ferenczi, Sándor. *Further Contributions to the Theory and Technique of Psycho-Analysis*. London: Hogarth Press, 1950.

Fichtenau, Heinrich. *The Carolingian Empire* (1949). New York: Harper and Row, 1964.

――――. "Zum Reliquienwesen im früheren Mittelalter." *Mitteilungen des Instituts für Oesterreichische Geschichtsforschung* 60 (1952).

Fleming, S. J. "Bronze Technology in China." In Fleming, *Ancient Chinese Bronzes*. London: Eskenazi, 1975.

Fletcher, William Younger. *English Book Collectors*. London: Kegan Paul, Trübner, 1902.

Floerke, Hanns. *Studien zur Niederländischen Kunst- und Kulturgeschichte: Die Formen des Kunsthandels, das Atelier und die Sammler in den Niederlanden vom 15.–18. Jahrhundert*. Munich and Leipzig: G. Müller, 1905.

Fokkens, Melchior. *Beschrijvinge der wijdt-vermaarde koopstad Amstelredamum*. 1662.

Foss, Michael. *The Art of Patronage, 1660–1750*. London: Hamish Hamilton, 1972.

Förster, O. H. *Kölner Kunstsammler vom Mittelalter bis zum Ende des Bürgerlichen Zeitalters.* Berlin: Walter de Gruyter, 1931.

Freud, Sigmund. "Beyond the Pleasure Principle" (1920). In Freud, *S.E.*, vol. 18 (1955).

―――. "Psycho-Analytic Notes on an Autobiographical Account of a Case of Paranoia" (1911). In Freud, *S. E.*, vol. 12 (1958).

―――. "Some Character-Types Met with in Psycho-Analytic Work: The 'Exceptions'"(1916). In Freud, *S.E.*, vol. 14 (1957).

―――. *Standard Edition.* 24 vols. London: Hogarth Press, 1953–1974.

Sigmund Freud and Art. Edited by Lynn Gamwell and Richard Wells. Binghamton, N.Y.: State University of New York, 1989.

Friederici, Georg. *Skalpierung und ähnliche Kriegsgebräuche in Amerika.* Braunschweig: Friedrich Vieweg, 1906.

Friedländer, Ludwig. *Roman Life and Manners Under the Early Empire.* 4 vols. (7th ed., 1908). London: Routledge and Kegan Paul, 1965.

Frijling-Schreuder, E. C. M. "Honoré de Balzac: A Disturbed Boy Who Did Not Get Treatment." *International Journal of Psycho-Analysis* 45 (1964).

Funke, F. W. *Orang Agung,* 1. Leiden: E. J. Brill, 1958.

Ganshof, F. L. *The Carolingians and the Frankish Monarchy.* London: Longman, 1971.

Gay, Peter. *Freud: A Life for our Time.* New York: Norton, 1988.

Geary, Patrick, J. *Furta Sacra.* 2d ed. Princeton: Princeton University Press, 1990.

Gelder, H. E. van. "Gegevens omtrent den porceleinhandel der Oost-Indische Compagnie." *Economische-Historisch Jaarboek* 10 (1924).

Gerson, Noel B. *The Prodigal Genius: The Life and Times of Honoré de Balzac.* New York: Doubleday, 1972.

Gessner, Conrad. "De Hortis Germaniae Liber Recens, una cum Descriptione Tulipae Turcarum." *Valerii Cordi: Annotationes in Pedacii Dioscoridis Anazarbei de Medica Materia Libros* 5 (1561).

Getty, J. Paul. *As I See It.* London: W. H. Allen, 1976.

Geyl, P. *The Netherlands in the Seventeenth Century,* vol. 1, *1609–1648.* London: Ernest Benn, 1961.

Gimpel, Jean. *The Medieval Machine.* London: Victor Gollancz, 1977.

Gimpel, René. *Diary of an Art Dealer* (1963). New York: Farrar, Straus and Giroux, 1966.

Glennisson, J. and J. Day, eds. *Textes et documents d'histoire du moyen age, XIVe–XVe siècles.* Paris: S.E.D.E.S.

Goncourt, E. and J. de. *Journal,* vol. 1. Paris: Flammarion, 1935.

Gordan, Phyllis W. G. *Two Renaissance Bookhunters.* New York: Columbia University Press, 1974.

Gosses, I. H. and N. Tapikse. *Handboek tot de Staatkundige Geschiedenis van Nederland.* Gravenhage: Martinus Nijhoff, 1920.

Gozlan, Léon. *Balzac en pantoufles*. 3d ed. Paris: Michel Lévy, 1865.

Green, André. *On Private Madness*. Madison, Conn.: International Universities Press, 1986.

Greencare, Phyllis. *Emotional Growth*. 2 vols. New York: International Universities Press, 1971.

Grisar, H. "Die angebliche Christusreliquie im mittelalterlichen Lateran." *Römische Quartalsschrift* (1906).

──────. *Il Sancta Sanctorum*. Rome: Civiltà Cattolica, 1907.

Grolnik, S., L. Barkin, and W. Muensterberger. *Between Reality and Fantasy*. New York: Jason Aronson, 1978.

Guiffrey, Jules, ed. *Inventoires de Jean Duc de Berry (1401–1416)*. 2 vols. Paris: Ernest Leroux, 1894–1896.

Gusinde, M. "Schädelkult, Kopftrophäe und Skalp." *Ciba Zeitschrift* 5. (1937).

Guth, Paul. *Mazarin* (1974). Munich: Heine Verlag, 1976.

Hagenback, K. R. *Kirchengeschichte des Mittelalters*. 2 vols. Leipzig: S. Hirzel, 1886.

Händler, Gerhard. *Fürstliche Mäzene und Sammler in Deutschland von 1500–1620*. Strassburg, 1933.

Hanotaux, Gabriel and Georges Vicaire. *La Jeunesse de Balzac* (1903). Paris: Librarie des Amateurs, 1921.

Harner, Michael J. "Jivaro Souls." *American Anthropologist* 64 (1962).

Hauser, Arnold. *The Social History of Art*. 4 vols. New York: Vintage, 1957.

Heckscher, William S. *Rembrandt's Anatomy of Dr. Nicolaas Tulp*. New York: New York University Press, 1958.

Heer, Friedrich. *The Medieval World* (1961). New York: Mentor, 1963.

Heine-Geldern, Robert von. "Kopfjagd und Menschenopfer in Assam und Birma." *Mitteilungen der anthropologischen Gesellschaft* 47 (Vienna, 1917).

Hennus, M. F. "Frits Lugt, Kunstvorser-Kunstkeurder-Kunstgaarder." *Maandblad voor Beeldende Kunsten* 26 (1950).

Herbert, John. *Inside Christie's*. London: Hodder and Stoughton, 1990.

Herrmann, Frank. *The English as Collectors*. London: Chatto and Windus, 1972.

Hervey, M. F. S. *The Life, Correspondence and Collections of Thomas Howard, Earl of Arundel*. London: Cambridge University Press, 1921.

Hibbert, Christopher. *The Rise and Fall of the House of Medici* (1974). London: Penguin, 1979.

Hill, G. F. "Sodoma's Collection of Antiques" (Giovanni Antonio Bassi, Il Sodoma). *Journal of Hellenic Studies*, 26 (1906).

Holst, Niels von. "Frankfurter Kunst- und Wunderkammern des XVIII Jahrhunderts, ihre Eigenart und ihre Bestände." *Repertorium für Kunstwissenschaft* 52 (1931).

279

Hoffmann-Krayer, E. and H. Bächtold-Stäubli. *Handwörterbuch des Deutschen Aberglaubens*. 10 vols. Berlin and Leipzig, 1927–1942.

Honour, Hugh. *Venice*. London: Fontana/Collins, 1965.

Houghton, Walter E., Jr. "The English Virtuoso in the Seventeenth Century." *Journal of the History of Ideas* 3 (1942).

Huizinga, J. H. *Dutch Civilization in the 17th Century and other essays*. London: Collins, 1968.

———.*Herfstij der Middeleeuwen*. Haarlem: H. D. Tjeenk Willink and Zoon, 1919.

———. *The Waning of the Middle Ages*. New York: Doubleday, 1956.

Humbert, Pierre. *Un Amateur: Peiresc*. Paris: Desclée de Brouwer, 1933.

Hunt, Herbert J. *Honoré de Balzac*. London: Athlone Press, 1957.

Hutton, J. H. "Head-Hunters of the North-East Frontier." *Journal of the Royal Society of Arts* 85 (1936).

Huyskens, A. *Quellenstudien zur Geschichte der Heiligen Elisabeth*. Marburg: Verlag Elwerth, 1908.

Isaacs, S. "The Nature and Function of Phantasy." (*Jaarboek Amstelodamum* 14 [1916]). *International Journal of Psycho-Analysis* 29 (1948).

———. *Social Development in Young Children*. 5th ed. London: George Routledge, 1946.

Jackson, Holbrook. *The Anatomy of Bibliomania*. 2 vols. London: Soncino, 1930–31.

———. *The Fear of Books*. London: Soncino, 1932; New York: Scribner's, 1932.

Jensen, A. E. *Die Drei Ströme*. Leipzig: Harrassowitz, 1948.

Jensen, J. "Collector's Mania." *Acta Psychiatrica Scandinavia* 39 (1963).

Joffe, Walter G. "A Critical Review of the Status of the Envy Concept." *International Journal of Psychoanalysis* 50 (1969).

Johnson, Stowers. *Collector's Luck*. London: Phoenix House, 1968.

Jones, Ernest. *Papers on Psycho-Analysis*. London: Hogarth Press, 1923.

Jucker, Hans. *Vom Verhältnis der Römer zur bildenden Kunst der Griechen*. Frankfurt: Vittorio Klostermann, 1950.

Justi, Carl. *Winckelmann und seine Zeitgenossen*. 3 vols. Cologne: Phaidon Verlag, 1956.

Jutting, W. S. S. "A Brief History of the Conchological Collections of the Zoological Museum of Amsterdam." *Bijdregen voor Dierkunde* 27 (1939).

Kaufman, W. "Some Emotional Uses of Money." *Acta Psychotherapeutica* 4 (1956).

Kendall, Paul Murray. *Louis XI*. London: Allen and Unwin, 1971.

Kessel, Johann Hubert. *Geschichtliche Mittheilungen über die Heiligthümer der Stiftskirche zu Aachen*. Cologne und Neuss: L. Schwann, 1874.

Khan, M. R. Masud. "Foreskin Fetishism and its Relation to Ego Pathology in the Male Homosexual." *International Journal of Psycho-Analysis* 46 (1965).

Kirn, Paul. *Friedrich der Weise*. Leipzig, 1926.

Knorr, Georg Wolfgang. *De Naturlijke Historie der Versteeningen, of uitvoerige Afbeelding en Beschrijving van de versteende Zaken, die tot heden op den aardbodem zijn ontdekt*. Amsterdam: Jan Christiaan Sepp, Boekverkooper, 1773.

———. *Verlustiging der oogen van den geest of verzameling van allerley bekende hoorens en schulpen*. Amsterdam, 1770.

Koestler, Arthur. *The Act of Creation*. London: Hutchinson, 1964.

———. *The Sleepwalkers* (1959). London: Penguin, 1968.

Kohl, Johann Georg. *Vom Markt und aus den Zelle*. Hannover, 1868.

Kohut, H. *The Analysis of the Self*. New York: International Universities Press, 1971.

Kötting, Bernhard. *Peregrenatio Religiosa*. Münster: Regensberg, 1950.

———. *Der Frühchristliche Reliquienkult und die Bestattung im Kirchengebäude*. Cologne: Westdeutscher Verlag, 1965.

Kraus, H. P. *A Rare Book Saga*. London: André Deutsch, 1979.

Krelage, Ernst H. *Bloemenspeculatie in Nederland*. Amsterdam: P.N. van Kampen en Zoon, 1942.

Krelage, Ernst H., ed. *Pamfletten van de tulpen-windhandel, 1636–1637*. Gravenhage 1942.

Kruijt, A. C. "Het Koppensnellen der Toradja's van Midden-Celebes." *Verslagen en Mededeelingen, afd. Letterkunde*, 4de reeks [4th series], III, Nederlandsche Akademie van Wetenschappen (1899).

Lamy, E. *Les Cabinets d'histoire naturelle en France au XVIIIe siècle et le cabinet du Roi (1635–1793)*. Paris, 1930.

Landolt, Elisabeth. "Late Humanistic Art and Collecting in Basle." *Apollo* (December 1976): 467–75.

Laurens, Annie-France, and Krzysztof Pomian, eds., *L'Anticomanie*. Paris: Editions de l'École des Hautes Études en Sciences Sociales, 1992.

Le Décor de la Vie Privée en Hollande au XVIIe siècle. Paris: Institut Néerlandais, 1965.

Leeuw, G. van der. *Phänomenologie der Religion*. Tübingen: Verlag J. C. B. Mohr, 1933.

Lehman, H. C. and Witty, P. A. The Present Status of the Tendency to Collect and Hoard. *Psychol. Review*. 1927.

Lehoux, Françoise. *Jean de France, Duc de Berri. 1: De la naissance de Jean de France à la Mort de Charles V*. Paris: Éditions A. et. J. Picard et Cie., 1966.

Leonardi Bruni Arretini Epistolarum. L. Mehus, ed. Florence, 1741.

Leonhardt, G. *Het Huis Bartoletti en zijn Bewoners*. Amsterdam, 1979.

Letts, M. *Mandeville, the Man and His Book*. London: Hakluyt Society, 1949.

Letts, M., ed. *Mandeville's Travels*. 2 vols. London: Hakluyt Society, 1953.

Lewis, D. B. Wyndham. *King Spider: Some Aspects of Louis XI of France and His Companions*. London: William Heinemann, Ltd., 1930.

Lewis, Lesley. *Connoisseurs and Secret Agents*. London: Chatto and Windus, 1961.

Lewis, Wilmarth. *Collector's Progress*. London: Constable and Co., Ltd., 1952.

Lhotsky, Alphons. *Geschichte der Sammlungen*. Vienna: Festschrift des Kunsthistorischen Museums, 1941–1945.

Loos, Anita. *Gentlemen Prefer Blondes*. London: Brentano's, Ltd.

Lorant, André. *Les Parents pauvres d'Honoré de Balzac*. 2 vols. Genève: Droz, 1962.

Lorenz, Konrad. *On Aggression*. London: Methuen, 1967.

———. *Das Sogenannte Böse: Zur Naturgeschichte der Agression* (Vienna: Dr. G. Borothra-Schoeler Verlag, 1963); *On Aggression* (1963). London: Methuen, 1966.

Lugt, Frits. *Les Marques de Collections*. Amsterdam, 1921.

———. Italiaansche Kunstwerken in Nederlandsche Verzamelingen in vroegere tijden. *Oud Holland*. 53, 1936.

———. *Treasures from the collection of Frits Lugt at the Institut Néerlandais*. Denys Sutton, ed. Paris. Apollo, 1976.

Lunsingh Scheurleer, T. H. *Leiden University in the 17th Century*. Leiden: Brill, 1975.

Luzio, A. and Renier, R. Il Lusso di Isabella d'Este, Marchesa di Mantova. *Nuova Antologia*. Serie 4, 63–65, 1896.

Lüthi, Karl J. *Aus meinem Sammlerleben*. Bern: Bibliothek des Schweizerischen Gutenberg-Museums, Nr. 1, 1926.

MacCurdy, E. *The Notebooks of Leonardo da Vinci*. New York: George Braziller, 1956.

Mackay, Charles. *Extraordinary Popular Delusions and the Madness of Crowds*. London: George G. Harrap, 1956.

Mackay, James A. *The Tapling Collection of Postage and Telegraph Stamps and Postal Stationery*. Aberdeen: British Museum, 1964.

Major, Johann Daniel. *Unvorgreiffliches Bedencken von Kunst- und Naturalien-Kammern insgemein*. Kiel, 1662.

Mandeville, John. *Mandeville's Travels*. Edited and translated by Malcolm Letts. 2 vols. London: Hakluyt Society, 1953.

Manetti, Antonio di Tuccio. *The Life of Brunelleschi*. Edited by Howard Saalman. University Park: Pennsylvania State University Press, 1970.

Martin, W. "The Life of a Dutch Artist, part 6: How the Painter Sold His Work." *Burlington Magazine* 11 (1907).

Maurois, André. *Prometheus: The Life of Balzac* (1965). New York: Harper and Row, 1966.

Mayer-Löwenschwerdt, E. *Der Aufenthalt der Erzherzöge Rudolf und Ernst in Spanien, 1564–1571.* Vienna, 1927.

McDougall, J. *Theaters of the Mind.* New York: Basic Books, 1985.

McMurrich, J. Playfair. *Leonardo da Vinci, the Anatomist.* Baltimore: Williams and Wilkins, 1930.

Meiss, Millard. *French Painting in the Time of Jean de Berry.* 2 vols. London: Phaidon, 1967.

Meldola, Abraham. *Tulpen und Staatspapiere.* Hamburg: Hoffmann and Campe, 1830.

Meyer, Carl. *Der Aberglaube des Mittelalters.* Basel: Felix Schneider, 1884.

Meyer, Karl E. *The Plundered Past* (1973). New York: Penguin, 1977.

Meyer-Steineg, Th. and Sudhoff, K. *Geschichte der Medizin im Überblick.* Jena: Verlag von Gustav Fischer, 1922.

Minchinton, Walter. "Patterns and Structure of Demand 1500–1750." In Carlo M. Cipolla, ed., *The Fontana Economic History of Europe, the Sixteenth and Seventeenth Century.* Glasgow: Collins, 1974.

Mocquet, Jean. *Voyage en Afrique, Asie, Indes Orientales et Occidentales.* Paris, 1617.

Modell, Arnold H. "A Narcissistic Defence Against Affects and the Illusion of Self-Sufficiency." *International Journal of Psycho-Analysis* 56 (1975).

Monumenta Germaniae Historica. Scriptorum, vol. 15, part 1, *Translationibus et Miraculis Sancti Germani.* Hannover: Bibliopolii Hahniani, 1887.

Muensterberger, W. "Between Reality and Fantasy." In S. Grolnik, L. Barkin, and W. Muensterberger, eds., *Between Reality and Fantasy,* pp. 3–13. New York: Jason Aronson, 1978.

―――. "The Creative Process: Its Relation to Object Loss and Fetishism." *Psychoanalytic Study of Society* 2 (1962).

―――. "Psyche and Environment: Sociocultural Variations in Separation and Individuation." *Psychoanalytic Quarterly* 38 (1969): 191–216.

Muensterberger, W., ed. *Man and His Culture: Psychoanalytic Anthropology After "Totem and Taboo."* New York: Taplinger, 1969.

Müller, Wolfgang J. *Der Maler Georg Flegel und die Anfänge des Stillebens.* Frankfurt a. M., 1956.

Mumford, Lewis. *The Condition of Man.* New York: Harcourt, Brace, 1944.

―――. *Technics and Civilization.* New York: Harcourt Brace, 1939.

Munby, A. N. L. *The Catalogues of Manuscripts and Trinket Books of Sir Thomas Phillipps: Their Composition and Distribution.* Cambridge: Cambridge University Press, 1951.

――――. *The Cult of the Autograph Letter in England.* London: Athlone, 1962.

――――. *The Family Affairs of Sir Thomas Phillipps.* Cambridge: Cambridge University Press, 1952.

――――. *Phillipps Studies.* 5 vols. Cambridge: Cambridge University Press, 1951–1960.

Mundinus (Raimondo Mondino de' Lucia). *Anothomia* (completed in 1316). Pavia, 1478.

Munting, A. *Waare Oeffening der Planten.* Amsterdam, 1672.

Müntz, Eugène. "Gem Collecting in the Middle Ages." *Journal des Savants* (1888).

――――. *La Renaissance en Italie et en France.* Paris, 1885.

Murray, David. *Museums, Their History and Their Use.* 3 vols. Glasgow: James MacLehose, 1904.

Nabokov, Vladimir. *Speak, Memory.* New York: G. P. Putnam's, 1960.

Neickel, Joh. Caspar. *Museographia.* Leipzig, 1727.

Newton, A. Edward. *The Amenities of Book-Collecting and Kindred Affections.* Boston: Atlantic Monthly Press, 1916.

Nicollier, Jean. *Collecting Toy Soldiers.* Rutland: Charles E. Tuttle, 1967.

Noack, F. *Das Deutschtum in Rom.* 2 vols. Stuttgart: Deutsche Verlagsanstalt, 1927.

Panofsky, E. "Abbot Suger of St. Denis." In Panofsky, *Meaning in the Visual Arts* (1955). London: Penguin, 1970.

Parry, J. H. *The Age of Reconnaissance.* London: Weidenfeld and Nicolson, 1963.

――――. *The European Reconnaissance.* London: Macmillan, 1968.

Partington, Wilfred. *Thomas J. Wise in the Original Cloth.* London: Robert Hale, 1946.

Peacham, Henry. *The Compleat Gentleman.* London: Francis Constable, 1634; facsimile ed., Oxford: Clarendon Press, 1906.

Penrose, B. *Travel and Discovery in the Renaissance.* Oxford: Clarendon Press, 1906; facsimile ed., Cambridge: Harvard University Press, 1952.

Perrenot de Granville, François Thomas. Letter to, dated February 28, 1605. *Jahrbuch der Kunsthistorischen Sammlungen des allerhöchsten Kaiserhauses* 19 (1889), nr. 16534.

Petit-Dutaillis, Charles. "France: Louis XI." In *Cambridge Medieval History*, vol. 8. Cambridge: Cambridge University Press, 1936.

Philippovich, Eugen von. *Kuriositäten-Antiquitäten.* Braunschweig: Klinkhardt and Biermann, 1966.

Phillips, Sir Thomas. Catalogue of *The Celebrated Collection of Manu-*

scripts Formed by Sir Thomas Phillipps. Property of the Trustees of the Robinson Trust, Sotheby's, London (June 27, 1966).

Piaget, Jean. *The Child's Conception of the World.* London: Paladin, 1973.

Piccolomini, P. *La Vita e l'opera di Sigismondo Tizio (1458–1528).* Siena, 1903.

Posthumus, N. W. "De Speculatie in Tulpen in de Jaren 1636–1637." *Economisch-Historisch Jaarboek* 12 (1926), 13 (1927), and 18 (1934).

―――. "The Tulip Mania in Holland in the Years 1636 and 1637." *Journal of Economic and Business History* 5 (1929).

Praz, Mario. *The House of Life.* London: Methuen, 1964.

Price, J. L. *Culture and Society in the Dutch Republic During the 17th Century.* London: B. T. Batsford, 1974.

Pyrard, François. *The Voyage of François Pyrard of Laval to the East Indies.* 2 vols. London: Hakluyt Society, 1887–1889.

Reich, Annie. "Pathological Forms of Self-Esteem Regulation." *Psychoanalytic Study of the Child* 15 (1960).

Reijnst, Elisabeth. "Sammlung Gerrit und Jan Reijnst" (typescript). Amsterdam: Rijksmuseum, 1964.

Reina, R. E. "The Ritual of the Skulls." *University Museum of Pennsylvania Expedition* 4 (1962), no. 4: 26–35.

Reitlinger, Gerald. *The Economics of Taste* (1963). New York: Holt, Rinehart and Winston, 1965.

Reuschel, Wilhelm. *Die Sammlung Wilhelm Reuschel.* Munich: Bruckmann Verlag, 1963.

Reznicek, E. K. J. "Het begin van Goltzius' loopbaan als schilder." *Oud-Holland* 75 (1968).

Rheims, Maurice. *Art on the Market* (1959). London: Weidenfeld and Nicolson, 1961.

Ribbing, Gerd. *Spansk Atlantkust.* Stockholm, 1952.

Richter, G. M. A. *Three Critical Periods in Greek Sculpture.* Oxford: Clarendon Press, 1951.

Ricketts, Charles. *Self-Portrait: Letters and Journals of Charles Ricketts.* Edited by Cecil Lewis. London: Peter Davies, 1939.

Riedel, J. F. F. *De Sluik-en Kroesharige Rassen tusschen Selebes en Papua.* The Hague: Nijhoff, 1886.

Robinson, J. Armitage. *The Times of St. Dunstan.* Oxford: Clarendon Press, 1923.

Roncière, C. de la. *La Découverte de l'Afrique en Moyen Age.* 3 vols. Cairo, 1929.

Rosenbach, A. S. W. *Books and Bidders.* Boston: Little Brown, 1927.

Rosenberg, Alfons. *Don Giovanni.* Munich: Prestel Verlag, 1968.

Róheim, Géza. "War, Crime and the Covenant." *Journal of Clinical Psychopathology.* 1 (1945).

Rycroft, Charles. *Anxiety and Neurosis.* London: Allen Lane, 1968.

Saarinen, Aline B. *The Proud Possessors*. New York: Random House, n. d.

Salutati, Coluccio. *Epistolario di Coluccio Salutati*. Edited by F. Novati. 3 vols. Rome, 1896.

Schack, William. *Art and Argyrol*. New York: Yosselson, 1960.

Schama, S. *The Embarrassment of Riches*. New York: Knopf, 1987.

Schärer, H. "Das Menschenopfer bei den Katinganern." *Tijdschrift voor Indische Taal-, Land- en Volkenkunde* (1938).

————. "Die Bedeutung des Menschenopfers im Dajakischen Totenkult." *Mitteilungen der Deutschen Gesellschaft für Völkerkunde* 10 (1940).

Scheicher, E. et al. *Die Kunstkammer*. Innsbruck: Kunsthistorisches Museum, 1977.

Scheller, R. W. "Rembrandt en de Encyclopedische Kunstkamer." *Oud-Holland* (n. d.).

Schierbeek, A. *Jan Swammerdam, Zijn Leven en Zijn Werken*. Lochem: De Tijdstroom, 1946.

Schreiber, Lady Charlotte. *Lady Charlotte Schreiber's Journals*, ed. Montague Guest. 2 vols. London: John Lane, The Bodley Head, 1911.

Segal, Morey M. "Impulsive Sexuality: Some Clinical and Theoretical Observations." *International Journal of Psycho-Analysis* 44 (1963): 407–18.

Seidel, P. "Friedrich der Grosse als Sammler von Gemälden und Skulpturen." *Jahrbuch der Preussischen Königlichen Sammlungen*, XIII (1892).

Seligman, Germain. *Merchants of Art*. New York: Appleton-Century Crofts, 1961.

Seruen, James E. *The Collecting of Guns*. Harrisburg, Penn.: Stackpole, 1964.

Seters, W. H. van. *Pierre Lyonet 1706–1789: Sa vie, ses collections de coquillages et de tableaux, des recherches entomologiques*. Gravenhage: Nijhoff, 1962.

Singer, Carles Joseph and C. Rabin. *A Prelude to Modern Science*. Cambridge: Wellcome Museum, 1946.

Smith, George. *Bishop Heber*. London: John Murray, 1895.

Sox, David. *Unmasking the Forger*. New York: Universe Books, 1987.

Speiser, Felix. "Note à propos des Dents de Cochon Déformées dans le mer du Sud et en Indonésie." *Revista Instituto Etnologico* 2 (1932).

Spener, Jo. Jac. *Das Spenerische Cabinet oder kurtze Beschreibung aller so wol künstlich- als natürlicher alter als neuer fremder als einheimischer courieusen Sachen*. Leipzig: Christoph Fleischer, 1693.

Speth-Holterhoff, S. *Les Peintres Flamands de Cabinets d'Amateurs au XVIIe siècle*. Amsterdam and Brussels: Elsevier, 1957.

Steinbeck, John. *Travels with Charley* (1962). New York: Bantam, 1976.

Steiner, George. "A Note on Language and Psycho-Analysis." *International Revue of Psycho-Analysis* 3 (1976): 253–58.

Strabo, *The Geography of Strabo*. vol. 4. Translated by H. L. Jones. Cambridge: Harvard University Press, 1927.

Stückelberg, E. A. "Reliquien und Reliquiare." *Mitteilungen der Antiquarischen Gesellschaft* 24 (1899).

Surville, Laure. *Balzac, sa vie et ses oeuvres*. Paris: Jaccottet, Bourdillat, 1858.

Tawney, R. H. *Religion and the Rise of Capitalism* (1922). London: Penguin, 1964.

Taylor, F. H. *The Taste of Angels*. Boston: Little, Brown, 1948.

Temple, Sir William. *Observations upon the United Provinces of the Netherlands*. London: Printed by A. Maxwell for Sa. Gellibrand at the Golden Ball in St. Paul's Church-Yard, 1673.

Thomas, Alan G. *Great Books and Book Collectors*. London: Weidenfeld and Nicolson, 1975.

Tolpin, Marian. "On the Beginning of a Collective Self." *Psychoanalytic Study of the Child* 26 (1972).

Tonellis, T. de, ed. *Poggii Epistolae*, vol. 1. Florence, 1832.

Tregear, Edward. *The Maori-Polynesian Comparative Dictionary*. Christchurch, N.Z.: Whitcombe and Tombs, n.d.

Tremayne, E. *The First Governess of the Netherlands, Margaret of Austria*. New York: G. P. Putnam, 1908.

Trevor-Roper, H. R. *The Crisis of the Seventeenth Century: Religion, the Reformation and Social Change*. New York: Harper and Row, 1968.

———. *The Plunder of the Arts in the Seventeenth Century*. London: Thames and Hudson, 1970.

———. *Princes and Artists*. London: Thames and Hudson, 1976.

Ullman, B. L. *The Humanism of Coluccio Salutati*. Padua, 1963.

Vessberg, O. *Studien zur Kunstgeschichte der Römischen Republik*. Lund: Acta Instituti Romani regni Suediae, 1941.

Von Schlosser, Julius. *Die Kunst- und Wunderkammern der Spätrenaissance*. Leipzig: Klinkhardt and Biermann, 1908.

Von Schwarzenfeld, Gertrude. *Rudolf II, der Saturnische Kaiser*. Munich: D. W. Callway, 1960.

Wallace, K. "Slim-Shin's Monument." *The New Yorker* (November 19, 1960): 104–46.

Wallis Budge, E. A. *Amulets and Superstitions*. London: Oxford University Press, 1930.

Walser, Ernst. *Gesammelte Studien zur Geistesgeschichte der Renaissance*. Edited by Werner Kaegi. Basel: Benno Schwabe, 1933.

———. *Poggius Florentinus*. Leipzig: B. G. Teubner, 1914.

Weiss, Roberto. *The Renaissance Discovery of Classical Antiquity* (1969). Oxford: Basil Blackwell, 1973.

Wen Fong, ed. *The Great Bronze Age of China.* New York: The Metropolitan Museum/Alfred A. Knopf, 1980.

Whitley, M. T. "Children's Interest in Collecting." *Journal of Educational Psychology* 20 (1929).

Wilken, G. A. "Iets over de schedelvereering bij de volken van den Indischen Archipel." *Bijdragen van het Koninklijk Instituut voor de Taal-, Land- en Vokenkunde van Nederlandsch Indië* 5 (n.d.).

Winckworth, R. "The Davila Catalogue." *Journal of Conchology* 22 (1946).

Winner, M. "Gemalte Kunsttheorie." *Jahrbuch der Berliner Museen* 4 (1962): 151–85

Winnicott, D. W. *The Child and the Family.* London: Tavistock, 1957.

——. *Collected Papers: Through Paediatrics to Psycho-Analysis.* New York: Basic Books, 1958.

——. *The Maturational Processes and the Facilitating Environment.* New York: International Universities Press, 1965.

——. *Playing and Reality.* New York: Basic Books, 1971.

——. "Transitional Objects and Transitional Phenomena." *International Journal of Psycho-Analysis* 34 (1953).

Winterich, John T. *A Primer of Book Collecting.* New York: Crown, 1966.

Winterstein, Alfred. "Der Sammler." *Imago* 7 (1921).

Wirz, Paul. "Der Ersatz in der Kopfjägerei und die Trophäenimitation." *Beiträge zur Gesellschaft- und Völkerwissenschaft* (1950).

——. *Die Marind-anim von Holländisch-Süd-Neu-Guinea*, vol. 2, part 3. Hamburg: Kommissions-Verlag Friederichsen, 1925.

——. "Kopfjagd und Trophäenkult im Gebiet des Papuagolfes." *Ethnologischer Anzeiger* 3 (1933).

Wittlin, Alma S. *The Museum, Its History and Its Task in Education.* London: Routledge and Kegan Paul, 1949.

Witty, P. A. and H. C. Lehnan. "Further Studies of Children's Interest in Collecting." *Journal of Educational Psychology* 21 (1930).

Worm, O. *Museum Wormiarum.* Leiden: Lugduni Batavorum, 1655.

Wurffbain, Friedericus Sigismundus. *Dissertiatio de Technophysiotameis von Kunst- und Naturalienkammern.* Altdorf: Henricus Meyer, 1704.

Zimmermann, Heinrich. Kunstgeschichtliche Charakterbilder, "Rudolf II und die Prager Kunstkammer." *Jahrbuch der Kunsthistorischen Sammlungen des Allerhöchsten Kaiserhauses* 25 (Vienna, 1893).